Dimitris Plantzos

c. 1200–30 BC Greek Art
and Archaeology

Translated by NICOLA WARDLE

Front cover: details of fig. 62, 155, 293, 525
Back cover: fig. 328

© 2016 Kapon Editions, Athens, Greece - Dimitris Plantzos
KAPON EDITIONS
23–27 Makriyanni St Athens 117 42, Greece
Tel. (+30) 210 9235 098, (+30) 210 9210 983 (bookshop)
e-mail: info@kaponeditions.gr www.kaponeditions.gr

English translation © 2016 Kapon Editions
First published in Greek and English by Kapon Editions

Lockwood Press, PO Box 133289, Atlanta, GA 30333 USA
www.lockwoodpress.com admin@lockwoodpress.com

ISBN: 978-1-937040-57-4

Library of Congress Control Number: 2016937540

Cover design by SUSANNE WILHELM

Dimitris Plantzos

c. 1200–30 BC Greek Art
and Archaeology

 LOCKWOOD PRESS

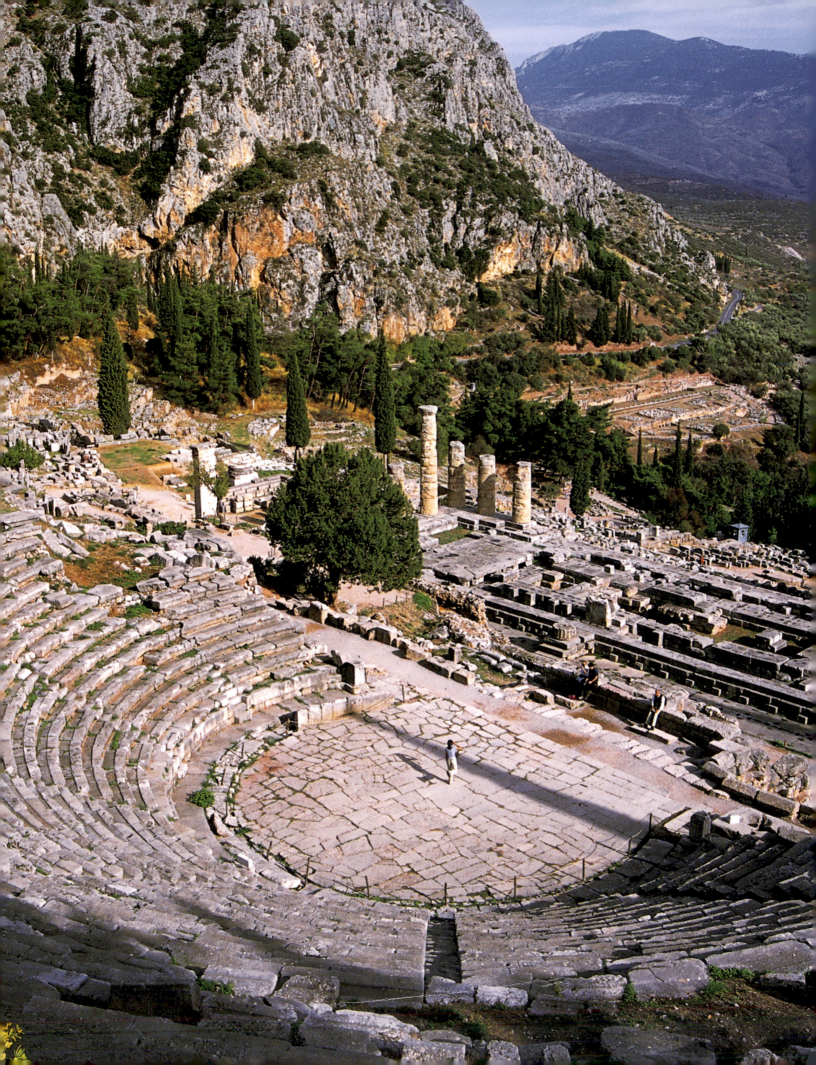

CONTENTS

7 Preface

10 **CHAPTER 1**
Classical archaeology: sources and methodology

34 Chronology
35 Map I: Greece and the eastern Mediterranean

36 **CHAPTER 2**
The Early Iron Age (1100–700 BC)

64 **CHAPTER 3**
The Archaic Period (700–480 BC)

140 **CHAPTER 4**
The Classical Period (480–336 BC)

226 Map II: the Hellenistic world

228 **CHAPTER 5**
The Hellenistic Period (336–30 BC)

300 Index
304 Sources of illustrations

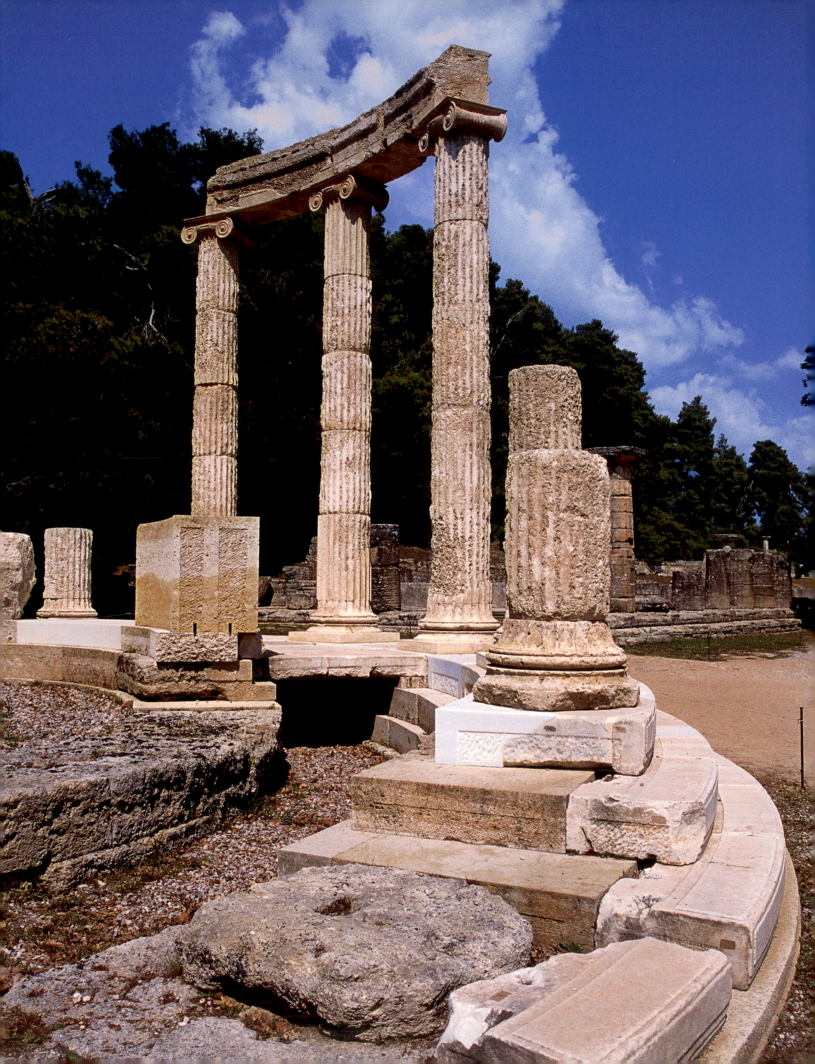

PREFACE

An awareness of the past, an historical sense if you will, is a prerequisite for any sense of the future and for the possibility of change. The Greeks' historical sensitivity is demonstrated first by their concern with their own myth-history and the uses to which it was put, then by the conscious efforts of their historians, the world's first, to record, explain, and provide cautionary models for the future.

JOHN BOARDMAN

Long before they became, rather unwittingly, an exalted paradigm for European modernity, the Greeks had worked to create a civilization based on its own materiality; on observation of nature and its laws; on love for the human body, its form and its aesthetic appeal, its strength and its weakness; on dedication to symmetry and rhythm, on the metaphysical power of decoration, on the texture of materials, on design, and color; on the cultural value of a narrative built through images; based, finally, on the ability of an image to record both present and past in meeting the needs of a society that communicated through literary and artistic narratives.

This did not only relate to the physical aspects of ancient Greek culture, that which we today call "Art." The Greeks did not separate art from craft, or indeed "high culture" from "entertainment." They did not have tourist-filled galleries or museums; they did not believe in "Art for Art's sake"; they did not have "semi-precious" stones. The material culture of ancient Greece is an inseparable part of what we call "Greek history": the first and second colonization, the creation of the hoplite phalanx, the reforms of Kleisthenes and the democracy of Perikles, as historical processes are all governed by the same faith in humanity, nature, and symmetry. At the same time as Greek artists labored to achieve realism in their art — or rather to achieve an idealistic version, so typical of ancient Greece, of a seemingly realistic genre— their philosopher contemporaries struggled to understand the role of *mimesis* ("imitation") in both the ideal and the real worlds.

If these observations seem to be influenced more by the picture we moderns have formed of ancient Greece, and less by the image the ancient Greeks had of themselves, it is because the Greeks and their culture have been subject to our own sensitivities for many centuries now: Greco-Roman civilization had the unexpected fortune, as we shall see in the first chapter of this book, to provide the cultural genealogy of Western modernity,

Page. 4: Delphi, the theater and the temple of Apollo. 2004.

Page. 6: Olympia, the Philippeion. 2007.

an ancestry that of course has been selectively edited. That which was the privilege of the ruling classes for centuries, a knowledge of the ancient Greek language, history, and art, did not remain untouched by the stifling embrace of the *kaloi kagathoi* ("the great and the good") of the modern world — art in particular was and remains a source of collectors' items for the economic elites in the west and, now, the east. In short, we "read" into the Greeks more of our own characteristics, properties, and qualities than theirs. We identify with the philosophy, the democracy, the art, and literature which (as we like to presume) the ancient Greeks bequeathed to us, but we barely understand the social justice that ruled the Greek *polis*, their morality of warfare, or their erotic practices for that matter.

Art, in particular, comes to us burdened with the cruelty of natural selection and the chance of discovery: materials common in the everyday life of the Greeks, such as wood or leather, do not survive the passage of time and it is often calculated that we know about only 10% of ancient works of art, and these only in the categories with the highest survival rate such as pottery (in other cases it drops below 1%). But even beyond this, ancient Greek art reaches us idealized by the Neoclassical passion for white marble (ignoring the fact that the ancient art works were vividly colored); mythologized by the romantic "charm of ruins" (ignoring the fact that ancient sites were places full of life and not places of refuge for cultural reminiscence and idle contemplation); traduced, ultimately, by the post-Classical (Roman, Renaissance, Modern, and Post-Modern) appropriation, use and abuse of the Classical past.

The teaching of Classical archaeology is — and should be— an acrobatic act of sorts, balancing between solid textual or material evidence and its interpretation. It is neither simply "archaeology" nor just "history." This book is addressed to those studying ancient Greek culture, but also to those interested in a concise, but thorough, overview of the material remains of the Classical Greek past. It combines the detailed — frequently, as well as inevitably, academic— study of the artifacts and of the categories into which modern science has placed them with an effort to make these often fascinating objects comprehensible as sources of historical and cultural information. This book discusses the main groups of facts and artifacts required for the study of Classical archaeology, providing the necessary terminology and methodology as well as short guides for further reading on each subject or period. Typical case studies enable a first assessment of what we know about Classical civilization and a basis for our conclusion and hypotheses. The introduction provides a brief account of the formation of the discipline of Classical archaeology as an aspect of classical studies, and of its aims, sources, and methods. After this introductory chapter the material culture of ancient Greece is set out, period by period, starting from the Early Iron Age and continuing through the Archaic, Classical, and Hellenistic periods (Ch. 2–5).

I am grateful to Rachel and Moses Kapon for their courage in taking on this publication in the Greek language back in 2011, for their friendship and positive encouragement over the years, as well as their opportune interventions concerning style and presentation. I am also grateful to Nicola Wardle who translated my original Greek text into English once Kapon Editions decided to take the extremely precarious step of attempting an international edition of the book, and to Lockwood Press and its people for embracing this effort in the United States. I am indebted to Panos Tsaligopoulos for his manifold support and encouragement since day one of this project. Finally, I warmly thank my colleagues and friends who agreed to read extensive excerpts of the book and to share with me, with intellectual and academic generosity, their views, and criticisms: Dimitris Damaskos, Antonis Kotsonas, and Anna Lemos saved me, indeed, from many an embarrassment, though, as it is customary to point out, all remaining blunders are my own.

In writing this book, I had the opportunity to recall with respect and admiration the scholarship of those who taught me, as much in the lecture theater as through the written page. This work of mine is dedicated to my teachers in the Department of History and Archaeology of the University of Athens and in the Classics Faculty in the University of Oxford, with the hope that they do not consider that their efforts were in vain. Finally, I dedicate this book to my first-year students at the Universities of Ioannina and Athens (2010–2015) who guided my steps with their interest, involvement or —alas!— their silence.

D.P.
March 2016

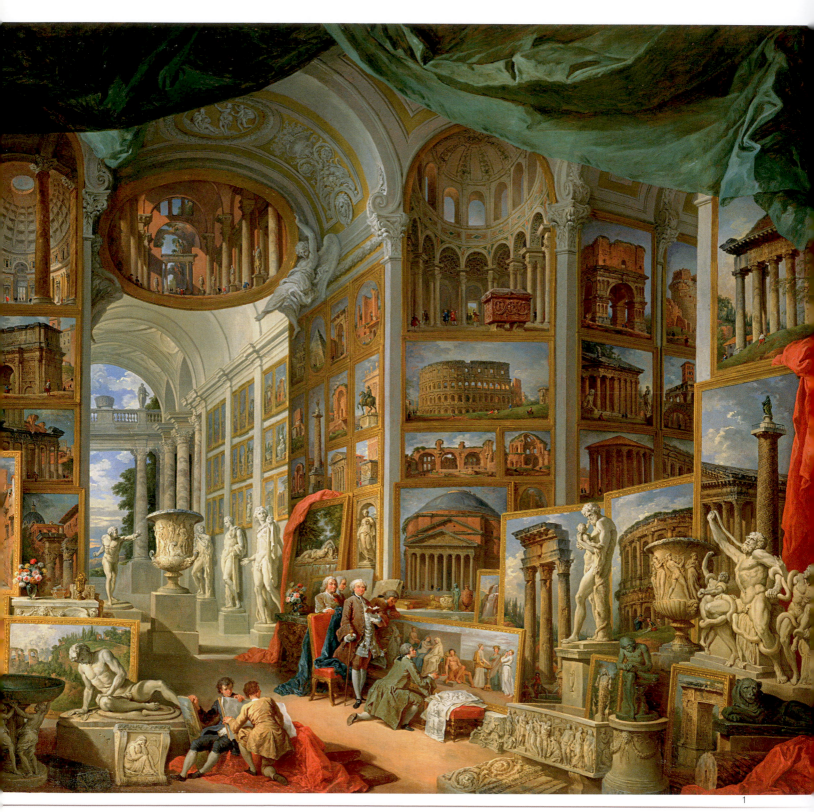

1. Giovanni Paolo Panini, Ancient Rome. 1757. New York,
Metropolitan Museum of Art 52.63.1.

CLASSICAL ARCHAEOLOGY
SOURCES AND METHODOLOGY

1. ARCHAEOLOGY

An interest in the past is common in most human societies. Over time, communities across the world satisfied their need for clear, authentic, and reliable knowledge of their history with mythical narratives, traditions, and chronicles, handed down, virtually unaltered, from generation to generation. The material remains of the past, the ruins of bygone days, the weapons, tools, or jewelry that had been used by those who lived on the same land many decades or centuries before, often gave birth to myths and fables, traditions, and rituals, religious convictions and superstitious beliefs: European villagers in the Middle Ages collected prehistoric stone tools found by chance, thinking that they were the work of some metaphysical force and thus were endowed with magic properties. A similar practice has been observed in several Indian tribes of North America in the fifteenth and sixteenth centuries AD. At the same time, the Aztecs in Central America were conducting religious ceremonies in the ruins of a civilization that had flourished in their area during the first millennium BC. In cultures where writing was known, such as the Egyptian and the Babylonian, material remains of the past became collectable objects, systematically studied as a source of knowledge about history already by the second and first millennia BC.

The very concept of *history*, however, is not common in human cultures. In many societies it does not exist, as the need for knowledge of the past is met by the recounting of stories of edifying and moralizing character. In ancient China in the second century BC, on the other hand, touring of ancient ruins and studying the material remains of the past was part, alongside the study of ancient texts, of historical research with the aim of recording what happened in the past, an exercise that had a paradigmatic and educational use. In ancient Greece, the task of recording historical events, undertaken so that they would not be forgotten, but also in order to form an object of admiration as well as a source of knowledge for later generations, had begun already by the fifth century BC. Herodotus and (chiefly) Thucydides attempted systematic recording and analysis of the facts at their disposal. Occasionally in their texts historical research is combined with the observation and evaluation of the material remains of the past. A typical example is the observation by Thucydides regarding the tombs of the ancient inhabitants of Delos, whom he recognized as Carians on the basis of their manner of burial and the type of weapons with which they had been buried (1.8). In the same period, the term *archaiologia* ("archaeology") was first used in Greek, to mean a "disquisition on the antique," that is an informed discussion about the past, usually conducted in the form of recounting past events.

Systematic observation of monuments was introduced into historiography much later, towards the end of the first millennium BC, when amongst the societies of the wider Greek area, but also in the rest of the eastern Mediterranean, the Greek culture of the fifth and fourth centuries BC began to be appreciated as an aesthetic and cultural paradigm. Pausanias, a second century AD traveler and geographer from Asia Minor, systematically describes public buildings, works of art, traditions, and customs from different areas of Greece with genuine

historical interest in his monumental work *Description of Greece*. At the same time, he avoids commenting on ruins or monuments that have no place in his own present.

Historical and archaeological investigations were carried out, as we shall see in following sections of this chapter, mainly after the onset of the Renaissance in the fifteenth century, when natural curiosity about the past was combined gradually with the belief in systematic study and critical evaluation of the sources at hand. The intellectual movement of the Enlightenment during the eighteenth century and after encouraged the belief that human civilization was the result of

As an academic discipline, **archaeology:**
- is dedicated to the collection, recording, analysis, and classification of material remains from the past
- employs a systematic analysis and interpretation of all archaeological evidence available in order to study past societies and their cultural environment.

continuous development and progress, while creating at the same time a need for this development to be scientifically documented. A little later, the emergence of Romanticism and the dramatic onslaught of romantic ideals created the perception that human societies (those that are usually described as "peoples," "nations," or "cultures") are living organisms imbued with innate natural predilections and destined to be "born," to "flourish," to "decline," and finally to "be lost" or "die." The creation of nation-states in Europe during the nineteenth century provided a significant impetus to the development of archaeology as an academic discipline investigating the material remains of a nation's past in order to demonstrate its historical legitimacy and assert its cultural exceptionality. Archaeologists were thus entrusted with the task of discovering, studying, and promoting vestiges of the past as tangible evidence upon which a nation's history was to be forged.

Today, archaeology is no more defined exclusively as the discovery of material remains — "archaeological treasures" — of the past, but as the systematic and multidisciplinary study of the societies that produced them.

2. CLASSICAL ARCHAEOLOGY AS AN ACADEMIC DISCIPLINE

Archaeology is part of an interdisciplinary academic network that includes history, anthropology, social anthropology, ethnography, and other *humanities*, that is academic fields focussing on the study of human cultures of the past and/or the present.

Classical archaeology is a specific branch of archaeology that studies the material remains of Greco-Roman ("classical") culture. Therefore, Classical archaeology is *also* part of classical studies, along with classical philology and classical ("ancient Greek and Roman") history.

The term *classical studies* refers to the branch of the Humanities that incorporates the literary, historical, and archaeological research into ancient Greece and Rome, i.e. **classical antiquity**. The object, therefore, of classical archaeology is the study of the cultures of ancient Greece and Rome that emerged in the Mediterranean during a period which is conventionally dated to between 1200 BC–AD 400.

In brief, Greco-Roman civilization:
- was already called **classical** in antiquity, because it was thought to express "classic" (i.e. positive) standards of timeless, universal human values (originally, the Latin adjective *classicus* referred to a rare privilege only the upper classes could afford).
- it became a source of inspiration and point of reference for modern western cultures (from the Renaissance to the present day).

As an academic discipline studying the material remains of Greco-Roman civilization, classical archaeology approaches classical culture through all its physical manifestations, and particularly:
- **natural environment:** the geophysical landscape and the spaces where human activity developed in classical antiquity
- **built environment:** the landscape that bears clear signs of human intervention (occupation, fortification, worship)
- **technology:** the means by which humans intervened in the environment during classical antiquity (including the techniques and the materials for building and the techniques for the acquisition, exploitation, and processing of raw materials)
- **material culture:** the entire process of material production, whether of objects of direct or indirect aesthetic value or not (the term includes every type of material product of technological or artistic endeavor).

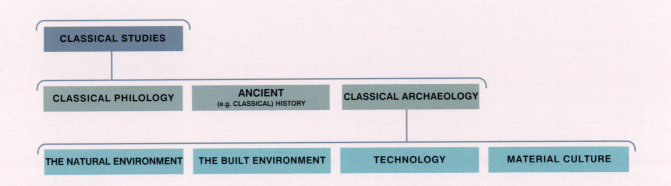

CLASSICAL CIVILIZATION AND GRECO-ROMAN "CULTURE"

The term culture usually refers to the *collective intellectual and material traditions generated by a certain community which, in turn, define the community itself*. Therefore, by saying that the subject of classical archaeology is the study of classical culture on the basis of its material remains we are referring to classical civilization as a whole, that is:

- material culture (arts and crafts, technology, architecture)
- social structures and institutions through which a given society operates itself (politics, economy, religion, tradition)
- ideas and values expressed via the society's intellectual and actual life (philosophy, literature, the natural sciences)

The interaction of these three spheres creates that which we call the "culture" of a particular human society:

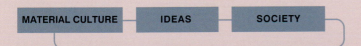

Classical archaeology, therefore, being the study of the whole of Greco-Roman culture, does not limit itself to the revision of material culture alone (which we often define restrictively as "art"); rather it also concerns itself with social structures, beliefs, and ideas of the past, given that the classical archae-ologist studies all facets of communal life, from cult practice and burial customs to technology and such politically motivated activities as war.

Therefore classical archaeologists act as *cultural historians* and the scope of their discipline may be defined briefly as follows:

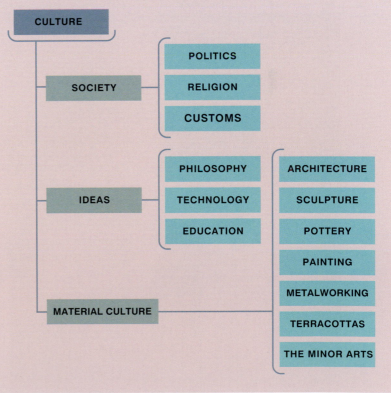

Classical archaeology thus has as its ultimate goal the systematic study of classical civilization in its entirety, using as a starting point the material remains of the past whilst also exploiting the evidence provided by the written record.

2.1 The discovery of classical civilization (Fifteenth–nineteenth centuries)

Co-existence with material remains from the classical past, whether ruined buildings or portable artifacts, affected the inhabitants of Medieval Europe in different ways. Quite often, Greco-Roman monuments fell victim to religious intolerance, such as the sculptural decoration of the Parthenon, which was severely damaged by early Christians as it was thought to be a symbol of paganism and impiety. In later times, scraps from earlier monuments were incorporated into new buildings as bearers of cultural memory. A typical example of this practice is the Panagia Gorgoepikoos in Athens (also dedicated to St. Eleutherios and known as "the Little Metropolis"), a church that is habitually dated to the twelfth–thirteenth centuries, but is perhaps significantly later. The church's exterior was almost entirely covered with material from antique buildings, while Greco-Roman sculptural reliefs were "displayed" on its façade, as if to embellish the building and "advertise" its ties to Athens' classical past (fig. 2).

During the Renaissance, widespread interest in classical literature, and the emergence of the classical ideal as cultural and aesthetic paradigm for the West, also generated an active

3

4

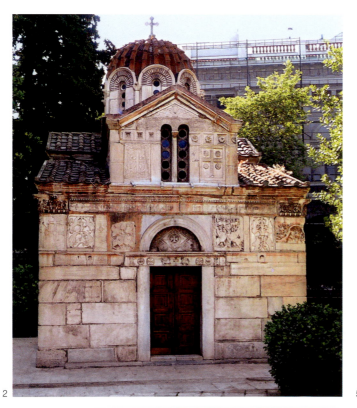

2

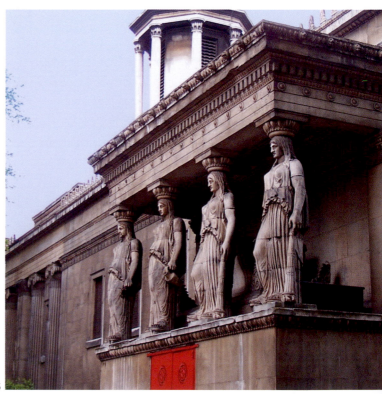

5

2. Athens, Panagia Gorgoepikoos. Twelfth–thirteenth century AD.

3, 4. Copies of drawings by Cyriac of Ancona. The west side of the Parthenon. Fifteenth century AD.

5. London, Church of St. Pancras. The Caryatid porch. 1819–1822.

interest in the material remains of ancient Rome (first) and Greece (a bit later). The Italian Cyriac of Ancona (1391–1453) is a good example of a learned archaeophile of his time, combining his love of antiquity with the practice of recording classical monuments and the collection of any artifacts he could locate, for study as well as trade purposes. Cyriac was an early-Renaissance merchant-venturer with self-taught knowledge of Latin and ancient Greek, and an active antiquarian who witnessed firsthand the collapse of the Byzantine east (as a matter of fact he seems to have taken part in the siege of Constantinople in search of treasure). In contrast to his contemporaries, who based their study of the classical past solely on literary sources, Cyriac departed from the philological approach to antiquity and turned to the systematic assessment of material remains from the classical past.

Combining his antiquarian interest and his empirical archaeological knowledge with his commercial skills, Cyriac funded his travels by supplying his rich and notable clients in the West, mainly in Italy, with antiquities — manuscripts, coins, sealstones, and sculpture. He imported ancient objects to Florence and Venice, working with famous collectors such as Cosimo de' Medici (1389–1464). Cyriac's pioneering contribution to the study of antiquities, however, lies in his practice of sketching architecture and copying inscriptions, which he considered to be more reliable historical testimonies than the ancient literature surviving to his day. At the same time, believing that their image should be preserved for future generations, he left behind dozens of descriptions and drawings. Since the original sketches of Cyriac have been lost, it is difficult to appreciate his efforts from the surviving copies, which contain misconceptions and errors (see fig. 3, 4). However, the positivistic "scholarly" way Cyriac approached the material remains of classical civilization is clear, essentially inventing the methods of recording that would centuries later be applied by classical archaeology. At the same time, on the other hand, it must be made clear that Cyriac's work was unique in the early Renaissance and did not find immediate successors.

The ideal of travelling, however, developed gradually and in parallel with the practice of collecting antiquities and transporting them to the West. As Greece seemed forbiddingly remote and rather inaccessible until late in the eighteenth century, Italy remained the usual destination for western antiquarian travelers. This gradually generated a trade of antiquities with the enthusiastic participation of the locals who now appreciated the market value of what their own land could provide: improvised "excavations" were constantly conducted in order to produce more such treasure, and the Italian *tombaroli* ("tomb robbers") became infamous for the clandestine services they could provide. At the same time, the organized tours of ancient sites and the systematic transport of antique works of art to the West fostered the image of classical civilization as a cultural and aesthetic paradigm. The arts of Greece and Rome, with their outstanding architecture and sculpture, were accepted as a field for cultivation by the western artists and as prototypes to be duly imitated. *Greek revival*, an eighteenth century aesthetic trend led by architectural practice, was the natural offspring of this strong commitment to classical aesthetics. For the architects of the period, as well as for their clients, the replication of the stylistic elements of Greco-Roman architecture (such as the Ionic or Doric order, the Corinthian column capital, and so on) was an example of the cultivation of architectural aesthetics. *Neoclassicism* thus

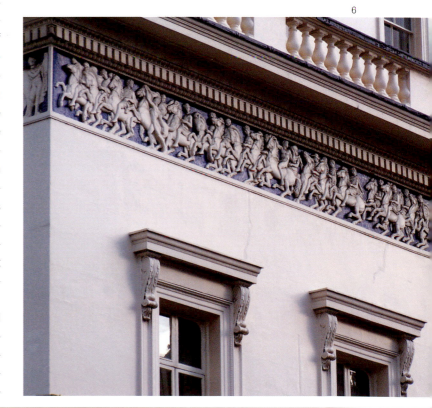

6

6. London, The Athenaeum. Copy of the Parthenon frieze above the façade of the building. 1824.

manifested itself as an intellectual strategy for the achievement and consolidation of a contemporary "modern" ethos, detached from the ideological confusion of the recent past. According to this view, the art of Rome (and secondarily, at that time, that of Greece) was characterized by a purity and transparency that were essential for cultural and aesthetic progress. Also, from the middle of the eighteenth century, as Greece became more accessible to western travelers and scholars, drawings and descriptions reached the centers of western Europe, in-spiring artists who had never seen the Acropolis of Athens up close. A typical example is the case of the British architects William and Henry Inwood (father and son), who designed and constructed *St. Pancras New Church* in London between 1819 and 1822 (fig. 5). Based on the plans of architects who had travelled to Athens, the two architects copied the Caryatid porch of the Erechtheion along the north and south sides of the building (which features on its west side a hexastyle propylon in the Ionic order).

7

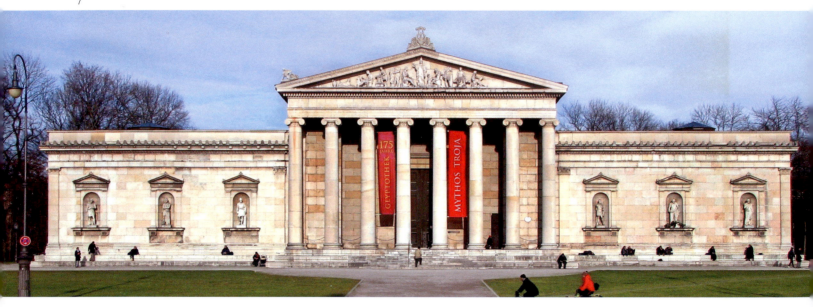

8

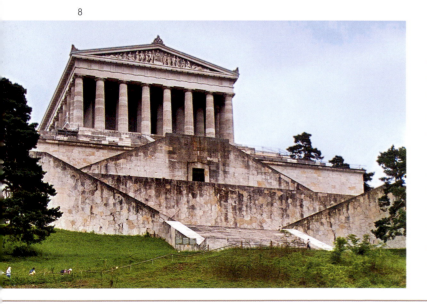

The removal of the Parthenon marbles to London at the beginning of the nineteenth century, and their subsequent purchase by the British Museum, brought the European public face to face with the classical art of Athens of the fifth century BC. Until then, artists, collectors, and antiquarians in the main knew only those Roman antiquities that Italy could provide, mainly Roman marble statues copying Greek originals. European acquaintance with authentic Greek art changed not only the way collectors and intellectuals perceived it, but also the way in which they now approached Greek culture at large. The interest that immediate contact with classical sculpture invoked is evident in the use of themes such as the Parthenon frieze in English buildings of the period. In fig. 6 we see the façade of the Athenaeum Club in central London, designed by the architect Decimus Burton in 1824: it carries a modern version of the frieze on a blue

7. Munich, Glyptothek. 1816–1830.

8. Regensburg, Bavaria. The German Valhalla. 1830–1842.

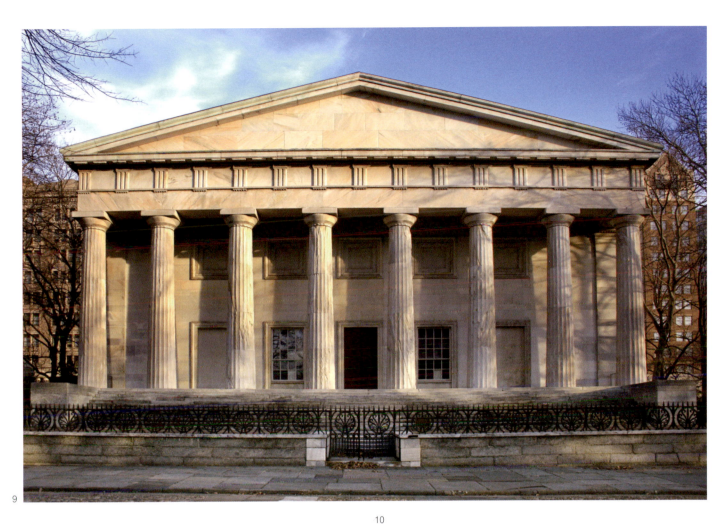

9

10

background, a work by the sculptor John Henning. According to the relevant records of the period, the cost of the frieze was about 5% of the total cost of the building. It is clear that for the members of the Club the use of the frieze from the Parthenon was a demonstration of respect for classical civilization, at the same time emphasizing their own exclusive affinity with it.

After the foundation of the Greek state in 1830, and the installation of the Bavarian monarchy in the country, Greece acquired its own version of Neoclassicism, as it had been applied for decades in Bavaria and the rest of central Europe. German Romanticism, an ideological movement with tremendous influence on the intellectual life of Europe in the late eighteenth and nineteenth centuries, showed special commitment to classical ideals which were now interpreted through a new lens. Considering that the German nation was characterized by a cultural

9. Philadelphia, Pennsylvania. Second Bank of the United States (1818–1824).

10. Nassau County, New York. Horatio Gates Onderdonk House. 1836.

11 12

affinity with ancient Greece, a series of prominent German intellectuals created a dynamic movement for the study and local adoption of classical tradition. The impact that material remains of the classical past had on contemporary culture was obvious: in 1815 King Ludwig I of Bavaria (father of Otto, later to be king of Greece) bought the pedimental and other sculptures from the temple of Aphaia on Aegina (see pp. 136–137). The sculptures were housed in a specially designed building, the *Glyptothek* ("sculpture gallery") in Munich, with its strictly Neoclassical architecture (fig. 7). Its architect, Leo von Klenze, followed Otto to Greece as his advisor. He was a dyed-in-the-wool Neoclassicist and one of the main exponents of romantic Neoclassicism, ideologies that sum up his works, such as the "Pantheon" on the banks of the Danube, near Munich (fig. 8).

The torrent of Greek revival was adopted with enthusiasm in the United States also by the beginning of the nineteenth century. The appointment of the architect Benjamin Henry Latrobe (1764–1820) as surveyor of public building in the newly established country was marked by the design and erection of many important public buildings in Washington D.C., in Philadelphia, and elsewhere. The free use of classical form created an exceptionally popular style that combined the principles, beliefs, and ambitions of a young nation with the heyday of a classical ideology from more than 2000 years earlier. The building of the Second Bank of the United States, by William Stickland in 1824 in Philadelphia, one of the most emblematic cities of American Independence, is only one among

many examples. It is a marble amphiprostyle building in the Doric style which copies the proportions of the Parthenon at three-fifths of the size of the original (fig. 9). The direct reference to its idealized archetype is exploited to express the new, the progressive, and the liberal, reviving in this way the constitutional values of civic republicanism. Soon the Neoclassical idiom was also adopted into domestic architecture, thus providing a symbolic connection between a newly emerged ruling class and the splendors of the past which were considered as one of its inherited privileges (see fig. 10).

The appropriation of classical civilization by the West favored the development of classical archaeology as a discipline, but at the same time deciding its fortune. In brief, classical civilization today:

- is an intellectual and cultural reference point for the western world.
- is the subject of political and social use (and abuse).
- for many Mediterranean countries, such as Greece, Italy, Turkey, or Cyprus, it is a component of national and cultural identity.

After its establishment, and particularly from the last decades of the nineteenth century, the Greek state, for example, developed a multidimensional strategy for the ownership of classical civilization, and its promotion to the international community as an intrinsic element of modern Greek cultural identity. The endless advertising campaigns focussing on Greek antiquities are typical, and have gradually encouraged the use of classical monuments of Greece in every type of commercial advertising (fig. 11–12).

In conclusion, therefore, classical archaeology:

- inherits the European tradition of antiquarianism
- adopts the belief that classical civilization is a cultural and educational model
- is influenced by the European cultural affectations of site-touring and artifact-collecting
- combines classical tradition with modern scholastic methodology.

2.2 Research methodology

In this book we are concerned with only one part of classical archaeology, the archaeology of the Greek world between 1200 and 30 BC. What we define as "Greek world" here is

11. Greek Tourism Organization, poster for the promotion of Greek tourism. 1952.

12. The classical past as a means of mythicizing the Greek present. From an international campaign titled "Live your myth in Greece." 2005.

roughly the area today occupied by the modern Greek state, with the important addition of many regions outside modern Greece, such as Asia Minor in present-day Turkey, South Italy and Sicily, the area of the Black Sea (present-day Ukraine, Russia, and Georgia), and North Africa (present-day Egypt, Libya, Tunisia, Algeria), as well as all the other areas where the Greeks of the first millennium BC came into contact with different cultures (such as the vast regions of Central Asia for the Hellenistic period). Therefore, although later in this chapter we will address issues relating to classical archaeology in general, the examination that follows centers on the archaeology of classical Greece.

As explained in the preceding sections, the *scholarly mission of classical archaeology as an academic discipline is* **to** **study** *and* **to interpret** *the material remains of classical civilization.* To achieve this purpose, an archaeologist must employ a series of methodological tools of which some come from the area of classical studies and some from the wider field of archaeology.

The basic aim of the archaeologist is to classify the material under study — be it of portable or non-portable nature — into broad categories in order to define usable groups which permit further analysis and the drawing of reasonable conclusions. **Classification**, as this process is called, goes back to the positivist spirit of the Enlightenment. Based on the principles of rational thinking, the philosophers and scientists of the "age of reason" tried to classify the whole of the natural world into scientific categories, establishing a hierarchy of general types and their subdivisions. The analytical system of human knowledge — a hierarchical chart of the different disciplines designed by the initiators of the *Encyclopaedia* Denis Diderot and Jean d'Alembert — included, according to their declared principles, every piece of human knowledge and experience, from chemistry and algebra to the classification of minerals and plants. The epistemological tool of classification was adopted by all the emerging sciences of the late eighteenth and nineteenth centuries as a first step of a rational approach to the material (and of the intangible, often enough) world. In some of them, such as archaeology, this remains evident to the present day. The archaeologist and, in particular, the classical archaeologist, classify their material on the basis of a series of criteria that will be discussed in the following sections.

2.2.1 MATERIAL AND TECHNIQUE

The material from which an object is made, but also the techniques with which it is made, form the essential elements of its identity and provide useful historical information. The procurement of raw materials, for example the mining of local stone or the use of imported brands whose superior quality was deemed preferable, are processes of historical interest that complete our knowledge of a particular society. The technology of ancient remains, beyond the information about the level of technical know-how a specific cultural group has reached over time, informs us about exchanges of an economic nature, such as trade, or even processes such as looting in a time of war.

As we shall discuss in the chapters that follow, several highly demanding techniques (such as the carving of monumental stone sculptures, the casting of metal, or the engraving of precious stones) were adopted by specific communities in Greece as part of a process of cultural exchange with the Middle East. The transmission of specialized techniques is not a simple matter of "borrowing," but demands specialized tuition which in turn requires systematic contact and cultural exchanges which far surpass trade of a sporadic nature. Historically, the transmission of a specialized technology from one geographical region to another is usually interpreted as an example of the settlement of people or small groups in one or the other.

The characteristics of an object or a monument such as its dimensions and shape, are also important elements of its identity. Systematic **description** is one of the main tasks of archaeological research: with emphasis mainly on the quantitative characteristics of the object, such as dimensions, shape, structure, but also with reference to certain qualitative characteristics, such as whether its execution is competent or not, the archaeologist is attempting a first interpretive approach and presenting, the object at the same time to the research community, especially those who will not have access to it. The description should thus be as free as possible from strictly qualitative judgments of an interpretive nature.

2.2.2 THE STUDY OF ICONOGRAPHY

The Greco-Roman civilization has been aptly called a "culture of images." As we shall see in a later section, imagery plays an important role in cultural communication in classical art. Consequently, classical archaeologists come systematically into contact with images on the objects they study. These

images need to be classified, described, and interpreted in exactly the same way as the objects themselves. Even more so, the description should be based on illustrations which show the monuments in such a way that they can be interpreted and evaluated as historical evidence (see also next page).

The **study of iconography** is a branch of classical archaeology that is concerned with the identification, description, and interpretation of the images in one class of material remains from a single civilization. As a branch of the history of art, the study of iconography developed in Europe during the sixteenth century and after, but saw a special floruit in the universities of Germany and France in the nineteenth century. As a formal research tool in the history of art, this area of study was adopted initially by classical archaeology —mainly in Germany in the nineteenth century— and is used even today, although it is no longer the main epistemological paradigm followed.

2.2.3 STYLE

According to the leading art historian of the twentieth century, Ernst Gombrich, "Style is any distinctive, and therefore recognizable, way in which an act is performed or an artifact made." Therefore the *functional* aspect of an object (its shape or use) must be distinguished from its *stylistic* aspect (its particular manner of construction). From this it becomes already abundantly clear that the manner in which an object is produced (its stylistic features, as we say) could affect its functionality (its content or its significance).

According to the epistemological principles of the history of art, style is a code for communication, i.e. a specific strategy in order to exchange cultural information and messages, but also a personal system of communication each artist develops personally (whether they were recognized by their community as "artists" or not). That which classical archaeologists usually determine as "style" may be a consciously chosen way of the manufacture and decoration of an object, whether the product of art or craft, an involuntary response to the figurative tradition of a particular place or an example of personal contribution and research of a specific group of artists. Ancient historians, for example, often attribute important innovations in the development of Greek architecture, sculpture, or painting to particular widely recognized artists (such as the sculptor Polykleitos or the painter Apollodoros) without being absolutely clear which of these are the personal contribution of the actual artist

ICONOGRAPHY studies the form, content, and meaning of images as they appear on monuments and every type of object created by any particular cultural group.
Images may be **pictorial** (or *figured*), that is rendering recognizable forms or compositions of a narrative nature, or **aniconic**, i.e. simple abstract shapes and patterns.

STYLE is the system of all particular technical and formalist elements, frequently idiosyncratic in nature, that differentiate a work of art from the works of other cultures, periods, or workshops.
In classical archaeology style is frequently used as a tool for the chronology and interpretation of the artifacts it studies.

and which are part of the wider development in the sphere of aesthetics within a given timeframe. The need to recognize important innovations in the world of art as the personal contributions of particular artists was a characteristic tendency of art history already in the Hellenistic period, but it gained considerable popularity in the nineteenth century, a large part of the twentieth century, and remains strong even today.

2.2.4 TYPOLOGY

As quantitative and qualitative characteristics of material remains of the past, technique, iconography, and style define the *type* to which an object may be assigned.

Typological classification or **typology**, i.e. the process of classifying the monuments into predetermined types (categories) according to their technological, iconographic, and stylistic characteristics, is the first step in understanding the material remains of the past and exploring their cultural relevance.

JOHN BEAZLEY (1885–1970)

Sir John Beazley, Professor of Classical Art and Archaeology at the University of Oxford from 1925 to 1954, is an iconic figure in twentieth century academia, representing classical archaeology's attempts to rationalize and regulate the immense, disorderly mass of anonymous material that centuries of chance discovery, overzealous collecting, and (more recently) systematic excavation had bequeathed to the discipline. He devised the best known, and most followed to date, "method" for the coherent, systematic and efficient study of Greek vases.

His work on Greek pottery and, in particular, his successful attempts to classify vases on the basis of their style, and his effort to identify different "hands" of vase painters based on existing signatures on the vases themselves or in a set of logical and aesthetic criteria he devised, had a profound influence in classical, but also many other branches of archaeology. His conclusions, moreover, are even exploited by those who had expressed their concerns about the reliability of the method. Before his death, Beazley had substantially completed his project, bequeathing to classical archaeology an important font of knowledge about individual products and their relationships and a comprehensive methodological system, even if the basis for this was never justified theoretically. He focussed his efforts on the pottery of Athens in the Archaic and Classical periods and in compiling catalogs in which he attributes particular vases to artists known by their signatures, such as Exekias or Euphronios. Similarly, in those cases where there was no signature, Beazley defined artists on the basis of the works which he attributed to them, giving them conventional names such as "the Amasis painter" (after the potter with whom, according to the traits of style and composition, this vase painter must have worked), "the Berlin painter" (after the museum that housed the typical example of this vase painter's work), "the Priam painter" (after a specific iconographic theme), and so on. The first two versions of his catalogs (*Attic Black-Figure Vase-Painters* in 1956 and *Attic Red-Figure Vase-Painters* in 1963) were revised and supplemented time and again. Today, the Beazley Archive at the University of Oxford houses a rich database, accessible electronically (http://www.beazley.ox.ac.uk/), and is an important source of research into vase painting and classical art in general.

Although until quite recently structuring a dry typology was considered, quite restrictively, as the sole occupation of an archaeologist, since the last decades of the twentieth century it is seen as an essential first step that nevertheless must lead to more substantial historical and cultural conclusions.

2.2.5 CHRONOLOGY

The primary task of typology is to establish a substantiated *chronological sequence*. **Dating** is the basis of archaeological science according to the scientific principles of the Enlightenment, building on a systematic and rational classification of the material world. The gradual discovery of the antiquity of the world from the Renaissance on, and the realization that the earth had a history longer than the few thousand years which one might suppose from reading the Bible, led, as early as the middle of the nineteenth century, to the "discovery" of European prehistory; the inevitable conclusion was that human civilization had seen several phases and fluctuations which covered a period of many tens of thousands of years.

At the same time, acceptance of evolutionary theory — according to which the origin and evolution of plants and animal species of the planet was the result of natural selection and the ability to adapt — encouraged the view that man, as *a species of the animal kingdom*, was himself a product of development. Therefore, man's origin and history (especially man's *prehistory*) could now be researched scientifically, by seeking tangible, material evidence in the same way as for the rest of the natural world. Similarly, the concept of development was adopted into the typology of material remains of human civilization.

The study of human prehistory through its material remains led to the adoption of the *Three Age System*: the division of prehistory into the *Stone Age*, the *Bronze Age*, and the *Iron Age* reflected the basic material employed by human technology

in each era, that is the raw material for the manufacture of tools and weapons. At the same time, it recalled the narrative of the Greek poet Hesiod (inspired by the poetry of the East), according to which the human race followed a degenerative path — from the *Golden Age*, to the *Silver*, to the *Bronze*, and the *Iron*. During the first century BC, the Roman poet Lucretius described a similar evolution in the material culture of man (the passage, that is, from stone to bronze tools and finally to iron), while the roughly contemporary Virgil, returning to the myth of Hesiod, supported the idea that the rise of Octavian as the leader of Rome marked the revival of the *Golden Age* for humanity. The Three Age System has been used to the present day for Greek prehistory and early history (Palaeolithic, Mesolithic and Neolithic periods, Middle and Late Bronze Age). For the early historical years (1100–700 BC) the term now used is the *Early Iron Age* from the Three Age System, rather than the older terms "Dark Ages" or the "Geometric period." These two terms came from the system of classification of classical archaeology which followed criteria derived from the history of art —from which come terms such as "Archaic," "Classical," "Hellenistic" art. The division of classical archaeology into chronological periods follows, therefore, a *mixed* system: after the Early Iron Age, rather than "Middle" and "Late," follows the "Archaic," "Classical," and "Hellenistic" periods, terms that derive from classical studies and were created in the eighteenth and nineteenth century. This sequence takes into account the classicizing background of classical archaeology (and other practical considerations, such as the fact that a hypothetical "Late Iron Age" for Europe essentially ended only with the industrial revolution in the second half of the eighteenth century).

From what has been said above, it is clear that division into periods, on whatever criteria, is of "conventional" and "generalized" character. The chronological boundaries are not understood as watertight and absolute, but as fluid markers that refer to stages in the process of change without setting them in stone. Some of the chronologies above refer to the ways in which we measure time, in years, centuries, and so on, and are not considered to have had a particular impact on the life of the people of that period. Quite simply put, nothing changed in Greek civilization on the "New Year's Day" of 1100 or 700 BC. What the division signifies is that, at the passage from the twelfth to the eleventh century or, in the same way, that from

THE ARCHAEOLOGICAL PERIODS OF CLASSICAL GREECE

- **The Early Iron Age (1100–700 BC)**
- **The Archaic period (700–480 BC)**
- **The Classical period (480–336 BC)**
- **The Hellenistic period (336–30 BC)**

the eighth to the seventh century, those characteristics that in the eyes of modern scholars mark the end of the Bronze Age in the first case and the beginning of the Archaic period in the second, took shape gradually. Other dates in the chronological table are specific and refer to known historical events according to the current dating system (480 BC: battle of Salamis, 336 BC: assassination of Philip II). These too are used conventionally and indicatively, as they form fixed points in Greek history, which had however significant, direct and indirect consequences for the form and the evolution of Greek civilization.

Within this framework and with the basic tools of typology, as has been explained above, the classical archaeologist attempts to date the material remains. A date in archaeology can be:

ABSOLUTE: the classification of material remains according to the exact historical moment of their manufacture, when it is known (such as a "silver tetradrachm of Mithridates VI Eupator from 90/89 BC").

RELATIVE: the classification of material remains in relation to others which are thought to be earlier or later (in the way that "the Anavyssos kouros is considered to be contemporary with the Munich kouros, but the Aristodikos kouros must be at least twenty years earlier than the other two").

Beyond examining by the naked eye, by which means the archaeologist observes, classifies, and interprets objects, archaeology uses methods developed by the natural sciences (such as radiocarbon dating or thermoluminescence). As, however, these methods are characterized by constraints in both accuracy and reliability, they are customarily used for the branches of archaeology where the intervals of time are much larger than those which can be determined in classical archaeology by more traditional methods. Nevertheless, the science of *Archaeometry*, which deals with the scientific analysis of material remains, is particularly useful in classical archaeology —essentially forming an organic part of it— as it can con-

tribute to matters of conservation of the object, and also provide answers to questions about its composition and the origin of the raw materials.

The goal of the archaeologist is to correlate a part of a typologically determined chronological sequence to an absolutely dated context. Let us suppose that during the excavation of a grave we found a number of objects, amongst which was a coin and a pot. Usually coins are a safe indication of an absolute date, as they are associated with specific periods in political history (kings, political leaders). On the basis of the coin, the tomb could be dated, with relative security, within a specific span of a few decades, or even years. Simultaneously the coin dates the *deposition* of the pot and the construction

of the tomb. The correlation of this specific pot to an absolute date helps in addition to date the earlier and later members of the relative sequence to which it belongs.

Fixed archaeological points in archaeological history mean events that have a direct and visible impact on the material culture. When, for example, the date of the destruction of a city is known securely on the basis of historical sources, then we can date the monuments that relate to it. Cases such as this in Greek archaeology are the destruction of the Athenian Acropolis by the Persians in 480 BC and the destruction of Olynthos in Chalkidiki by the army of Philip II in 348 BC. These dates are the lowest limit for the dating of earlier remains (*terminus ante quem*) while for those that follow these dates define the earliest

JOHANN JOACHIM WINCKELMANN (1717–1768)

The German **Johann Joachim Winckelmann** was the first great antiquarian in the history of classical archaeology. Through his considerable work, he forged an impassioned, emotional relationship with antiquity which deeply affected the methodology of classical archaeology. His work *Gedanken über die Nachahmung der griechischen Werke in der Malerei und Bildhauerkunst* was published in 1755, and had an English translation (*Thoughts on the Imitation of Greek Works in Painting and Sculpture*) in 1765. This was a first attempt at the systematic study of ancient sculpture, which laid the foundations for the methodical study and interpretation of classical art. With his work Winckelmann put into practice the idealization of classical antiquity, calling on Europeans to embrace his message that "the only models of life and education were those of ancient Greece."

Until Winckelmann, no attempt had been made to date ancient statues or other antiquities which the collectors and antiquarians of the sixteenth, seventeenth, and eighteenth century hastened to collect. Frequently no distinction was made between Greek and Roman art in the first place. In general, it was Roman art that was preferred by collectors and antiquarians of the period. In 1764 Winckelmann presented his masterpiece *Geschichte der Kunst des Alterthums* (*The History of Art in Antiquity*), where for the first time he laid out a timeframe into which classical works could be placed, divided into pre-Classical, early Classical, Classical, and post-Classical, implying that art had followed an evolutionary path from its primitive stages to its apogee and ultimately its decline. Specifically ancient Greek art appeared to be divisible in the following way:

- Earlier period (–480 BC)
- Mature Classical period (480–400 BC)
- Late Classical period (400–250 BC)
- Period of Imitation (250 BC)

In Winckelmann's work, which was deeply inspired by the onset of German Romanticism, stylistic analysis is the key to aesthetic comprehension and interpretation. Although he was studying Roman copies and not original Greek works, such as the Parthenon marbles which he never saw, Winckelmann was particularly successful in defining these periods, especially given that he did not have any complete system of scholarship or research on which to base his own observations. In his work we find the first holistic, all encompassing interpretive theory for classical archaeology, a complete system of theories, techniques, and methods aimed at providing explanations and interpretations for the surviving works, their history, and their significance. Although his work today only has historical interest, it is clear that he laid down the fundamental principles of the classification of the works of art in antiquity, devising a chronological system whose essence remains unchallenged.

possible chronological horizon (*terminus post quem*). An important fixed chronological point for the art of the sixth century BC is the construction of the *Treasury of the Siphnians* at Delphi (fig. 216). According to written sources the monument was built in the short period of Siphnos' prosperity, and a little before the sacking of the island by the Samian army in 525 BC. The architectural sculpture of the building can be related to other developments in Greek art of the period, which can, on the basis of stylistic comparisons, be dated in relation to the same chronological marker.

2.3 Classical archaeology and Greek art

As has already been emphasized, a large part of the material remains that a classical archaeologist studies belong to the category of art. Although ancient Greek society did not maintain our own distinction between what we recognize as "fine arts" and ordinary, unambitious crafts, it is certain that a considerable number of artifacts we now possess from the Greek world performed a role similar to that of art in modern western societies. Essentially this means that works of sculpture or monumental painting, for example, did not have a utilitarian or everyday character, but attempted to connect with their viewers, impressing them with their technique, their iconography, and their style. Even in the case of functional objects, such as pottery, it is clear as much from their construction as from their decoration that they tried to communicate with their user in the same way as monumental art.

It is therefore necessary in the study of classical culture to recognize its contribution to the development of aesthetic values and at the same time try to understand the role of material remains as works of art within the society that created them. Similarly, over and above the intentions of their creators, ancient works of art —of sculpture, of architecture, but also the simple vases of their period— were adopted in modern Europe as standards for western aesthetics and as symbols of classical heritage. Therefore, even if by the term "classical heritage" we mean the full range of concepts and achievements —from democracy and equality before the law to drama and the technique of pictorial representation— sometimes, for practical but also symbolic reasons, we identify the entirety of classical civilization exclusively through its art. Even more so, in the eyes of the "civilized world" the entirety of global cultural heritage is identified symbolically with our familiar image of ancient Greek monuments. It is not by chance that the logo of UNESCO (the United Nations Educational, Scientific, and Cultural Organization), the organization that is which cares for the *whole* of worldwide cultural heritage, both tangible and intangible, refers directly to ancient Greek architecture (fig. 13). This is not because ancient Greek civilization is considered any more important than other, earlier or later expressions of cultural identity from across the globe, but because the concept of studying the past first appeared in the modern history of humanity with a focus on the classical past. Since the western European ruling classes of the eighteenth century and later founded their eclectic affinities with classical civilization in the study, collection, and ultimately ownership of its material culture, the foundations were laid for the scholarly study of its remains. The mission of the classical archaeologist of the twenty-first century is to evaluate the substantial cultural inheritance evident in the remains of Greco-Roman art and, in addition, to evaluate the effect it had on western culture —and continues to do so to the present day.

Ancient Greek civilization, as we still recognize it from our everyday experience, was a culture immersed in pictorial representation: stone reliefs adorned with narrative scenes, public and private monuments in city and countryside, paintings on vases recalling mythical and historical events as well as scenes of everyday life, figures of gods and (later on) mortals depicted on coins and weaponry and also, we assume, on textiles or on clothing. These same images made a strong impression on the Romans who played an important, and frequently decisive, role in Greek politics at least from the second century BC. Roman

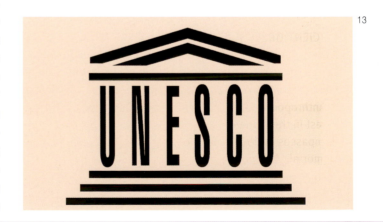

13

13. The logo of UNESCO, in the form of a classical temple.

civilization adopted the basic principles of Greek artistic expression, but transformed them through new concepts and applications. The result of Roman intervention was that the distinctive nature of ancient Greek civilization was preserved and survived to be adopted later in the West as a cultural paradigm.

Ancient Greek art is, therefore, a pictorial art. Its communicability was based on the deployment of images as cultural currency, in a circulation of iconographic types, themes, conventions, and forms, which were directed at those who were able to decode them, that is to understand the mythological or factual reference which they hid. A divine figure is, for example, identified by age, physical attributes but —mainly— by the "attributes," the symbols that they carry (a thunderbolt for Zeus: fig. 397; an aegis for Athena: fig. 312). These concepts and images confirm the cultural ties between the artists and their audience, creating an exclusive circle of those who could "read" the letter and comprehend the spirit of Greek art. Often when we study pictorial representations on vases or in sculpture we assume that behind them is hidden a literary reference which has not survived to our time (see fig. 132, 256). As such Greek art is fundamentally fragmentary and suggestive, based on symbol, iconographic form, and conventional connotation. The structure of Greek art is such that only detailed analysis of the objects themselves, and of their iconography, can lead us to comprehend the themes of cultural interaction or the aesthetic and artistic choices involved, as well as to describe their historical background.

The inherently narrative character of Greek art also influenced the composition of figured scenes. Generally, narrative scenes in classical art are rendered in an *abbreviated* way (termed "syn-optic" by some scholars), which seems to violate the temporal sequence of the events themselves. In fig. 105 we see a vase from the seventh century BC. The story of the blinding of Polyphemos, well-known from Homer's *Odyssey*, is recounted in the scene on the neck. Odysseus, followed by his companions, is attempting to escape from the cave of the Cyclops by blinding him. The narrative is rendered succinctly: according to the Homeric text, Odysseus tricked Polyphemos into drinking wine he had with him in order to make him drunk and helpless and make it easier to blind him. In the scene, however, we see two narrative moments of the story joined in one: Polyphemos drinks Odysseus' wine, at the very same moment that Odysseus and his companions are stabbing the monster in the eye.

Art can, consequently, be understood as an integral part of ancient Greek culture which fulfilled a wide variety of social functions.

CULTIC: works of art are intended as the objects of worship or as cult statues.

RITUAL: because works of art or craft were used in ritual actions, such as the cult of the dead or in burial customs.

POLITICAL: in some cases the figurative scenes in Greek art have direct or (more often) indirect political character.

UTILITARIAN: a significant quantity of utilitarian, every day, ancient objects bear decoration that transcends their functional use.

According to this, ancient Greek art constitutes a complex cultural phenomenon. The systematic study of classical art from the second half of the nineteenth century to the present day has accumulated a weighty corpus of theoretical views, scholarly approaches, and the results of research during a long process of re-examination, deconstruction, and verification.

ANCIENT GREEK ART: AN OVERVIEW

Greek art interacts with its viewer through its two inherent qualities:

■ **Anthropocentricism:** ancient Greek art shows a primary interest in the human form and its actions. "Human form" encompasses every manifestation, real or imaginary, mortal or immortal. Anthropomorphism is intrinsic to ancient Greek culture —even items which are not clearly related to the human form, such as vases, share human characteristics in some way or other: in the case of vases the Greeks used terms from human anatomy to describe their parts, e.g. *lip* (for rim), *shoulder* for the transition to the body of the vase, *belly* for the body of the vase itself, and *foot* for the base.

■ **Narrativity:** the images in ancient Greek art refer to mythical or historical events and situations. The scenes are not rendered as "photographic snapshots" of those stories or incidents but, in a suggestive and often abstract way, help the viewer recall accounts or descriptions already known to them from the oral or written tradition.

The approaches that have been historically applied to the research of ancient Greek art may be summarized as follows:

2.3.1 THE ART-HISTORICAL APPROACH

This is the oldest, rooted back in the Renaissance and the humanist tradition. Following a modernist agenda, though one essentially influenced by Romantic notions on the nobleness of art and the uniqueness of aesthetic experience, the study of the material remains of ancient society as objects of *artistic* value was systematized in the universities of Germany, chiefly during the second half of the nineteenth century. With an emphasis on style —and secondarily on iconography— this method, obviously affected by the discipline of art history, attempted to study classical monuments based on their aesthetic impact across the ages. The basic principles of this approach are the belief in the independence of art as a cultural phenomenon and the autonomy of the individual artist as an intellectual agent of his time. The same principles also underpinned the classification of Greek art on the basis of its creators (even when they were not known), a method to which German archaeologist Adolf Furtwängler (1853–1907) and his British counterpart John Beazley, already mentioned, made significant contributions.

2.3.2 THE LINGUISTIC APPROACH

The development of disciplines such as linguistics and literary theory during the first half of the twentieth century greatly influenced the humanities and particularly anthropology and sociology. According to the new epistemological paradigm, culture could be studied as a *language*, i.e. as a complete system of communication with an independent structure. The so-called *structuralist* approach to the study of classical culture takes as its starting point the premise that the essence of ancient Greek art is narrative (both mythological and literary) and, accordingly, art is expressed as a language. As part of a *text*, an artwork is considered to express the underlying structures of collective thought built in every cultural expression of the group under study: the difference, for example, between private and public, sacred and profane, male and female, and so on. While the art-historical approach focusses on the creative process, structuralist methodology uses art as a gateway to the understanding of the culture that produced the work under examination. The privileged field of action of this approach is iconography, and specifically a branch of it dubbed **iconology**. According to this division (which is not however accepted by everyone) iconography is concerned with the factual elements of the image (what the artwork *depicts*) while iconology looks at its interpretation (what the artwork *means*). In essence this is not a single method but a combination of frequently disparate studies and approaches with a common starting point in structuralist theory. Amongst the most influential classicists who employed this methodology were the French classicists Pierre Vidal-Naquet (1930–2006) and Jean Pierre Vernant (1914–2007).

2.3.3 THE ANTHROPOLOGICAL APPROACH

In the last decades of the twentieth century several anthropologists appear to have questioned the certainty of their predecessors that remains of material culture formed either "art" or "language." For the study of classical culture this would mean the final exit from the Western European classicizing tradition, a problem that does not appear to be resolvable. As we shall see in the following chapters, the material creations of classical culture interacted with their users and viewers in many different ways —as much by means of their form as of their content.

PLINY THE ELDER (AD 23–79)
Gaius Plinius Secundus, better known as Pliny the Elder, was a Roman nobleman who combined a military career with his own interests in natural history. He was born in c. AD 23 and died in August AD 79, while observing the volcanic eruption of Vesuvius which destroyed Pompeii and Herculaneum. Pliny was a polymath and a prolific author; his *Natural History* is one of the longest Latin texts to have survived through the Middle Ages. In its thirty-seven extant books Pliny writes about cosmology, astronomy, geology, geography, zoology, botany, and mineralogy. Included in this vast project are extensive accounts of sculpture in marble and bronze, painting, and gem cutting: his lists of artists, works, patrons, collectors, and critics, as well as his reports from the art market of his time, read like an art history, setting a pattern that to some degree is still followed today.

Their study, therefore, can only acquire interdisciplinary character by exploiting methodologies from other branches of learning devoted either to the study of antiquity or cultural studies.

2.4 Classical archaeology as history

According to the Neoclassicist imagination, as expressed in the mural decorating the Central Building of the University of Athens, *History* and *Archaeology* are two sisters studying the past arm in arm (fig. 14): classically attired, the former is shown writing down on her proverbial *annals*, the latter holding a Greek artifact — a black-figure vase. This wall painting by the Austrian artist Karl Rahl (completed by another artist after his death) depicts Otto, the first King of Greece, enthroned and surrounded by figures representing a pantheon of all the academic disciplines practiced in the newly established kingdom of Hellas. Amongst them, History and Archaeology, as pillars of the nation's self-understanding and promoting, study the past and in so doing support the *present* of the fledgling Greek state.

This ideologically charged depiction demonstrates the importance of knowledge of the past for modern culture, as explained above, but also highlights the significance of interdisciplinary teamwork between historians and archaeologists. The collaboration between history and archaeology is multifacetted. In the chapters that follow we shall meet many cases where historical texts seem to acquire substance through the material remains of the past they describe: the work of sculpture known as *the Tyrannicides,* only copies of which survive from the Roman period, is a work of art whose erection is confirmed by ancient authorities (fig. 239). Similarly, the excavation of the house of the shoemaker Simon in the ancient Agora of Athens confirms in a breathtaking way the literary evidence describing the visits of Socrates to this very shop two and a half thousand years ago (fig. 296). The search for material evidence in order to confirm or reshape the historical discourse concerning the past is the primary task of the classical archaeologist. Archaeologists are usually bound, therefore, by the ideological strategies of ethnic or cultural groups to which they belong or for whom they work.

However, archaeology shares with history a fundamental question: what is the appropriate subject of their academic pursuit and how to go about studying it. Already from the first half of the twentieth century, the most influential historians in Europe and North America were no longer content to research a particular period of the more distant or recent past, but concerned themselves with the basic question of what is the *nature* of history and what its mission is. Such enquiries demonstrated the ambiguity of the term *history* in itself: beyond the events as such (*res gestae*), history was shown to be a *discourse* regarding the events (*historia rerum gestarum*), with an emphasis now on a critical approach, on interpretation, and not simply in fact-based narrative. Accordingly, the work of the classical archaeologist, as has already been mentioned, is the evaluation of the material remains of the past as historical sources and not simply their discovery and classification. This process requires multidisciplinary research and constant reviewing of the conclusions of previous research. Even though archaeology studies material remains, that is *tangible* historical evidence,

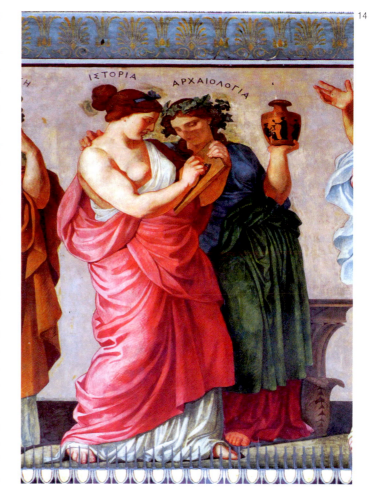

14

14. Karl Rahl, mural from the Central Building of the University of Athens (detail): History and Archaeology. 1888.

study of culture by French sociologist Pierre Bourdieu (1930–2002). Exploitation can take many forms, from absolute idealization to extreme commercialization, or even the destruction or looting (mainly by local communities or individuals who decide to exploit "their" ancient monuments for personal gain). The established state, in contrast, is obliged to ensure that the monuments of the past that are within its care are protected for the global community and following generations. **Management of Cultural Resources** (often termed "Cultural Resource Management" and abbreviated as "CRM"), is a relatively recent interdisciplinary field, which deals with the theoretical and practical needs of the protection and exhibition of cultural monuments. The discipline of **Museum Studies** is also involved with the protection, interpretation, and exhibition of tangible and intangible cultural heritage, which has as its main objective the management of museum collections (which consist either of cultural relics of man's past or objects of natural history), but also every space where works of art are collected and displayed (such as, for example, art galleries). Museum Studies, as an academic discipline, is a branch of **Museology**, a field of learning which appeared mainly in European universities in the 1960s with the aim of investigating and promoting the cultural and educational role of museums in contemporary societies. The goal of Museum Studies is the aesthetic presentation and promotion of the material remains of the past (frequently referred to as museography), the organization, management, and promotion of archaeological sites as well as the use and exploitation of listed buildings.

From the end of the twentieth century and later, the concept of "cultural heritage" has taken on a greater weight in the intellectual life of, mainly, western, societies where sociology and cultural anthropology have had an effect, but also as a result of the development of cultural studies (which include heritage management and museum studies). This development also affected classical archaeology, as the material remains of the Greco-Roman past are not used any more merely for the study of classical culture but as part of a wider "cultural experience" (see fig. 17–18).

In Greece the care of antiquities was already the preoccupation of the representatives of the civil authorities even before the foundation of the Greek state, as protection measures for the "remains of Greek art or history" formed part of the decrees

ILLICIT TRAFFICKING OF GREEK ARTIFACTS AND ITS PREVENTION

In the years of the so-called prescientific archaeology, that is before archaeological excavations were systematized (fifteenth–eighteenth centuries), the main aim of antiquarians was normally the haphazard search for antiquities and their subsequent removal to countries in the West. Although from the nineteenth century it had become clear in the archaeological community, as has already been mentioned, that the objects discovered in excavation "lose their voice" as historical and cultural witnesses when they are divorced from their archaeological context, illegal excavation and the smuggling of antiquities continues, even today, to prejudice scientific research. Such depredations are mainly caused by the desire by local populations and foreign opportunists for financial gain, though other causes may be conflicts arising from religious hatred, political rivalry, or wars between ethnic groups sharing the same land.

In an attempt to persuade the developed countries of the world to prevent the smuggling of antiquities in their territory (in the hope that the closure of the thriving antiquities market would, in time, prevent further clandestine excavations and the destruction of archaeological sites throughout the world), UNESCO in 1970 and 1972 established two fundamental Conventions for the protection of worldwide heritage. The first refers to the *Means of Prohibiting and Preventing the Illicit Import, Export and Transfer of Ownership of Cultural Property* and has been ratified by all 129 member states of the organization. The text states that "cultural property constitutes one of the basic elements of civilization and national culture, the true value of which can be appreciated only in relation to the fullest possible information regarding its origin, history and traditional setting," and as a result "it is incumbent upon every State to protect the cultural property existing within its territory against the dangers of theft, clandestine excavation, and illicit export," since every state is bound by "moral obligations to respect its own cultural heritage and that of all nations."

The World Heritage Convention of 1972, ratified to date by 191 member states, sets out "the duties of states in identifying potential sites and their role in protecting and pre-

15. Ancient Corinth, Archaeological Museum. c. 1910.

16. Athens, excavations being carried out by the American School of Classical Studies in the area that today is the archaeological site of the Ancient Agora. July 1931.

17. London, British Museum. The redesign of the central atrium between 1997 and 2000 created a single space for "timeless, multicultural experience." March 2003.

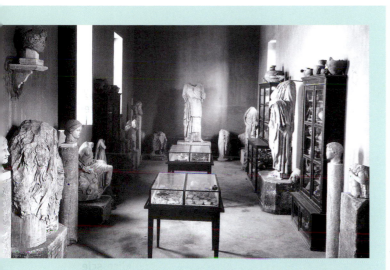

15

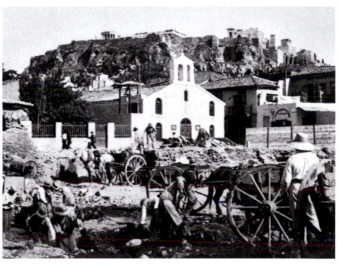

16

serving them." By signing the Convention, each country pledges to conserve "not only the World Heritage sites situated on its territory, but also to protect its national heritage." The signatory states are encouraged "to integrate the protection of the cultural and natural heritage into regional planning programmes, set up staff and services at their sites, undertake scientific and technical conservation research and adopt measures which give this heritage a function in the day-to-day life of the community."

Archaeological sites and monuments "of outstanding universal value" are included in the so-called "World Heritage List," according to a set of criteria, ranging from aesthetic to cultural, historical, or even natural. Among the monuments so far included, we find the Athenian Acropolis, the sites of Delphi, Olympia, and Delos in Greece, the classical towns of Pergamon and Ephesus in Turkey, the remains of Rome, Pompeii, and Herculaneum in Italy, the city of Petra in Jordan, the Masada fortress in Israel, and so on.

of the Temporary Administration and the decisions of the National Assemblies already from the time of the Greek War of Independence (1821–1827). In 1829, the Greek Governor Ioannis Kapodistrias founded the first Greek museum with the aim of "collecting all of the antiquities that the territory of Greece still covers." The emphasis on classical Culture was in the first years of the existence of the Greek state the main characteristic of state responsibility for the material remains of the past, something that continued for a large part of the twentieth century. Classical civilization was in this way treated as an integral part of the national identity of contemporary Greece.

The exhibition of finds followed the standard international model with an emphasis on their classification by period, material, and type (see fig. 15). Gradually the Greek state turned to the systematic exploitation of classical monuments with the aim of attracting tourists and the general economic management of the Greek cultural capital. Central to the cultural policy of the Greek State, already by the last decades of the nineteenth century, was the systematic and extensive **restoration of ancient monuments** in order to make them accessible to the general public, frequently also for their use (as is the case with ancient theaters and odeia). The restoration of monuments therefore became an important field of research for classical civilization. At the same time it was promoted as an indication of the modernization of the country, to such an extent that it demonstrated Greece's care for the monuments on her soil in accordance with international protocols and prescriptions (see

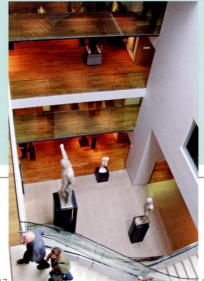

17

18

18. Oxford, Ashmolean museum. The museum, founded in the seventeenth century, was recently renovated with the aim of uniting the separate collections (antiquities and modern monuments) and the joint exhibition of original works and casts with the aim "to enhance our understanding and enjoyment" of beautiful objects. November 2009.

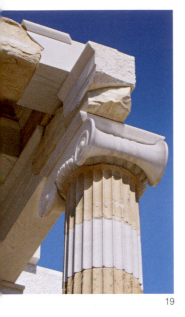

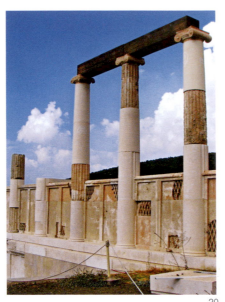

figs. 19–20). The restoration of monuments thus constitutes an integral part of the modern identity of the Greek state.

An example of the modernization of the country is also the renovation of the old museums and the re-exhibition of their collections or the construction of new ones, such as the Acropolis Museum in 2009 (fig. 21). The building that follows the theoretical directions of modern architecture, seeks, according to its architects, a "visual dialogue" with the archaeological site of the acropolis, while displaying the exhibits as works of Greek and worldwide cultural heritage.

Finally, in the twentieth century Greece collaborates with a series of international organizations dedicated to the preservation of world cultural heritage, such as U.N.E.S.C.O. which has been mentioned already, I.C.O.M. (International Council of Museums) and I.C.O.M.O.S. (International Council on Monuments and Sites, with a Greek branch since 1972).

19. Athens, Acropolis. Restoration of an Ionic column of the Propylaia. May 2009.

20. Epidaurus, Sanctuary of Asklepios. Restoration of the Abaton. October 2007.

21. Athens, the new Acropolis Museum.

SELECT BIBLIOGRAPHY

Classical archaeology and history of ancient Greek art

S.E. Alcock & R. Osborne, *Classical Archaeology*. Oxford: Blackwell (2007).

M. Beard & J. Henderson, *Classical Art. From Greece to Rome*. Oxford: Oxford University Press (2001).

W.R. Biers, *The Archaeology of Greece*. London: Cornell University Press (2nd ed. 1996).

J. Boardman, *Greek Art*. London and New York: Thames & Hudson (4th ed. 1996).

R.T. Neer, *Greek Art and Archaeology: A New History, c. 2500–c. 150 BCE*. London and New York: Thames & Hudson (2011).

M. Robertson, *A History of Greek Art*. Cambridge: Cambridge University Press (1975).

T.J. Smith & D. Plantzos (eds), *A Companion to Greek Art*. Oxford: Wiley – Blackwell (2012).

J. Whitley, *The Archaeology of Ancient Greece*. Cambridge: Cambridge University Press (2001).

Archaeological theory and the history of classical archaeology

D. Damaskos & D. Plantzos (eds), *A Singular Antiquity. Archaeology and Hellenic Identity in Twentieth-Century Greece*. Athens: Benaki Museum (2008).

S.L. Dyson, *In Pursuit of Ancient Pasts. A History of Classical Archaeology in the Nineteenth and Twentieth Centuries*. New Haven and London: Yale University Press (2006).

M. Johnson, *Archaeological Theory. An Introduction*. Oxford: Blackwell (1999).

I. Hodder & S. Hutson, *Reading the Past. Current Approaches to Interpretation in Archaeology*. Cambridge: Cambridge University Press (3rd ed. 2003).

C. Renfrew & P. Bahn, *Archaeology: Theories, Methods and Practice*. London and New York: Thames & Hudson (5th ed. 2008).

A. Schnapp, *The Discovery of the Past*. London: British Museum Press (1994).

M. Shanks, *Classical Archaeology of Greece. Experiences of the Discipline*. London and New York: Routledge (1996).

A. Snodgrass, *An Archaeology of Greece. The Present State and Future Scope of a Discipline*. Berkley: University of California Press (1987).

B.G. Trigger, *A History of Archaeological Thought*. Cambridge: Cambridge University Press (2nd ed. 2006).

Cultural resource management

T. Bennett, *The Birth of the Museum. History, Theory, Politics*. London and New York: Routledge (1995).

E. Hooper-Greenhill, *Museums and the Shaping of Knowledge*. London and New York: Routledge (1992).

Classical archaeology on the world wide web:

Classical Art Research Centre, University of Oxford: http://www.beazley.ox.ac.uk/index.htm (databases, bibliography, images)

Perseus Digital Library, Tufts University USA: http://www.perseus.tufts.edu/hopper/ (Greek and Latin texts, figures, encyclopaedia of Classical sites)

Zenon, German Archaeological Institute: http://opac.dainst.org/ (bibliography)

AWOL: *The Ancient World Online*, British and French Schools in Athens: http://ancientworldonline.blogspot.com (archaeological news)

Stoa, Kentucky University USA: http://www.stoa.org/ (images, texts)

Οδυσσεύς, Greek Ministry of Culture: http://odysseus.culture.gr/ (Greek archaeological sites and museums)

CHRONOLOGY

1100–700 BC EARLY IRON AGE

1100–1050 BC: Submycenaean period	*Population movements*	
1050–900 BC: Protogeometric period		*Protogeometric Style*
900–700 BC: Geometric period	*Contact with the East*	*Geometric Style*
Early Geometric (900–850 BC)		
Middle Geometric (850–760 BC)	*Settlement of Greeks in*	
Late Geometric I (760–735 BC)	*the Near East and western Mediterranean*	
Late Geometric II (735–700 BC)	*Homer*	
	Hesiod	
	Emergence of the city-state	

700–480 BC ARCHAIC PERIOD

700–620 BC: "Orientalizing period"	*Tyranny*	*Protocorinthian Style*
	Greek colonies in Egypt and around the Black Sea	*Protoattic Style*
		"Daedalic" Style
		Monumental Sculpture
620–560 BC: Middle Archaic period	*Solon*	*Monumental Architecture*
		Black-figure Style
560–480 BC: Late Archaic period		*Red-figure Style*
	Kleisthenes	
	490 BC: Battle of Marathon	
	480 BC: Battle of Salamis	

480–336 BC CLASSICAL PERIOD

480–450 BC: Early Classical period	*Aeschylus, Sophocles, Euripides*	*Severe Style*
	Athenian League	
450–400 BC: Middle Classical period	*Aristophanes*	
	Herodotus, Thucydides	
	Peloponnesian War	*High Classical Style*
400–336 BC: Late Classical period	*Socrates, Plato*	

336–30 BC HELLENISTIC PERIOD

336–275 BC: Early Hellenistic period	*Dissolution of the Persian Empire*	
	Portraiture	
275–150 BC: Middle Hellenistic period	*Establishment of the Hellenistic Kingdoms*	
		Floruit of Pergamene sculpture
	197 BC: Battle of Cynoscephalae	
	168 BC: Battle of Pydna	
150–30 BC: Late Hellenistic period	31 BC: Battle of Actium	
	Destruction of the Ptolemaic kingdom	

MAP I: GREECE AND THE EASTERN MEDITERRANEAN

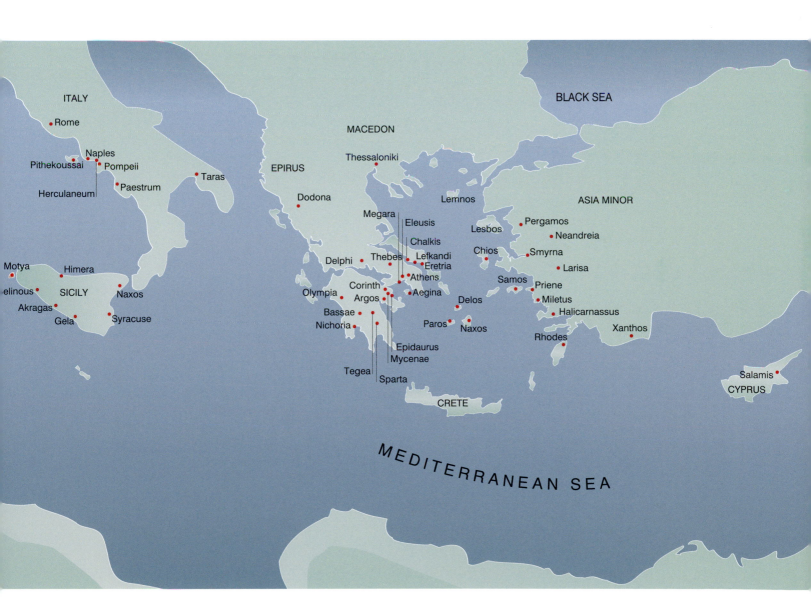

ITALY

• Rome

Naples
Pithekoussai • • Pompeii
Herculaneum • Paestrum

• Taras

Motya •
elinous •
Akragas •
Gela •

Himera •
SICILY

Naxos •
Syracuse •

EPIRUS

• Dodona

MACEDON

• Thessaloniki

Megara
Eleusis
Chalkis
Delphi • Thebes • Lefkandi
Eretria
Athens
Corinth •
Olympia • Argos • Aegina
Bassae •
Nichoria •
Epidaurus
Mycenae
Tegea
Sparta

CRETE

BLACK SEA

Lemnos

ASIA MINOR

Lesbos
Chios •

Pergamos •
• Neandreia
Smyrna •
• Larisa

Samos •
Delos •

Paros •
Naxos •

Priene •
• Miletus
• Halicarnassus
Rhodes •
Xanthos •

Salamis •
CYPRUS

M E D I T E R R A N E A N S E A

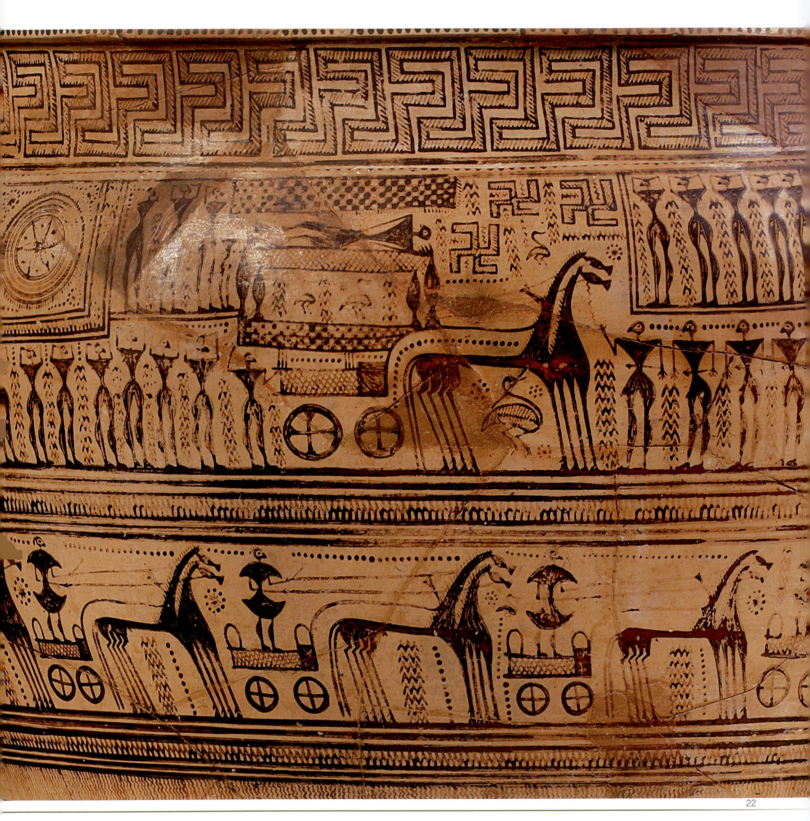

22. Attic Geometric krater (detail of fig. 62).

THE EARLY IRON AGE
(1100–700 BC)

The period from the collapse of the Mycenaean Civilization at the end of the second millennium BC until the end of the eighth century BC is called the Early Iron Age. It is a period of major changes in the way of life in Greece compared to the past. In a space of four centuries, roughly from 1100 to 700 BC, ancient Greek culture gradually took on the form it was to have for generations to follow.

The name of the period is derived from the use of iron which became gradually more widely used during this period for making tools and weapons, in contrast with the preceding Bronze Age. While up to the twelfth century BC the basic material for the construction of tools and weapons was bronze (a copper and tin alloy), its gradual replacement by iron brought about a revolutionary change in the organization of the economy. The new material was more affordable, as there was a relative abundance of iron ore deposits in Greece in contrast to copper or tin ores, which had to be imported and to which access in the Bronze Age was controlled by the central palatial authority. The replacement of bronze with iron necessitated the learning of new techniques, such as forging, and it is possible that the craftsmen of Greece imported this new technology from Cyprus.

The Early Iron Age is divided into three periods:

- Submycenaean (1100–1050 BC)
- Protogeometric (1050–900 BC)
- Geometric (900–700 BC)

Before proceeding to a study of the Early Iron Age we will offer a short summary of the period preceding it, which marks the end of Greek prehistory.

1. THE END OF MYCENAEAN CIVILIZATION (1200–1100 BC)

The period between 1600–1100 BC is called the Late Helladic, or Mycenaean period. It is the final phase of the Bronze Age (3200–1100 BC), during which important prehistoric cultures emerged in Greece, such as the Cycladic, the Minoan, and the Mycenaean. The Mycenaean civilization, in particular, flourished principally in mainland Greece during the Late Helladic period. Although it was the natural continuation of the culture of the Middle Helladic period (2000–1600 BC), it presents several distinctive features:

FORTIFIED CITADELS During the Late Helladic period the so-called palatial centers (such as Mycenae, Tiryns, Thebes, Pylos) dominated Greece. They appear to be centers of political, military, and even religious power with a rural hinterland under their control. The palatial society of the prehistoric Aegean did not leave any political heritage for the later inhabitants of the Greek land bar one, the obviously mythologized memory of the institution of kingship. Some examples of their skills, however, (such as the monumental "Cyclopean" walls of Mycenae or those on the Athenian Acropolis), remained visible and may have influenced, to some degree, the later development of Greek art and technology.

ARTS AND CRAFTS The Mycenaean palaces appear to have been centers of development for crafts (metallurgy, pottery, goldworking, and minor arts) as well as housing workshops for their production. Often the materials they used were imported from the Near East, Egypt, or the Balkan Peninsula, and Central

Europe, evidence for the relationship of the Mycenaean world with cultures outside Greece.

IMPOSING BURIAL STRUCTURES The upper echelons of Mycenaean society were buried in monumental "beehive" (*tholos*) and chamber tombs, usually family ones, and accompanied by numerous rich grave goods.

CONTROLLED LITERACY The Mycenaean palaces used, mainly for administrative purposes, a system of writing, called by modern scholars Linear B, which has been shown to represent an early form of the Greek language.

1.1 "The coming of the Greeks"

Linear B texts available to us suggest that Greek-speaking populations lived in the Greek mainland by the middle of the second millennium BC. The time of their arrival and the itinerary they followed remain a matter of speculation as evidence is inconclusive. According to some scholars, the archaeological and linguistic record suggests population movements and the destruction of settlements a little before 2000 BC, at the beginning of the period we today call the Middle Bronze Age (2000–1600 BC). According to this view, new racial groups (later to be identified as "the Greeks") gradually settled in Greece in this period, apparently having come over land from the north. Changes in the culture of the ensuing period include apsidal rather than rectangular buildings, new burial structures, new styles of pottery, the use of horses, and, most importantly, an early form of the Greek language. A new cultural amalgam is thus emerging, in many ways anticipating the Greek civilization of the first millennium BC: gods old and new, "pre-Hellenic" place names (such as Corinth, Hymettus, Parnassus) adopted by the new populations, new myths, and a new social order.

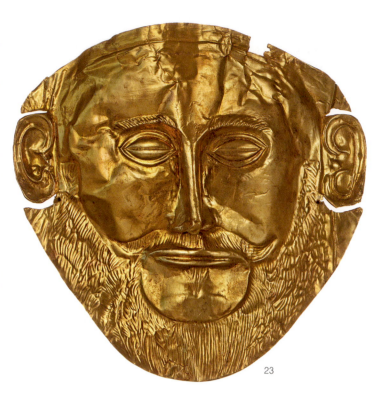

23

1.2 Art in Mycenaean Greece

The following period, the Late Helladic/Mycenaean (1600–1200 BC) marks the unparalleled peak of the new civilization. The establishment of an emerging ruling class by the newly arrived Greek-speakers, the relations with Minoan Crete and the Near East, the spread of new technologies and the amassing of wealth all define Mycenaean Greece. The Greeks of the Mycenaean period have been tentatively identified with the "Achaeans" of the Homeric epics (see pp. 53–55) which seemed to have preserved distant memories of historical events occurring towards the end of the Mycenaean period. Homer's fable of "Mycenae rich in gold" was confirmed archaeologically by

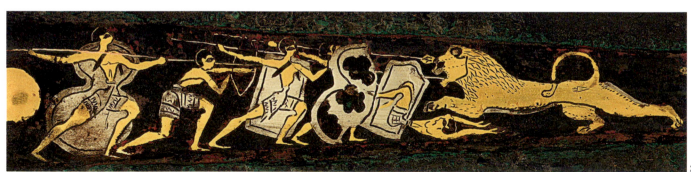

24

23. Mycenae, gold burial mask. Sixteenth century BC. Athens, National Archaeological Museum 624.

24. Mycenae, bronze dagger with hunting scene. Sixteenth century BC. Athens, National Archaeological Museum 394.

the discovery of the royal shaft graves of the sixteenth century BC, whose rich offerings, symbols of social status but also of military supremacy, create the picture of a distinct ruling class, with strong international contacts and ventures abroad. During the fifteenth century BC, the Mycenaean ruling class buried its dead in monumental beehive tombs like those at Mycenae but also to be found in the rest of the Peloponnese and in the regions of mainland Greece where the Mycenaean civilization flourished.

The archaeological evidence available, corroborated by the administrative documents which have been deciphered to date (see p. 38 for Linear B), indicate that the palatial centers of Mycenae, Tiryns, and Pylos controlled the local agricultural and "industrial" production (oil, wine, perfume, textiles) as well as the trade networks. The excavations of Late Helladic sites have revealed that Mycenaean Greece imported copper, ivory, glass, precious stones, and other exotic and rare materials. The palace workshops produced objects which displayed wealth and social status and frequently ended up in the tombs of their owners. The objects themselves demonstrate the complex and sophisticated skills that were needed for their manufacture: in many objects we meet the goldsmiths' crafts of hammering and inlay, engraving in miniature, granulation, and cloisonné (see p. 54).

Mycenaean visual arts (wall- and vase painting, glyptic) are distinguished by their rich decoration, the schematic and minimalist rendering of mass and space, the use of vivid colors and bold outlines, the love of symbolic insinuation rather than "realistic" representation. Subject matter comes from the world of the gods and other mythical creatures, consisting of mythical, but at the same time ritual scenes, as well as themes from the idealized daily lives of an almost heroized warrior aristocracy: the noble deeds in war and hunting which we meet in glyptic, painting, pottery, and the minor arts of Mycenaean civilization probably reveal its historical roots, as much as the way in which the Mycenaean ruling class wished to portray itself.

Around 1200 BC the Mycenaean palace centers collapsed and were never again rebuilt. With their destruction, the majority of the crafts which had flourished under their control were forgotten, including writing. Although life continued in many areas of Greece, as shown by the substantial settlements of

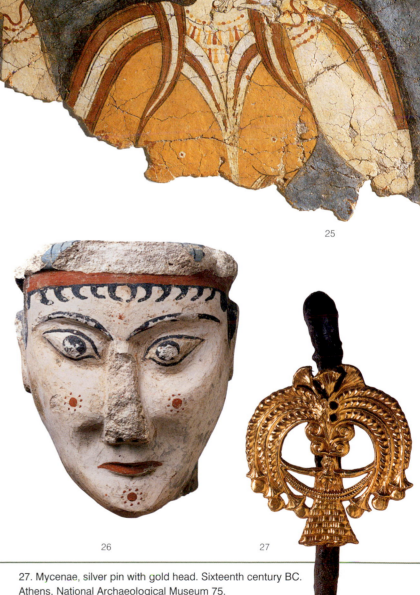

25

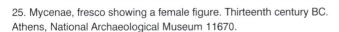

26 27

25. Mycenae, fresco showing a female figure. Thirteenth century BC. Athens, National Archaeological Museum 11670.

26. Mycenae, plaster head of a female figure. Thirteenth century BC. Athens, National Archaeological Museum 4575.

27. Mycenae, silver pin with gold head. Sixteenth century BC. Athens, National Archaeological Museum 75.

this date found in Attica, Crete, Rhodes, and elsewhere, Mycenaean civilization appears to have declined gradually until around 1050 BC.

The Late Helladic was followed by a period of political and social decline (1100–1050 BC), termed Submycenaean, and accompanied by economic downturn. Formerly historians called the period from the end of the Mycenaean period until the seventh century BC the "Dark Ages" or the "Greek Middle Ages," in comparison to European history, as a result of the absence of historical or archaeological data from this long period of time. As research has progressed, it has been shown that, despite the economic collapse which is evident in some areas of Greece, the first three centuries of the first millennium BC are characterized by intense social and political development which would lead to the spectacular rise of Greek civilization.

1.3 The destruction of Mycenaean civilization and the "Dorian invasion"

Mycenaean civilization was destroyed at the moment of its greatest prosperity; as excavations of many Mycenaean citadels show (chiefly those at Mycenae, Tiryns, Athens), it appears that, around 1250 BC there were general attempts to reinforce their fortification walls (see below p. 43), presumably because of the fear of attack. Excavations at all Mycenaean sites in Greece show clear signs of destruction and abandonment around 1200 BC. Some of these sites, like Mycenae, were reoccupied, even if temporarily, while others were permanently deserted. These upheavals caused large-scale movements and migrations of populations to the west and east, to new sites which were established from Cephalonia to Cyprus.

Historians and archaeologists have attempted to explain the Mycenaean collapse in many ways: besides the so-called "Dorian invasion" which will be discussed below, other theories include the possibility of widespread drought and famine which could have caused upheaval and conflict, an earthquake or other natural disasters, attacks by hostile tribes, such as the "Sea Peoples" (see below) or rebellion of the local landless peasantry (who probably came from the pre-Greek populations) or even slaves. In any case, the general collapse of the Mycenaean palaces defines the limits of palatial bureau-

cracy as well as the economic dead-end which Greece had reached in a period of widespread turmoil, population movements, and the suspension of trading contacts or the dissolution of former alliances. The disintegration of the Mycenaean world created an economic, political, and cultural vacuum that modern scholarship finds extremely difficult to describe in a satisfactory fashion.

1.4 The "Sea Peoples"

The collapse of Mycenaean civilization occurred against the background of widespread upheaval which seems to have thrown the whole of the wider region of the eastern Mediterranean and the Near East into turmoil. The definitive collapse of the formerly all-powerful Hittite Empire, which dominated Anatolia in the second millennium BC, is related to these dis-

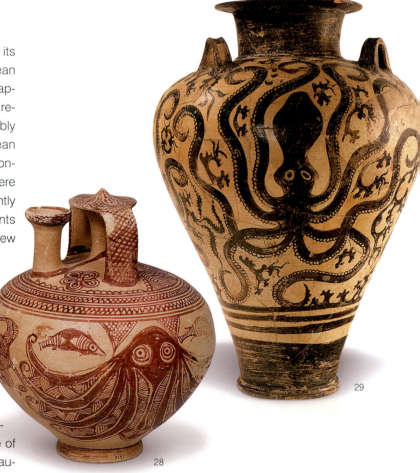

28

29

28. Mycenaean stirrup jar from Attica. Twelfth century BC. Athens, National Archaeological Museum 9151.

29. Mycenaean three handled amphora from Argos. Fifteenth century BC. Athens, National Archaeological Museum 6725.

CHARIOTS

The invention of the chariot –a simple horizontal platform supported on two wheels and drawn by one, two, or more horses– can be placed in the second millennium BC. It was immediately adopted by the great civilizations of Egypt, Anatolia, and Mesopotamia as a light and swift means of transport, a convenient weapon of war but also a symbol of high social status and power. In Greece chariots appeared in the transition from the Middle to the Late Helladic periods, that is around 1600 BC, probably as the result of Hittite influence. Even if the terrain of Greece did not permit the development of military formations with widespread use of chariots, the Linear B tablets demonstrate their relatively general use in the Mycenaean centers. The limestone funeral stele in fig. 30 is the oldest representation of a chariot in Greece. It is dated to the sixteenth century BC and comes from Grave Circle A at Mycenae (Tomb V). It depicts a man in a chariot armed with spear and bow, while a man on foot, armed with a sword, fights in front of him. Chariots are frequently depicted in later Greek art, principally in mythological contexts (see fig. 62). Gradually, however, their use was confined to displays of ceremonial character such as ritual processions. Already in the Homeric epics, chariots are only used in battle as a means of transport for fully-armed heroes and not during the encounter itself.

turbances. Many of the cities of the empire were destroyed as a direct result of the activities of these groups, while the Hittite capital at Hattusa was abandoned and fell to ruin before its final destruction in a great fire. A little earlier, hostile tribes had descended upon Egypt, whose army repulsed them with difficulty. We do not know the racial or cultural origin of these attackers, who are described in Egyptian sources as "Peoples of the Sea." These "Sea Peoples," as modern scholarship would term them, returned to Egypt at the beginning of the twelfth century BC causing widespread destruction once more. The city of Troy is often presumed by modern historians to be one of the victims of these invaders in the wider eastern Mediterranean region. According to this view, the destruction of Troy around 1250–1200 BC is reflected in the siege immortalized as the "Trojan War" in the Homeric epics almost half a millennium later.

Were the Mycenaean Greeks responsible for the destruction of Troy as Homer would have it? Should, in that case, the Mycenaeans be counted as one of "the Sea Peoples"? What role did this enterprise of theirs play in the destruction of their own citadels a little after the presumed attack on Troy? It is difficult to provide an answer to these questions, since both the archaeological and the literary sources seem confused. Beyond the picture of catastrophe emerging from the excavations of the Mycenaean palaces, it is relatively certain that the Mycenaeans ("Achaeans") were in contact with the Hittites during the thirteenth century and that there was a much contested city or region in the same period known to Greek-speakers with the Hellenized name of "Ilion" (a synonym for Troy in later years); some scholars also postulate that the "Achaeans" are listed as one of the "Sea Peoples" in the Egyptian chronicles of the period.

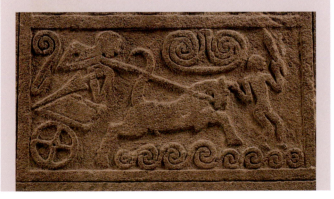

30

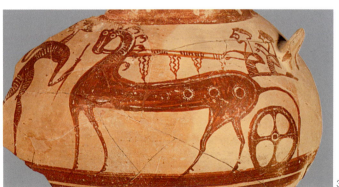

31

30. Mycenae, limestone tombstone from Grave Circle A. Sixteenth century BC. Athens, National Archaeological Museum 1428.

31. Mycenae, krater fragment showing a chariot. Thirteenth century BC. Athens, National Archaeological Museum 1668.

32. Mycenae, the Lion Gate. Thirteenth century BC.

1.5 The "Dorians"

Modern historiography often attributes the final breakdown of the Mycenaean world to an invasion by the "Dorians," described as a Greek speaking tribe who until this point had lived in the mountain regions of the Pindus, in Epirus and Thessaly. According to these theories, these culturally backward, unsophisticated but war-loving northern Greeks living in the periphery of the Mycenaean world were powerful enough to capture the rich palaces, bringing with them a series of innovations such as the use of iron. On the one hand this view is based on the accounts by later Greek historians and mythographers who spoke of the return of the "Heraclidae": these were the mythical sons of Herakles and their offspring, returning to their ancestral homes in the Peloponnese (see p. 49). This myth was supposed to explain the fundamental division of the Greek populations in the Classical period into the Ionians and Dorians. On the other hand, and according to the archaeological evidence available, the advent of the Dorians, which cannot be described as an organized invasion, must have happened substantially later, around 1000 BC, when the political and cultural changes attributed to them had already taken place for other reasons. Moreover, the import of iron into Greece does not seem to have happened from the north but from the Near East —most likely through Cyprus. In this case, both the new material and the technology associated with it seem to have been passed on further north through Greece rather than the other way round.

2. PROTOGEOMETRIC PERIOD (1050–900 BC)

The period during which the first signs of new social and political organization appear, along with the first signs of cultural recovery for Greece, is called the Protogeometric. The term refers to the prevalence of geometric symbols decorating the pottery and also to iconographic elements in other crafts and arts in this period as well as in the art of the Geometric period (ninth–eighth century BC). The Protogeometric, which coincides with the eleventh–tenth centuries BC, is characterized by a strong break with the preceding Mycenaean civilization, even though it has some elements of continuity with it.

2.1 Mycenaean past: break and continuity

The archaeology of the Early Iron Age demonstrates that the culture of Greece radically changed in this period in comparison to that of the Mycenaeans. Elements of cultural change in the Early Iron Age are as follows:

THE LION GATE

Fig 32 shows the Lion Gate, the main entrance to the citadel of Mycenae. The gate, which was built around the middle of the thirteenth century BC as part of the expansion and strengthening of the walls of the fortress, bears relief decoration in the relieving triangle crowning it: two lions face each other (in the so-called "Heraldic" pose) resting on two altars, with a Minoan-style column (narrowing towards the base) between them. The relieving triangle is a characteristic element of megalithic Mycenaean architecture that aimed to relieve the horizontal stone lintel from the crushing weight of the overlying structure of the building. The Lion Gate is, therefore, an example of the few but important distinguishing features of Mycenaean art that we will encounter in the Greek art of the historical period:

MONUMENTAL CHARACTER The building, but also the sculpture, impress with their volume, their material, and their imposing dimensions. It is transformed thus into a symbol of secular, possibly even divine, power.

PICTORIAL CHARACTER The imposing quality of the monument is reinforced by the iconographic subjects of the composition, the two lions —symbols of power and possibly royal supremacy— and the abbreviated depiction of the palace building which they are shown guarding: the column is crowned by horizontal roof beams that doubtless refer to the Mycenaean *megaron* (a Mycenaean palace's great hall), protected by this same fortification wall.

POLITICAL AND SOCIAL STRUCTURE The collapse of the Mycenaean palaces and the appearance of new tribal groups in Greece led to restructuring of the local societies resulting in the eventual emergence of the *city-state* in the following centuries.

TRADE AND EXCHANGE The once intensive contacts with the peoples of the Near East, but also with the European mainland, were interrupted temporarily before reviving towards the end of the period.

LITERACY The use of writing, which, moreover, never became widespread amongst the cultures of the Bronze Age, was abandoned until the eighth century BC, when it returned with the introduction of the Phoenician alphabet.

MONUMENTAL ART The monumental architecture, painting, and sculpture which flourished to a greater or lesser degree under the patronage of the palatial centers of the Bronze Age was abandoned for several centuries, until the seventh century BC when the social and political conditions had matured enough for their revival.

DECORATIVE ARTS At the same time, the "minor" decorative arts of the Bronze Age, such as jewelry making, seal carving, and ivory working, were abandoned or declined significantly. As "luxury" crafts, which require a mature social and economic environment in which to grow, these were revived in the Greek world of the ninth and eighth centuries BC under the influence of the Near East once again, when the social conditions permitted.

Nevertheless there are some important elements of continuity from the Mycenaean past which should not be overlooked:

PARTIAL ETHNIC CONTINUITY Despite the advent of new ethnic

THE WARRIOR VASE

The period following the destruction of the Mycenaean palaces, Late Helladic IIIC according to current terminology, appears to have lasted from 1200 to around 1100 BC. It is a period of migrations, invasions, and upheavals, as well as changes in the lifestyle of the inhabitants of Greece. The art of the period naturally derives from the Mycenaean, but several elements appear, such as the narrative character of pottery decoration, which were to become the defining characteristic of Greek art.

Fig. 33–34 show a wide-mouthed bowl —which the Greeks of the first millennium BC would call a "krater"— on which we see six warriors fully accoutered for war: they are wearing tunics and breastplates, helmets (possibly leather-made) with horns and plumes, and they hold a semi-circular shield in their left hand and a spear in their right. The small sacks that appear to be tied to the spears of the soldiers possibly contain military rations (perhaps symbolizing in this way the start of a campaign). To the left of the warriors is a female figure wearing a long robe, probably standing in a pose of farewell or blessing. Even if the scene belongs to a period during which iconographic codes had not yet become crystallized, it appears to be a clear attempt to convey an entire narrative scene, which refers to specific mythical or historical events in the recent or more distant past. Thus it may be assumed that the scene on the vase expresses in some way the historical reality of its time.

33

33, 34. Mycenae, the Warrior Vase. Twelfth century BC. Athens, National Archaeological Museum 1426.

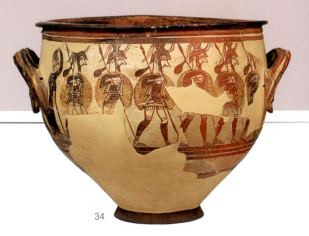

34

groups in Greece, the survival of others can be observed whose origins can be traced from the Mycenaeans.

PARTIAL LINGUISTIC CONTINUITY The use of Linear B in the Mycenaean palaces testifies that at least a few ruling groups in the Mycenaean world spoke an early form of the Greek language.

SURVIVAL IN RELIGION AND MYTH Specific iconographic elements, and especially the information provided by the Linear B tablets from the Mycenaean palaces, testify to the Mycenaean origin of several deities and other mythological characters that are encountered in the Greek world of the first millennium BC.

SURVIVAL OF SEVERAL FORMS OF ART AND TECHNOLOGY Although the highly developed arts of the Mycenaean period fell into decline, several, such as the essential elements of pottery making, survived, to revive dramatically in the Protogeometric period.

A PROTOGEOMETRIC BURIAL

In fig. 35–40 we see a grave of the Protogeometric period from Athens. It is a primary cremation, as the excavated remains show (fire-blackened stones and charcoal). In the southeastern edge of the pit a circular pit was dug in which the cinerary urn was placed upright, covered with another, smaller pot, which has been used as its lid. The grave goods included other, smaller pots, as well as a pair of iron pins (to secure clothing, especially women's) and a bronze ring.

The grave goods as well as the type of cinerary urn that was used, an amphora with horizontal handles on the belly, indicate that this grave belonged to a woman.

During the Early Iron Age amphorae with horizontal handles were used in Athens as a rule as cinerary urns for women, while for male cremations the cinerary urn was as a rule an amphora with vertical handles (see fig. 60).

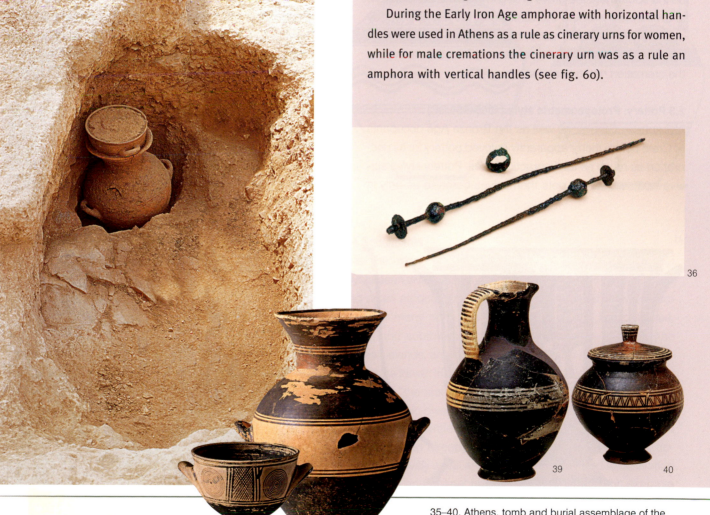

35–40. Athens, tomb and burial assemblage of the Protogeometric period. Tenth century BC.

44

is the settlement at Nichoria in Messenia, which appears to have been established in the tenth century BC on the site of an earlier Late Helladic settlement which had been temporarily abandoned. One innovation we may observe here, which is, however, a general trend in Greece during this period, is the construction of apsidal buildings, rather than the rectangular ones of the Late Bronze Age (see fig. 44). The houses of this type were built of raw mud bricks on a stone foundation, with a thatched roof. Gradually their dimensions were increased (the building in fig. 44 has a length of 8–10 m, while buildings of eighth century BC date in the same settlement measured up to 16 m).

From the ninth century on, the picture of decline and abandonment changes and according to archaeological evidence an increase in population can be observed. These developments, which had major political implications, are reflected in several foundation myths preserved from this period: the *synoecism* of Athens, i.e. the unification of the small townships of Attica under the leadership of the legendary King Theseus, or the "return of the Heraclidae" discussed above, symbolizing the attempt by Sparta to establish itself in its region, are mythical narratives; they do, however, reflect the political processes which were developing already by the end of the Bronze Age and which led gradually to the formation of the city-state.

45

THE LEFKANDI SETTLEMENT

The excavation of the Early Iron Age settlement at Lefkandi, between the later cities of Chalkis and Eretria on the island of Euboea, has shown that during the period between 1100 and 700 BC this island experienced an economic prosperity which was due largely to trade relations with other areas, even outside of Greece. Excavation brought to light material remains from around 2000 to 700 BC. The graves of the settlement contained gold jewelry and luxury items which were imported from the Near East. Already in the ninth century it appears that a metal workshop was operating in the town (the excavation produced molds for casting).

A characteristic example of a grave good from Lefkandi is the clay figurine in fig. 46, 36 cm in height, representing a centaur, a mythical creature thus gradually making its entrance into the repertoire of Greek art. This remarkable object was found split between two tombs dating to around 900 BC. The decoration on the figurine, which is similar to that on Euboean pottery of the period, and the local clay of its make, testify to its local production; its method of construction, however (which has been associated with Crete), and its iconography, betray strong oriental influences but also recall the Late Helladic period. As the creature is portrayed with six fingers in his right hand, and a blemish painted on his right knee, it seems that the figurine is alluding to a specific mythical narrative; some think of the fable according to which Herakles had inadvertently inflicted an arrow wound on the knee of Chiron, a centaur celebrated in Greek myth for his nurturing skills as a foster father to heroes such as Achilles, Ajax, or Herakles himself.

An important building, 48–50 m in length and 10–13 m wide, appears to have been a sort of monument for the settlement and is usually called the "Heroon": it was built of mud brick on a stone foundation with an apsidal plan and it appears that it was surrounded by a roofed veranda with wooden columns (fig. 45). Two pit graves were found inside the building: one of a man, with his cremated remains placed in a bronze cauldron, and beside it the burial of a woman

44. Nichoria, Messenia. Plan of a house from the Protogeometric settlement. Tenth century BC.

45. Lefkandi, Euboea. Reconstruction drawing of the Heroon. c. 1000 BC.

(possibly a sacrifice). The grave goods were particularly rich for both and included, in addition to the weapons for the man, metal jewelry and imported luxury goods, as well as four horses buried in a separate pit. The use of the building (which may or may not predate the burials) and its conversion into a monument date to the period between 1000–950 BC. Culturally it forms the link between Mycenaean and historical Greece, as it provides valuable material evidence for the vague mythological and literary memories which the Greeks of the Classical period preserved from their heroic past. The wealth and type of grave goods, as well as the associated grave with the horses, recall the burial customs described by Homer (see *Iliad* XVIII), even if they date to more than two centuries before the epics. It confirms the assumption that the Homeric poems retain memories both from the distant, mythical past of the Bronze Age as well as the more recent "Heroic" past of the tenth and ninth centuries BC.

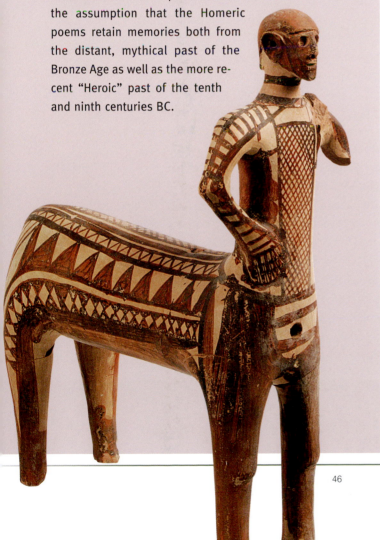

46

46. Lefkandi, Euboea. Clay figurine of a centaur. c. 900 BC. Eretria, Archaeological Museum 8620.

3. GEOMETRIC PERIOD (900–700 BC)

The time from the end of the tenth century BC down to the end of the eighth is called the Geometric period. Its name comes from the art of the period, in particular the pottery, the decoration of which was filled with geometric motifs. The Geometric period is divided into the following sub-periods:

- Early Geometric (900–850 BC)
- Middle Geometric (850–760 BC)
- Late Geometric I (760–735 BC)
- Late Geometric II (735–700 BC)

The ninth and (mostly) the eighth centuries BC were the period during which the political concept of the city-state emerged, as a result of social and political processes that had already been set into motion in the preceding period. In particular the Geometric saw:

- The formation of **new settlements** as a result of population movements during the previous period. A gradual population expansion has been observed before the end of the ninth century BC but mostly during the eighth.
- The appearance of **new political institutions** with gradual (perhaps from the eighth century) weakening of the institution of kingship and its replacement with aristocratic regimes.
- The economy remained largely **agricultural**, directed towards the economic self-sufficiency of the community, resulting in political isolation.
- In parallel, the **development of small-scale industry** has been observed, mainly for the manufacture of clothing, utensils, tools, and furniture.
- Consolidation of the **social stratification** in classes: land owners, farmers, those without land (*thetes*), and slaves.

At the same time, the eighth century BC was a turning point in Greek history which is marked, definitively this time, by the exodus of Greeks from the boundaries of their homeland, economic and cultural interaction with the West and the East, and the consequent rise in their standard of living. The historical and cultural developments during the eighth century BC include:

COLONIZATION Already before the middle of the eighth century Greeks had initially founded trading centers and then fully fledged colonies in Italy, Sicily, and around the northern Aegean. The purpose of colonization, which continued even until the sixth century BC, was to address the problem of rising population in Greek cities, to resolve political conflicts

between local aristocratic factions, to develop trade relations, and gain access to metal deposits. The exodus of the Greeks from their homeland, in collaboration but also frequently in rivalry with the other peoples of the eastern Mediterranean basin, such as the Phoenicians (a people living in the area of Lebanon), provided them with a series of important stimuli that marked the course of Greek civilization. A key role in this process of osmosis was played by the island of Cyprus, with a significant Greek presence already by the end of the Mycenaean period, but also major Phoenician settlements, particularly active in trade.

INTRODUCTION OF THE ALPHABET An immediate result of trading contacts with the Near East was the introduction of the Phoenician alphabet before the middle of the eighth century BC and its wide dispersion throughout the whole of the Greek world. In contrast with the Mycenaean past, and also the practice of theocratic regimes in the East, such as Egypt, literacy was for the first time in Greece a right for all and not a privilege of the aristocracy or the priesthood (see fig. 47–48).

EPIC POETRY Most experts place the composition of the *Iliad* and the *Odyssey*, the two monumental epic poems that combine the already mythical Mycenaean past with cultural references to recent history, in the eighth century BC. With the work of Hesiod, who is placed around the same time, or a little later, the relationship between Greek culture and literary expression and dissem-

ination was consolidated. Hesiod's *Theogony*, in particular, presents for the first time the complete Greek pantheon and its mythical genealogy. It is a *succession myth*, where the passage from one primordial era to another is explained by the succession of one generation of ancient gods to the next (Uranus – Kronos – Zeus). The Greek theogony has many striking parallels with similar succession myths of other cultures, such as the Babylonian and the Hittite, which date to the second millennium BC.

LOCAL CULTS AND PANHELLENIC SANCTUARIES During this period the religious system of the Greeks was consolidated and local and panhellenic sanctuaries were founded. These recognizable places of worship for Greeks at large, though also visited by pilgrims from east and west, operated as centers of development for Greek art and especially architecture, sculpture, painting, terracottas, and minor arts.

THE BIRTH OF FIGURATIVE ART Forgotten after the end of the Mycenaean period, and after a few sporadic and isolated attempts in the previous period which had no successors, pictorial scenes made a dynamic comeback in the realm of Greek art.

As a result of these processes, the Greeks came to recognize and promote their common cultural heritage, despite the political and military conflicts between different cities. The establishment of the Olympic Games in 776 BC, according to tradition, highlights the way in which the Greeks perceived themselves as a distinct entity in the Mediterranean world.

3.1 Pottery: Athenian Geometric style (900–700 BC)

The Geometric style of pottery was a natural progression from the Protogeometric. Since Athens appears to have been the most important center for production of Geometric vases, the developments there also influenced the other workshops. Protogeometric pottery shapes continued into the Geometric but now appear intentionally taller and more slender, and are generally larger in size. A typical new shape in the period is the oinochoe with a flat base and the footless skyphos (fig. 49). Pottery decoration appears highly varied in this period.

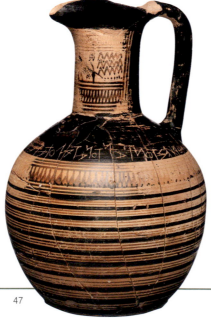

47

48

47, 48. Attic trefoil-mouthed oinochoe. c. 750–735 BC. The inscription mentions how the vase will be given as a prize in a contest between dancers. Athens, National Archaeological Museum 192.

49. New Geometric Shapes: a. Skyphos, b. Trefoil-mouthed oinochoe.

Geometric style in pottery: an overview

DECORATION A wide variety of Geometric themes: meander, rosette, swastika, chequer-board and triangular motifs, crosses, crosses within circles, and so on.

SILHOUETTE As with the Protogeometric style, the decoration of the pots is exclusively rendered in silhouette (brown/black gloss over the pale body of the pot).

GEOMETRIC COMPOSITION Geometric pottery is characterized by a dense geometric composition which is supported by the balanced arrangement and symmetry of the motifs used. The decoration of each vase is conceived as a unity.

TECHNICAL SKILL Technological progress is evident in the potting quality of Geometric vases both in terms of decorative composition which is frequently highly demanding as well as in firing, which determines the final appearance of the pot and enhances its iconographic content.

FIGURED SCENES In the Geometric period and particularly from the middle of the eighth century on, the vases begin to host scenes with iconographic references to myth, recent history, and daily life.

50 51

The development of Athenian pottery in the Geometric period shows that there was a proliferation of geometric motifs so as to cover the entire surface of the pot by the end of the period:

DURING THE EARLY GEOMETRIC PERIOD Vases tended to be painted entirely black, with decoration restricted to the neck and shoulder. The absence of the circles and semi-circles of the previous period is noticeable. These are now replaced by linear motifs such as the meander (fig. 50).

DURING THE MIDDLE GEOMETRIC PERIOD The number of decorative zones increased significantly, while circles made a revival in some shapes, now however framed by linear decorative zones. Human figures and animals make a tentative appearance (fig. 51).

DURING THE LATE GEOMETRIC PERIOD I Some pots become monumental in design and size, covered almost entirely with geometric patterns, while they now include figurative scenes with wholly narrative character (fig. 61, 62–63).

DURING THE LATE GEOMETRIC PERIOD II The austere geometric composition and decoration was gradually abandoned and the pots give the impression of fatigue. Curvilinear designs appear at the same time. On the other hand, there is now a prominent increase in iconographic references to events from the world of myth and epic (fig. 79).

3.2 Other production centers of Geometric vases

Even though, as already observed, Athens dominated the production of Geometric pottery, there were other important centers during the period, such as Corinth, Argos, Euboea,

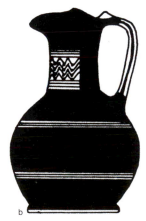

a 49 b

50. Attic Geometric amphora. c. 900–850 BC. Athens, National Archaeological Museum 18121.

51. Attic Geometric amphora. c. 850–800 BC. Athens, National Archaeological Museum 216.

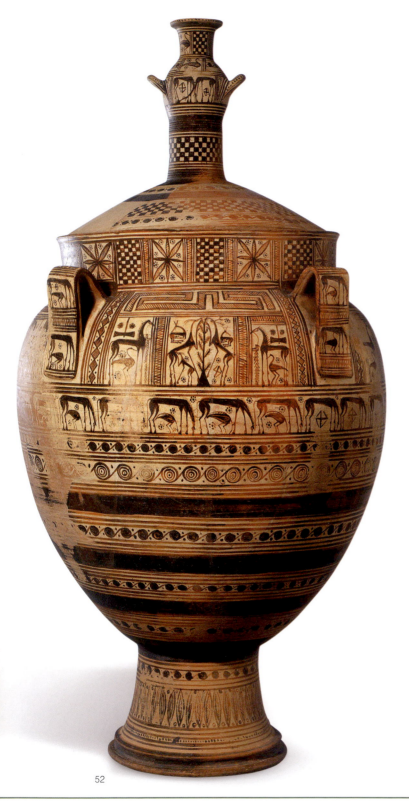

52

52. Euboean Geometric krater with a scene of "the tree of life" and animals. c. 750 BC. New York, Metropolitan Museum of Art 1874.51.965.

and Crete. From the middle of the eighth century BC figurative scenes were included in these workshops also, sometimes of plain character (such as horses and human figures) and sometimes more complex (hunting scenes). Around the middle of the eighth century BC contacts by these cities with the world of the East appear to proliferate: several themes from the Eastern repertoire were adopted into Greek pottery at this time, such as the so-called "tree of life," which can be seen in important examples of Euboean Geometric pottery (fig. 52).

In any case, the iconographic and symbolic realm of the vases relates to the world of the nobles, the main customers of potters in this period, and as such relate to their interests: exploits in war or hunting, mythical tales, and so on. The type and shape of the vases (kraters, amphorae, oinochoae, and skyphoi) are those which were typically used in social gatherings of men of the ruling class, through which the aristocratic ethos of the time was promoted and reinforced. The krater in particular, the vessel that the Greeks used to mix wine with water according to their time-honored custom, gradually came to represent male bonding, mainly in the ruling class, as expressed in the ritual consumption of food and wine. This practice reflects the Homeric epics, where similar rituals belong to the heroic past of the Bronze Age. As will be noted in the next chapter, these social events were to be transformed, by the impact of practices that the Greek aristocrats borrowed from the East, into the *symposium*, which was to be a characteristic feature of Greek culture in the centuries to come (see pp. 98–99).

The spread of literacy and literature, as we have seen, was crucial for the development of Greek culture during the eighth century BC, affecting both the use and the appearance of art, especially the pottery. A typical example is the vase dating to c. 750–725 BC, found at Pithekoussai, the colony that the Euboeans had founded before the middle of the eighth century BC off the Italian peninsula on the island of Ischia in the Gulf of Naples. It is a kotyle, a drinking vessel similar to the skyphos, which was evidently used at feasts (fig. 53). It was manufactured by a northern Ionian workshop and is decorated in the typical Geometric style of the period, but has an inscription in verse written in the Euboean alphabet, which may be completed as follows:

53

54

νεστορος […] ευποτον ποτεριον
hος δα τοδε πιεσι ποτερι[ον] αυτικα κενον
hιμερος αιρεσει καλλιστεφανο αφροδιτες

I am Nestor's cup, good to drink from.
Whoever drinks from this cup, him straightaway
the desire of beautiful-wreathed Aphrodite will seize

The lines refer, albeit indirectly, to the king of Pylos in the *Iliad* (XI 632–637). The dissemination of the Ionian epic tradition to the small community of Pithekoussai and such skillful use of alphabetic writing only a few decades after its introduction into Greece, are important indications of the way and the speed with which cultural influences travelled in this period.

3.3 The archaeology of the Homeric epics

The location of the archaeological sites of Troy and Mycenae by Heinrich Schliemann in the nineteenth century demonstrated that the legends of the Homeric epics had an historical basis, even if this had to be sought in the midst of a complex web of mythology, later additions, and literary tropes. Today we recognize that, even if the Iliad and the Odyssey recount events that can be supposed to have taken place in the Late Helladic period, in reality they describe Greek society in the Early Iron Age, especially the period between the later ninth and eighth centuries BC. The distant memories of the Bronze Age are mingled in this way with more recent political and cultural realities which also survived, often in an altered from, until the moment at which the epics were composed.

The survival of actual remains from the Bronze Age, such as the cyclopean walls of Mycenae and the Athenian Acropolis, but also of objects that were either discovered by chance or preserved as heirlooms, must have contributed to the recycling of memories from the Mycenaean past. It is not uncommon to find such heirlooms from the thirteenth or twelfth centuries as

offerings in tombs, even two centuries later. Perhaps this is the way Homer was inspired of the Mycenaean scepters that he describes, by Mycenaean examples such as that found at Kourion in Cyprus, dating from the middle of the twelfth century BC (fig. 55). The silver riveted swords of the Achaeans, decorated with gilded rivets, which have been discovered in several important Mycenaean grave contexts such as Grave Circle A at Mycenae (fig. 56), are also described in the epics with remarkable archaeological precision.

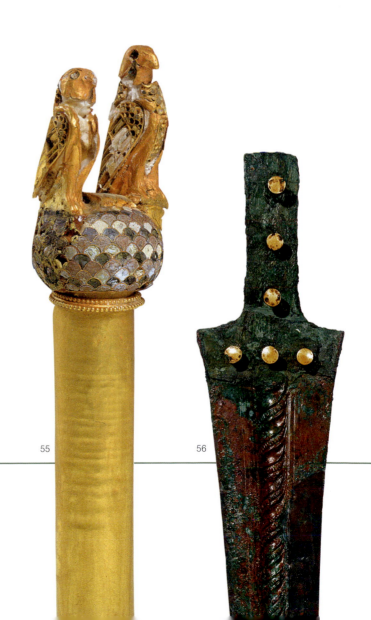

55

56

53, 54. Geometric kotyle with inscription. c. 750–725 BC. Ischia, Archaeological Museum of Pithekoussai 166788.

55. Kourion, gold scepter. c. 1150 BC. Nicosia, Museum of Cyprus.

56. Mycenae, bronze sword with gold decoration. Sixteenth century BC. Athens, National Archaeological Museum 752.

THE TOMB OF THE "RICH ATHENIAN LADY"

A particularly rich Middle Geometric grave provides important evidence for the way in which the economic and social conditions of the period are reflected in burial customs. It is the cremation burial of a pregnant woman found in the area over which the Agora of Athens extended in the Classical period and dates to around 850 BC. The cinerary urn was an amphora with horizontal handles, with the typical decoration, for the period, of meanders and concentric circles in panels (fig. 58).

The grave goods were numerous and rich: a necklace, probably imported from the Near East, small items of ivory, gold rings, and a pair of precious gold earrings (fig. 57). The latter are the earliest example of sophisticated gold-working in Greece after the end of the Bronze Age. They used two particularly difficult techniques, *granulation* (soldering small beads of gold onto the surface of the jewelry)

and *filigree* (the decoration of the surface of the jewelry with single or multiple strands of gold wire). Both of these techniques were in use during the second millennium BC, but were abandoned with the collapse of the Mycenaean palaces. Their revival during the Geometric period is attributed to contacts between Greek craftsmen with workshops in the east or to eastern craftsmen who moved to Greece during this period as a result of warfare and turmoil in their homeland.

Equally interesting is the accompanying vase in the form of a jewelry box (pyxis) from the grave (fig. 59). The lid of the vase is decorated with five egg-shaped ornaments, with skylight-like openings on top, which have been identified as granaries. It is possible that this exceptional pyxis alludes to the source of wealth for the deceased –land ownership: owning land, in combination with aristocratic descent and financial standing, were the main characteristics of the ruling class in Athens, as well as in other Greek cities in the Geometric period.

57

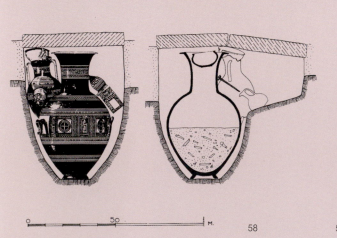

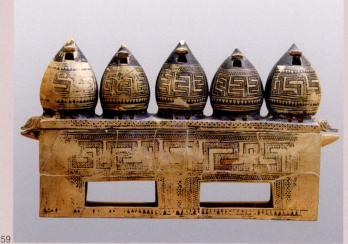

58 59

57. A pair of gold earrings from the tomb of the "rich Athenian lady." Ninth century BC. Athens, Museum of the Ancient Agora J148.

58. Athens, the "tomb of the rich Athenian lady." c. 850 BC.

59. Attic Geometric pyxis. c. 850 BC. Athens, Museum of the Ancient Agora P27646.

In consequence, the mixture of elements from separate cultural horizons with very different archaeological characteristics gives the epics a pervasive impression of anachronism: so while the Homeric heroes carry bronze weapons just like the Mycenaeans they are supposed to represent, iron and iron working are not unknown in the epics. In contrast, the metal tripod cauldrons are described in the epics as rich gifts, something that seems to reflect their use in the ninth and eighth centuries BC (p. 58–59), much more than their probably lesser significance in the Late Helladic period. As far as funerary practices are concerned, even if cremation was not unknown in the Late Bronze Age, the Homeric burials remind us much more of the archaeological finds from the Early Iron Age. In the same way the religious practices of both the Achaeans and the Trojans in the epics resemble those we know from the archaeology of the Early Iron Age rather than of the Mycenaean period.

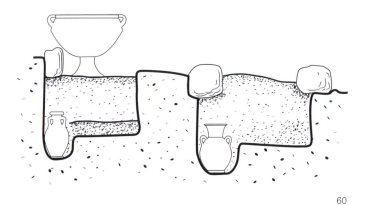

60

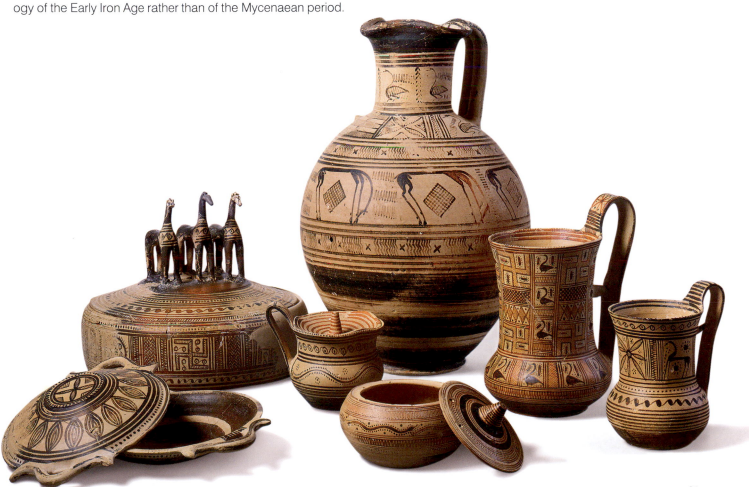

61

60. Reconstruction diagrams of graves of the Geometric period at Dipylon, Athens. The large krater to the left is the grave marker for a man, the cremated remains of whom were placed in a funerary urn with vertical handles. On the right is a cremation burial of a woman, who has a cinerary urn with horizontal handles and two unworked stones as markers.

61. Athens, burial assemblage from the grave of a woman. Eighth century BC. Athens, Museum of the Kerameikos.

THE DIPYLON VASES

The eighth century BC, mainly its middle and late phases, was a period of great prosperity for Attica: this is reflected in an increase in population, trade with areas outside of Greece, imports of luxury goods, as well as the emergence of a new aristocracy with portable wealth who made their presence felt and claimed supremacy over the old aristocracy of landowners.

An important group of graves dating from the second half of the eighth century BC have been excavated in Athens, in the so-called Dipylon cemetery near to the Kerameikos. Their distinctive feature is the use of colossal vases which stood above the graves, as their *sema* ("grave marker"). These markers took the form of utilitarian vessels –an amphora for women and kraters with a pedestal foot for men– but in monumental proportions, which transformed them into impractical objects, destined for funerary use (the amphora in fig. 63 is 1.55 m tall and the krater in fig. 62 is 1.23 m). In practice their bases were perforated, both to avoid the accumulation of rain water but also to aid the pouring of liquid offerings onto the grave. The choice of a krater as a marker for male graves was not by chance, as the specific shape symbolized the lifestyle of men of aristocratic descent.

The Dipylon Vases, as this particular category is conventionally called, demonstrate the degree of technical skill which the Athenian potters had mastered during this period, both in potting and in vase painting. Their surfaces are covered with Geometric motifs, with only a limited number of black-painted bands. Rows of meanders, lozenges, and animal friezes dominate and are repeated monotonously. Both ornamental and figurative motifs are executed with meticulous precision. The main pictorial elements of the Dipylon vases are the figurative scenes which are typically associated with the burial customs of the period. Two types of scenes may be found on the Dipylon vases:

PROTHESIS This is the laying out of the deceased by the family before burial. The body is depicted on the funerary bier beneath a shroud with mourners, men and women, standing, sitting, or crouching on either side or even underneath it (fig. 63).

EKPHORA This is the transportation of the body to its place of burial on a wagon, after the process of prothesis had been completed (fig. 62, 22).

In the Dipylon vases we also find secondary scenes such as:

CHARIOT PROCESSIONS These typically accompany the scenes of *ekphora* on kraters (fig. 62). It is not certain if these scenes reflect the actual burial practices of the time or if they refer to mythical events.

BATTLE SCENES These are also typically to be found on grave markers for male burials (kraters) and possibly refer to events in recent history or to the mythical past of the family to which the glorified deceased belonged.

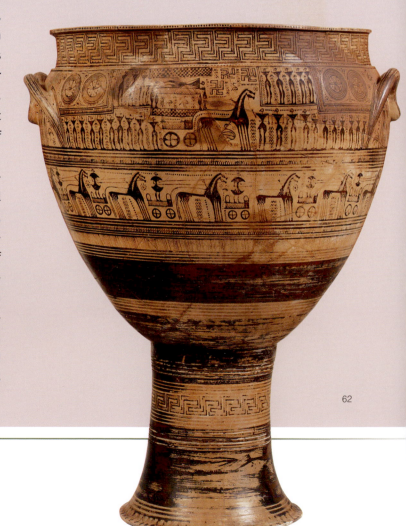

62

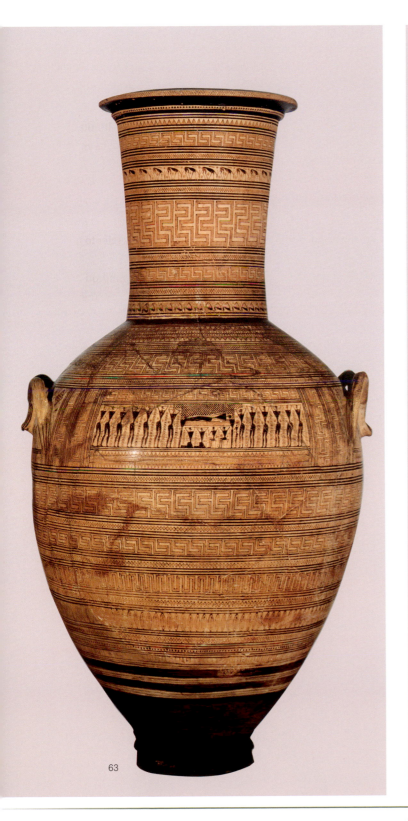

SHIP SCENES It is possible that the depiction of warships in secondary scenes on these vases (fig. 64) refers to actual or mythical exploits of the deceased or his ancestors.

The depiction of the human figure on the Dipylon vases is, as with the rest of Geometric art, simple but effective: the figures are formed from distinct shapes (triangles, squares, and so on) and hence appear clear, so they can fulfill the role appointed to them in the particular scene (mourning, fighting, and so on). Depth and filling details are depicted "cumulatively," as with the funeral shroud that is shown hanging over the body rather than covering it, the mourners depicted beneath the bier as a way of denoting they are actually seated in front of it, or the chariot horses that appear one on top of the other.

The Dipylon vases demonstrate the attempt of the Greek artist to conquer representation: the symbolic figures of humans, animals, and objects appear schematic and unnatural, but at the same time completely expressive. The limited and strictly standardized iconographic repertoire is used eloquently to remind and not to describe, situations and narratives of the recent and mythical past. In this way narrative is combined with social symbolism.

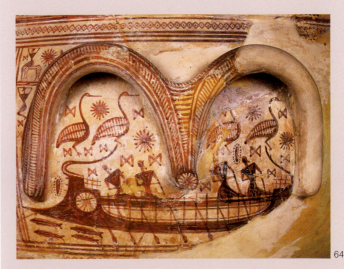

63

64

62. Attic Geometric krater with scene of ekphora. c. 745–740 BC. Athens, National Archaeological Museum 990.

63. Attic Geometric amphora with scene of prothesis. c. 755–750 BC. Athens, National Archaeological Museum 804.

64. Fragment of an Attic Geometric krater with a depiction of a warship. c. 745–740 BC. Paris, the Louvre A517.

THE FLAT-BASED PYXIS

A pyxis was a small storage vessel in which women frequently kept their jewelry. The name of the vase comes from *pyxos*, the ancient Greek word for birch wood, an evergreen bush used for the same purpose to the present day. Since these objects were normally wooden, the name of the most frequently used material was adopted for them and then transferred to the equivalent clay versions. As personal objects, pyxides are frequently found as offerings in the tombs of the historic period.

The type of pyxis with a broad flat base and lid with a handle in the shape of a horse or horses (as many as four) appeared towards the end of the ninth century BC and remained in use until the Late Geometric period (fig. 65). The horse, as a symbol of power, wealth, and social status, came after the constitutional reforms of Solon at the beginning of the sixth century BC, to constitute the determinative characteristic of the social class of the *hippeis* ("horsemen"), ranking second after the landowners.

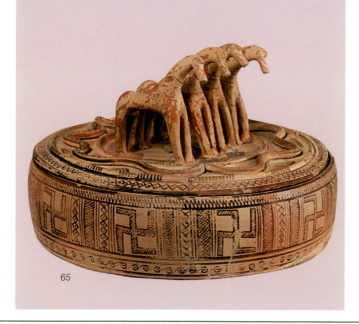

3.4 Figurines

The creation of local and Panhellenic sanctuaries during the Geometric period provided an enormous impetus to the development of monumental as well as minor arts. Metal and clay votive offerings were dedicated by the scores during this period at the great sanctuaries such as Olympia and Delphi. Votives from perishable materials, such as wood, ivory, or bone, were also made to be dedicated to these sanctuaries, but very few of them have survived. Human and animal figures were rendered in miniature in an austere Geometric style, in the same way as on the pottery of the period.

Frequently the figurines which have survived were originally made as decorative fittings for metal vessels such as tripod cauldrons (fig. 68). These vessels were generally made of hammered bronze, with cast legs. They were dedicated as valuable offerings at the great sanctuaries of the period (as bronze did not cease to have an exchange value in the ancient world). A common theme in this category of figurines is the warrior (fig. 69–70, 73) but there are also figurines that depict mythical or

Geometric figurines: an overview
- Geometric form
- Schematic, minimalistic representation
- Lack of anatomy
- Decorative character

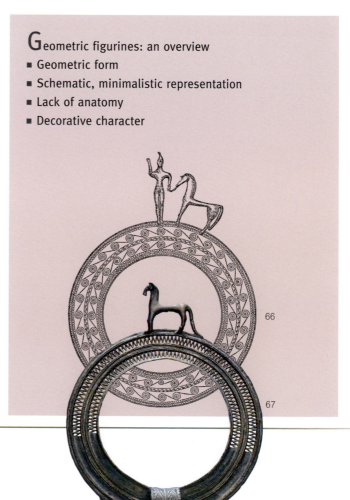

65. Attic Geometric pyxis. Eighth century BC. Athens, Museum of the Kerameikos 1310.

66. Olympia, handle from a bronze tripod with attached figurine of a horse and groom. Eighth century BC. Olympia, Archaeological Museum.

67. Olympia, handle from a bronze tripod cauldron with attached figurine of a horse. Eighth century BC. Olympia, Archaeological Museum.

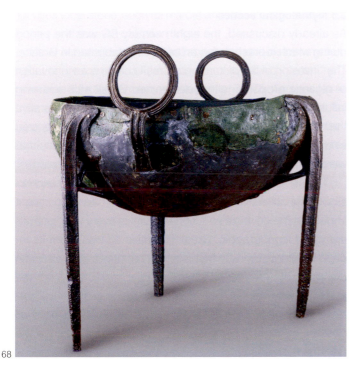

68

monstrous creatures. Finally, a particularly widespread category of bronze offerings of this period was the bronze horses, often with decorated bases (fig. 66–67, 71, 81). The shapes of the horses, like those of the human figures, recall their counterparts depicted on the pottery of the period, as they are rendered in the same abstract and schematic way.

Excavation of the great sanctuaries of Greece, such as that at Olympia, has demonstrated that on the periphery of the

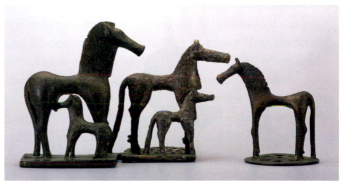

71

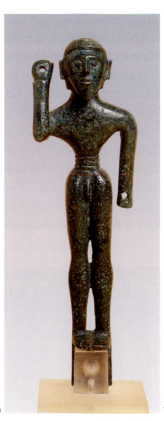

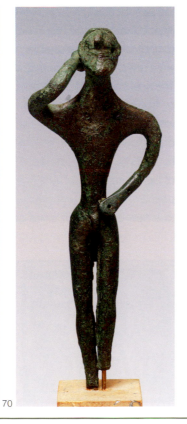

69 70

sanctuaries there were workshops for the mass production of clay and metal figurines, which were offered for sale to visitors. We may assume that itinerant craftsmen visited the great sanctuaries from time to time seeking commissions. The tripod cauldrons, in contrast, which were items of great value, were special commissions and must have arrived at the sanctuaries with their dedicators.

Gradually the Geometric style was transformed under the impact of external influences. A typical example of this trend is the group of female ivory figurines found in an Athenian tomb of the late eighth century BC (fig. 72). The material used was a luxury good for the period. Many ivory objects found in Geometric graves were imported from Syria or Egypt, but these appear to have been made in Greece, by Greek craftsmen, who tried to adapt eastern influences —such as the naked maidservants, odalisques, or deities— to contemporary Geometric tastes:

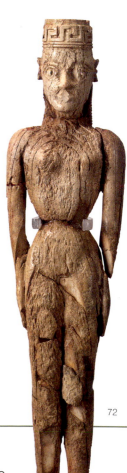

72

68. Olympia, bronze tripod cauldron from the sanctuary of Zeus. Ninth century BC. Olympia, Archaeological Museum B1240.

69. Olympia, bronze figurine of a warrior. Eighth century BC. Olympia, Archaeological Museum B4600.

70. Bronze figurine of warrior. Eighth century BC. Athens, National Archaeological Museum 6616.

71. Delphi, bronze horse figurines. Eighth century BC. Delphi, Archaeological Museum.

72. Athens, ivory figurine of a woman. c. 730 BC. Athens, National Archaeological Museum 776.

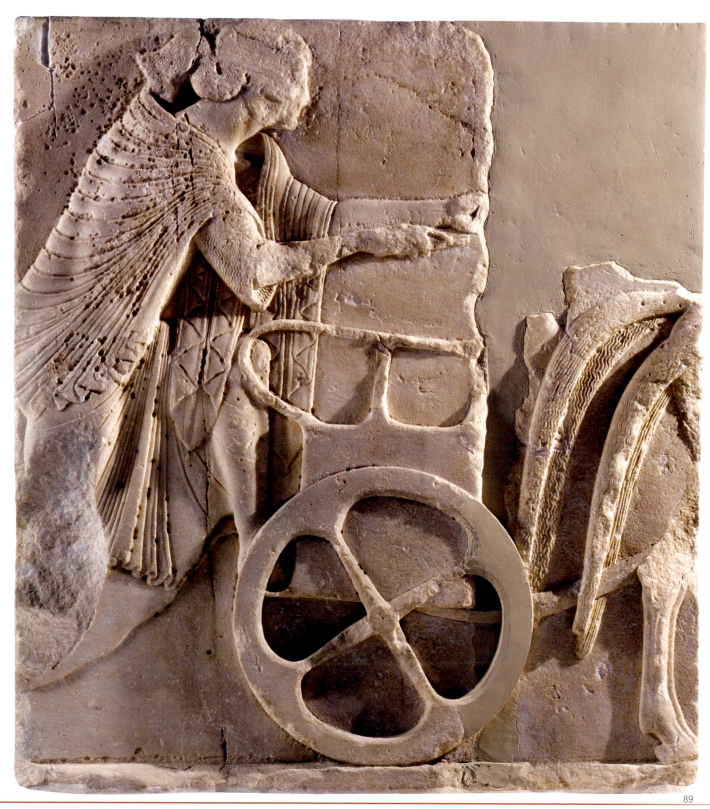

89. Athens. Marble frieze block from the Archaic "Old Temple" on the
Acropolis. Sixth century BC. Athens, Acropolis Museum 1342.

THE ARCHAIC PERIOD
(700–480 BC)

The seventh and the sixth centuries BC were a period of great social and political change in Greece. It was the time when the political structure of Greek society was definitively formed, the concept and operation of the city-state was fixed and the nature of Greek culture was determined. Previously underappreciated, the culture of the period had been neglected (and this is reflected also in the term "Archaic" we use for it, implying that it was somewhat inferior in comparison to the Classical period that succeeded it), but is now considered to be the expression of a politically and spiritually mature society. Archaic Greek culture not only left important legacies for the following generations, but was also a source of inspiration for European culture of more recent years.

The Archaic period is divided into three subperiods:

- The Early Archaic period (700–620 BC), known as the "Orientalizing" period.
- The Middle Archaic period (620–560 BC).
- The Late Archaic period (560–480 BC).

During the Archaic period in Greece a series of changes in the economic and social organization may be observed:

ECONOMIC DEVELOPMENT During this time there was a great expansion of other economic sectors beyond agriculture such as seafaring, trade, and crafts. This economic growth resulted in the emergence of new social strata, holders of wealth in goods, rather than land, who came into conflict with the older landowning aristocrats by claiming a share in exercising political power. The economic confidence of the emerging classes is reflected in the art of the period that increasingly expressed a newly found will to social and political advancement.

COLONIZATION Throughout the duration of the period the phenomenon of the so-called second colonization continues, as a result of the need to restore social peace and stability in the "old" Greek cities, where the increase in population had brought traditional rural economy to its limits. The foundation of colonies and the continuing exchange of raw materials and finished products with the East and West opened the horizons of Greek culture and sped up the process of material and spiritual interacculturation with other peoples.

POLITICAL ORGANIZATION The economic and political inequalities that had been created in Greek cities by the end of the Geometric period led to strong expressions of social dissatisfaction and unrest. *Stasis* (revolution) was a frequent event in Greek cities during this period and usually led to bloodshed and division. Political stability was restored as a rule with the implementation of legislative reforms that recognized the political rights of social strata beyond the aristocratic class. Such reforms in Sparta (which the ancient Greeks attributed to Lycurgus, who was probably a mythical and not a historic character) are placed at the end of the seventh century BC. In Athens, Draco in 630 BC and Solon in 594 BC brought about definitive changes, while similar reforms were undertaken in other Greek cities. In this way the difference in social classes was gradually consolidated on the basis of property (both in goods and land) rather than descent.

TYRANNY This was a new form of government which overturned the dominance of the aristocratic class. The politicians of the period, called *tyrants* by the Greeks, were men usually of aristocratic origin themselves who attempted to seize power with

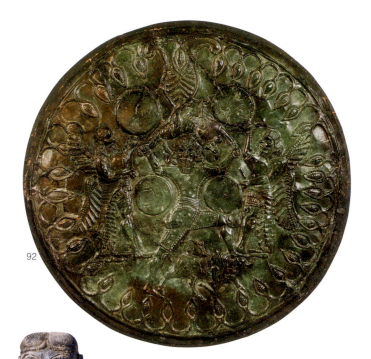

92

more closed form, and with an in-turning rim. These valuable vessels are decorated with heavy attachments in the form of griffin- or lion-head protomes, although there are also attachments in the form of a siren (sometimes a bearded male one) or a sphinx (fig. 94). The first examples of these fixtures, which were found in their scores in the great sanctuaries such as that at Olympia, Delphi, Samos, and elsewhere, were hammered, just as their Syrian prototypes were, which they copy quite faithfully. Eventually, these decorative attachments became cast rather than hammered, and it appears that the Greek craftsmen modified them to their own tastes in iconography and technique (fig. 95–96).

Even if these sizeable bronze votives in panhellenic sanctuaries were of monumental character, like the grave markers of the Geometric period (see the Dipylon vases, fig. 62–63), *monumental art* is in reality only attained in the following era, as we shall see. The trend towards monumentality is also visible in the few "free-standing" statuettes that are known to us,

have had important ivory workshops during the whole of the seventh century, where woodcarving must also have flourished at the same time. Only a few examples of the latter have been preserved (with the exception of Samos, where the environmental conditions have permitted the survival of many wooden objects). Syria appears to have been the main source of raw materials and technological expertise. Several of the examples of ivory work in Greece, however, seem to have Lydian origins: an interesting example is the figurine of a male deity with a lion from the sanctuary of Delphi, 24 cm tall, featuring on its base a decorative motif which in a way recalls the Greek meander but seems to have been of Lydian origin and was also used in the art of East Greece in later periods (fig. 93).

The field of metalworking also received important influences: the tripod cauldron, which was an open shape in the Geometric period (fig. 68), now became deeper, with a

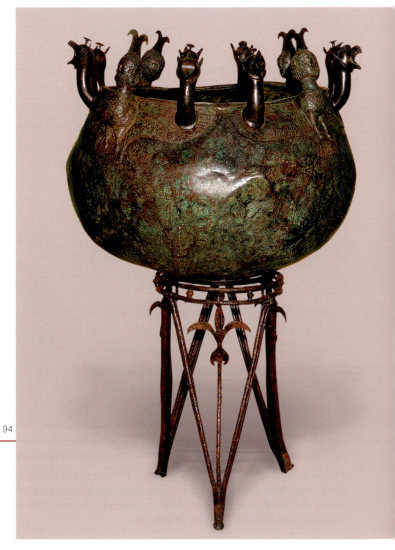

93

94

92. Idean Cave (Crete), bronze drum with a scene of a god (Zeus?) taming a lion. End of the eighth/beginning of the seventh century BC, Heraklion, Archaeological Museum 9.

93. Delphi, ivory figurine of a male deity with a lion. Seventh century BC. Delphi, Archaeological Museum 9912.

such as the so-called *Mantiklos Apollo* from Thebes. The bronze statuette, preserved to a height of 20 cm, represents a standing male with long, neatly coiffed hair with his left hand extended (the right is missing, as are the lower legs and feet: fig. 98). The form is closer to the Geometric prototypes from the eighth century —indeed it recalls the schematic forms on Geometric pottery, which places it early in the seventh century— and barely contemporary with orientalizing works. It is particularly slender, with a long neck and narrow waist, but is better modeled than the figurines of the previous period. Its most distinctive feature, however, is not iconographic or technological but lin-

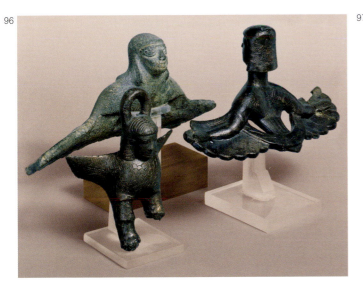

guistic: a quite long inscription, which is engraved in the *boustrophedon* style (that is each line begins alternately from left and right) on the figure's thighs. The text informs us of the name of the dedicator and of the recipient, as well as the reasons for the dedication. We learn that it was the dedication of someone called Mantiklos to Apollo, therefore the sculpture must represent the god, with a (now lost) bow and arrow. The text is as follows: (fig. 97):

μαντικλος μ ανεθεκε Fεκαβολοι αργυροτοχσοι τας [δ] εκατας τυ δε φοιβε διδοι χαριFετταν αμοιF[αν]

Mantiklos dedicated me to silver-bowed Apollo as a tithe (=1/10) and you, Phoebus, give him a beautiful reward.

The details of the inscription that capture our interest are primarily the fact that the statue addresses the viewer in the first person (dedicated *me*); the likeness of the god is thus imbued with animate properties. Also of interest is the reference to the name of the dedicator, and to the custom of offering one-tenth of the annual yield to the gods in the form of a dedication such as this, with the aim of appeasing their possible envy. All these are elements which, from this period onwards, were incorporated into the practice of dedicating Greek sculpture and would be particularly prominent in the following century.

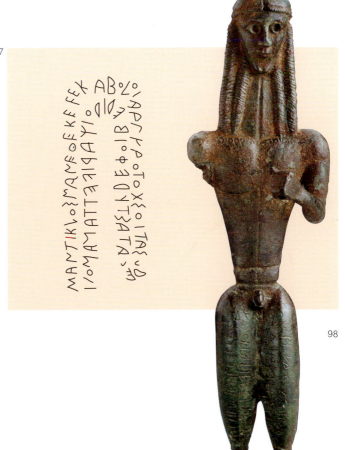

94. Cyprus, Salamis, bronze cauldron with tripod stand. c. 700 BC. Nicosia, Cypriot Museum.

95. Olympia, bronze cauldron attachment in the shape of a griffins' head. Seventh century BC, Athens, National Archaeological Museum 6159.

96. Delphi, bronze cauldron attachments in the shape of sirens. End of the eighth/seventh century BC. Delphi, Archaeological Museum.

97, 98. Bronze figurine from Thebes, dedicated by Mantiklos. Early seventh century BC. Boston, Museum of Fine Arts 3.997.

1.2 Pottery

The seventh and the sixth century BC was a period of great breakthroughs in Greek pottery. The most important workshops in Greece, such as the Corinthian and the Attic, but also the many smaller ones (Boeotian, Euboean, Cycladic, Cretan, Argive, East Greek), were particularly active, encouraged by the trade that flourished during this period. As the potters supplied storage pots not only for the transport and consumption of wet and dry foods, but also for other goods such as perfume, continuous output was essential. The volume of production affected also the development in typology and technology, while commercial competition required the maintenance of a recognizable local character. If for us today Corinthian or Athenian pottery is easy to recognize, at least in the case of closed vessels, it is because in the past it was the "trademark" for the product it contained (for example Corinthian perfume or Athenian olive oil). The constant quest by the potters to create imaginative styles of form or decoration for the pots reflected the requirements of their customers and the needs of a market which greatly surpassed the narrow confines of their city, and could,

depending on the moment, include the whole of Greece as well as areas beyond, such as Anatolia, the Black Sea, or Etruria. Let us summarize here Archaic pottery's basic traits:

TECHNICAL DEVELOPMENTS Archaic pottery was a natural continuation of the pottery of the Geometric period; now, however, decorative and firing techniques achieve significant breakthroughs with spectacular results, such as the Protocorinthian and the Protoattic styles which will be discussed below, but also the black-figure style which we shall study in the next section. At this time the range of types of Greek pottery was developed and consolidated with new shapes or the development of older ones, and with a clear division of their use and their iconographic program.

DEVELOPMENT OF ICONOGRAPHY During this period the increase in the number of figured scenes on Greek vases is impressive: scenes of myth or worship, scenes of everyday life or —as supposed by some scholars— scenes that refer to actual events, were used systematically with the aim of drawing attention to those vessels which were destined for display (such as those used at the symposium) or for ritual use.

ORIENTALIZING POTTERY: AN OVERVIEW

FORGETTING GEOMETRY Already from the end of the eighth century the once strictly Geometric character of decoration on the pots was "broken," and a shift was attempted towards more curvilinear and free forms.

DECORATIVE THEMES Pottery of this period adopted the repertoire of orientalizing art: lions, griffins, sphinxes appeared on the pots influenced by imported luxury items such as metal vessels and ivory or wooden artifacts, and also (we assume) textiles which appear to have particularly influenced pottery decoration. At the same time, a series of fill motifs made their appearance, such as the *lotus flower*, the *guilloche*, and various plant motifs.

SHAPE DEVELOPMENT AND ELABORATION The new shapes that appeared in this period reflected the uses for which they were intended, such as the perfume trade.

OUTLINE VS SILHOUETTE The increased preference for pictorial scenes, but also the examples of Eastern art, which although stylized must have charmed the Greeks with their sophisticated elegance, led to the replacement of the silhouette technique with that of the outline: the craftsmen drew their subjects in outline, using incised details where needed (as in facial features). Soon, however, the silhouette technique would return forcefully in combination with the technique of incision, leading to the birth of *black-figure style*.

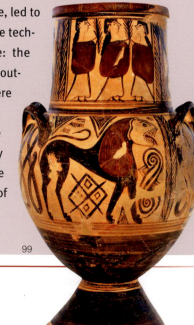

99

1.2.1 ORIENTALIZING POTTERY: CORINTH

The most important pottery workshop during the seventh century BC was that at Corinth. Already by the last decades of the eighth century Corinthian potters had moved away from the Geometric style, which had never been particularly popular with local workshops. The predominance of Corinth in international trade during this period created a great demand for its pottery. Corinthian pots, which combined the cream color of the local clay with detailed and frequently polychrome decoration, were particularly popular around the whole of the Mediterranean where, on occasion, they inspired local imitations.

The orientalizing Corinthian pottery is called Protocorinthian (so as to distinguish it from the pottery of the following period) and is subdivided into three periods:

- Early Protocorinthian (c. 720–690 BC)
- Middle Protocorinthian (c. 690–650 BC)
- Late Protocorinthian (c. 650–630 BC)

The period between Protocorinthian and Corinthian (which covered the greater part of the sixth century BC) is termed the

- Transitional period (c. 630–610 BC)

The iconography of the Protocorinthian style is characterized by the frequent friezes of animals or mythical creatures, but also by figured scenes (fig. 101). The most characteristic Protocorinthian vessel of this period is the *aryballos*, a miniature spherical or ovoid container best suited for the transport of perfume or volatile oils. Typologically, it develops from the older rounded type of the Early Protocorinthian period to the more slender ovoid shape of Middle Protocorinthian (fig. 100). Finally during Late Protocorinthian the elegant piriform aryballos (pear-shaped with a narrow base) emerged. The chronology of Protocorinthian aryballoi has been based on the excavations of Greek colonies in South Italy and Sicily for which the date of their foundation is related by Thucydides (Syracuse: 734 BC, Taras: 706 BC, Gela: 690 BC). Since it is logical that the earliest types of pottery should be absent from the more recent colonies, a stepped system of chronology for Protocorinthian pottery has been constructed, which also helps with the dating of other pottery workshops, examples of which are found in tombs or other archaeological groups along with the more popular Corinthian pottery of the period.

As an oil container, the aryballos accompanied young athletes to the gymnasium and the palaestra, but also soldiers, as the oil was used both as a body lotion of sorts as well as for odor control. As such, the aryballos quickly came to symbolize youth in Greek iconography, as can be seen in several scenes of Archaic date (fig. 138, 199c).

At first, Corinthian potters used the outline technique (especially during the first period, see fig. 101a). Already by the first half of the seventh century, however, they had almost exclusively turned to rendering figures in silhouette, with the

100

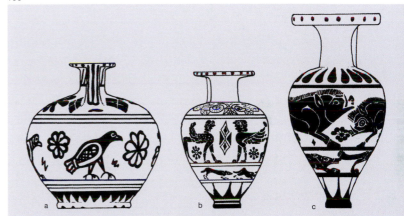

101

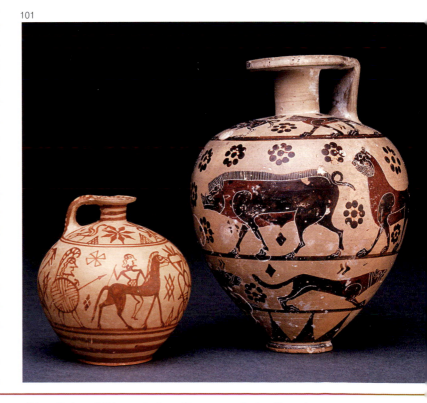

99. Eretria, amphora in the orientalizing style. Seventh century BC. Athens, National Archaeological Museum 12077.

100. Shapes of Protocorinthian aryballoi: a. spherical, b. ovoid, c. piriform.

101. a. Protocorinthian aryballos with a scene of a hoplite and horseman. c. 700 BC. b. Protocorinthian aryballos with a frieze of wild beasts and animals. c. 650–620 BC. London, British Museum 1969.1215.1, 1860.404.16.

THE CHIGI VASE

The vase in fig. 102–103 is one of the most interesting examples of Protocorinthian pottery. It is an *olpe* (a pitcher, a variant of the oinochoe), 26 cm high, with an obvious influence of metal work in its shape and some of its decorative elements, but also notably inspired by Assyrian iconography. The central theme of the vase is two hoplite phalanxes who are marching in step towards each other. The creation of the hoplite *phalanx* ("infantry battalion") during the seventh century BC fundamentally changed the way Greek cities conducted warfare, while accelerating the formation of new coalitions within local communities: while traditional warfare revolved around the *phratry* ("kinfolk"), a social division according to class, the basic component of a phalanx was the *hoplite*, a heavily armed foot soldier who fought beside his fellow conscripts in a tight formation. Gradually, the hoplite phalanx in every city began to be recruited on geographical criteria and no longer by descent. In the troubled political climate of the seventh century, when participation in political power was a constant demand of the emerging social classes, equal participation in the defense of the city —or in pursuit of the public interest— was obviously a source of collective and personal pride, which at the same time secured political rights.

It is therefore no accident that this type of imagery appeared in vase painting, especially in Corinth: in 657 BC Kypselos, of aristocratic decent himself, seized power which until that point had been held by the Bacchiad family. In this enterprise the new *tyrant* had the support of the regular army which he himself had organized. According to Herodotus (5.92), Kypselos had received a prophecy from the oracle at Delphi which foresaw he was to "bring justice" to Corinth, by applying a new legislative framework of political rights and removing power from the nobles.

The Chigi vase (named after the collection of antiquities to which it originally belonged) is not the only Protocorinthian vase that depicts hoplites at war, but it is the most complete and best preserved example: the men march side by side, fully armed, with short breastplates, greaves, enveloping "Corinthian" style helmets, and round shields. The aim of the phalanx was to maintain the formation at any cost, because to break ranks meant defeat and certain death. Discipline and cohesion guaranteed a hoplite army's effectiveness, turning the phalanx into a formidable war machine. As the seventh century poet Tyrtaeus (frags. 11, 31–34) sang : "stand and fight the enemy, leg to leg, shield to shield, crest to crest, helmet to helmet, chest to chest." Similar songs aimed to strengthen the army's resolve and it is typical that on this vase behind one of the phalanxes we find a flute-player playing, no doubt, some military march.

102

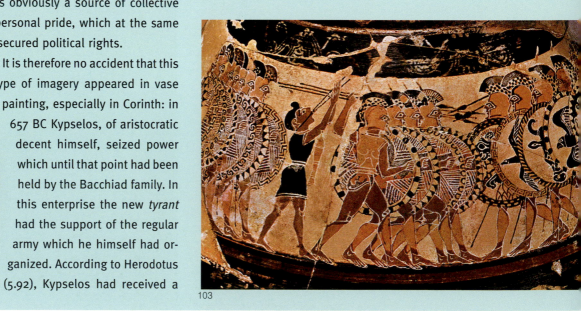

103

102, 103. Protocorinthian olpe with a scene of a hoplite phalanx, a chariot and horse procession and hunting. c. 650–640 BC. Rome, Villa Giulia 22.679.

104. Protoattic hydria with scenes of animals and a dance. c. 700 BC. Athens, National Archaeological Museum 313.

important addition of incision which was used to show anatomical detail or to distinguish individual features (see fig. 101b). It is a technique employed in orientalizing metalworking which possibly inspired the potters: to some extent the detailed decoration on the Corinthian pots was the work of engraving as much as of painting. Added colors were often applied on top of the blackish or brown silhouettes, made of the same sort of clay slip: usually these were purple, white, or brown, and were used to enhance the design. These secondary colors (which were added to the finished vase before firing) give vitality to the iconographic decoration and add to the stylized naturalism that it exhibits (see fig. 102–103).

1.2.2 ORIENTALIZING POTTERY: ATHENS

The orientalizing pottery of Athens is a continuation of the Geometric. Conventionally, Attic pots of the orientalizing period are called Protoattic. The seventh century was a period of experimentation with a gradual elimination of the Geometric models and the introduction of new ones. In contrast with the pottery of Corinth, Protoattic pottery only had access to a local market since it does not appear to have been exported beyond the wider geographical boundaries of Attica, to such regions as Aegina or Boeotia. In contrast, Attica was flooded with imported Corinthian and other pottery, as is demonstrated from grave assemblages, especially from the middle of the century.

Protoattic pottery is divided into three periods:
- Early Protoattic (c. 700–675 BC)
- Middle Protoattic (c. 675–650 BC)
- Late Protoattic (c. 650–630 BC)

Protoattic pots are typically tall and large bodied. Figured scenes are more common than on Protocorinthian pottery and are frequently accompanied by inscriptions. The Athenian vase painters of the period preferred the technique of outlining which they combined with silhouette. During the Middle Protoattic period incision was introduced sporadically into Athenian pottery, probably under the influence of Corinth. This technique was to become more widespread in later years.

The vessels of the Protoattic pottery repertoire are usually taller than their Corinthian counterparts. Most usual shapes are the amphora, the hydria, the krater, and the kotyle.

The hydria in particular is a very common Greek vase designed for carrying water. Its three handles are characteristic of the shape: one vertical (mainly used when the vessel is empty) and two horizontal (to facilitate the carrying of the vessel when full). In fig. 104 we see a characteristic example of the early period where elements of geometric iconography, such as the friezes of grazing deer, are combined with new elements, such as lions. As far as technique is concerned, the vase combines outline with silhouette, attempting to achieve color variety and the by now well-known sophisticated naturalism of orientalizing art. The scene of dancing that is depicted on the neck of the vase has been identified by some as the *geranos* (crane-dance), the dance, that is, that the young men and women of Athens performed after Theseus killed the Minotaur; it probably however depicts a religious festival or ritual closer to everyday experience.

1.2.3 ORIENTALIZING POTTERY: OTHER WORKSHOPS

The orientalizing style appeared in all the pottery workshops in Greece during this period, beginning already from the late eighth century BC. In many of these areas these styles continued into the middle of the sixth century when the main centers of pottery production, such as Athens and Corinth, had turned in new directions.

In the islands, and especially in the Cyclades, many workshops developed independently of each other. The so-called "Melian" workshops, which in the past were attributed to the island of Melos, are today connected with certainty to the island of Paros. They were characterized by large shapes, imaginative compositions, and relative polychromy. Fig. 109 is a moderately large pithamphora, 95 cm high, with a scene depicting Apollo in a chariot pulled by winged horses arriving at the sacred island of Delos, where his sister Artemis welcomes him. On the neck is a duel between two warriors, which

THE POLYPHEMOS AMPHORA

The vase in fig. 105 comes from the grave of a small child in Eleusis. It is the largest preserved Protoattic pot (1.42 m high) and is decorated with two separate figured scenes inspired by myth. On the belly is the hero Perseus who, after beheading the Gorgon Medusa, is fleeing from her sisters Euryale and Stheno. Perseus is rushing to the protection of the goddess Athena after his deed. On the neck of the vase is a scene of the blinding of the Cyclops Polyphemos by Odysseus and his companions. The vase displays a strong combination of silhouette and outline, as well as increased use of added white coloring. The alternation of black with white on the pots of the Middle Protoattic period characterizes the so-called *black and white style*, an experimental phase of Attic pottery, which was succeeded by a relatively short phase of polychromy, influenced, most probably, by the corresponding multicolored style of the Protocorinthian workshop.

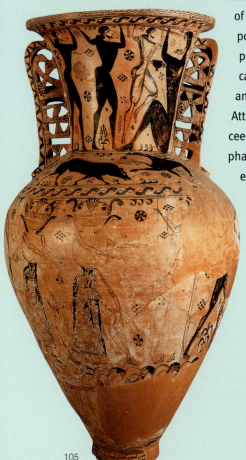

105

is laid out in accordance with Homeric tradition in three panels: in the central panel the two opponents are shown with the armor, over which they are probably fighting, lying between them. The two smaller side panels hold the two patron goddesses of the warriors (similar scenes may be found in the *Iliad*, e.g. XXIII 797–800). Also from a Cycladic workshop is the remarkable oinochoe in fig. 106: the neck of the pot is modeled into the shape of a griffin protome which recalls the bronze attachments on the cauldrons of the period (fig. 95). At the same time both the decoration of the pot, with the figures of animals and the plethora of non representational decorative motifs, also emphasizes the orientalizing character of the workshop.

The orientalizing pottery of East Greece is characterized by the so-called wild goat style, with repeated friezes of animals or monsters (with the most common being the wild goat from which it takes its name). The striking decoration of this style appears to have been inspired from Eastern textiles: the pots carry yellow or white slip (from a dilute suspension of clay) and the figures are rendered in outline, silhouette, added colors, and (very rarely) incision. The exact origin of the style is not known, but it developed in the areas of Miletus, Samos, Chios, Ephesus, and elsewhere. The most characteristic shape in the style is the trefoil-mouthed oinochoe (fig. 107), with strong influences from metal prototypes, especially the shape of the mouth and the modeling of the handle with discs on either side. The wild goat style rarely included mythological or figurative scenes in general. An important exception is the plate in fig. 108: the scene in the center of the plate shows the duel between Menelaos and Hector over the body of Euphorbus. Three inscriptions — exceptionally rare in this category of pottery — identify the figures. Even if the scene does not belong to any known epic, it is, despite this, "Homeric": it belongs, that is, to the wider epic tradition that was flourishing in Ionia at the time this vase was made. On this plate, a characteristic shape in East Greek pottery, we can see some of the main subsidiary or fill motifs of Archaic vase painting which were used to fill the gaps between the scenes on the pot:

- the *guilloche* (forming the ground line on which the figures stand)
- the *rosette* (a circular daisy-like flower), and a variant of it,
- the *dot rosette* (rosettes which are formed using only small dots)

105. Protoattic amphora with a scene of the pursuit of Perseus by the gorgons after the beheading of Medusa (on the belly) and the blinding of Polyphemos (on the neck). c. 660 BC. Eleusis, Archaeological Museum 2630.

106. Cycladic oinochoe with a neck in the shape of a griffin. c. 680–670 BC. London, British Museum GR 1873.8–20.385 (A 547).

107. East Greek oinochoe with a frieze of animals and beasts. c. 640–630 BC. Athens, National Archaeological Museum 12717.

- the *spiral* (on the interior of Menelaos' shield and in the complex shape at the top center of the scene)
- the *lotus flower* (in the center of the scene above the shields of the heroes).

The plethora of fill motifs in the decoration of Greek vases during this period, but also during the preceding Late Geometric, has led some historians to talk of a *fear of empty space* ("horror vacui") in Greek art. The term that is used especially for modern European art, has specific historical and interpretive connotations, and it would be good to avoid its use for Greek art. Here, it seems, the proliferation of such pattern work appears to have different origins and content.

Workshops producing orientalizing pottery also operated in Crete, as well as at Argos, Euboea, Boeotia, and Laconia.

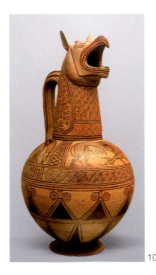
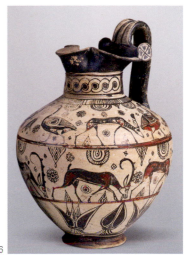

106

107

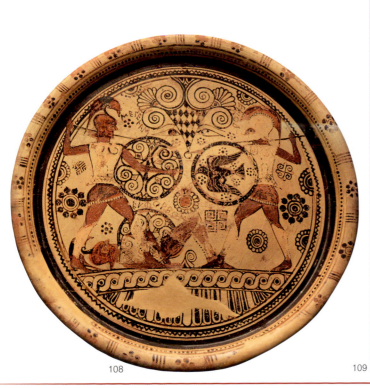

108

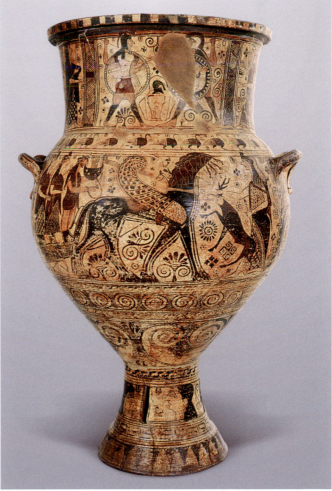

109

108. East Greek plate with a scene of Menelaos fighting Hector. c. 610–600 BC. London, British Museum GR 1860.4–4.1 (A 749).

109. Cycladic pithamphora from the Parian workshop. Apollo and Artemis (on the belly) and an epic duel (on the neck). c. 640–630 BC. Athens, National Archaeological Museum 3961 (911).

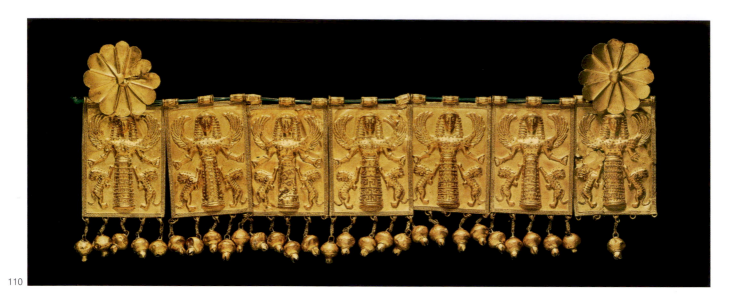

110

1.3 Sculpture: the "Daedalic" style

The numerous imports of clay or ivory figurines during the seventh century that depicted the Syrian goddess Astarte (whose Greek equivalent was Aphrodite) brought to Greece the widespread fully frontal standing goddess type. The material and the size of the imports contributed to this as well as to the speedy copying in small-scale of Greek crafts such as figurines and jewelry. At the same time *molds* for the mass production of such clay figures and jewelry arrived in Greece, which made the dissemination of the style easier.

The Greek versions of Syrian prototypes preferred the female form to be thinner and, in the final stage of development of the style, dressed. This happened since the Greeks do not appear to have identified female plumpness with fertility, unlike their Eastern contemporaries, while the idea of female nudity, with few exceptions, was slow to become universally accepted in Greek art. In fig. 110 is a necklace from Kameiros on Rhodes which is made of gold plaques about 4 cm high. Each plaque has been made individually using the repoussé technique (that is hammered from the underside into a hollow mould of metal or stone). The seventh century is the "golden age" of Rhodian jewelry-making, with strong influences from Syrian and Phoenician prototypes, frequently in Egyptianizing style. These influences are attributed to the presence of Phoenician craftsmen on the island at this time who specialized in the production of perfume as well as in miniature arts such as jewelry. The figures

on the necklace, which may be seen in many other pieces of jewelry, in plaques, figurines, and other small objects of the period, are characterized by strong stylization, especially in the rendering of the head and the hair, strict frontality, and striking decorative arrangement. A typical example is the Protocorinthian aryballos, a variant of the ovoid type, dating to the middle of the seventh century BC (about 7 cm high) which has its upper part modeled into the shape of a woman's head (fig. 111). This part of the vase was mold made, which explains the wide distribution of this type throughout Greece.

A little after the seventh century BC, these stylistic features appear also in stone sculpture, creating the so-called *Daedalic* style.

In sculpture the Daedalic style appears to have developed first in Crete, from where come many limestone figures which date to the second half of the seventh century BC. Limestone was available in relative abundance in Crete (which did not have marble) as

110. Gold necklace with plates with a repoussé scene of the "Mistress of the Animals." Second half of the seventh century BC. London, British Museum 1128–1130.

111. Protocorinthian aryballos with a battle scene (on the belly) and plastic decoration on the neck in the shape of a woman's head. c. 655–650 BC. Paris, Louvre CA 931.

111

well as in the rest of Greece. As a material it was soft and easy to carve and it provided the craftsman the opportunity to experiment with the different forms and decorative elements which were so loved in orientalizing art.

The most typical example of Daedalic sculpture is the so-called *Auxerre Goddess* (from the city of Auxerre in France where it was once to be seen; today it has been transferred to the Museum of the Louvre, see fig. 112): it is a limestone sculpture, representing a standing female with her right hand across her breast. It is probably meant to be a goddess or a mortal in a pose of worship. The discovery of a similar statue in Eleutherna in Crete confirms the Cretan origin of the *Auxerre Goddess*, but also the type of figure to which it belongs. The figure is 62 cm high, roughly one-third life size. She wears a long robe gathered at the waist with a wide belt and the *opi-*

blema (a short cloak which is common on female figures of the period) over her back and shoulders. Her features are the same as those we have observed also in Daedalic minor arts (see. fig. 110, 111): strong stylization, frontality, and the absence of natural detail and articulation. It is a sculpture with the typical heavy decoration, the unnatural rendition of the hair, the large buckle in the center of the belt (which probably derives from metal prototypes), the triangular head, the long, thin fingers, and so on. Of special interest is the rich painted decoration that the sculpture originally carried:

112

DAEDALIC STYLE: AN OVERVIEW

In brief, the **Daedalic style**, which appeared in Greek art (in the minor arts, jewelry making, and sculpture) around the middle of seventh century BC, is noted by:

SHAPE The individual figures are composed of simple geometric shapes that appear somewhat unnatural and rather frigid.

DECORATION As a result of the origin of this style in the minor arts, there is a relative sophistication in the decoration, with fill motifs and additional pattern work.

ABSENCE OF THE MONUMENTAL For the same reason, the art of the Daedalic style is not monumental, but mainly decorative in character.

TWO-DIMENSIONALITY As in Geometric art, the figures do not represent humans or gods but act as their *symbols*: they use, that is, recognizable details to create an approximation of a human (or animal) figure, without being interested in the realism, or lack of it, which the work created. This results in the figures being more or less two-dimensional, without depth or

modeling, and they lack a natural connection of their parts (in the anatomy of the human figure, for example, the individual elements appear to be simply placed on the body and not naturally joined to it).

RIGIDITY Daedalic works appear stiff and rigid: they lack any interest in realism, opting for symbolism instead. Besides technical constraints of the period, this may also be attributed to the style's Eastern origins.

RENDERING OF THE HEAD The rendering of the human head in Daedalic art is most typical. It is characterized by: *a long triangular face* (in early examples; it becomes *ovoid* in later examples), a *low forehead, superficial details*, schematically rendered and unconnected, and the wig-like hair, an idiosyncratic rendering of the hair in a stylistic and unnatural manner which recalls the Egyptianizing styles of Phoenician and Syrian figures which were imported en masse into Greece during the seventh century.

112. Sculpture of a female in limestone. c. 640–630 BC. Paris, Louvre 3098.

TYPES OF GREEK TEMPLES:

PROSTYLE TEMPLE A simple rectangular cella, without antae but with a single row of columns in front of it.

AMPHIPROSTYLE TEMPLE With both ends formed as above.

TEMPLE IN ANTIS Two columns are inserted between the extensions of the two long walls of the cella (the antae). In this case the temple is characterized as *distyle in antis.* In later periods the columns could be even more (up to six – *tetrastyle, hexastyle in antis*).

TEMPLE IN DOUBLE ANTIS With columns in antis at both ends. A double distyle in antis temple is defined as *amphidistyle in antis.*

PERIPTERAL TEMPLE With a colonnade (*pteron*) all around. The peripteral temples may be divided according to the arrangement of the pronaos and the opisthodomos into "peripteral in antis" and "dipteral in antis." The Parthenon, which is a special case in Greek architecture (see p. 155–162), may be characterized as a peripteral hexastyle amphiprostyle temple since it combines a full pteron with six columns in antis on each short side.

DIPTERAL TEMPLE With two colonnades all around (double pteron).

PSEUDODIPTERAL TEMPLE When the outer pteron is set well out from the cella wall, giving the impression that there should be a second colonnade which, however, is absent.

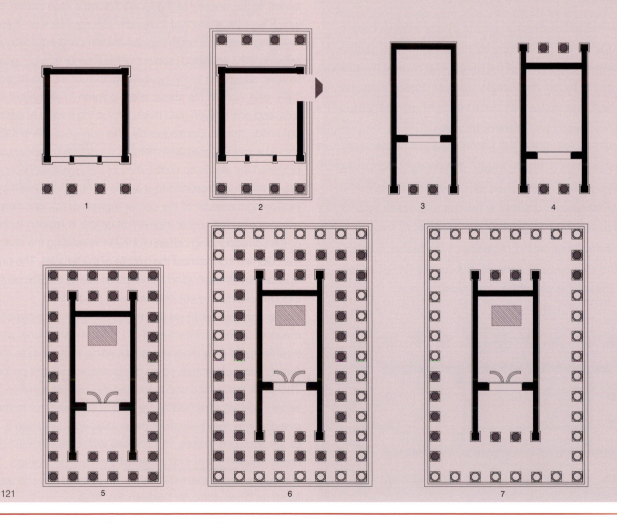

121. Ground plans of ancient Greek temples: 1. prostyle
2. amphiprostyle 3. in antis 4. Amphiprostyle in antis 5. peripteral
6. dipteral 7. pseudodipteral.

DORIC ORDER: BASIC TERMINOLOGY

Greek temples employ the post-and-lintel system, practiced in Greece already during the Bronze Age. The foundations of the building are set onto the natural rock. The built base on which the temple rests is called the *stereobate* and the highest part of this, serving as a leveling course which can be barely distinguished from the ground level, is called the *euthynteria* (5). The *crepidoma* or *crepis*, the platform on which the temple sits, is usually *three-stepped* (4). The upper step of the *crepidoma* is called the *stylobate*, the level on which the columns stand (12). Doric columns have no base but rest directly on the stylobate. The space between the two columns is called the *intercolumniation* and the distance between the axes of two consecutive columns is called the *interaxial spacing.*

The column (3) is formed of *drums* (25). Normally the diameter of the column drum gets smaller from bottom to top (the column is characterized as "tapering"). Frequently, however, the sides of the Doric columns present a convex curve at about two-thirds of their height from the base, thus appearing to swell slightly, a feature that is characterized as *entasis.*

Doric columns are *fluted* (with hollowed out flutes that meet at a sharp ridge, the *arris*) (24). In the Doric order the columns have between 16 and 20 flutes.

The Doric column capital (10) is formed from a block-shaped slab, the *abacus* (19), and a circular "cushion," the *echinus* (20). The transition from the shaft of the column to the capital is called the *hypotrachelium* or *necking* (22). On the *hypotrachelium* are decorative elements that translate to stone elements from the order's wooden prototypes: these are the *annulets*, which "bind" the *hypotrachelium* to the *echinus* (21), and the *astragals*, on the lower edge of the *hypotrachelium* where it meets the shaft of the column (23).

The *entablature* (2) of a monumental building comprises the *architrave* (9), the *frieze* (8), and the horizontal *cornice* or *geison* (7).

The Doric architrave (which is essentially the horizontal beam of the building) has at its upper part a *taenia* (17), a narrow horizontal projection, and below it, at intervals, are the *regulae* (18), small rectangular strips from which "hang" six studs or

drops, the *guttae* (14), probably a reminder of the nails that were used in wooden temples at this point.

The Doric frieze is a horizontal feature which runs around the entire building above the architrave with alternating *triglyphs* (15) and *metopes* (16). The triglyph is formed of two vertical channels, three ridges, and two half-channels. The *metopes* are square plaques that are decorated in relief (older examples may be painted), although they can also be left blank.

The cornice projects well out above the frieze. On its underside it has horizontal rectangular strips which slope gently down, the *mutules* (13), from which also hang drops (14).

The triangular pediment crowns the narrow sides of the temple (1). Its back wall is called the *tympanon* (28) and the sloping sides carry *raking cornices* (27). Above the latter is the *sima* which is in effect the gutter for the building (26). The pediment is usually decorated with sculptural compositions and has sculpted *acroteria* above its three corners (6).

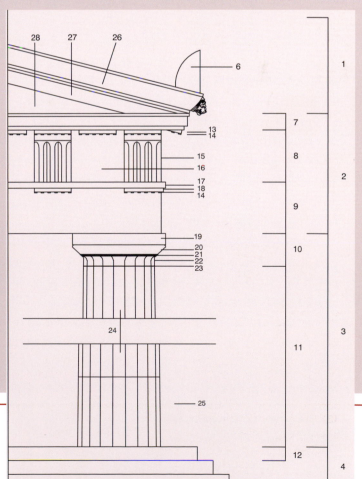

122. The elements of the Doric order.

IONIC ORDER: BASIC TERMINOLOGY

The structural elements of the building remain the same. The Ionic column rests on the stylobate with a simple or complex *base* which consists of alternating concave and convex sections (11). The curved section is called a *torus* (23) and the concave the *scotia* or the *trochilus* (24). Between the base and the stylobate there may be a rectangular *plinth* (12).

The flutes on the shaft of the Ionian column are separated by narrow flat strips (21) and are usually more numerous than those on the Doric column (more than 24).

The Ionic column capital (9) comprised three parts: the *echinus* (18) and the *abacus* (16), which are proportionately thinner than those on the Doric column capital and usually have carved decoration, and the *volute* (17) which terminates in *eyes* (19).

The Ionic *architrave* (8) is simpler than that of the Doric and is divided horizontally into three *fasciae* (15). The Ionian frieze is continuous (7) and typically bears relief decoration. In contrast, there is no frieze on many temples of the Ionic order in Asia Minor, but rather toothed projections from the cornice called *dentils*. The *geison* is also simpler, without the Doric *mutules* or *guttae*. Pediments on Ionic buildings receive sculptural decoration as an exception rather than as a rule.

An early version of the Ionic column capital was the so-called Aeolian or Protoionic (fig. 123). It comprises two volutes which rise on either side of a palmette, while the *hypotrachelium* has rich floral decoration. Typical examples of the type come from the Aeolian cities of Larisa and Neandreia and date to the beginning of the sixth century BC.

At the end of the fifth century a variant of the Ionic style developed, the so-called "Corinthian order." It is identified mainly by its column capital, which is essentially a sculpted composition that returns to the floral decoration of the Protoionic capitals (fig. 126). It takes the form of a basket which is surrounded by acanthus leaves, a leafy shrub native to

Greece. The upper part of the column capital is decorated with spirals, four on each side, symmetrically arranged in pairs. The whole composition is crowned by an abacus with concave sides and relief decoration.

123

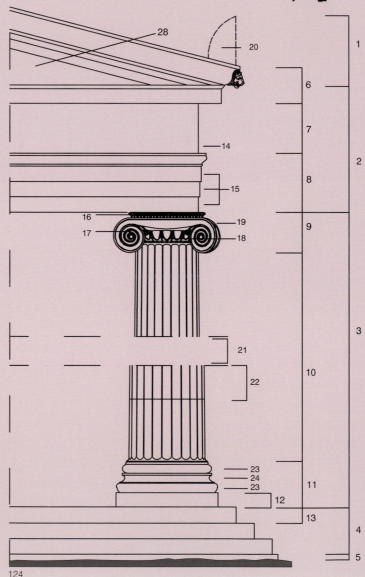

124

123. The Aeolian or protoionian capital.

124. The elements of the Ionic order.

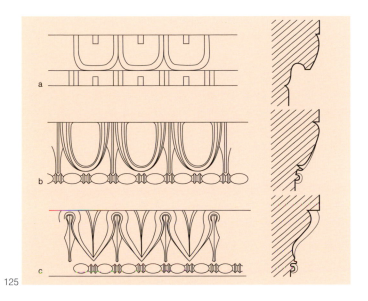

125

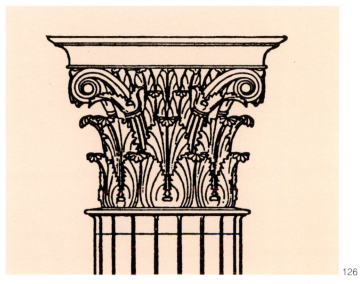

126

127

125. Elevation and section of the standard molding types: a. Doric·
b. Ionic· c. Lesbian.

126. The Corinthian capital.

127. The "problem of the corner triglyph" (diagrams).

2. The sixth century BC

During the Middle and Late Archaic period (c. 620–480 BC) the orientalizing influences receded and ideas borrowed from outside Greece were incorporated into a newly emerging Greek idiom. The historical conditions favored the emergence of a more or less uniform Greek culture —at least as regards contact with the East and West. At the same time Greek art attained a consistent character, always under the leadership of the more successful workshops, such as the Attic for pottery or the Peloponnesian for metallurgy.

In summary, during the sixth century BC:

■ The Greek cities —mainly those on the mainland— flourished. The consolidation of tyranny facilitated political and social processes, which would lead, gradually, to the emergence of democracy in several city-states such as Athens.

■ In contrast, many Greek cities in East Greece were under the rule of the Lydians and Persians who were great patrons of Greek art. In several cases we are able to observe the movement of craftsmen from Ionia and other regions of East Greece to the Greek mainland but also west, to areas such as Etruria.

■ Through their constantly developing colonies in Italy and Sicily, the Black Sea, north Africa, and elsewhere, the Greeks had the opportunity to develop trade and cultural exchanges with almost all of the then known world. As a result mainly of the economic penetration of Greeks into the well-established trade networks of the Mediterranean, but also because of the ensuing economic boom, the Greek cities towards the end of the Archaic period needed to deal with Carthaginian expansion from the west and that of the Persian Empire to the east. These attacks intensified the feeling of a single "ethnic" identity which was shared by the Greek cities in contrast to the "barbarians." The victorious repelling of the foreign threat created a self-confidence amongst the Greeks which was to distinguish them in the Classical period. It is no coincidence that certain ancient historians passed on the tradition that the two crucial confrontations in 480 BC —the victory over the Carthaginians at the Battle of Himera and the victory over the Persians at the Battle of Salamis— occurred on one and the same day, wanting perhaps to emphasize the significance and the magnitude of the Greek victories. As we shall see in

the following chapter, this date forms an important boundary between the Archaic and Classical period.

■ The new political, social, and economic conditions favored the development of monumental art (architecture, sculpture, and painting) as well as the more "humble" pottery which benefitted from the increase in trade. The city-state became the most important patron of the arts in Greece at this time, along with the aristocratic class which used the arts to highlight and promote its social and cultural ideals.

2.1 Pottery

The sixth century offered ideal conditions for the development of Greek pottery, especially in those workshops, like Athens, which were associated with blooming commercial activity. Technical perfection, stylistic sophistication, and wealth of iconography became standard trademarks for the Greek vases of the period and favored their dissemination well beyond the borders of their homeland. Although not a monumental art as such, or of great value in itself, pottery forms the connective tissue in the study of Greek art, especially that of the sixth century, when significant technical and stylistic developments brought it to the forefront of Greek industry.

2.1.1 THE ATTIC BLACK-FIGURE STYLE

Attic black-figure style was one of the most successful brands in the black-figure technique, as it combined its innate decorative character with the Athenian tendency towards monumentality, a trend that had already been evident from the Geometric period (pp. 56–57).

The manufacture of black-figure vases is a highly demanding technical process: as stated in the previous chapter (p. 46–47), the black "color" of the Greek vases is not achieved by using pigments. It is no more than a suspension of clay combined with some form of alkali (e.g. potash that can be made from wood ash). During the firing of black-figure pots the temperature of the kiln initially reached 800°C/1472°F in oxidizing conditions (with the vents in the kiln open). The reduction phase (without oxygen) then follows at a temperature of up to 945°C/1733°F at which point the carbon monoxide in the atmosphere of the kiln reacts with the ferric oxide (Fe_2O_3) contained in the clay to create ferrous oxide (FeO), which has a black color and crystallizes to create a glossy appearance. The third and final phase of the firing is once again oxidizing, when

128. Attic black-figure amphora with a scene of Perseus being pursued by the Gorgons after the beheading of Medusa (on the belly) and Herakles wrestling Nessos (on the neck). c. 615–605 BC. Athens, National Archaeological Museum 1002 (CC657).

the surfaces which were initially left the color of the clay returned to their red color, but the painted areas, which had already stabilized, remained shiny black, covered in what we usually refer as "glaze."

As is evident from the description above, the iron content in the clay is what gives Greek vases their natural red or orange-red color (the "color of the clay" as we say), according to the region: Attic clay, for example, with a higher iron content, has a strong red color in contrast to Corinthian or Argive clays which are more creamy-yellow. An important role in the decoration of a vase is played by the *slip*, a dilute clay suspension with which the pot is coated after throwing and before decoration. The chemical reaction of the components in the slip during firing gives the surface of the vessel more color and shine, an effect that was sought in the fine pottery of many workshops in the Archaic period.

A typical example of early Attic black-figure is an amphora of monumental proportions (height 1.22 m): Herakles is shown on the neck of the vase, killing the centaur Nessos, while the belly depicts the pursuit of Perseus by the gorgons after he beheaded their sister, a scene from which the hero himself is bizarrely absent (fig. 128). The vase was possibly made to be used as a grave marker for a tomb in the Athenian Kerameikos. The craftsman used the new decorative idiom in combination with fill motifs (such as the rosettes and the guilloche) from the older tradition. Characteristic too is the labeling of the figures with inscriptions — ΗΕΡΑΚΛΕΣ (Herakles) and ΝΕΤΟΣ (Netos= Nessos)— a new practice on which black-figure painters capitalized with remarkable enthusiasm.

The distinctive use of added color and inscriptions is also to be seen on the monumental lebes depicting the wedding of Peleus and Thetis which dates to around 580 BC and was preserved along with its black-figure stand (fig. 131). The vase is the first signed work in Athenian pottery. It is signed by the vase painter Sophilos (Σοφίλος μ' ἔγραφσεν — Sophilos painted me).

The lebes is a shape derived from metalworking and it was used in addition to the krater for mixing wine with water at a symposium. The scenes on this example by Sophilos reveal influences from Corinthian pottery, such as the use of fill motifs, the presence of friezes with beasts, and mythical creatures, as well as the extensive use of added colors such as white and purple. The main scene, which fills the zone on the upper part

The **black-figure technique: an overview**
- Invented by Corinthian potters in the seventh century BC.
- Adopted by Athenian pottery workshops around 630 BC.
- Combined the techniques of silhouette and incision.
- Frequently used added colors.

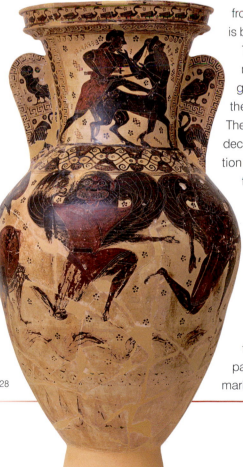

128

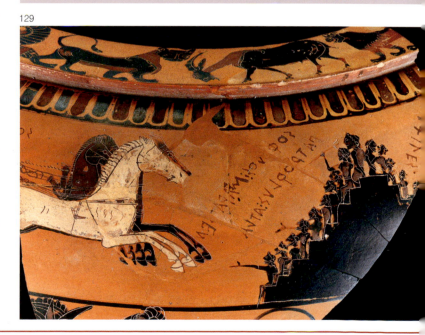

129

129. Fragment of an Attic black-figure lebes with a scene of Achilles and a chariot race (the funeral games of Patroklos). c. 580–570 BC. Athens, National Archaeological Museum 15499κ.

INSCRIPTIONS ON GREEK POTS

The first inscriptions on Greek pottery appeared in the late eighth century BC and their use became widespread after the first quarter of the sixth century BC. They are divided into two types:

PAINTED INSCRIPTIONS *(DIPINTI)* These are usually painted onto the surface of the pot with the same liquid paste which was used to decorate it (and as such they date from the time the pot itself was made). They usually name the divinity, hero, or object depicted, though often enough they carry the signature of the potter or vase painter. The earliest signature of a potter (c. 700 BC) is on a fragmentary Late Geometric krater from Pithekoussai:]ΙΝΟΣ Μ ΕΠΟΙΕ, i.e. "[...]inos made me." Another krater, dating to around 660 BC, was also made on the Italian peninsula by a Greek immigrant potter who signed himself as *Aristonothos*. The form ἐποίνσεν ("made") is most common in the signatures of potters, while the signatures of vase painters used the form ἔγραψεν ("egrapsen"; the verb γράφω in ancient Greek means "to paint"). We frequently meet abbreviated signatures, but there are many instances when someone signs as both potter and painter. We often refer to painted inscriptions on vases with the Latin term: *dipinti*.

INCISED INSCRIPTIONS *(GRAFFITI)* These are usually incised after the completion of the pots, sometimes even years or centuries after that. They are usually dedicatory inscriptions or of commercial character, mentioning the dedicant of the offering or the cost of the vessel, but they may also be of social character, such as the inscription on *Nestor's cup* (p. 53). As with dipinti, Latin also provides a term for incised inscriptions on pottery: *graffiti*.

130

130. A merchant's inscription from a red-figure krater listing numbers of vessels and their retail prices. c. 420 BC.

131. Attic black-figure lebes with stand. It depicts the wedding of Peleus and Thetis and friezes of beasts and mythical creatures. c. 580 BC. London, British Museum GR 1971.11–1.1.

of the vase, shows Peleus at the entrance of his palace receiving the official guests for his wedding (amongst them, and identified by inscriptions, are the Olympian gods and other characters such as the centaur Cheiron). Emulating the styles of Corinthian pottery, which maintained until this period its appeal both within and outside Greece, is possibly the strategy by which the Athenian potters of the sixth century introduced their products onto the international market. In any case this and other products from the same workshop appear to have been manufactured with export in mind, as they were found in areas such as Etruria.

Mythical scenes, with their direct reference to the world of epic and the broader mythological cycles, were the typical preoccupation of Athenian vase painters and seem to have secured them the preference of their Greek and Etruscan customers (see fig. 132). Of importance, from this perspective, is a fragmentary example of a kantharos from the middle of the

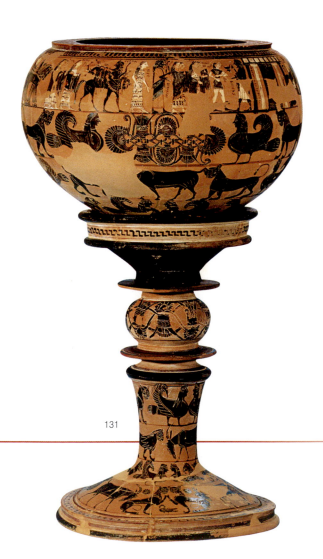

131

THE FRANÇOIS VASE

The François vase, as the volute krater in fig. 132 is called after the name of the man who discovered it in Italy in 1844, is a grandiose example of the middle phase of Attic black-figure, in the second quarter of the sixth century BC. It is signed twice: by Kleitias as the painter (*Κλ[ε]ιτίας μ' ἔγραφσεν* – "*Kleitias painted me*") and by Ergotimos as the potter (*Ἐργότιμος μ' ἐποίεσεν* – "*Ergotimos made me*").

The krater by Kleitias and Ergotimos, 66 cm tall, highlights the miniaturist and decorative quality of Attic black-figure. Its decoration consists of nine mythological scenes and a frieze with beasts and mythical creatures, in the style of Corinthian and Proto-attic pottery. A central position is held, once again, by Peleus receiving the gods on the day of his wedding, while a Centauromachy, the hunt for the Calydonian boar and the return of Hephaestus to Mount Olympus are also depicted. There are 270 figures of people and animals (8–12 cm tall on average), the majority of which are identified by inscriptions. Such was the enthusiasm of Kleitias for inscriptions that he labeled the animals, including the dogs who took part in the Calydonian boar hunt, and even objects: *vomos* ("altar"), *hydria*, *krene* ("fountain house"), and even *lithos*, for the stone that is being brandished by one of the Centaurs. The exhaustive use of inscriptions does not seem to be dictated as much by the needs of the narrative as by the literary background of ancient Greek art itself. All the pictorial scenes of the vessel refer to incidents found in the epic cycle or variations of them, as well as to stories that probably belonged to epics lost to us today. The recourse to written elements in this way, elements that probably belonged to some literary narrative known to the users of the vase, are thought to have functioned in parallel with painted scenes. Let us not forget that the pot is a krater, a vase destined to narrate "stories" in the middle of a symposium, aiding in this way communication between diners.

It should be noted furthermore, that this particular vessel travelled outside of the borders of the Greek world very quickly after its production. In fact it is probable that its destination was already known to Kleitias when he painted it. Perhaps then the iconographic composition of the vessel, as well as the execution of the pictorial themes, are a product of the aesthetic preferences of its final recipients and the way in which these were interpreted by its manufacturers.

132

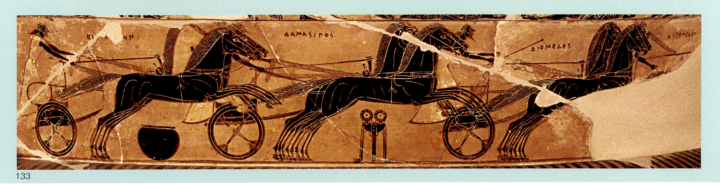

133

132. Attic black-figure volute krater (the François Vase) with mythological scenes. c. 570–565 BC. Florence, Archaeological Museum 4209.

133. The funeral games for Patroclus. Detail from the painted decoration on the krater in fig. 120.

ATTIC POTTERY SHAPES: AN OVERVIEW

Symposium vessels, but also vessels destined for everyday use, are the most common shapes in Attic pottery. The *amphora* is the most common, and from the sixth century it became smaller in comparison to Geometric and orientalizing types. It is sub-divided according to the outline of the shape, the transition of the neck to the body of the vessel and principally the shape of the base and of the handles. A variation of the amphora is the *pelike*, with a low belly and more stable shape, ideal mainly for trade in oil or perfume.

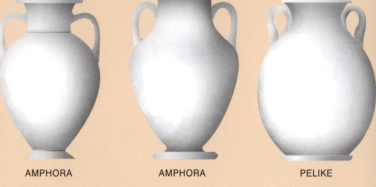

AMPHORA　　　AMPHORA　　　PELIKE

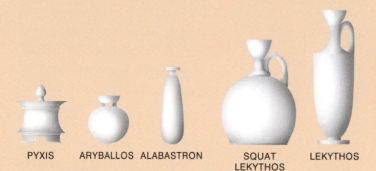

PYXIS　　ARYBALLOS　ALABASTRON　　SQUAT LEKYTHOS　　LEKYTHOS

The *lekythos*, the *alabastron*, and the *aryballos* were used as perfume bottles with a wide distribution, but also as grave goods, since the anointing of the body with aromatic oils was part of the burial ritual. The *pyxis* is a typical woman's accessory, used as a jewelry or cosmetic holder.

The *kylix*, the *skyphos*, and the *kantharos* are types of drinking cup, and the *oinochoe* was the basic type of jug for drawing wine out of a krater. The *psykter* (cooler) was also related to the symposium. It was a specially designed vessel that helped to keep the wine at the perfect temperature. It was either placed full of wine into a krater full of cool water, or alternatively, they filled it with water and placed it in a krater full of wine. Finally the *hydria* with its characteristic three handles, was the basic vessel for transporting wine.

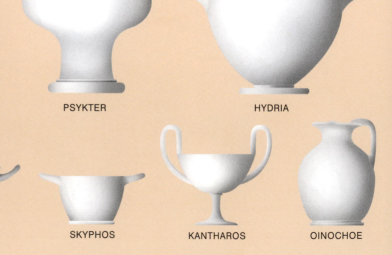

PSYKTER　　　　　　HYDRIA

KYLIX　　　KYLIX　　　SKYPHOS　　KANTHAROS　　OINOCHOE

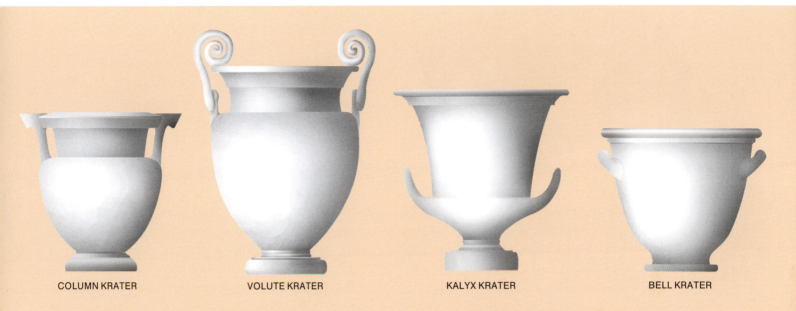

COLUMN KRATER VOLUTE KRATER KALYX KRATER BELL KRATER

The *krater* (with four variations: column, volute, calyx, and bell) was the pot used to mix wine with water, and as such occupied a central position in the symposium. The *lebes* has a similar use. In both Greek and international scholarship this is also called, probably mistakenly, a *dinos*: the word, whose literal meaning is "vortex," is also used in ancient Greek to mean a "large cup," thus referring to a drinking vessel and not to a storage vessel for liquids such as the lebes or krater. The *stamnos* was used in a similar way to the krater.

The *lebes gamikos* and the *loutrophoros* were used in wedding ceremonies but also as grave goods in the graves of unmarried men and women. A variation of the loutrophoros is the *loutrophoros-amphora* (with two vertical handles, destined for men) and the *loutrophoros-hydria* (with three handles, for women).

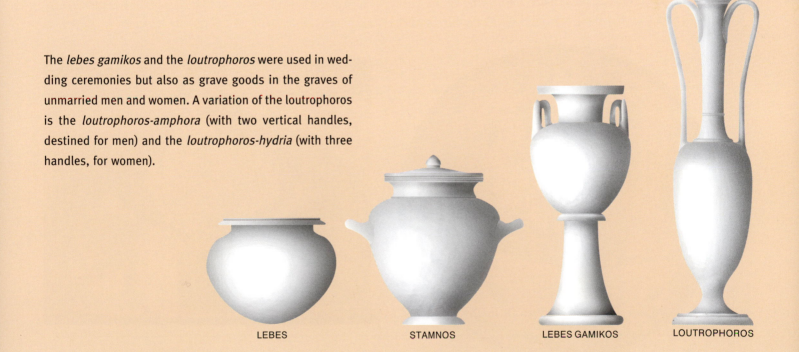

LEBES STAMNOS LEBES GAMIKOS LOUTROPHOROS

sixth century BC that depicts Achilles talking to his horses (fig. 135). The vase is signed by Nearchos as both potter and painter, a fact which demonstrates that the two skills were frequently, possibly more often than not, combined (Νέαρχος μ' ἔγραφσεν κὰ[ποίεσεν] = Nearchos painted me and [made] me). The use here also of added white and purple color is typical, as is the delicate incision. Even though the names which Nearchos gives to the horses do not match the ones associated with Achilles in the Homeric tradition (*Iliad* XIX 392–393), it is clear that the scene is a story well known to viewers both in and outside Greece.

The sobriquet "the Lydian" with which one of the vase painters of the middle of the sixth century BC signed his work,

demonstrates that in the Kerameikos, the deme of Athens where the majority of the Athenian pottery workshops were located, Athenians, metics (foreign workers), and probably also slaves worked side by side. Among the makers of Attic black-figure style who signed the vases, Exekias stands out, a potter and painter working in the third quarter of the sixth century. His shapes are distinguished for their elegance and ingenuity —the creation of the kalyx krater is attributed to him. His painting stands out for his love of detail, his subtle incision, and the decorative overall appeal of his work. Some characteristic examples of his production are his "Dionysus Cup," a kylix depicting Dionysus sailing on its interior (fig. 136), and the amphora with a scene of Ajax and Achilles playing draughts (fig. 137). The first is signed by Exekias just as the potter (Ἐξηκίας ἐπο[ί]ησε). In the interior of the vase Dionysus sits in a warship drawn on a rich red-orange (coral) background, made from a specially mixed clay slip, rich in kaolin (china clay). The scene refers to the seafaring adventures of the god, when he was kidnapped by Etruscan pirates unaware of his identity; as such, it is well suited for the decoration of a symposium cup —especially one made for export to Etruria itself!— as it combines, in superb tong-in-cheek fashion, a reference to the god of wine and pleasure with the manner in which the god punishes his enemies (or anyone oblivious of his potency).

The second example (fig. 137) bears two inscriptions: Ἐξηκίας ἐποίησεν and [Ἐξη]κίας ἔγραφσε κἀποίησέ με ("Exekias

135. Fragment of an Attic black-figure kantharos showing Achilles talking to his horses. c. 560–555 BC. Athens, National Archaeological Museum 15.166 (Ακρ. 611).

136. Attic black-figure kylix with a scene of Dionysus at sea in a boat. c. 540–535 BC. Munich Archaeological Museum NI 8729 (SH 2044 WAF).

ΟΝΗΤΟΡΙΔΗΣ ΚΑΛΟΣ (ONETORIDES IS HANDSOME)

The amphora by Exekias (fig. 137), in addition to the signature of the artist and the inscriptions that name the heroes, bears another inscription which is reproduced on both sides: ΟΝΕΤΟΡΙΔΕΣ ΚΑΛΟΣ, which means "Onetorides is handsome" and belongs to a series of inscriptions written on Attic vases that name young Athenians of the period commending them for their beauty. The "kalos inscriptions," as they are called, have preserved an insight into everyday life in Athens, and an echo of discussions between members of the aristocratic class which reached the Athenian Kerameikos as special orders or even as jokes.

The pederastic ethos, i.e. the quest by mature men, mainly from the ruling class, for same-sex lovers from among the younger members of their class –"paides"– had a great influence on Greek art, particularly in the Archaic period. Although modern research has reached no final conclusion about this aspect of private (but also public) life of the ancient Greeks, it is clear that the boundaries between what we call today heterosexual or homosexual love were not understood in the same way that western societies of the twenty-first century define them.

According at least to written sources, but also depictions in art, the Athenians, as well as other Greeks, had the custom of approaching young boys in the gymnasium or elsewhere offering them gifts in return for their favor. Potential lovers, in their attempt to win the trust and regard of young boys and eventually to make them their lovers, offered them different pets as gifts (fig. 138–139). Literary sources and pictorial scenes both make mention of dogs, horses, and even foxes, as well as doves and other varieties of birds (see Aristophanes *Birds* 707, where many different types of birds were considered appropriate as gifts for the "paides").

The symposium, as we also know from the similarly named work by Plato, written almost a century and a half after the creation of the vessels we are discussing here, was a venue for sexual relations between men and their younger lovers, even if, as many suggest, full sexual intercourse occurred rarely. The use of inscriptions which name the "handsome ones" on symposium vessels, allows us to form a better understanding of events at a symposium in the Archaic period. Furthermore, the use, in such inscriptions, of names belonging to Athenians who later became officials and are known from other sources, provides useful evidence for dating.

138

139

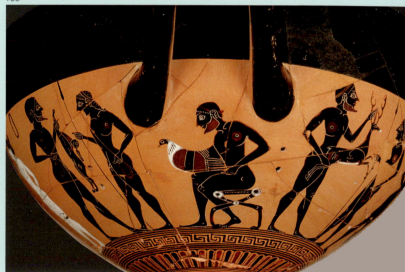

137. Attic black-figure amphora with a scene of Achilles and Ajax playing draughts. c. 530 BC. Rome, Vatican Museum 16757 (344).

138, 139. Attic black-figure kylix with a scene of erotic discourse between men and boys. Bearded men approach young boys with gifts such as hares, doves, or deer. c. 550 BC. Paris, Louvre A479.

made me" and "[Exe]kias painted and made me"). The use of the first person in inscriptions is typical, and gives the impression that the work of art itself, endowed with animate qualities, addresses the viewer directly, as also happens with sculpture (p. 69). The scene of the two heroes throwing dice in a supposed lull in the Trojan War is not known from any preserved text; it is, nonetheless, a reference to the Homeric world at large, especially familiar to the Greeks of the Archaic era (but also to those admirers of Greek culture from outside Greece). Delicate incision highlights the heroes' features, and the use of inscriptions (like speech bubbles as it were) —Achilles is shown calling out τέσ[σ]αρα ("four") and Ajax, τρία ("three") — brings the scene to life.

The iconographic repertoire of the Attic black-figure style was not restricted to mythological scenes. There is a wealth of pictorial representations with subjects from the daily life of ancient Athenians (festivals and ceremonies, athletics and education of the young, war scenes and scenes from the life of women). A typical example is the hydria in fig. 141, which depicts four women at a fountain house. The use of added white to render the women's skin is typical, a contrast black-figure painters seem to love; the depiction of the fountain house and

the hydriai on an actual hydria, i.e. on a vase that was used for exactly the purpose shown, is also quite interesting. In this vase, and in many similar vases which date to the last quarter of the sixth century BC, we may also observe the direct impact of the economic and social conditions of the time: it is known that among the public works that were carried out in Athens by the tyrant Peisistratus (who was in power, with breaks, from the middle of the sixth century to 527 BC) and his two sons (527–510 BC) was the construction of large public fountain houses. The provision of clean drinking water via an extensive supply system which Peisistratus also built (fig. 140), must have changed the everyday lives of the Athenians and also inspired scenes such as this, with the gathering of young women at the fountain house of the neighborhood.

140

Next to their appearance, Greek vases often counted on signatures in order to achieve commercial impact, as is evident in a special category of Attic vessels, the so-called "Nikosthenic amphorae" (fig. 142). The main characteristic of these vases is the bold large signature they bear (Νικοσθένης ἐποίεσεν — Nikosthenes made me), referring probably to the owner and head of a highly productive pottery workshop. The Nikosthenic vases, and in particular the amphorae, are copying Etruscan metal prototypes, a device that appears to be a deliberate strategy in order to penetrate the Italian market.

The *Panathenaic amphorae* form a unique category of Attic black-figure vases. These amphorae contained the olive oil that was given to the victors of the events in the Great Panathenaia, the major religious festival that occurred in

140. Athens, sections of a clay water pipe with painted symbols. 525–500 BC.

141. Attic black-figure hydria with a scene of women at a fountain house. c. 520–510 BC. London, British Museum 1843.11–3.49 (B329).

142

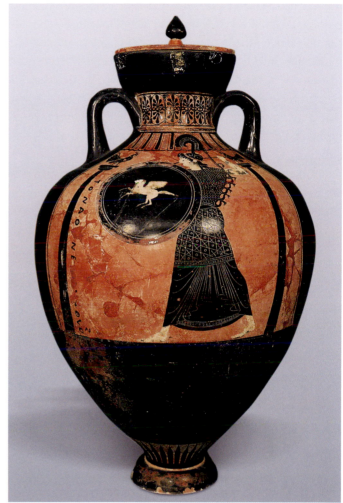

143

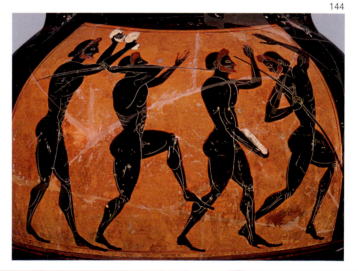

144

Athens every four years. They were made especially for each event, in order to control the quantity and quality of the product contained in them. They were large vases (their height sometimes exceeded 70 cm) that contained around 38 liters of oil. A victor could win up to 140 amphorae of oil, which he could go on to sell. As a result, these vases were widely distributed. The production of the Panathenaic amphorae must have begun around 566 BC, when, according to ancient literary sources, the games were reorganized. Their production continued without pause until the fourth century AD. The technique used was black-figure until they ceased to be produced, even though the black-figure style had by then long been abandoned for other types of pottery. Their iconography remained almost unchanged: the main side of the vase depicted

142. Attic black-figure "Nikosthenic" amphora. c. 520–510 BC. Paris, Louvre F 107.

143. Panathenaic amphora. c. 490 BC. Taras, Archaeological Museum 115474.

144. Panathenaic amphora showing pentathletes. c. 530–520 BC. London, British Museum.

Athena Promachos between two columns topped with cockerels and with the inscription τῶν ἀθήνηθεν ἄθλων ("for the games held in Athens," fig. 143) and the back side illustrated the contest with which the particular amphora was associated (wrestling, pankration, foot races, see fig. 144). From the fourth century BC the name of the eponymous archon was also indicated, while the Panathenaic amphorae of the Hellenistic period showed the name of other officials of the relevant year, as a way of checking the quality of their content. The Panathenaic amphora shape also appears in Attic red-figure production in the fifth century BC, as well as in the southern Italian workshops of the fourth century BC.

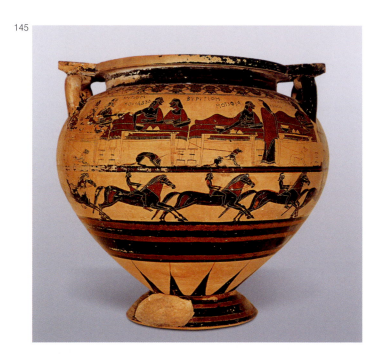

145. Corinthian black-figure column krater with a scene of a symposium and horse-racing. c. 600–590 BC. Paris, Louvre E635.

146. Detail from the handle of the vessel in fig 145: it depicts the "palace" kitchen and the preparation of the dinner. On the left is a lebes with stand and an oinochoe for the symposium that will follow.

2.1.2 BLACK-FIGURE STYLE BEYOND ATHENS

As we saw in the previous section (p. 71–73) the black-figure style was invented in Corinth, and developed from Protocorinthian pottery. The Corinthian workshops during the sixth century maintained their preference for decorativeness and polychromy, qualities that had made Corinthian pottery popular in the Etruscan market. Corinthian black-figure shapes, such as the krater, were exported to Etruria until the middle of the sixth century BC when, as explained above, they continued to influence Athenian potters, especially in the first decades of the century.

A typical example of such an exported Corinthian vase of the sixth century is a column krater from Etruria, height 46 cm, the main scene of which is dedicated to a mythical symposium which the Oechalian King Eurytos held in honor of Herakles (fig. 145). It shows the protagonists, identified with inscriptions in the Corinthian alphabet, reclining on couches, according to well established practice. The daughter of the king, Iole, is shown standing; she was to become the bone of contention between Herakles and Eurytos, leading finally to the deaths of everybody involved. The scene on the krater, with mythical heroes depicted happily and unsuspectingly celebrating, conceals an element of tragic irony as symposiasts may have been expected to know the final outcome of the myth. The scene with its rich furniture, vessels, and dishes, the polychrome clothing, and even the scene from the kitchen of the palace below one of the two handles (fig. 146), form a complete whole, in combination with the inscriptions which appear to have an additional decorative value.

The pottery workshops in East Greece implemented a version of the black-figure style influenced by the local orientalizing tradition of the seventh century. An interesting example from an Ionian workshop is the "Bird-catcher cup" (fig. 147): it is a black-figure kylix, similar to those from the Attic workshop, but with variations in decoration: instead of incision, the details are *reserved*, that is left unpainted. Depicted on the interior of the cup, in the typical circular area of the kylix which is called the *tondo,* is a bearded man wearing a *perizoma* (a simple loin-cloth covering the hips) between two luxuriant vines. On the left of the scene a large bird is flying towards its nest, while lower down a snake and a grasshopper can be seen. Although in the past the man in the center of the scene was considered

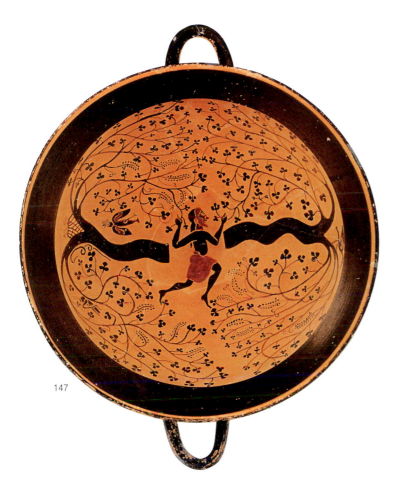

and their vitality, as well as the use of mythological scenes, especially from the exploits of Herakles. The hydria in fig. 148 is a typical example: an anonymous hero (Perseus or possibly even Herakles) confronts a sea serpent under the gaze of a seal and two dolphins. The liveliness of the scene is complemented by the use of polychromy and rich floral decoration (ivy leaves, anthemia).

Finally, it should be noted that painted pottery forms only a fraction of the entire production, which for the most part consisted of unpainted or monochrome vessels, as well as those with simple banded decoration.

148

to be a hunter, it seems more likely to be a god associated with nature, probably Dionysus himself.

Several categories of black-figure vases look Ionian, but owing to their almost exclusive distribution in the West, they are generally thought to have been made by Ionian potters who had moved to Etruria. The most typical example of this class are the so-called Caeretan vases. They are a group of vessels (consisting almost exclusively of hydriai) mostly excavated at Caere in Etruria (modern Cerveteri). The prevailing view is that they are the product of a small number of potters from East Greece, possibly from the city of Phocaea, who worked in the area during the last quarter of the sixth century BC. The characteristics of the Caeretan vessels are the use of polychromy

147. Ionian black-figure kylix depicting a god between two trees representing a dense forest. c. 550 BC. Paris. Louvre F68.

148. Caeretan black-figure hydria with a mythical contest between a bearded hero and a serpent. c. 530–520 BC. Stavros S. Niarchos Collection A061.

THE SYMPOSIUM

Communal feasting had been part of the Greek culture since at least the Early Iron Age. The Homeric poems often describe scenes of eating and drinking between men of note, though with significant inconsistencies. Heroes in the *Iliad* and the *Odyssey* are described mixing wine with water, as later Greeks did, and they are often shown enjoying the entertainment provided by hired singers and dancers while feasting. It was in the Orientalizing period, however, that the Greek way of communal drinking acquired its standard form. Some time in the seventh century BC, Greeks adopted the practice of reclining while eating and drinking, especially, it would seem, on formal occasions. This radically new approach to communal feasting seems to have been copied from Persia.

The *symposium*, as this new social ritual was called, was primarily a drinking party, following directly after dinner, in specially designed and furnished rooms called *andrones* (men's quarters; see fig. 152). Seven to fifteen men, or sometimes more, would recline on couches (*klinai*) arranged along the room's four walls. As a result, the door to the room had to be placed off-center so as to allow for this alignment of rectangular klinai to work. This arrangement facilitated conversation and gave a feeling of equality to the participants. Their chosen leader for the night (the *symposiarch*), would decide what the evening's wine-to-water ratio would be. Judging by literary sources, five parts water to two of wine seems to have been the most acceptable dilution, though the matter was always open to debate. Topics of conversation had also to be agreed upon, it seems, while song and dance were provided by the symposiasts as well as paid professionals –both men and women. Although classical authors continuously advice moderation when it comes to symposia, it seems that they were rarely as "tame" and orderly as they appear in most of Greek art.

In terms of the paraphernalia used in the symposium, the krater was the "king" of the evening, as this is where wine was mixed with water (cf. fig. 149). Many of the kraters surviving from the Archaic and the Classical periods seem to conform with their intended usage, even though they were often chosen as burial gifts as well. Jugs and cups were also necessary equipment. Cups, in particular, were expertly designed in the sixth and fifth century BC so as to facilitate drinking, whilst at the same time inspired conversation through their iconography, often intended as a playful or even mocking commentary on the evening's proceedings. The cup in fig. 150, for example, belongs to an extensive

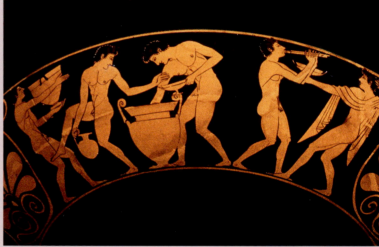

149

group of Greek vessels showing the symposium itself: executed in the red-figure style (see below, pp. 100–101), the cup shows a number of reclining symposiasts enjoying their wine in convivial merriment, holding large skyphoi in their laps. A number of vases are shown, in black silhouette, on the floor, while several of the men are depicted playing the *kottabos*, a drunken-skill game of sorts, whereby the participants fling the lees of their wine at a basket in the center of the room (also shown in fig. 150) trying to avoid, one assumes, one another or breaking their cup.

Although the symposium was a Greek institution par excellence, ritual banqueting was quite widespread in antiquity

149. Attic red-figure kylix with young revellers. c. 480–470 BC. London, British Museum 1836.0224.114.

150. Attic red-figure kylix with symposium scene. c. 480–470 BC. London, British Museum 1836,0224.212.

151. Attic red-figure kylix with symposiast (interior). From Tanagra, Boeotia. c. 500 BC. Athens, National Archaeological Museum A 1357.

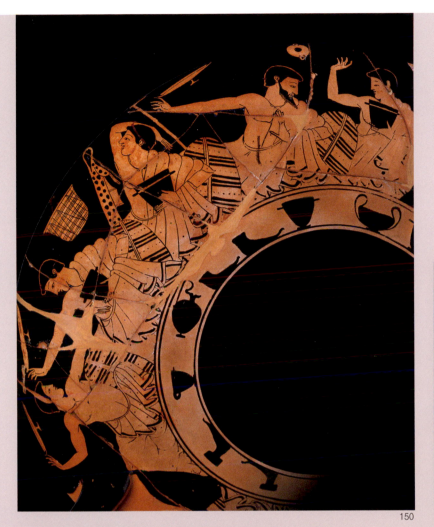

150

151

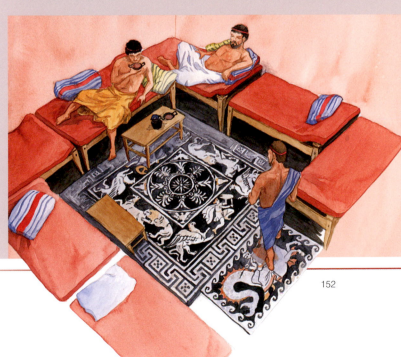

throughout the Mediterranean and the Near East. Greek vases featuring symposium scenes became, therefore, quite popular with an international clientele, such as the Etruscans, who also favored reclining as a sign of wealth and social status. Greek symposium vases, as a result, soon became favored commodities for an international market ranging from the Celts in Western Europe to Persia and Mesopotamia.

152

152. Eretria, "House of the Mosaics." Reconstructions of the andron. Fourth century BC.

2.1.3 THE ATTIC RED-FIGURE STYLE

The intensive use of the black-figure style in the pottery work-shops of Attica gave rise to a series of experiments which led to the invention of the *red-figure style*.

The invention of the red-figure style is placed around 530 BC on the basis of stylistic comparisons with the Siphnian Treasury (p. 132–133), a building in the sanctuary at Delphi which, as we saw in a previous section (p. 24) serves as a fixed chronological point for the art of the Archaic era. The poly-chrome sculpture of the period, a typical example of which is the frieze on the treasury, appears to have been the inspiration for Athenian vase painters who tried to imitate in their work the iconography and style of the sculptures. The period of the first experiments is characterized by a series of so-called "bilingual" vases, with black-figure on one side and red-figure on the other. Soon, however, the red-figure style prevailed, as it suited the needs of both artists and customers for more complex scenes, with more realistic representation of the anatomy and clothing. During the last decades of the sixth century the production of Attic red-figure was characterized by the work of a single group of artists who, as is demonstrated by their signatures on their vases, as well epigraphic evidence from other forms of art, had developed working and social relationships with each other. Amongst them were the vase painters Euphronios, Euthymides, Phintias, and Smikros, some of whom also signed as potters.

An interesting example of the pottery production of this period is the famous "Euphronios krater" which was also found in an Etruscan tomb (fig. 154–155). It is signed by the potter Euxitheos and by Euphronios as the vase painter. The main side of the vase refers to the death of Sarpedon, son of Zeus, who fought at Troy against the Greeks, but was cut down by Patroclus suited in the armor of Achilles (*Iliad* XVI 666–675). On the vase Sarpedon's dead body is shown

153

153. Attic red-figure amphora showing Hermes with a satyr. c. 495–490 BC. Berlin, Archaeological Museum F 2160.

The red-figure technique: an overview

■ Appeared in Athens around 530 BC and dominated Attic pottery until the end of the fourth century BC.

■ Depicts red, *reserved* figures (the color of the clay) on a background which was painted black, i.e. a complete reverse of the black-figure style.

■ Uses painted lines or thick black brush marks ("relief lines") to complete the outline of the figure and render anatomical detail, which became more realistic, especially towards the end of the Archaic period.

■ In contrast with the black-figure style which was defined by its stylish, and quite decorative, aspect, the red-figure is more painterly, since the reserved technique it developed made the drawing of anatomical and other details much easier and a lot more effective.

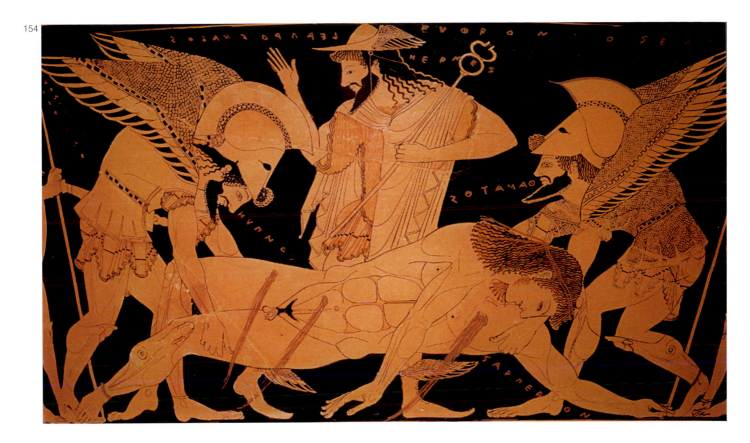

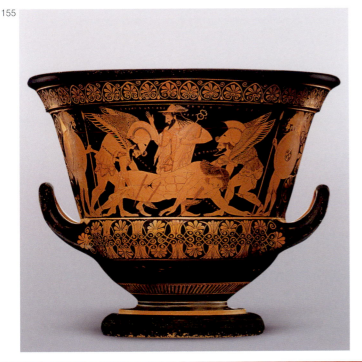

stripped of his armor, ready to be carried to Lycia, his homeland, by his twin brothers Hypnos (Sleep) and Thanatos (Death), under the guidance of Hermes.

Towards the end of the Archaic period (500–480 BC) the vase painters of Attica achieved more accurate anatomical representation, influenced perhaps by the wider trends in sculpture, mainly that executed in relief, but also the minor arts of the period (see p. 125, 138). The amphora in fig. 153, which is attributed stylistically to the artist conventionally called "the Berlin Painter," shows the extraordinary potential of the mature red figure style: it depicts Hermes with his caduceus, walking (or dancing?), holding a kantharos and an oinochoe, and a satyr who is playing the *barbiton*, a more elongated version of the lyre; between them we see a deer. The scene, which probably represents part of a satyr play, is notable for its striking contrast between the red figures and the black background, the anatomically correct configuration of the bodies, and the daring composition with partial overlapping of the three figures.

154, 155. Attic red-figure kalyx krater depicting the body of the dead Sarpedon, taken up by Hypnos (Sleep) and Thanatos (Death). c. 515–510 BC. Rome, Villa Giulia.

POTTERS AND PAINTERS

Making pots, "*kerameuein*," was back-breaking and frequently dangerous work, a profession which probably brought more to the owners of the workshops and the sellers of the products than to the artists who spent their days kneeling on the ground, exposed to the sun or to the dangers of the kiln (fig. 158). In Athens, after Solon's reforms at the beginning of the sixth century BC, the potters, along with other *demiourgoi* ("makers") – i.e. manual laborers– belonged to the class of the *thetes* or of the *zeugitai*. Metics and even slaves must have worked alongside them.

Archaeological and epigraphic evidence on the other hand provides a picture of affluent potters, who had the ability to dedicate important and expensive sculptures for the sanctuaries in their city. A votive relief from the end of the sixth century from the Acropolis (fig. 156) is usually thought to represent a potter, naked but for a humble himation draped over his lap, who is giving thanks to the goddess Athena –the protectress of manual workers– and holding two kylikes as examples of his

work. Alternatively, however, the relief could portray a metalworker, perhaps a silversmith. The inscription that this particular votive would have initially had is not preserved, but there are similar inscriptions on other dedications which refer to (or are thought to refer to) potters (see also pp. 126–127). Many historians think that the well-known potter Euphronios (fig. 155) is the dedicator of a now lost votive, the inscription of which can be completed as follows:

ευφρονιος [ανεθεκε]ν
κεραμευς [τ αθεναι[αι δ]εκατεν

Euphronios, the potter, dedicated (me),
As a tithe to Athena

A little later, in 490 BC, is the epigram from another votive from the Athenian Acropolis: Πείκων εὐξάμενος, κεραμεύς, δεκάτεν ἀνέθεκεν τ' Ἀθεναῖαι: "Peikon the potter, having offered his prayers, dedicated the dekate to Athena." As we have seen (p. 69), the tithe –*dekate*– was one-tenth of one's annual income. Even modest calculations of the cost of a votive relief demonstrate

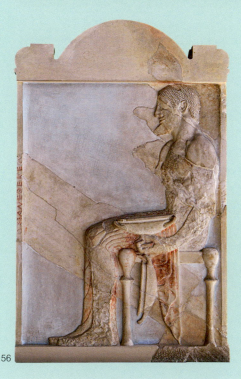

156

157

156. Attic votive relief depicting a potter. End of the sixth century BC, Athens, Acropolis Museum 1332.

157. Attic red-figure amphora with a dancing scene. c. 510 BC. Munich, Archaeological Museum 2307.

158

that Euphronios and Peikon, who are mentioned in the two inscriptions, were professionals of good financial standing, probably owners of their workshops, even if they both started their careers as manual laborers themselves.

The Athenian potters of the period 530–500 BC, who were mentioned above, left behind a series of inscriptions and other details on the vases, which help us understand their social position. The vase painter Euthymides signed a vase as "the son of Pollias" (ἔγραφσεν Εὐθυμίδης ὁ Πολ[λ]ίου), a name that associates him with the Athenian sculptor, known from written sources and inscriptions (fig. 157). On the same vase is the curious inscription hος ουδεποτε ευφρονιος ("as never [did], Euphronios") without specifying whether it is the skill as a painter which is the object of comparison between the two fellow potters –or perhaps their dancing talents. In the hydria in fig. 159 a young pupil at music school is named as Euthymides, while Smikros placed himself in the center of a symposium scene with other young men and hetaerae on a vase he has himself signed. The playful character of these inscriptions and scenes appears to conceal the tendency of potters at this time to introduce a kind of social commentary into their work, at least while their pots remained on display to the public before being sold. Even though their social status remains lowly, we must not forget that during the Peloponnesian war, three or four generations after Euphronios, the fate of Athens literally rested in the hands of *demiourgoi* such as Kleon the tanner or Hyperbolos the lamp-maker.

2.2 Sculpture

As already discussed in previous sections, ancient Greek societies were interested in the monumental use of art already in the eighth and seventh centuries BC: the ceramic grave markers of the eighth century such as the Dipylon vases (p. 56–57) and the bronze votives, such as the large tripod cauldrons (p. 59; 68), are impressive for their size, the value of their material, or the technical skill required for their construction. As such, they fulfill the basic role of a *monument*: to mark human activity within a social framework and to promote a system of values and ideas which expresses —or may be thought to express— those of its dedicator.

The concept of monumentality in Greek art, however, only reached concrete form with the sculpture of the Archaic period, when in the sanctuaries and the cemeteries of Greece the first really imposing sculptures made their appearance. It was with those that, for the first time in Greek art, the concept of monumentality was fully formulated and realized.

159

158. A votive plaque showing a kiln (drawing). Sixth century BC. Berlin, Archaeological Museum F893.

159. Attic red-figure hydria with a scene of a music lesson. c. 510 BC. Munich, Archaeological Museum SH 2421 WAF.

Monumental art: an overview

DURABLE MATERIAL Stone, and for the Greeks marble, was the basic material for the production of monumental art. The new technology which was imported from Egypt during the Archaic period permitted the Greek sculptors to excel, little by little, in the use of a fine grained material such as marble. Compared to other types of stone, and because of its crystalline structure, marble proved durable and at the same time workable, as well as visually attractive. Gradually, it replaced limestone in Greek sculpture, while the use of bronze became more prominent from the late sixth century on.

TECHNICAL ACHIEVEMENT A monument impresses with its technical perfection: the monumental Dipylon vases (fig. 56–57), for example, demonstrate original, ambitious and daring techniques for their period. At the same time, however, Daedalic sculpture was limited to shallow carving and in a relatively "easy" –soft– material (fig. 111). The marble sculptors of the Archaic period, on the other hand, from already as early as the Daedalic period, appear to have been willing to pursue bolder directions and to experiment with the resilience of the material and with their tools. The iron tools which were used in Greek sculpture, the point, the flat and claw chisels (fig. 160), in combination with fine-grained Greek marble, gave the Greek sculptors the ability to achieve exquisite and complex surfaces. The *aris* and the *trypanon* (types of drill) were used to drill holes and to work details in the anatomy or clothing. Sculptors were able in this way to achieve, by the end of the Archaic period, a key aim of Greek

art, the convincing imitation of the human form and the clothing on it. The final polishing of the marble surface was done with *emery*, a particularly hard stone which comes from the Cyclades, especially Naxos. We must not forget also that the final appearance of the statue was accomplished by the use of color, which will be discussed in a later section (p. 119).

IMPOSING SIZE The natural and supernatural dimensions of the sculptures appear to be the rule during this period, under the influence of Near Eastern and Egyptian prototypes. In combination with the technical skill of the sculptor, the monumental size of the work captivates the viewer with its presence and promotes unequivocally the values that are expressed by the sculpture.

RITUAL FUNCTION The use of sculpture in this period was confined to funerary and votive contexts, and directly connected with the ritual domains of life in the community. Although *cult statues* in stone or bronze have been found, it is thought more likely that the majority of the cult statues in the cella of a temple were wooden *xoana*, probably aniconic or only of a somewhat "primitive" form. Either as a votive or as a grave marker, the statue is called upon to mark the prestige of the dedicants, their social status, and their financial standing, to show their origin and to define their influence both inside and outside the boundaries of the community to which they belonged. Monumental works of art are therefore *complex products of multi-level social interaction*.

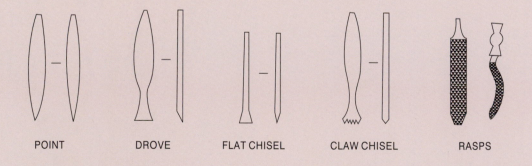

POINT DROVE FLAT CHISEL CLAW CHISEL RASPS

160. The main tools used in Greek sculpture.

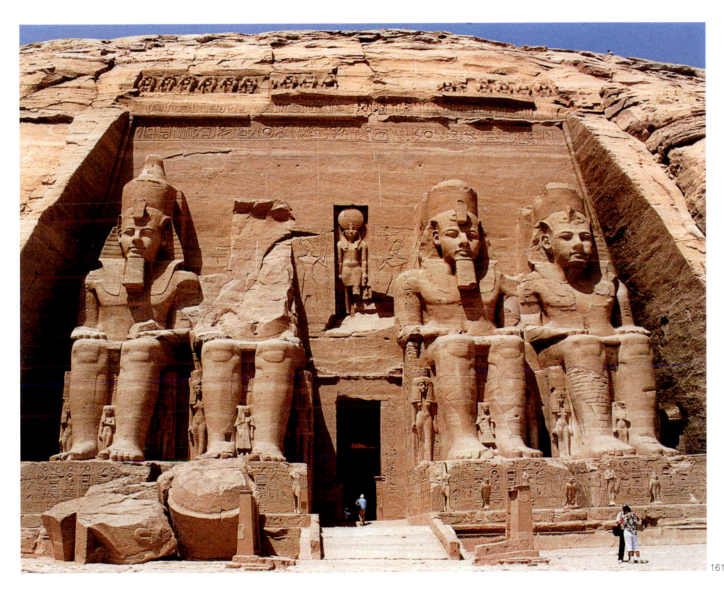

161

The stimulus for monumental sculpture is thought to have come from Egypt. Already by the seventh century BC, the Greeks had been in regular contact with Egyptian culture: Pharaoh Psamtik I (known to the Greeks as Psammetichos; 664–610 BC) had used Greek and Carian mercenaries, especially from the islands and East Greece, whom he then permitted to settle in specially assigned areas of his realm. These communities served as trading posts between Greece and the rest of the Mediterranean, and also as centers of cultural exchange. The Greeks appear to have adopted morphological and technical elements from the Egyptian art of the period, in combination with the orientalizing iconographic repertoire which had already taken shape during the previous century (p. 66–79). The graffiti by Greek mercenaries on Pharaonic sculptures at Abu Simbel (fig. 161–162) demonstrate how the Greeks

162

ΒΑΣΙΛΕΟΣΕΛΘΟΝΤΟΣΕΣΕΛΕΦΑΝΤΙΝΑΝΨΑΜΑΤΙΧΟ
ΤΑΥΤΑΕΓΡΑΨΑΝΤΟΙΣΥΝΨΑΜΜΑΤΙΧΟΙΤΟΙΘΕΟΚΛΟΣ
ΕΠΛΕΟΝΘΑΘΟΝΔΕΚΕΡΚΙΟΣΚΑΤΥΠΕΡΘΕΝΙΣΟΠΟΤΑΜΟΣ
ΑΝΙΘΑΛΟΓΛΟΣΟΣΔΒΧΕΠΟΤΑΣΙΜΤΟΑΙΓΥΠΤΙΟΣΔΕΑΜΑΣΙΣ
ΕΓΡΑΦΕΔΑΜΕΑΡΧΟΝΑΜΟΙΒΙΧΟΚΑΙΠΕΛΕϘΟΣΟΥΔΑΜΟ

161. The colossal statues of Abu Simbel in Upper Egypt on whose bases graffiti were inscribed by Greek mercenaries in the service of Pharaoh Psammetichos II (595–589 BC), who was campaigning in the area in 591 BC in order to fend off the aggressive moves by the kingdom of Nubia.

162. The inscription mentions the Pharaoh's campaign and is signed by Archon, son of Amoibichos and Pelekos, son of Eudamos.

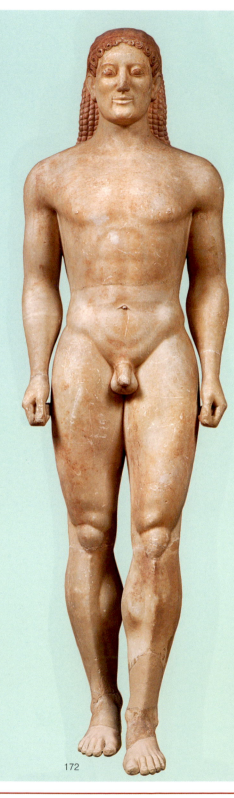

172

THE ANAVYSSOS KOUROS

The kouros from Anavyssos in Attica, slightly larger than life size at 1.94 m, is one of the best examples of the type, as it allows us to reach some useful conclusions regarding its use and importance (fig. 172).

It is a funerary monument, a marker for the grave of a young man called Kroisos, who, as the inscription carved on to the base informs us, was killed in battle:

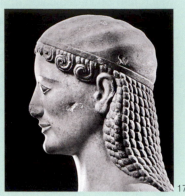

173

ΣΤΕΘΙ:ΚΑΙΟΙΚΤΙΡΟΝ ΚΡΟΙΣΟ
ΠΑΡΑΣ ΕΜΑΘΑΝΟΝΤΟΣΗΟΝ
ΠΟΤΕΜΙ ΓΡΟΜΑΤΟΙΣ:ΟΛΕΣΕ
ΘΟΡΟΣ:ΑΡΕΣ

στηθι : και οικτιρον κροισο | παρα σεμα θανοντος ον
ποτ ενι προμαχοις : ολεσε | θορος : αρες

*Stop and mourn beside the monument for Kroisos
whom raging Ares destroyed in the front line*

Technically the statue represents the developed form of the type: the movement is rendered almost convincingly rather than completely "frozen" in a frontal pose: the musculature, even if it remains only superficial, is no longer flat but modeled more efficiently and as a result the statue appears to the viewer as a natural unity. An interesting element is the confidence with which the artist left the hands free from the body, with the forearms following the curvature of the hips without being fully attached to them. The final stage of this process, before the kouros type was completely abandoned, is represented by *Aristodikos*, a kouros from an Attic cemetery, whose arms extend daringly forwards, with only two unnatural-looking supports linking them to the body (fig. 174). The name of the deceased is carved on the base in the genitive case: ΑΡΙΣΤΟΔΙΚΟ ("of Aristodikos").

The robust figure of Kroisos, its youthful vitality, the neatly cut hair with its spiral-like curls on the forehead, in combination with the touching inscription, communicate the *ethos* that the sculpture projects: the young hoplite appears to mourn the loss of his life but at the same time both he and his family (who erected the monument) are proud of his bravery. As we saw in a previous section (p. 72), participation in a hoplite phalanx was the ultimate duty for a Greek citizen, which at the same time permitted him to exercise his rights as a participant in public affairs. For this reason the only garment that Kroisos is depicted as wearing is the thin *pilos* which covered the top of his head, a knitted cap which went under the helmet as protection from shocks or scratches. Thus, although the young hoplite is depicted naked, the presence of the soldier's cap he is wearing is sufficient reminder of the heroic way in which he lost his life.

The statues of the kouroi, accessible only to the upper social strata, express with their iconographic typology the aristocratic ideals of what the Greeks referred to as *kalokagathia* (nobility of body and spirit): the statues represent young men who are handsome in body (*kaloi*) and in soul (*agathoi*) –distinguished in athletics and in war, their physical prowess mirroring their inner perfection. According to the perceptions of the time, both were natural privileges of the members of the ruling class, who because of their noble birth and wealth, were the only ones who could freely exercise physical and mental development. Although battle in the front line of a phalanx was the democratic way of conducting war, having retained few memories of the heroic ideals of bygone eras, Athenian art maintained its vital contacts with the ruling class and its ideology, given that it was from this class that the majority of its customers came.

174

between the torso and the limbs attached to it; this, in combination with the fact that they often appear "Egyptian-like," supports the idea that they had been laid out in a grid, in the same fashion as Egyptian stone cutters are known to have been doing for centuries. According to this technique, sculptors divide up the figure they want to create into a grid of equal squares on a preliminary sketch. On this basis they calculated the size of each part and the ratios between them (fig. 170). Several ancient historians even provide descriptions according to which certain sculptors of this period used a grid and detailed measurements in their work.

With the passage of time, the familiarity of working with marble and the technical improvements in their iron tools helped the sculptors to produce kouroi which appeared more accurate anatomically and more naturally articulated. The face was usually now dominated by the so-called "Archaic smile," a conventional rendering of the cheeks and lip muscles which is reminiscent of a smile (frequently, however, it looks somewhat forced). The purpose of this feature remains obscure; if it was really meant to suggest a slight smile, as most of these statues' appearance indicates, then in the opinion of most modern scholars its purpose was to give vibrancy to the figure, thus expressing a "joy of life" which in the art of the period could be associated with the ideal concept of the human form. A typical example is the so-called *Volomandra Kouros*, so named after its find spot in Attica, where the facial muscles have been shaped into a vibrant smile (fig. 171). This kouros was also funerary, i.e. it had been raised as a marker above the grave of a young man. The use of Parian marble for this statue suggests that materials, and possibly craftsmen as well, did travel from one part of Greece to another during this period.

Other local Archaic sculpture workshops developed outside of Attica. Although each one of these stands out in its own way stylistically, they all are markedly Archaic. Thus the kouroi of Attica appear muscular and robust, while their Peloponnesian counterparts are heavier and seem rather conservative. A typical example is the group of Kleobis and Biton from Delphi (fig. 175). Although they are a little larger than life size (1.94 m tall) the two young men appear stocky, with squared backs and bulky chests, as well as large heads (one-seventh of the total height). Placed symmetrically, one beside the other, they form a unified group. The names of the two kouroi are carved on their bases,

172, 173. Attica, marble kouros from Anavyssos. c. 530 BC. Athens, National Archaeological Museum 3851.

174. Attica, marble kouros from the Mesogeia. c. 510–500 BC. Athens, National Archaeological Museum 3938.

as is the name of the sculptor, but this is not preserved fully: [Πολυ]μεδες εποιFε ηαργειος, i.e. "the Argive [Poly]medes made (us)." The identification of the dedicator with the city of Argos, from where the sculptor of the group came, confirms the Peloponnesian origin of the work, and also highlights its connection with the well-known story which Herodotus relates (1.31): Kleobis and Biton were the sons of the priestess of Hera, whose wagon they pulled for about 8 km to the sanctuary when her oxen became unavailable. Proud of their deed, their mother prayed to the goddess, asking her to give them the "noblest fate"; her request was granted instantly, even if somewhat cruelly, and the two young men died the same evening, at the moment they were glorified by all for the respect they had shown their mother. We do not know whether this story ever happened, but finding the two inscribed kouroi at Delphi demonstrates that it was particularly important to the city of Argos, considered a famous event in the history of the city. Conservative characteristics are also pres-

ent in the Boeotian workshops, where individual features appear more conventional and less sophisticated than in Attica. An interesting sculpture was found at Tanagra in Boeotia, a funerary stele (see also p. 124–126 below) displaying a pair of kouroi (fig. 176). The two youths, still preserving some Daedalic characteristics, are shown marching side by side, with their arms round each other, Dermys on the left with his left foot brought forward and Kitylos on the right, stepping off with his right leg, thus providing the symmetry necessary for the composition. The two figures are named with inscriptions, while the base bears a third inscription which informs the viewer that the funerary monument was set up in honor of the two young men by one Amphalkes, presumably their father. The sculpture is fashioned from coarse Boeotian limestone which does not allow for detailed modeling. The ineptitude, furthermore, of the sculptor is clear in the unnatural way with which the hand of one boy embraces the shoulders of the other, positioned much higher than its anatomically correct

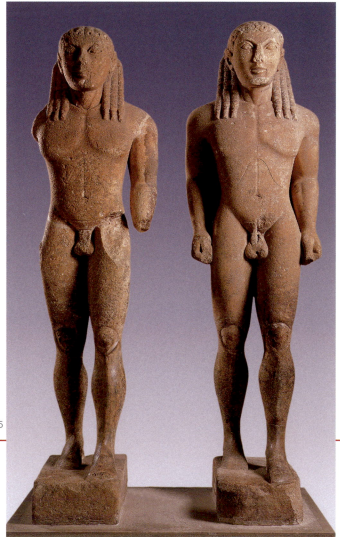

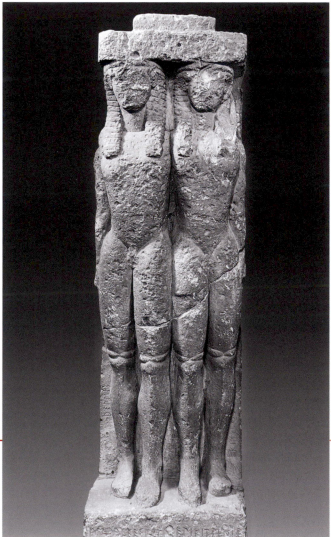

175

176

position. Although typologically this funerary work could be characterized as a *relief*, the two figures have been carved almost completely in the round. In contrast with the Greek mainland, the island workshops, such as those of Naxos and Paros, produced kouroi that were more slender with less developed musculature. Other Cycladic workshops also produced kouroi: a typical example is a kouros from Melos, carved in Naxian marble, which dates to the middle of the sixth century BC (fig. 177). The young man is particularly slender, with ill-defined musculature. The individual contours of the sculpture are fluid, while many details of the musculature remain barely developed. In Ionia and in the rest of East Greece it appears that attributes of a good life varied; some kouroi appear clothed, but even when they are not they seem fleshy and less athletic, with round faces, an exaggerated smile and somewhat narrowed eyes. The influence of Eastern art is, moreover, apparent in works such as the monumental kouros from Samos (fig. 178). This stood 5.5 m tall, and was one of the statues which adorned the approach to the temple in the sanctuary of Hera. According to the inscription carved on the left thigh the statue was dedicated by a man called Ischys. As we shall see in the next section (p. 120–123) the East Greek workshops produced other types of Archaic sculpture in larger sizes than on mainland Greece.

177

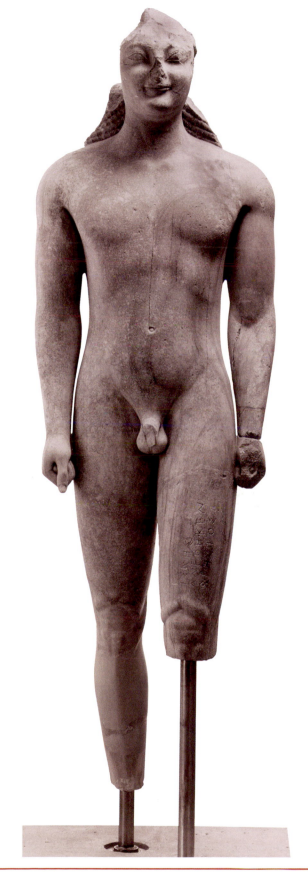

178

The English word "marble" derives from the Greek *marmaron* (μάρμαρον), meaning "crystalline rock" or "gleaming stone." Though soft, marble tends to be resistant to shattering, thus enabling the sculptor to render his figures in greater plasticity. Marbles may be fine- or coarse grained depending on their crystalline structure; the colored veins of many varieties are usually due to mineral impurities such as clay, silt, iron oxides, and so on.

175. Delphi, twin kouroi, Argive workshop. c. 580 BC. Delphi, Archaeological Museum 467, 1524.

176. Tanagra, funerary sculpture in limestone. c. 580 BC. Athens, National Archaeological Museum 56.

177. Marble kouros from Melos. c. 550 BC. Athens, National Archaeological Museum 1558.

178. Samos, marble kouros from the sanctuary of Hera. c. 570 BC. Samos, Archaeological Museum.

2.2.2 ARCHAIC SCULPTURE: THE KORE

In Archaic art, the kore represents the female version of the kouros. The term refers to a young, unmarried girl.

The female figures of the seventh century (fig. 111), with clothing falling in heavy folds, were the forerunners of the type of kore which had a spectacular career during the first half of the sixth century BC. An important part of this development was played by the typology of clothing and its execution. Thus, while the majority of female statues of the seventh century wore long robes and *epiblemata* without distinguishing features, already by the first decades of the sixth century the korai seemed to favor the thin Ionian chiton. In a few later sculptures, around 570–560 BC, the himation also makes its appearance, most commonly worn diagonally in the Ionian fashion: one of the earliest examples of this type is the *Kore of Cheramyes* from 560 BC (fig. 163). The statue represents a standing female with her left hand brought to her chest and her right hand held against her side. She wears a chiton belted at the waist, a diagonal himation, and a heavy, foldless epiblema with one end passing under the belt. Along the vertical edge of the epiblema is carved an inscription: χηραμυης μ ανεθεκεν τ ηρι αγαλμα, ("Cheramyes dedicated me to Hera [as] agalma"). The use of the term *agalma* (an object which represents pleasure, from the verb *agallomai*, "to be filled with joy") for the votive offerings of the sanctuary is worth noting here (p. 131).

A few years before the middle of the sixth century the korai begin to put forward one foot, raising at the same time the chiton with the corresponding hand in a movement that is thought to have aided walking —a movement showing simultaneously a young girl's charm as well as modesty. Just as the kouroi were expected to showcase the male virtues as recognized in their era, so too

179. Samos, marble kore from the Heraion. c. 560 BC. Paris, Louvre Ma 686.

ΧΗΡΑΜΥΗΣΜΑΝΕΘΙΚΕΝΤΗΡΗΙΑΓΑΛΜΑ

The kore: an overview
- The type appeared in the seventh century and was used, with variations, until the end of the Archaic period.
- It represents a standing young woman, usually dressed in a chiton and himation.
- Korai have a particularly ornate hairstyle and usually hold an offering (a dove, flower, or fruit).
- They are adorned with precious jewelry (necklaces, diadems, earrings, and bracelets).

FEMALE GARMENTS IN GREEK ART

Clothing, mainly for women, was the basic way in which Greek artists could show the contour and the movement of their figures. This is particularly obvious in the fifth century when sculpture turned systematically towards more natural representation. Already, however, in Archaic sculpture it is clear that the evolution in the kore type was complementary to the manner in which the clothing was executed, and in the technical solutions that were devised to show its volume and texture.

Greek clothing for both men and women usually consisted of rectangular pieces of fabric which were fitted to the body with belts, buckles, or pins.

The *chiton* is the most common attire for women (and, indeed, for men): it was folded in two along its width and wrapped around the body. The two upper corners were fastened with buttons along the shoulders and upper arms and the garment was belted at the waist with a narrow girdle. In this way "sleeves" were formed through which the arms were passed (fig. 180a). Sleeved chitons are identified by the small folds created by the buttons across the shoulders and along the length of the upper arms of the figure.

The *himation* is frequently worn over the chiton, usually fixed diagonally across one shoulder (fig. 180c, see fig. 181).

the korai advertised those of women: according to later Greek authors, such as Aristotle, echoing nevertheless older traditional views, a beautiful body and impressive stature, wisdom, and industriousness were the virtues essential in a female. As such, the clothing and jewelry of a free woman, particularly a woman of aristocratic descent, ought to emphasize her physical beauty and her inner being, as well as her social standing. At the same time, women and their caretakers had to make sure that public opinion was not offended by an excessive display of wealth or coquetry even if in our eyes — and even those of a Greek of the Classical period — some korai seem rather overdressed. On the Athenian Acropolis, a long sequence of dedications from the second half of the sixth century BC seems to express exactly these perceptions of female appearance and behavior. In the same way that the kouroi were dedicated to the sanctuary by members of the leading class as *agalmata* in honor of the goddess and her followers, so the korai express the religious convictions of the dedicator, and at the same time are indicators of social status. The kore in fig. 188, made from island marble and with a height of 1.82 m, illustrates the characteristics of the mature phase of the type: the fine multi-folded chiton clings to the girl and thus shows the contours of her body underneath, while the himation, worn over the right shoulder and under the left armpit, covers the upper part of the body

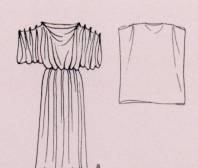
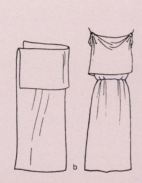

180

The *peplos* is a heavier garment, with bulkier folds, which is associated usually with Doric tradition. It is fixed to the body in the same way as the chiton, but leaving a part of it folded outwards to hang loose over the chest and back (fig. 180b). It is fixed on the shoulders with pins and as a result does not form sleeves. Just like the chiton, the peplos is belted around the waist. The bulge which is formed above the belt is called the *kolpos*, while the piece of material which hangs in front is called the *apoptygma* ("ovefold"). The length of the overfold is related to the height of the figure: the younger the girl, the longer the overfold has to be. As a result, very young girls who are still growing might be depicted with a longer apoptygma, and frequently in this case the peplos is belted above it.

Although the chiton became widely accepted as the most appropriate attire for the kore, the use of the peplos continued, particularly in cases where it was desirable to distinguish between different traditions or in the case a specific type of attire was associated with a specific goddess. One such example is the *Peplophoros* from the Athenian Acropolis, a statue about two-thirds life size (1.17 m), which depicts a standing female figure wearing a belted peplos above an ankle-length chiton (fig. 181). The left arm of the figure, which has not survived, was once stretched out from the elbow. Because of its clothing, the sculpture is considered to represent a goddess.

181

180. The types of female clothing in ancient Greek art.

181. Athens, marble kore from the Acropolis. c. 530 BC. Athens, Acropolis Museum 679.

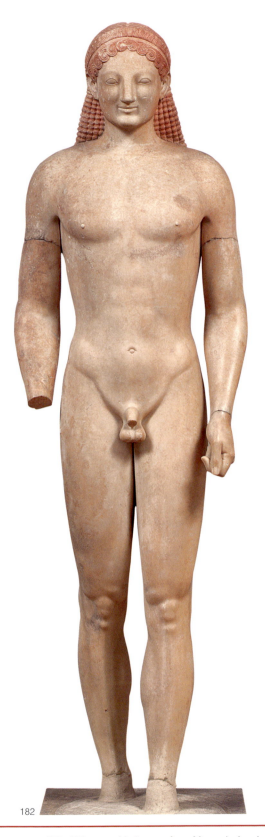

PHRASIKLEIA

The funerary statue of Phrasikleia (fig. 185), from the area of the ancient Attic deme of Myrrinous (modern Merenda) in the Mesogeia plain, is a typical example of the funerary use frequent for this type of kore (as with the kouroi). It depicts a standing female figure with an ankle-length sleeved chiton belted at the waist. Her left arm is folded against her chest with a lotus flower held in her finger tips, while her right hand gently pulls the chiton to the side. The traces of colored pigment on the surface of the statue, as well as the incised outlines of the decoration, remain visible to the naked eye, indicating that the chiton was colored red with scattered decoration: rosettes, four-pointed stars, and swastikas. Meanders and tongue-like motifs decorate the hems and other sections of the kore's attire. The hair is fashioned as beaded ringlets with waves on the forehead. The girl wears a crown of lotus flowers, a heavy necklace, earrings, and bracelets.

The narrative whole is completed, as in other examples, by an epigram carved on the base of the statue:

ΣΕΜΑΦΡΑΣΙΚΛΕΙΑΣ
ΚΟΡΕΚΕΚΛΕΣΟΜΑΙ
ΑΙΕΙΑΝΤΙΛΑΜΟ
ΓΑΡΑΘΕΟΝΤΟΥΤΟ
ΛΑΧΟΣΟΝΟΜΑ

σεμα φρασικλειας | κορε κεκλεσομαι
αιει αντι γαμο | παρα θεον τουτο | λαχος ονομα

Monument of Phrasikleia | kore I will be called
Ever more, for instead of marriage | by the gods this | name fell to me.

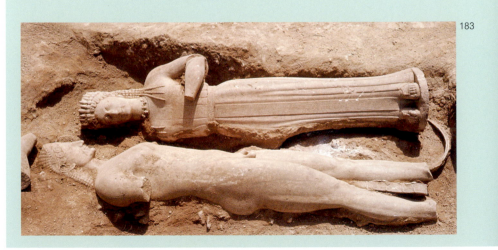
183

182. Attica, marble kouros from Merenda (ancient Myrrinous, in the Mesogeia). c. 530 BC. Athens, National Archaeological Museum 4890.

183. Phrasikleia and the slightly later kouros in fig. 182, were found buried in a trench beside the place where they originally stood. The burial of the two statues probably occurred after their destruction during the Persian invasion of 480 BC.

184–185. Attica, marble kore from the Mesogeia. c. 550–540 BC. Athens, National Archaeological Museum 4889.

We have here, therefore, the use of the term *sema*, for a funerary monument, but also the term *kore* for an unmarried girl. The epigram expresses the grief for a life lost before it had fulfilled, according to the morals of the time, the destiny of womanhood –i.e. to pass from being a *kore*, to becoming a woman, to marry and to have children. This sentiment, however, is combined with the masterly depiction of the young girl, which thus shows the physical and spiritual gifts she was endowed with. The use, once again, of the first person in the epigram is typical, almost as if the statue was speaking, embodying the spirit of the dead girl. It is pertinent to note here, however, that although they bear inscriptions which identify them with particular individuals –Phrasikleia, Kroisos, Aristodikos– Archaic statues were not portraits as such. As we have already seen, Archaic statues were symbolic of human existence (the idea of beauty, of youth, and so on) without imitating reality. In general, Archaic sculpture depicts the *archetypal image* of the male or female form.

It is worth mentioning, finally, that the base of Phrasikleia also bears the signature of its sculptor, Ἀριστίων πάρι[ος μ' ἐπ]ό[ε]σε, i.e. "Aristion from Paros made me." The signature of the sculptor in addition to the Parian marble used to make the statue show that there was remarkable mobility between the workshops of Archaic sculpture and that for a sculptor from Paros was possible to work in Attica, or the reverse.

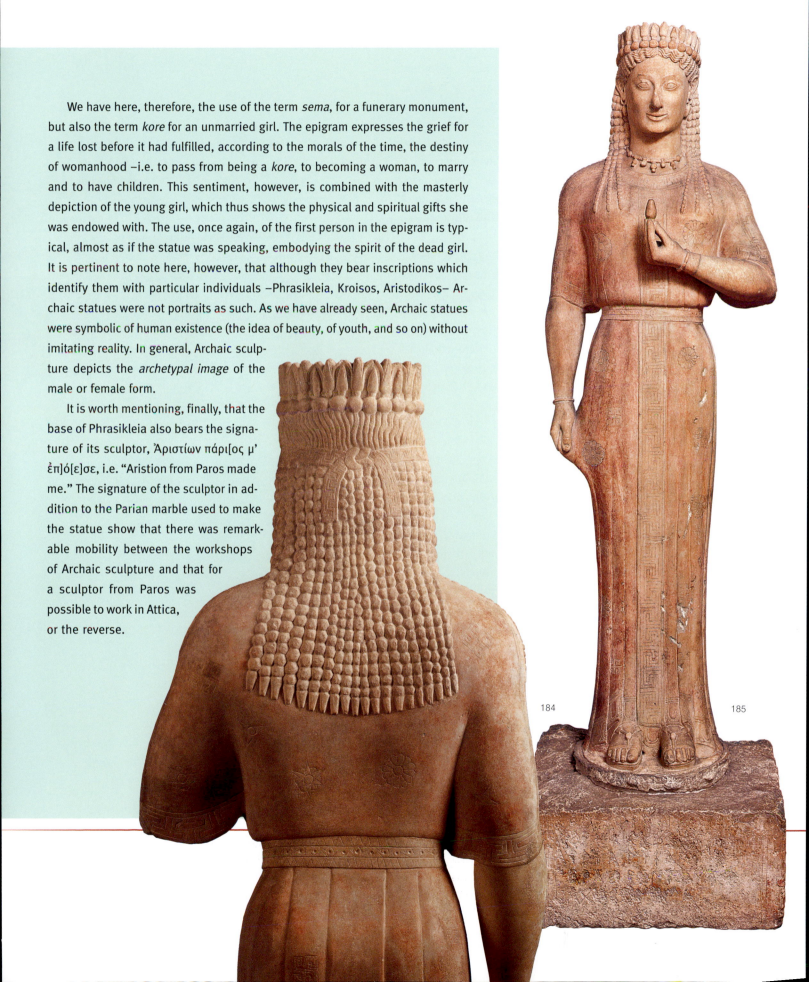

184

185

with thick, heavy folds (the deepest parts of the himation were drilled out). The hairstyle is particularly detailed, with long tight ringlets, while the forehead is crowned with wavy curls with coiled ends. The kore's jewelry is precious, according to the fashion of the period: a *stephane* on the head, disc-like earrings, and bulky bracelets on her left wrist (the right hand is not preserved).

The Archaic smile disappears gradually around the beginning of the fifth century BC, as the sculptors began to experiment with new ways of rendering facial and other features of the human form.

A particular typological element of the kore, self-evident in Archaic and Classical sculpture, is the use of *color*. Although it also occurs on the kouroi —as on every other type of Archaic sculpture— color is particularly visible in the Archaic korai, as it was primarily used to decorate their garments. Both the main parts and the hems of the garments were heavily decorated with colored meanders, rosettes, and so on (see fig. 186–187). The hair and also the flesh of the figures, especially of women, were colored as was the precious jewelry (such as diadems, earrings, necklaces, and bracelets) which the korai are depicted wearing. In this way the color completed the narrative function of the statue. As a result of the poor preservation of the color on the surface of the sculpture, modern viewers —even archaeologists themselves— frequently

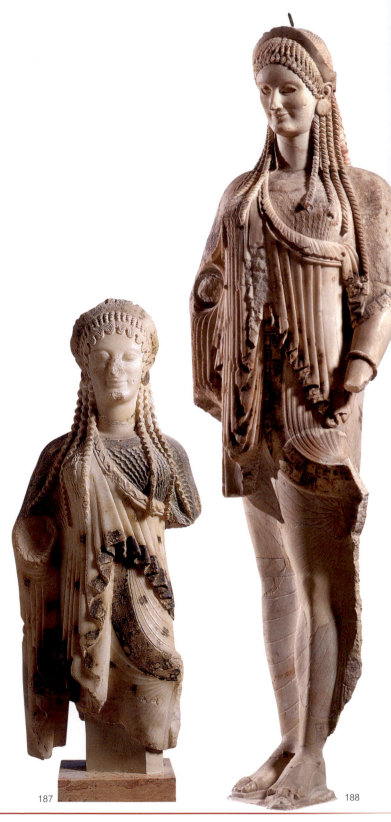

186

187

188

186. Athens, marble kore from the Acropolis. c. 500–490 BC. Athens, Acropolis Museum 685.

187. Athens, marble kore from the Acropolis. c. 515 BC. Athens, Acropolis Museum 675.

188. Athens, marble kore from the Acropolis, c. 515 BC. Athens, Acropolis Museum 682.

forget what a key component color was for the aesthetic appearance of ancient statues (even today, this element is rarely mentioned in many museums of ancient Greek art!). The coloring of the surface of the sculpture was achieved on the basis of a painted or incised preliminary drawing. The pigments were usually made of minerals (red or yellow ochre, azurite, cinnabar, haematite) ground into powder. The application of the color onto the surface of the sculpture was accomplished with the help of a binding material (such as egg yolk), so that the pigment took on the form of a thick paste. When molten wax was used as a binding material, the technique was called *encaustic*, a method described by several classical authors (see p. 184). Since there was not a single surface of an ancient statue that remained unpainted, the appearance of Greek sculpture must have been entirely different in antiquity from that to which we have become used today (fig. 189–190).

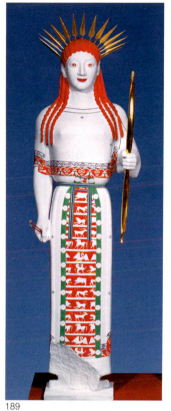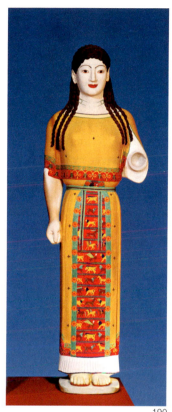

189 190

Having completed now the study of the two main types of Archaic sculpture, the kouros and the kore, it is worth revisiting briefly their main characteristics:

RIGID TYPOLOGY The kouros, as much as the kore (but especially the former) strictly followed a basic formula, to an extent not observed in other, later categories of Greek art which are characterized by greater diversity.

SYMMETRY AND STABILITY The figures appear to stand harmoniously and imposingly still with only a symbolic hint of motion.

FRONTALITY AND STYLIZATION The figures are usually strictly fully frontal, with stylized forms which are rendered with an emphasis on decorativeness. Only in a few examples (see fig. 172, 174), can we observe the suggestion of a twist in the body or motion ("latent movement").

SUPERFICIAL ANATOMY, CONVENTIONALITY, AND DECORATIVENESS The aim of Archaic sculpture was not realism. The individual figures are indicated in a symbolic and conventional manner.

INTRINSIC SOCIAL REFERENCES The narrative context of the two types is defined by their use. As we have seen, the use of the kouroi and korai is usually *votive* or *funerary*. In both cases the sculptures embody and mediate the social ideology of their time, with direct reference to aristocratic morality and the attempt to establish it as a cultural standard.

189, 190. The colored decoration of the Peplos Kore (fig. 181): suggested reconstructions.

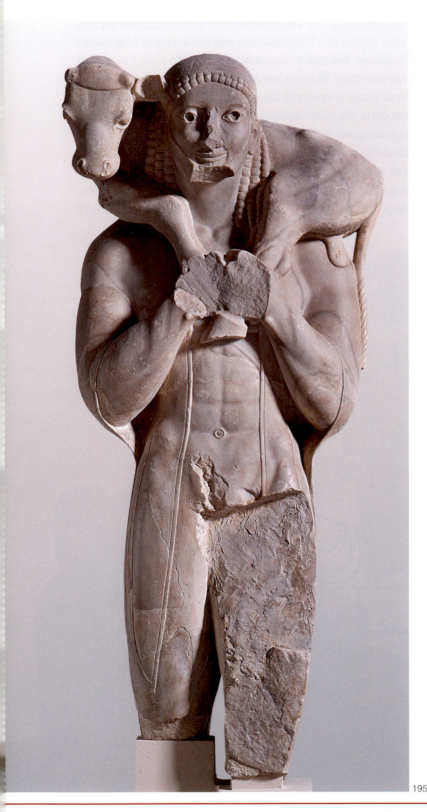

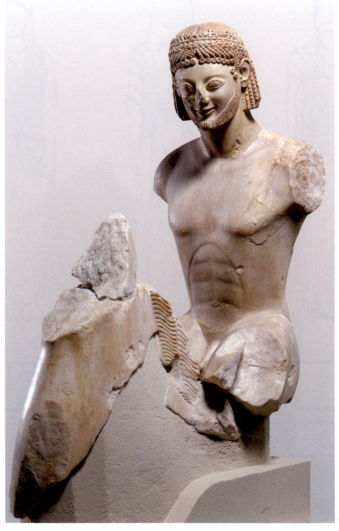

the higher classes participated as cavalry in war. A typical example of this type is the so-called *Rampin horseman* (from the name of the original collector, to whom part of the statue belonged: fig. 196). The statue, 1.10 m total preserved height, is made from island marble and is thought to belong to a group of two horsemen portraying the Dioscuri.

ANIMALS AND MYTHICAL CREATURES Animals such as lions and dogs (besides the horses of the horsemen) appear quite frequently in the iconography of Archaic sculpture, along with mythical creatures and beasts such as the sphinx or the siren. The *Naxian Sphinx*, a colossal dedication made by Naxos to the sanctuary at Delphi, is one of the earliest examples of the

195

196

195. Athens, marble votive statue from the Acropolis. c. 570–560 BC. Athens, Acropolis Museum 624.

196. Athens, marble statue of a horseman. c. 550 BC. Athens, Acropolis Museum 590, Paris, Louvre Ma 3104.

type, and also one of the first appearances of the Ionic column capital in mainland Greece. This mythical creature, with the body of a lion, sickle-shaped wings taken from Assyrian tradition and the head of a kore, is depicted seated on its hindquarters on top of an Ionic column (fig. 198). The dedication, 12.5 m in height, aims to advertise the political and cultural superiority of Naxos in this period.

2.2.4 ARCHAIC SCULPTURE: FUNERARY STELAI

As explained in a previous section, the kouroi and korai could also have a practical use, i.e. to be set up as grave markers above the graves of young men and women. Besides the free standing statues, grave markers could also take the form of a

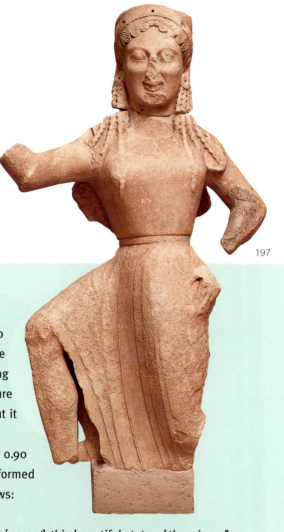

197

THE ARCHERMOS NIKE

Nike was a minor deity in the Greek pantheon, a symbol of victory in war, but also success in athletic events or any other type of competition. In Archaic iconography she is depicted in the "kneeling run" position, with extended legs and one knee touching the ground, as this was a widely used convention for a sculptor to show that the figure was flying through the air. In Archaic sculpture the type had a mainly votive use, but it could also be used in architecture as an *akroterion*.

The marble Nike from the sanctuary of Delos (fig. 197), preserved to a height of 0.90 m, with wings on her back and ankles, was a dedication to Apollo as the inscription informed any visitor to the sanctuary. Although only fragmentary it can be completed as follows:

μικκια[δηι τοδ αγα]λμα καλον ν[ικην πτεροεσσαν?]
αρχερμω σο[φ]ιεισιν νκηβω[λε δεχσαι απολλον]
[τ]οι χιοι μελανος πατροιων ας[τυ ...]

[Apollo], who sends arrows far, [accept] this beautiful statue, [the winged] N[ike], masterful work of Archermos, [dedicated by] Mikkiades, from Chios from where comes Melas, his father, also.

The reference in the epigram to Mikkiades, son of Melas from Chios, and also the name of the sculptor, Archermos, match the information given to us by Pliny in his *Natural History* (36.11–13), according to which "the sculptor Melas lived on Chios and afterwards his son Mikkiades and even later still his grandson Archermos, whose sons Boupalos and Athenis became the most famous sculptors of their time." Statue bases with their names are preserved in many areas of Attica and Greece and it seems, therefore, that they are members of a "dynasty" of well-known sculptors, whose reputations transcended their own time, reaching as far as the first century AD, when Pliny wrote his text on the basis of earlier stories which are, however, not preserved today.

197. Delos, marble statue of Nike. c. 550 BC. Athens, National Archaeological Museum 21.

and Khrysaor (fig. 205), who leapt from her blood after she was beheaded by Perseus. The use of a Gorgon in this position, something which was repeated frequently in the temples of the sixth century BC, is considered to have had an *apotropaic* function, i.e. it protected the worshipping viewer from evil. The scene on the pediment is not unified: two leopards flank the central figure, followed by mythological scenes, possibly of Titanomachy (a battle of the Olympians against their primeval enemies, the titans) and in the corner are figures of fallen men, probably fallen opponents. The whole composition is executed in relatively high relief, with incised decoration and other detail which would have originally been highlighted with added color.

Around 540 BC a new temple to Apollo was built in Corinth (fig. 209). It is a peripteral, amphidistyle in antis tem-

ple with 6×15 columns. The cella was divided into three aisles, but between the cella and the opisthodomos lay a second cella, in the form of a closed room with four columns supporting the roof (fig. 208). In the temple one can observe several peculiarities of the early Doric order, such as the squatting echinus of the capitals and the particularly obvious entasis of the columns.

During the sixth century giant temples were built outside the Greek mainland. At the sanctuary of Hera on Samos two dipteral Ionic temples succeeded one another in 570 BC and 530 BC (see fig. 211). Around the middle of the sixth century BC the people of Ephesus began to build the temple of Artemis, famed in antiquity, a dipteral temple with a deep pronaos (fig. 209). At the same time important developments

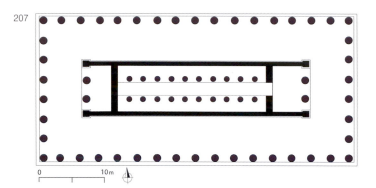

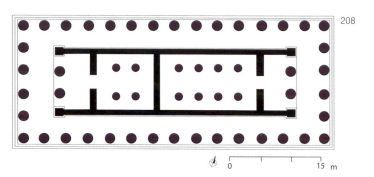

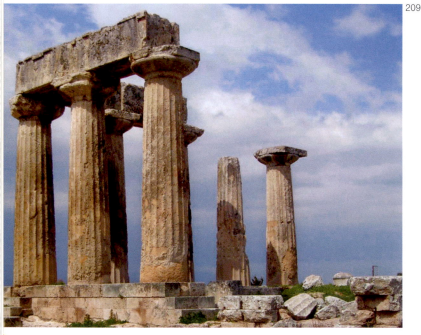

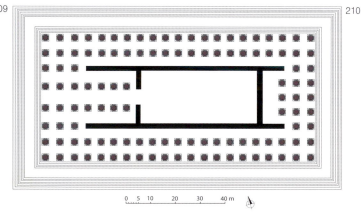

in the Doric order may be observed in South Italy and in Sicily. A typical example is the first temple of Hera at Paestum in South Italy where we can see once again an early version of the Doric order (fig. 212).

A number of important sculptural groups were made in the sixth century BC to decorate temples and other secondary

207. Corfu, temple of Artemis. Plan. c. 580 BC.

208, 209. Corinth, temple of Apollo. c. 540 BC.

210. Ephesus, temple of Artemis. Plan. Sixth–fifth century BC.

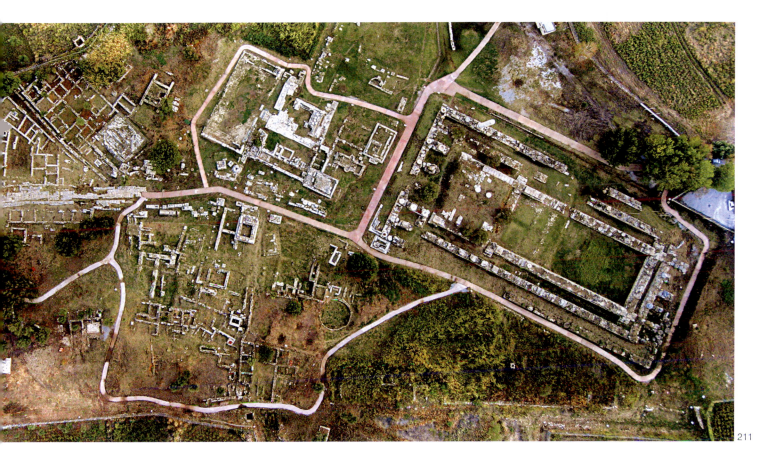

211

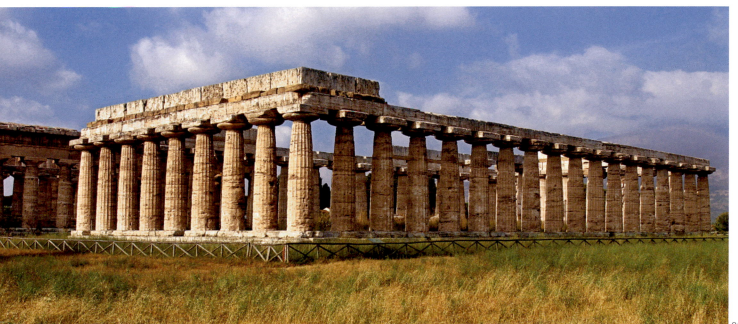

212

211. Samos, archaeological site of the Heraion.

212. Paestum, temple of Hera. c. 550 BC.

SANCTUARIES AND CULT PRACTICES IN GREECE

Greek religion was fundamentally secular in concept. It was one of the most influential polytheistic religions of the ancient world; as such it recognized a number of deities, of greater or lesser importance, each with its own, well defined sphere of influence: marriage, war, and all other domains of human experience. Compared to monotheistic religions, whether in antiquity or in our time, Greek religion varied considerably: it had no professional priesthood as such, no holy book or sacred texts, no doctrine, no dogmatic orthodoxy. The narrative and ideological foundations of ancient Greek religion were the Homeric epics and the poems of Hesiod, as well as later versions of the myths outlined there. Therefore the oral tradition played an important role in Greek religion, as it determined both its ideological background and the way in which worship was expressed. The same is true of the religious functionaries of ancient Greece: with the exception of certain specific categories such as seers or augurs, the priests and priestesses in Greece were not appointed for life, nor did they have to follow special studies to carry out their tasks. Their priestly duties stemmed from secular power (e.g. the leader of a family or some institution with the authority to specific rituals) and their office was a function of social status and financial standing. Religious power, therefore, was the responsibility of the state. In addition, the priesthood might be dependent on age also, since there were deities (such as Artemis) whose priestesses had to be young girls, and others (such as Demeter) who traditionally had older, married women as priestesses. It is a hierarchy based on family life and the stages of a human life, as the Greeks had developed a religious system based on human experience, in order to reflect and support the social structures in the exploration of sexuality, the relationships between genders, and the whole cycle of life. Religious ceremonies were an opportunity for social expression and integration: they were not based on solitary prayer but on group celebration. Many scenes from ancient Greek art (see fig. 213–214) depict processions, sacrifices, and other public rituals, underscoring their social significance.

In accordance with this, the minor and major sanctuaries of the Greek world were not limited to the exercise of worship or personal prayer, but were areas for communal development. Places of worship could exist both inside and outside the domestic context, or in specially designated public spaces. The term *temenos* for the sanctuary, moreover, comes from the verb *temno* ("to cut"), which initially referred to a piece of land cut off from public use with the aim of dedicating it to worship.

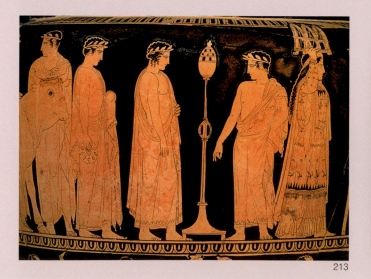

213

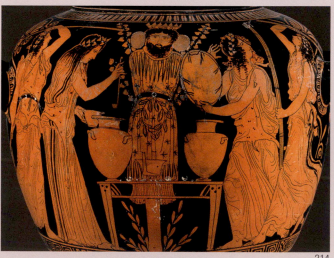

214

213. Detail from an Attic red-figure volute krater: sacrificial procession, at the head of which is the priestess. She steadies the kanoun (a basket with offerings which were used in such rites) on her head with her hands. Behind her are garlanded young men leading the bull to sacrifice. Between them stands a metal incense burner (*thymiaterion*). c. 440–430 BC. Ferrara, Archaeological Museum 44894.1.

214. Detail from an Attic red-figure stamnos. Worship of Dionysus. Naples, Archaeological Museum 2419.

The area of a sanctuary was marked out by the *peribolos* (enclosure) and the entrance was via the *propylon* (gate), which frequently had a monumental character. Near to the entrances to the sanctuary were *perirrhanteria*, usually stone water-bowls for the symbolic cleansing of the pilgrims (fig. 215). The central focus of the sanctuary was the altar, around which the religious ceremonies took place. Ancient Greek altars could be simple mounds of the ash from sacrificed animals, rough boulders, or more monumental structures. In Greek vase painting they are often depicted as a low cylindrical or four-sided construction crowned with spirals, much like Ionic capitals (see fig. 336).

The ritual of sacrifice included the *libation* (i.e. the pouring of liquids such as water or wine from a ritual vessel such as the phiale), the burning of perfumed substances in incense burners, and finally the sacrifice of animals. Usually the bones, the fat, and other similar parts of the sacrificial victim were burned on the altar, while the edible parts were distributed amongst those present. In other cases, mainly in sacrifices to *chthonic* deities of the underworld, the slaughter of the animal was done in such a way that the blood poured onto the earth, while the animal itself was burned in its entirety (a *holocaust*). Sacrifices of this type could be conducted in a *bothros* (a pit dug into the ground) or an *eschara* (metal hearth stand placed on the ground). The number of animals for sacrifice, or the type/s of animal depended on the tradition of the relevant cult. The *hecatomb*, a Homeric term that refers to the sacrifice of a hundred cattle, marks the richest possible sacrifice, an expression of the highest honor to the gods.

DIVINE EFFIGIES

The temple housed the cult statue. As it was not a place for worship, access to the interior was reserved to the priests, a closed number of officials, and the occasional V.I.P. guest. As we saw in a previous section (p. 114), the ancient Greek word for statue was *agalma*: the term suggests the offering that is meant to please its recipient, that is the deity, as well as its

viewer. Gradually, the use of the word was confined to the statues decorating the sanctuaries, as they were their most prominent embellishments; by the fifth century BC, the term changed its meaning to stand for "statue." Frequently, in later years, *agalma* was only used to suggest a divine statue, while *andrias* referred to effigies of mortals. The term *kolossos* was used initially for statues of particular significance and antiquity, usually of mythical descent. Gradually, it came to refer to sculptures of extraordinary ("colossal") size, a meaning that it has retained to the present day (as in "colossus"). For the representation of mortals (mostly) the term *eikon* ("image") was often used, a reference to the belief nurtured by Greek philosophers that art is supposed to *mimic* reality. The term *xoanon*, finally, comes from the verb *xeo* ("to carve," "to incise"), and usually refers to age old cult statues of mythical origin made of wood. Several of these ancient cult statues, like that of Athena Polias on the Athenian Acropolis are referred to by the poetic *vretas*, a term of doubtful origin and etymology.

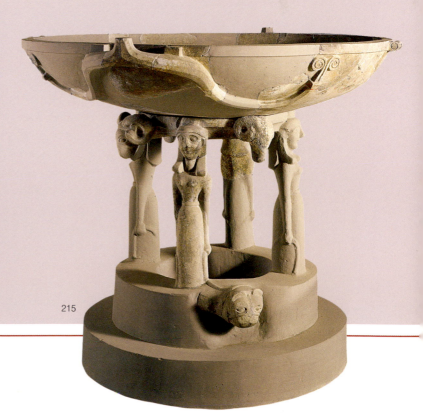

215

215. Isthmia, marble perirrhanterion (lustral basin). Sixth century BC. Isthmia, Archaeological Museum.

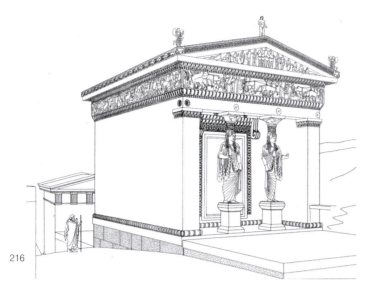

216

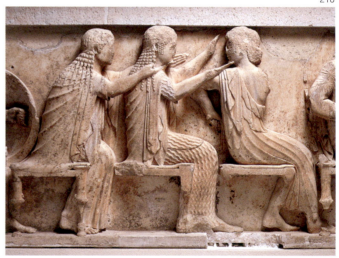

218

stead of columns, that is supports that took the form of a kore, something that was quite common in East Greece and is seen in other treasuries at Delphi (fig. 216). The east pediment depicts the struggle between Herakles and Apollo for control of the Delphic tripod, in the presence of Zeus and other deities (fig. 219).

There are many different scenes depicted on the frieze, such as the Trojan War and the council of the gods, Gigantomachy, and so on (fig. 218, 220–221). The carving is particularly deeply cut, especially on the pediment, with vivid and plentiful colored decoration (which included painted inscriptions), but also the addition of metal weapons. The work represents the peak of Archaic sculpture, characterized by stylistic flair and narrative completeness.

buildings at major sanctuaries. Several of these come from *treasuries*, small temple-like buildings which were dedicated by different city-states at the panhellenic sanctuaries such as Delphi, Olympia, Delos, Samos. They took their name from their use, the protection of portable valuable dedications, mainly of metal.

An important example is the **Treasury of the Siphnians**, which dates to a little before 525 BC. The secure dating of the monument is owed to historical information that the building was paid for from the revenue of gold and silver mines which had been found recently on the island; as Siphnos was invaded by the Samians soon after, the mines were short-lived. Therefore the sculptural decoration provides a *fixed chronological point* for the study of ancient sculpture. The building takes the form of a simple distyle in antis temple with *caryatids* in-

Around 520–510 BC the exiled Athenian Alcmaeonid family took on the cost of rebuilding the temple at Delphi which had been destroyed by fire. According to Herodotus (5.62–63), the Alcmaeonidae proceeded to use marble for several parts of the temple, such as the façade and the east pediment (the west pediment, with a scene of Gigantomachy, was of limestone). The East pediment depicted the arrival of Apollo at Delphi. The god is shown fully frontal, in a chariot, accompanied by Leto and Artemis. To the right and left stood three korai and three kouroi. As we saw in a previous section (p. 126) the Athenian sculptor Antenor has been associated with the renovation of the temple. His kore from the Athenian

217

216. Delphi, treasury of the Siphnians. Drawing. c. 525 BC.

217. Delphi, marble kore from the east pediment of the temple of Apollo. c. 520–510 BC. Delphi, Archaeological Museum.

219

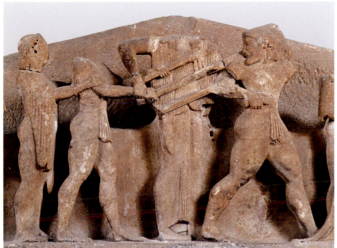

220

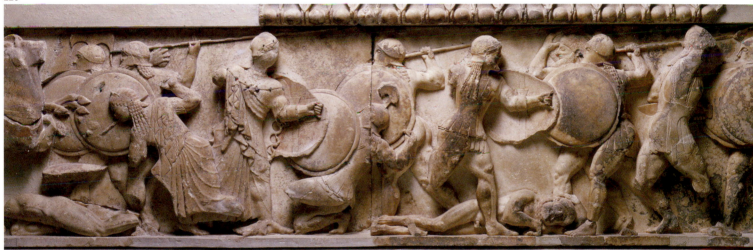

221

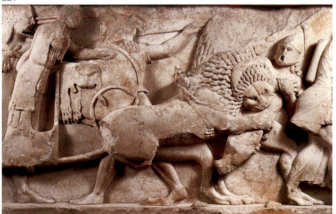

Acropolis (fig. 203) shows considerable stylistic similarities with the korai from the pediment at Delphi (fig. 217), particularly in the pose, the arrangement of the clothing and the use of the drill to render the folds.

The temple of **Aphaia on Aegina** (in honor of a minor local deity who in a later phase was identified with Athena) is a typical example of a Doric temple from the transition between the Archaic and Classical periods (fig. 229). The temple is peripteral, amphidistyle in antis, with 6×12 columns and dimensions of 28.8×13.7 m and therefore shorter than the earlier examples of the Doric order (fig. 230). It was built in limestone, which was originally coated with plaster. The cella was divided into three aisles by two double colonnades in the Doric order. Such two-tiered colonnades were preferred from 500 BC on since the shorter columns of each level had a smaller diameter and thus took up less space in the interior of the building. The marble pediments depict battle scenes, with uniform scale and composition, using the device of the fallen warrior to fill the narrow angle at both ends. Both compositions depict scenes from the first and second Trojan Wars, as Aegina had taken part in both, with Telamon and his son Ajax respectively. In the center of the scenes stands Athena, as protectress of the Achaeans. It is believed that the west pediment is at least a decade older than the east. The second, indeed, is more sophisticated in the conception of its composition, in the modeling of the figures and the execution of individual scenes (fig. 228–231).

218–221. Delphi, treasury of the Siphnians. (218) section of the east frieze (council of the gods), (219) pediment, (220–221) section of the north frieze (gigantomachy). c. 525 BC. Delphi Archaeological Museum.

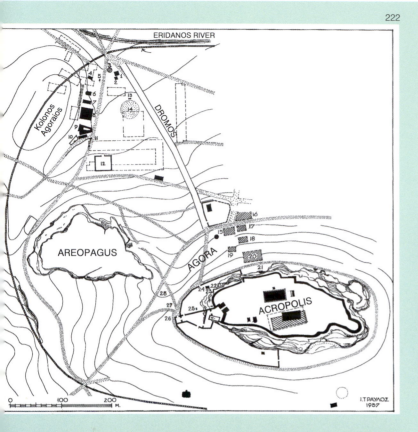

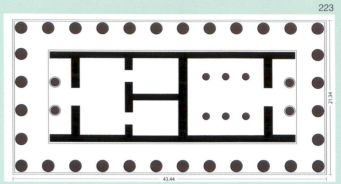

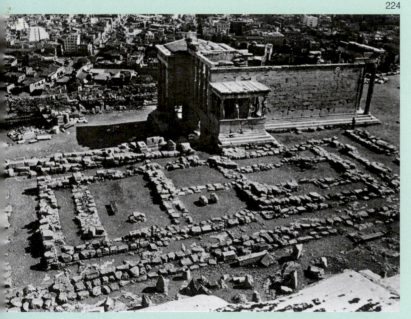

THE ATHENIAN ACROPOLIS: ARCHITECTURAL SCULPTURE FROM THE SIXTH CENTURY

During the sixth century BC the division between private and public space in Greek city-states was consolidated. In Athens, the sixth century saw a final negotiation between space reserved for public worship (such as the Acropolis) and the seats of power and administration (chiefly the Agora). The reorganization of the Panathenaia in 566 BC and the tyranny of Peisistratus contributed to this. While until this point, following the old, now mythical Mycenaean tradition, the seat of civic power was based on the Acropolis and around its slopes, around 590–580 BC the rock was gradually turned into a sanctuary. At this time the first monumental temple was built on the Acropolis, the so-called *Hekatompedon* (literally the term means "100 [Doric] feet long," i.e. 32.71 m).

At the same time, the flat area to the northwest of the Acropolis, as far as the Eridanos river, which from 1400–600 BC had been used without a break as a burial ground as well as a space suitable for workshops, was turned into a public space, mainly for athletic displays and festivals. Then in this area, which gradually changed into the *Agora*, i.e. a place for public assembly for administrative purposes, the first secular public building was erected (which was possibly also the residence of the Peisistratids). In 522 BC the *Altar of the 12 Gods* was established; a place of asylum and refuge, the altar was also used as a focal point for Athenian life, as road distances were measured from

222. Athens, the Acropolis and the Agora at the end of the Archaic period (J. Travlos).

223, 224. Athens, plan and view of the state of the foundations of the "Archaic temple" today. Middle of the sixth century BC.

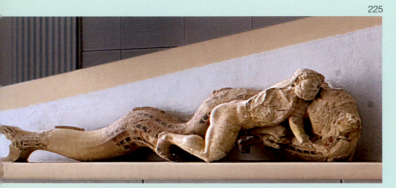 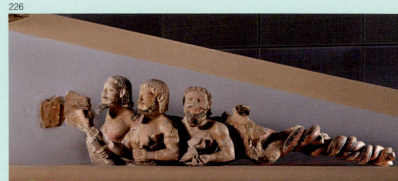

it, and so it marked the imaginary center of the city (see fig. 222). The spatial reorganization of public space in Attica also incorporated the new water system (see p. 94 and fig. 140), with visible boundary stones marking out the area of the Agora, where the so-called "Southeastern" monumental fountain house was built, which may possibly be identified as the *Enneakrounos* known from written sources (fig. 222).

During the sixth century BC in addition to the Hekatompedon, there appears to have been a second temple, identified from inscriptions as the *archaios neos* "the old temple." The foundations of this temple have been preserved, and are today visible between the later Erechtheion of the Classical period and the Parthenon (fig. 224). It was, on the basis of the surviving elements of the superstructure, a Doric peripteral temple, amphidistyle in antis (fig. 223). Both the old temple and the Hecatompedon (which was also a peripteral temple) were built of limestone with parts of the sculptural decoration in marble, see fig. 88. It is thought that, at the same period, there were also other temple-like buildings in the sanctuary, probably smaller temples dedicated to local heroes such as Kekrops or Erechtheus, or perhaps buildings of a secular nature.

A large number of fragments have survived from this period from pedimental groups which decorated the two temples and possibly the other smaller buildings in the sanctuary. The sculptures are carved from *Aktite* stone, a type of limestone quarried at Piraeus. Amongst them one group, which has been conjecturally reconstructed from many fragments, stands out in particular: it consists of two mythological scenes, in one (on the left) Herakles battles with a Triton (a monster with a fishtail) and in the other, on the right, a three-bodied daemon is depicted watching the outcome of the struggle (fig. 225–226). It has been suggested that in the center of the composition, which is thought to have decorated the west pediment of the Hekatompedon, was a scene of lions tearing a bull to pieces. The rich color on the figures, especially on the body of the fish and the snakes, is of particular interest as are the orientalizing elements in the scene, such as the execution of the wings on the three-bodied daemon which recall Assyrian prototypes. In addition to this composition, other groups depict scenes from the life and labors of Herakles, however, the dating of all the limestone sculptures from the Acropolis is particularly speculative.

The same temple probably also bore sculptural decoration in Hymettan marble, including a relief polychrome cornice as well as leopards in relief with incised circular spots. The pedimental sculptures from the Archaic Acropolis followed older trends in featuring more than one scene in each pediment, usually of apotropaic character (such as the Gorgon, snakes, or animals tearing apart their victims). Around 525 BC, however, the old temple was refurbished, probably by the Peisistratids, and was given a monumental pedimental composition of Parian marble. The theme was Gigantomachy and the scene forms a single thematic unit for the first time: Athena dominates the east pediment; she wears her *aegis*, a type of protective covering for the chest with a "fringe" of snake heads to drive off her

225, 226. Athens, section of the limestone pedimental group from the Archaic Acropolis. c. 580–570 BC. Athens, Acropolis Museum.

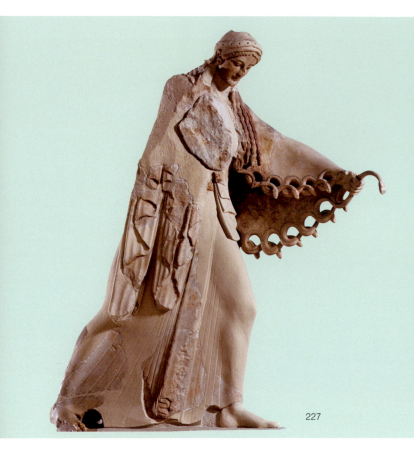

227

rivals (fig. 227). In the west pediment we have, again, a scene of a lion ripping apart a bull. According to one view, the refurbishment of the temple should date to just after 510 BC, after the expulsion of the Peisistratids and the reforms of Kleisthenes. If this is the case, the Gigantomachy could be seen as an allegorical representation of the triumph of democracy.

The fragmentary nature of the finds from the Archaic Acropolis, the number of monuments and the concatenation of the different phases of the sanctuary's use do not permit us to draw up a clear picture of the chronology and the function of the different remains. Most of them come from large deposits in pits, in which the broken fragments of sculpture were buried after the destruction of the Acropolis by the Persians in 480 BC. These are the so-called *Persian destruction deposits* which have great importance for Classical archaeology, as we shall see in the next chapter. If, however, the buildings of the Archaic Acropolis, or the majority of them, are to be associated with the Peisistratids, then it is possible that the destruction and the burial took place at the end of the period of tyranny, so that there would be a recognizable "Tyranny deposit."

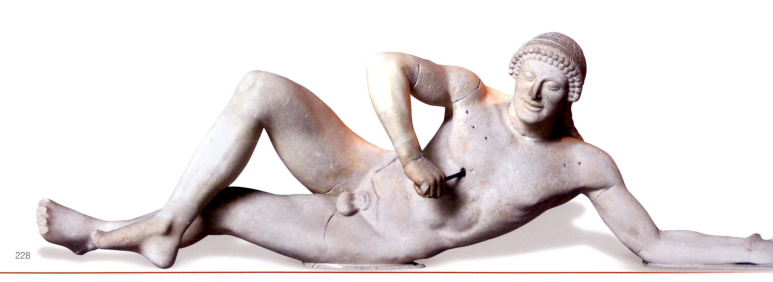

228

227. Athens, marble statue of Athena from the pedimental composition of the Archaic temple. c. 525 BC. (or 510 BC). Athena, Acropolis Museum.

228, 231. Aegina temple of Aphaia. Marble figures from the pediment of the temple: (228) west. c. 500–490 BC; (231) east. 490-480 BC. Munich, Glyptothek 79, 85.

229, 230. Aegina, temple of Aphaia. 500–480 BC.

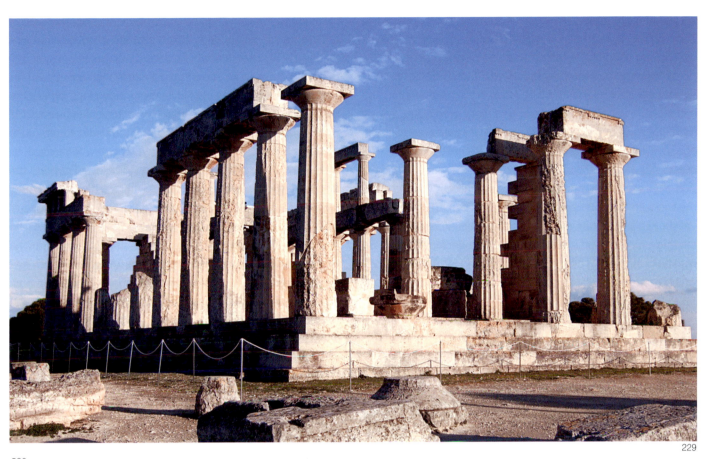

229

230

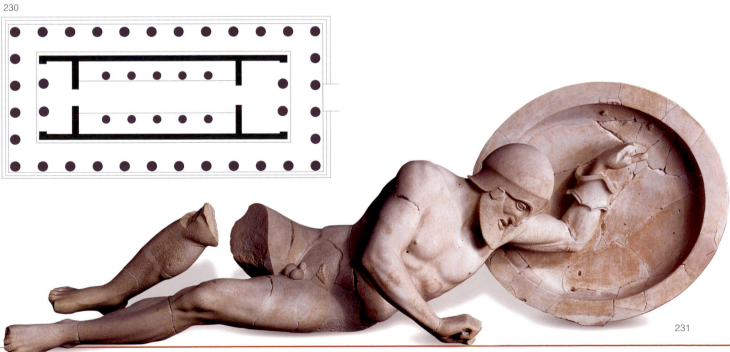

231

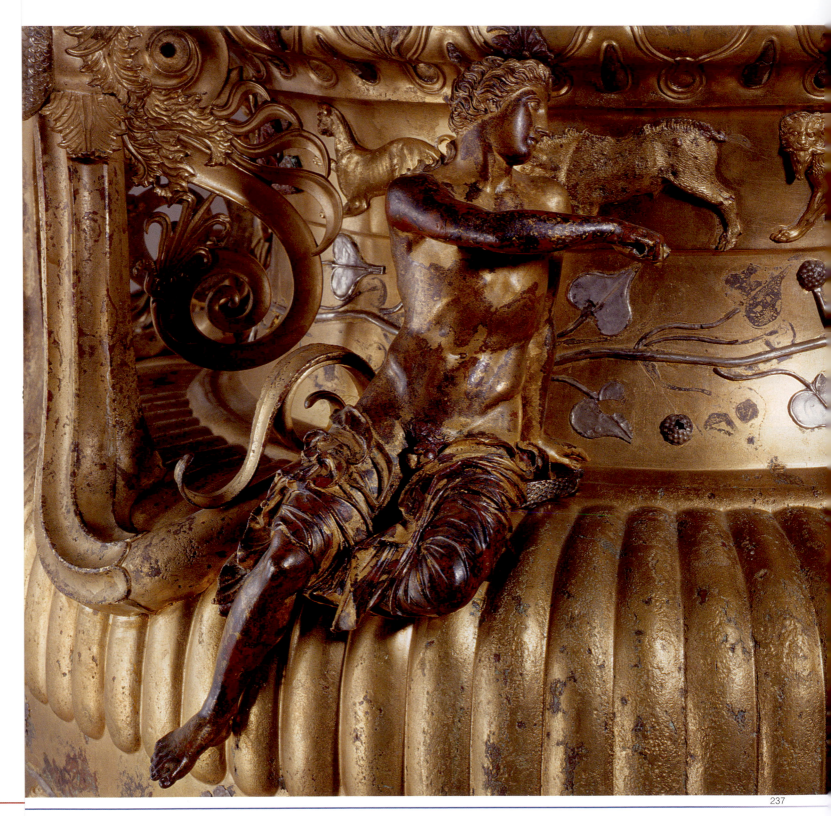

237. Detail of the vase in fig. 399.

THE CLASSICAL PERIOD
(480–336 BC)

The fifth (after 480 BC) and the fourth centuries BC are called the Classical period. As we saw in a previous section, the term refers to the culture of ancient Greece and particularly to Athens as an intellectual, "Classical" prototype for later years. The conventional boundaries for the Classical period are the year 480 BC when, with the battle of Salamis, the Greeks emerged triumphant from the vicissitudes of the Persian Wars, and 336 BC when, after the death of Philip II of Macedon and the start of Alexander's campaign against the Persian Empire, the center of gravity of Greek culture moved eastwards.

In brief, the Classical period is characterized by:

CITY-STATE SOCIO-POLITICS The removal of the Persian threat during the first decades of the fifth century BC demonstrated that the Greek city-state was endowed with the political and military structure to ensure its survival and development. The political reforms which had occurred in many Greek cities during the sixth century BC, with the most important example being the reforms of Kleisthenes in Athens in 508/7 BC, put into practice —albeit temporarily— the ideal of isonomy (equality under the law) which had been pursued from as early as the seventh century. The development of Athenian culture —of literature, philosophy, and art— during the fifth century can only be interpreted in the context of a "democratic ethos" of sorts governing everyday life in Attica in the Classical period.

DEMOCRACY AT LARGE Although Athens was the strongest democracy in the Classical period, democratic government saw a wide dissemination and defined the political life of the Greeks during the following two centuries. Democracy proved to be an equally important patron of the arts as the tyrannies of the previous decades had been: not only drama and poetry, architecture and sculpture, but also all the major events of wider social life, such as religion and athletics, passed into the hands of the *demos* —the citizenry as a whole— of the Greek cities.

MIDDLE CLASSES TO THE FORE The Persian Wars marked the triumph of democratic government that replaced the older social paradigm of aristocratic hegemony. The political, economic, and cultural life of the city-state left the control of the old aristocratic families, whilst art ceased to express exclusively the ethos of the aristocracy. It was the city's merchants, seafarers, and artisans who now set the pace in the running of the regime.

INTELLECTUAL PEAK What makes Classical art "Classical" is the maturity with which it emerged in the wide area of the Greek world during the second quarter of the fifth century BC. Although the burden of representation of Classical Hellenism falls usually to Athens because of the volume of artistic production there during the fifth and fourth centuries BC (historical and philosophical texts, drama, architecture, sculpture, and painting), we should not overlook the contribution of other cities to the idiom of Classical culture, including the Greek colonies in the East and West.

1. THE FIFTH CENTURY BC

Known to later generations as the "Golden Age," the fifth century actually began with the decisive removal of the Persian threat in 480–479 BC (from this point on the Persian kingdom was principally involved in the political life of the Greek cites through diplomatic means) and it ended with the crushing of Athens by the Spartans during the Peloponnesian War (431–404 BC), a conflict that affected the entire Greek world. It included the foundation of the Athenian League (478 BC), through which Athens sought to achieve (for a time successfully), a leading role amongst the Greek cities, but which led finally to the quarrel with Sparta.

Sanctuaries remained, in this period also, the main space for expressing material culture. The minor and major sanctuaries of the cities, as well as the great Panhellenic sanctuaries, both provided a platform for the development of art: they overflowed with monumental buildings, sculptures, paintings, pottery, and the minor arts, whether as public state commissions or private dedications, with the aim of honoring the gods while at the same time advertising their dedicators' social and political standing. Moreover, the public space of the city, the *agora*, took on a greater importance during the Classical period, because it was here that the political and social activities of a Greek city were concentrated. Finally, the *cemetery* during this period was also part of the public space, where a distinctive dialogue developed in relation to social values.

1.1 Sculpture: the "Severe Style" (480–450 BC)

Naturalism was already the clear goal of Greek art and particularly of sculpture, by the last decades of the fifth century BC. The old conventions (such as the "Archaic smile" or conventional frontality) were gradually abandoned during the first couple of decades of the fifth century and were replaced by a new standard called the "Severe Style," largely because of its sternness and its seemingly introvert outlook.

The invention of *contrapposto* (counterpose) was the chief success of figurative art in the Classical period, and eventually became one of the key elements that made Greek sculpture acceptable to other cultures, such as the modern West. It is, after all, one of Greek art's main legacies to the representational systems of later periods. The so-called *Kritian Boy*, probably the oldest surviving statue of the Severe Style, a work of c. 480

SEVERE STYLE: AN OVERVIEW

In Greek sculpture, and in Greek art in general, "Severe Style" is the term used to describe a new way of rendering human figures emerging right before or soon after 480 BC and completing its course around 450 BC. Severe Style figures are distinguished for the following:

LACK OF THE ARCHAIC SMILE The development of a more natural way of rendering the muscles of the face led to the abolition of the "smile." The features of the face, particularly the eyes, the cheeks, and the chin, were now rendered with contour and volume. The change in the profile of the face – mainly with the rounded cheeks, the long, straight nose, and the heavy chin– determined a new, and quite universal, appearance of Greek sculpture and constituted its distinctive style during the early classical period.

INTROSPECTION Both the expression on the face and the pose of the figure create, to the modern viewer at least, a feeling of sobriety and introspection. Female clothing also contributes to this, as the Ionic chiton is replaced by the heavier peplos which did not permit such sophistication in the drapery.

MUSCULATURE The areas of bare flesh on the figures, particularly of the men, are rendered with a view to anatomical accuracy. The muscles are now shown as softer, "abbreviated" versions, and the parts of the body appear to have a natural articulation. At the same time the dressed figures highlight the fluidity of the form of the human body and the unpredictability of its movement.

NATURAL POSE A new, more natural pose is invented for the figures, both male and female, in order to make them appear more relaxed and convincing. In contrast to the strictly frontal pose of Archaic statuary, Severe Style figures bear their weight on one leg while the other remains relaxed. Although this seems rather banal to us today, this simple change opened an entirely new chapter in the way art imitated reality. The shifting of the legs was mirrored by other parts of the body –shoulders, chest, hips– in what Renaissance artists and critics would term "*contrapposto.*"

BC, shows the changes that had occurred in relation to the Archaic style (fig. 238). It represents the naked figure of a standing male, in a relaxed pose, with the weight of his body on his left leg, while his relaxed right leg is bent at the knee. In the relaxed pose of the figure the horizontal lines across the buttocks and shoulders slope in opposite directions towards the relaxed and the weight-bearing leg respectively. The body and the individual details are rendered naturally; long gone are the superficial and artificial renderings and the summary execution of Archaic sculpture. The *Boy*'s figure creates the impression of fluidity and naturalism in the rendering of the flesh, while his posture manages to recreate the rhythm of a living body. His facial features — rounded cheeks, tight, fleshy lips, heavy, swollen chin — are rendered with plasticity and the transitions from one part to the next are smooth and natural. The hairstyle of the boy is particularly detailed, with the hair wrapped around the wreath he is wearing, leaving a few loose curls at the nape of the neck. The eyes were inset in a different material.

In comparison with the kouros of the sixth century we may observe the following (see fig. 166–174):

- While the kouroi are characterized by *stylization*, the boy is defined by its *naturalness*.
- Archaic art may be distinguished by its penchant for *frontality*, early Classical by its sense of *movement*.
- The Archaic *symmetry* is replaced with the Classical *counterpose*.
- While in Archaic sculpture the anatomy or the hairstyle are characterized by extrovert *ornamentality*, Classical sculpture is governed by *introspection*.
- While the aim of Archaic sculpture was the *symbolism* of the human figure, the aim of Classical art was its *representation*.

The *Kritian Boy* is perhaps the latest work which was found in the Persian invasion deposits on the Acropolis. As we saw in a previous section (p. 136) the stone fragments that the Persians left behind in 480 BC were buried by the Athenians after the battle of Salamis in order to cleanse the sanctuary of Athena. We thus have an important fixed chronological point in the study of Greek art, since it accurately dates the emergence of the Severe Style. The conventional name of the statue refers to the sculptor Kritias (or Kritios) to whom it is supposedly attributed. According to literary sources, Kritias and Nesiotes, two important Athenian sculptors during the early Clas-

sical period, undertook to make the bronze statue of *The Tyrannicides* in 477 BC, which replaced an earlier one, a piece by Antenor, which the Persians had taken with them in 480 BC. Harmodius and Aristogeiton, the two Tyrannicides, although they had attacked the Peisistratid tyrant "out of erotic chagrin," as classical authors relate, were honored by the Athenians as heroes of democracy. According to Thucydides (6.54–59) Harmodius was the *eromenos* ("beloved") of Aristogeiton; the tyrant Hipparchus, however, tried to enter into a love affair with the youth. The two lovers conspired against Hipparchus and his brother Hippias, but in the end only murdered the former, before they themselves were killed by his bodyguards. We do not know what form the Archaic statue group by Antenor took, but there are many later Roman copies of the second version (fig. 239). In these we can see the way in which the sculptors of the Early Classical period addressed movement and musculature, according to the principles described above. Similar iconographic and technical elements with the *Kritian Boy* may also be seen on the so-called *Blonde Youth*, the head of a marble statue that depicted a young boy in roughly the same pose (fig. 240). The molding of the face is typical, with the sullen lips, the puffy eyes, and the heavy, rounded chin. It should be noted that also in this period

238

238. Athens, marble statue of a youth from the Acropolis. c. 480 BC. Athens, Acropolis Museum 698.

the sculptures were heavily colored (the yellow color of the hair gave the sculpture in fig. 240 its conventional name).

Early Classical art retained many of the subjects of the Archaic period, such as the standing male and female figures, the warrior, and so on. There is, however, a gradual shift in terms of content, as the old aristocratic ideals fade away. The *Tyrannicides* is a good example: although the two sculptures refer, both pictorially and conceptually, to the ethos of pederasty (p. 93), the work promotes the ideals of resistance to tyranny. Whatever the motives of the two men were, through their actions they became icons for the Democratic faction forever (a misconception which Thucydides felt obliged to expose). Even if, however, the figures of the *Kritian Boy* or the *Blonde Youth* referenced ancestral virtues of sophrosyne or bravery, in the same way that the kouroi did in the previous period, it appears that this gradually changed, as democracy increasingly usurped the ideals of aristocracy in order to replace them with its own vision. Since many of the works of art commissioned in the fifth century were public initiatives (such as the *Tyrannicides*, as well as architectural pieces for sanc-

239

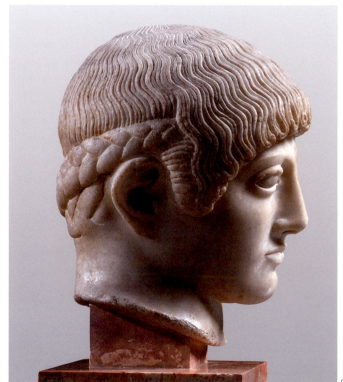

240

239. The Tyrannicides. Marble copy of a bronze statue from 477 BC. Naples, Archaeological Museum G103–104.

240. Athens, head of a marble statue from the Acropolis. c. 490–480 BC. Athens, Acropolis Museum 689.

tuaries, the agora, and elsewhere) it is to be expected that art would change gradually.

The female figures of the period usually wore the peplos. The deep folds in the voluminous material enhanced the robustness of the form. A typical example is the *Mourning Athena* from the Acropolis, a relief 50 cm high which dates to c. 470 BC (fig. 241). The goddess is shown with the peplos belted over the long overfold. She wears a "Corinthian" style helmet (see p. 149) and leans on her spear, lifting her left foot up behind her. The meaning of the scene escapes us but its solemnity and the simplicity of the clothing is characteristic.

The *peplophoros* ("peplos wearing") type is standard for the depiction of female figures during the Classical period. From Roman copies we know that a series of bronze *peplophoroi* statues were made between 470 and 450 BC, probably depicting goddesses. The type is represented also in minor arts, in figurines (fig. 242), but also on objects such as mirrors, incense burners (fig. 396). The heavy folds of the peplos were used to cover completely the weight-bearing leg, leaving only the relaxed one in outline, in true *contrapposto* fashion.

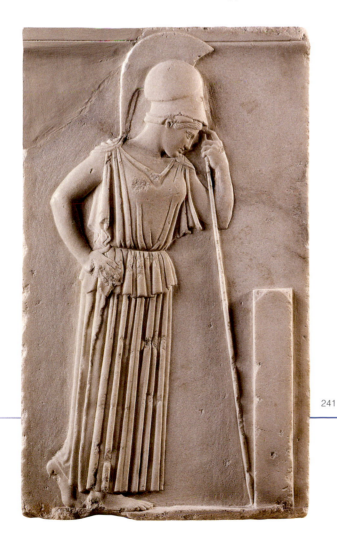

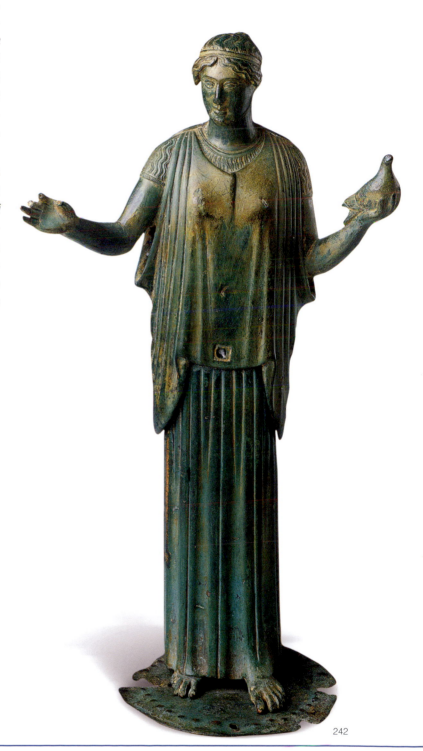

241

242

241. Athens, marble relief depicting Athena from the Acropolis. c. 470 BC. Athens, Acropolis Museum 695.

242. Bronze statue of a woman from the area of Pindus. c. 460 BC. Athens, National Archaeological Museum Kar. 540.

243 244

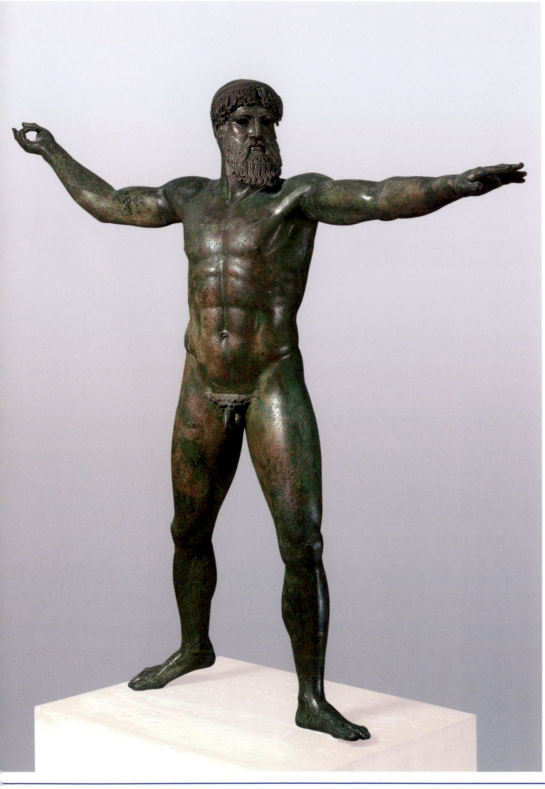

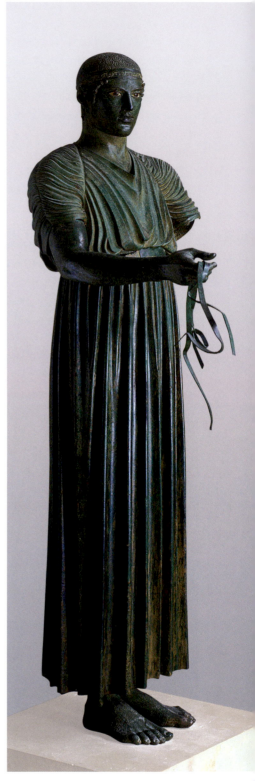

243. Bronze statue of Zeus. c. 460–450 BC. Athens,
National Archaeological Museum 15161.

244. Delphi, bronze charioteer. c. 478–474 BC. Delphi,
Archaeological Museum 3484, 3520, 3540.

The advancement of bronze casting during the period, with the perfecting of the "lost wax technique," significantly influenced the development of sculpture. Owing to this breakthrough, bronze gave the sculptor the ability to achieve more demanding poses for his figures, while perfecting at the same time the rendering of anatomy and clothing in awe-inspiring naturalism. This is especially clear with pieces such as the *Artemision Zeus*, an impressive statue, 2.09 m in height, whose arm span reaches 2.10 m (fig. 243). The statue was found in the sea, off cape Artemision, on the northernmost edge of Euboea. The daring pose of the god in motion, which represents him hurling a thunderbolt in the stance of a javelin thrower, was not possible in marble, as bronze has entirely different tensile qualities; a marble statue could not possibly have its limbs extended in the same way. Even in the statue of the *Charioteer* from Delphi (fig. 244), made slightly earlier, the plasticity of molten bronze is visible in the fashioning of the clothing, as well as the features of the face. The *Charioteer*, which was dedicated by Polyzalos of Gela in commemoration of his victory at the Pythian games in 478 or 474 BC, as well as the *Artemision Zeus*, demonstrate the quality of dedications made in Greek sanctuaries during this period.

The wide distribution of the Severe Style is testified to by finds from all over the Greek world. The *Seated Goddess of Berlin* (fig. 245), for example, a cult statue of a deity from Taranto (ancient Taras), shows adherence to the Archaic tradition — mainly with regard to the type and rendering of clothing — but the shape of the anatomical details, especially of the face and the execution of the folds, belongs to the Severe Style (gentle modeling, flexible contours, and natural proportions). Another example is the bronze head of Apollo from Tammasos in Cyprus, which came from a large statue of the god (fig. 248). Apollo is depicted as young and beardless, with the typical heavy features of the period. The hairstyle is particularly detailed with two braids forming a knot above the forehead and spiral-like ringlets framing the head. Several of the ringlets were made separately and have been broken off.

Other important sculptures of the period are known only from later copies. In contrast to stone, metal in antiquity was costly and recyclable. Thus, a damaged bronze statue was not buried as a marble one would be, but was melted down in order to reuse the metal. The copies of Roman date, usually

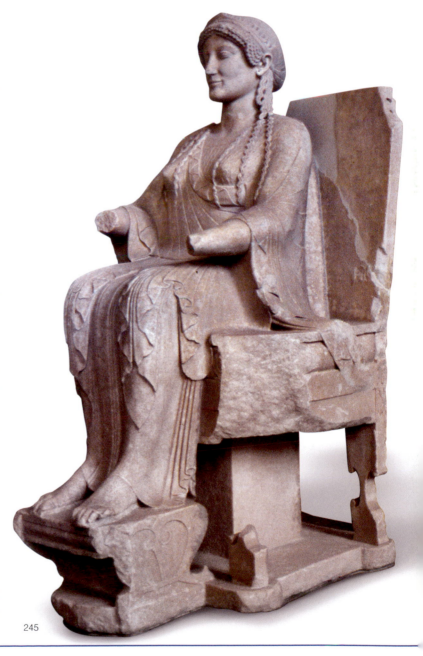

245

245. Taras (Taranto, Italy), marble statue of a goddess. c. 470–460 BC. Berlin, Archaeological Museum 1761.

THE LOST WAX TECHNIQUE

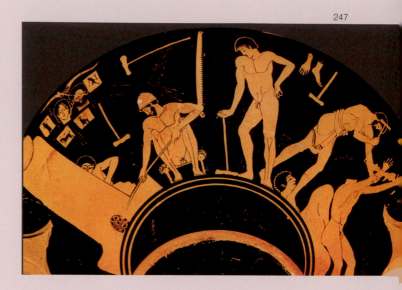

This laborious and demanding casting technique lies behind the great advances in the art of sculpture during this period. It is based on the use of wax models, to which it owes its name and the versatility of the modeling (fig. 246):

- During the first stage, a rough clay model of the final version is created by the artist.
- Then the figure is formed in wax around the clay core. The sculptor at this point adds all the details of the sculpture including anatomical features, elements of clothing, and so on.
- When the modeling of the figure is complete the sculpture is covered with a thick layer of clay to form a mold.
- Molten metal is then poured into the mold through specially made tubes and takes the place of the wax which melts away, "lost" as it were, via drainage tubes placed into the mold.
- By the time that the metal has cooled down it has taken the form of the "lost" wax. The mold is then removed and the complete sculpture receives its finishing touches (usually the addition of ringlets to the hair style or further engraving).

Bronze statues were typically cast in separate parts (the body, the head, and so on) and assembled later. In the case of smaller sculptures or their parts the mold could remain intact, so that it could be used to make further copies. Usually the eyes in bronze statues were inset and made from glass, bone, or colored stone. Other details added included the nipples or the lips in pure copper so as to appear red, or silver teeth (the *Artemision Zeus*, for example, has channels above the eyes to add eyebrows). As a result, the polychrome sculptures, in combination with the golden sheen of their metal surface, achieved a strikingly realistic appearance. Although metal ageing and corrosion do not allow us to know the original color of those Greek sculptures we possess, we do know that ancient sanctuaries and other owners of bronze statues made sure their surface was kept polished: inscriptions from the fourth and second centuries BC record appointments of specialist staff entrusted with the task of cleaning and polishing of the bronze statuary kept in sanctuaries; even the tragic poets make references to that effect. With the boom in bronze sculpture in this period, it is no coincidence that an Attic vase dating to c. 490 BC illustrates what happens in a foundry, with the master sculptors, their assistants, and apprentices shown working beside the kiln, or assembling the sculptures, or giving them their finishing touches (fig. 247).

246. Sketches of the successive stages for casting a bronze statue.

247. Attic red-figure kylix with a scene of a foundry. c. 490 BC. Berlin, Archaeological Museum 2294.

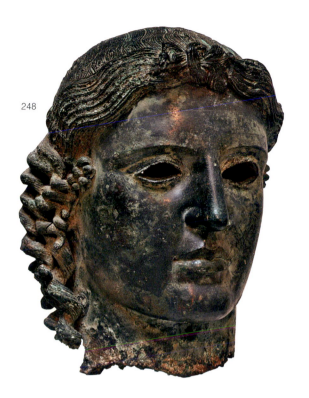

248

fashioned in marble, preserve details from the works of the Classical period, an era which was especially loved by the Romans. A typical example of a Roman copy of a Severe Style statue, famous in later years, is the *Discobolos* by Myron, many Roman copies of which were preserved in marble (fig. 250). Roman authors, such as Pliny (*Natural History* 34.57–58), mention Myron from Eleutherai, a city on the border between Attica and Boeotia, as the first sculptor who achieved "true to life" works. Among those referred to frequently is a statue of an athlete who is preparing to throw the discus, a work which is recognized in Roman sculptures such as that in fig. 250, in which the copyist preserved several Severe Style details such as the shape of the head or the short hair. The attempt by the sculptor to represent the athlete as poised for action is typical and departs in this way from the rigidity of earlier works.

THE CORINTHIAN HELMET

Greek helmets came in many different types in the Archaic and Classical periods. The most widely used was the so-called *Corinthian helmet*, known to Herodotus (4.180), which probably took its name from its place of origin, even if it was used across the whole of Greece. The type appeared at the end of the eighth century BC. It represents an important achievement in Greek metalworking as for the first time the helmet consisted of a single sheet which was hammered into the shape desired. The Corinthian helmet gradually replaced older types which were assembled from several pieces of metal, a feature that made the helmet less safe. While the first examples of Corinthian helmets were simpler, the type gradually took on a more anatomical shape, with the development of the dome in the shape of a human head, the addition of the nose guard, and the extended band guarding the neck. At the same time, in the developed type, to which the example in fig. 249 belongs, the cheek guards became larger and acquired an angular lower corner. This type was in use throughout the period of the Persian Wars and appears to have taken on a symbolic importance for the following generations up to the Roman period, even when it had been replaced with other styles. In moments of respite the helmet could be pulled back as in fig. 241.

An important feature of the helmet was the crest, usually made from horse hair, a feature designed to invite awe in the opponent.

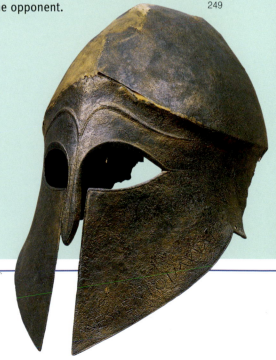

249

248. Tamassos (Cyprus), bronze head of Apollo. c. 460–450 BC.
London, British Museum 1958.4–18.1.

249. Bronze helmet of Corinthian type. Sixth century BC.
Olympia, Archaeological Museum M53.

The invention of the Corinthian helmet, which provided greater security in battle at close quarters while not allowing anything except the necessary communication with the immediate surroundings, coincided with the development of the hoplite phalanx (p. 72) that marched into battle head-on. Later in date is the Chalcidian style of helmet, in which the cheek pieces are less projecting and the nose guard is shorter. Thus it completely freed the mouth and improved the possibility of communication during battle. The cheek pieces were frequently articulated, making the helmet more versatile. The Attic type was a variant of the Chalcidean designed anatomically to fit the head perfectly without a nose guard, but with flexible cheek pieces and the possibility of adding more than one crest.

CLASSICAL SCULPTURE: THE PROBLEM OF ROMAN COPIES

The study of Greek sculpture, especially for the period of the Severe Style and later, is interwoven with the study of so-called Roman copies. The Roman copies cover a serious gap in our knowledge of Classical sculpture as the vast majority of the original works have not been preserved. At the same time, however, their study presents important idiosyncrasies which must be taken into account. In brief the Roman copies:

■ Express the Roman affection for the **Classical aesthetic.** Roman art-lovers of the late first century BC and the first–second centuries AD appreciated greatly Greek art of the fifth and fourth century BC, particularly the sculpture and monumental painting of the period, and thought it expressed the highest aesthetic ideal. Works of sculpture and painting from Greek sanctuaries or agoras, were plundered systematically by Roman generals to enrich public and private collections of art in Italy. At the same time, specialized copyists devised methods of accurately recreating the Greek prototypes, in order to meet demand for such reproduction which kept rising.

■ They constitute an **important source of information** about the lost original works, mostly made of bronze. As has already been mentioned, the recycling of metal did not allow, except rarely, the survival of bronze works. The copying of them by the Romans preserved information that would otherwise have been completely lost.

Roman copies present, however, serious **technical difficulties** as sources for the study of Classical sculpture:

■ *Change in material.* The change from the bronze of the prototype to the marble for the copy alters the original appearance of the sculpture and its character.

■ *Alteration of the pose or even the identity of the original.* Frequently, for aesthetic or, most likely, technical reasons, in the copies there is the addition of a support in the form of a tree trunk (see fig. 311) which was not there in the original, because, as we have already discussed, a statue cast in bronze is endowed with structural properties not afforded by stone. In several cases even the original identity of the sculpture is altered to meet the needs of the new market.

■ *Uncertainty in attribution.* The cases where one or more copies can be attributed with certainty to a Greek original which is known only from indirect written sources are few (the *Discobolos* is one such rare exception). Usually, the confused information we possess and the distorted view of the copies create serious problems for those studying Classical art and do not always lead to safe conclusions.

In accordance with the above, the so-called Roman copies should be regarded as *independent artistic creations* of the Roman period, intended to cater for the special aesthetic requirements of the Roman elite; they can, however, be used as *indirect* sources for the study of Classical art.

1.2 The temple of Zeus at Olympia

The temple of Zeus in the sanctuary of Olympia is the most typical example of temple architecture from the first half of the fifth century BC (fig. 253). It is a Doric peripteral, amphidistyle in antis temple with 6×13 columns. Here was applied the standard ratio for the columns of a Doric temple, where the number of columns on the long sides is equal to double those on the short side +1 (here: 6×2+1=13). The long walls of the cella enclose a two-tiered Doric colonnade. The two pediments contained freestanding compositions which are important

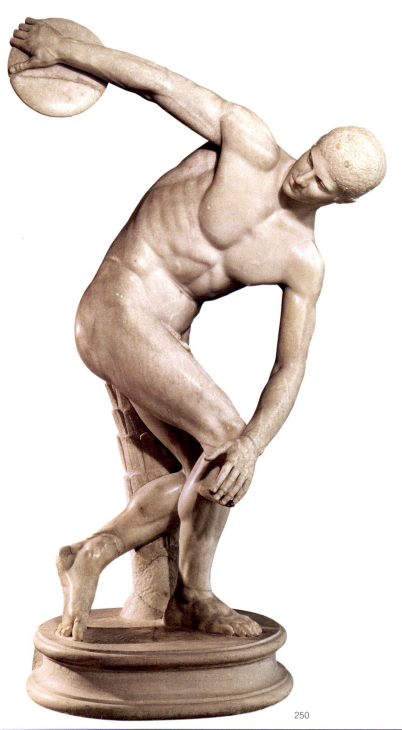

250

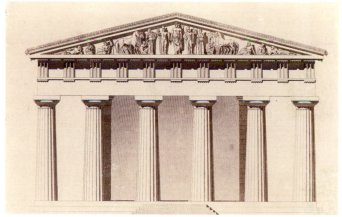

251

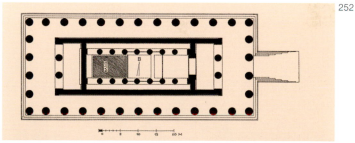

252

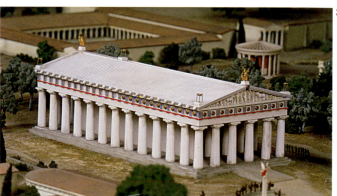

253

250. Marble statue of the Discobolos (discus-thrower). Roman copy of a bronze statue, 450 BC. Rome, Museo Nazionale Romano 126371.

251–253. Olympia, temple of Zeus. c. 470–450 BC.

examples of the Severe Style, while relief metopes adorned the pronaos and the opisthodomos, not the external entablature as was more usual. The temple was built after 470 BC, after the victory of Elis in the war against its neighboring Pisa, and before 456 BC, when the Spartans dedicated a shield to Zeus in memory of the victory against the Argives at the battle of Tanagra in 457 BC. According to Pausanias (5.10.2–10), the temple was designed by a local architect, Libon. It was built with local shelly limestone, which was covered originally with plaster to give it the appearance of marble. The architectural sculptures were of Parian marble. The cult statue, a work by the Athenian sculptor Phidias (which, however, was made later, between 435 and 425 BC) and one of the most famous chryselephantine works in antiquity, depicted Zeus seated on a throne.

The east pediment of the temple depicted, according to Pausanias, the preparations for a chariot race between King Oenomaus of Pisa and Pelops, the mythical founder of the Olympic Games (fig. 256). According to the myth, Pelops, if victorious in the chariot race, would take Hippodameia, the king's daughter, as his wife. However, he used trickery to defeat his opponent with the result that his descendants (Atreus was his grandson and Agamemnon his great grandson) were afflicted by a curse. The scene on the pediment is composed of static figures, detached from each other, in contemplative poses. In the center Zeus watches over the contest, flanked by the two antagonists and their consorts —Sterope, the wife of Oenomaus and Hippodameia, the future bride of Pelops. They are followed by the chariots, an old soothsayer who appears to foresee the final outcome, and finally in the corners of the pediment the personification of the rivers Alpheios and Kladeos as geographical references to the place where the scene was located.

The west pediment depicts the Centauromachy, the battle, that is, between the Lapiths and the Centaurs when the latter kidnapped the women of the former during the wedding of Peirithous, King of the Lapiths (fig. 257). The king of Athens, Theseus, was a friend of Peirithous and a guest at the wedding, and he took part in the hostilities. In the center of the pediment stands Apollo as a restorer of order flanked by the two heroes and groups of Centaurs and Lapiths.

The figures on the pediment were approximately one and a half times life size, with the central figures of the gods reaching 3.15 m. They were carved in the round and attached in various places to the pediment which was about 1 m deep. Whether still or in motion, the forms seek to give the natural

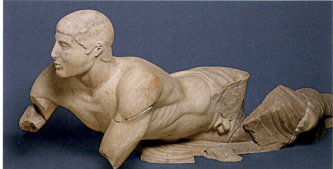

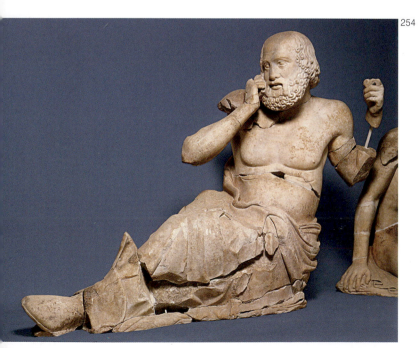

feel of the human body through the modeling of the muscles and the volume and texture of the clothing. Hippodameia from the east pediment is a peplos-wearing figure rendered in the standard Severe Style, with the weight-bearing leg completely hidden beneath the heavy drapery of the clothing. In the figures of the rivers and the soothsayer (see fig. 254–255) the gentle shaping of the clothes and the anatomy gives the impression

254. Olympia, temple of Zeus: the soothsayer from the east pediment.

255. Olympia, temple of Zeus: Kladeos from the east pediment.

256

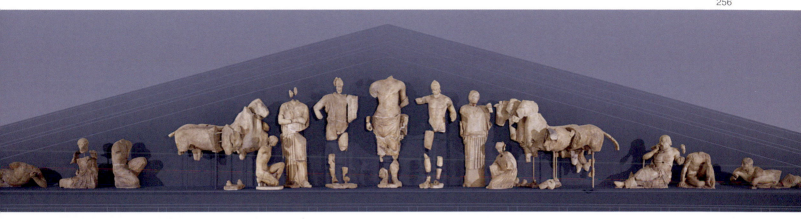

257

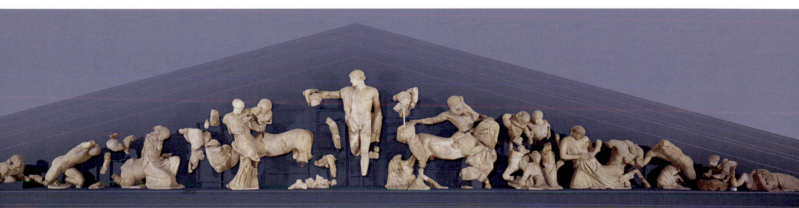

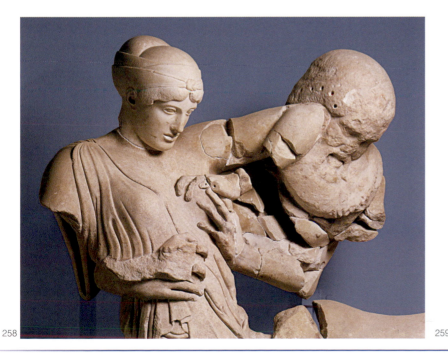

258

259

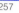

256, 257. Olympia, temple of Zeus: pedimental sculptures; (256) east pediment; (257) west pediment.

258. Olympia, temple of Zeus: a Centaur and Lapith from the west pediment.

259. Olympia, temple of Zeus: Apollo from the west pediment.

of age and the contours of a twisting body. This is the first time in Greek art that an old man is depicted in a realistic manner, without any attempt at idealization. The volume and the folds of the clothing are used similarly in the scenes of struggle (fig. 258), in order to give a feeling of violent movement. Although there are imperfections in the composition, the pediments of the temple of Zeus are without doubt a most impressive display of Early Classical art.

The metopes depict for the first time in a known monument the twelve labors of Herakles in their standard sequence with six metopes on the pronaos and six on the opisthodomos. The composition of the scenes is particularly successful and the arrangement of the anatomy and the clothing, with softly modeled forms and surfaces, recalls the rendering of the figures from the pediments (fig. 260–261). The handling of the detail remains linear, but the systematic search for methods of rendering each scene more realistically is apparent, in a persuasive way that satisfies the expectations of the viewer. The narrative scenes on the temple of Olympia had,

or appeared to have had, a specific literary work as their model rather than a general mythological narrative. This shows that the purpose of representational Greek art, particularly from this period on, was to call to the mind of the viewer images that were described in literary tradition. It seems that this is how the artists tried to create pictures that corresponded to those the viewers had formed in their mind while listening to a myth being narrated (or sung). The literary background of Greek narrative, therefore, created the need for realistic images, as far as was possible, and seems eventually to have led the Greek artists to choose realism as a way of representing their subject matter. At the same time, the figures themselves remain idealized throughout the Classical period, in response to the way Greek thought conceived human nature and the ideal state of man.

This amalgam of idealism and realism seems to have developed rapidly in sculpture, the chief representative of Greek art, across the whole of Greece. From the island of Mozia off the west coast of Sicily, the site of the Phoenician colony of

260

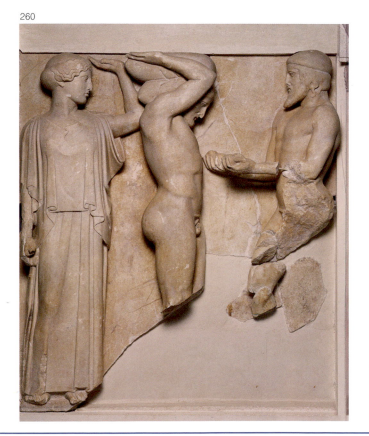

261

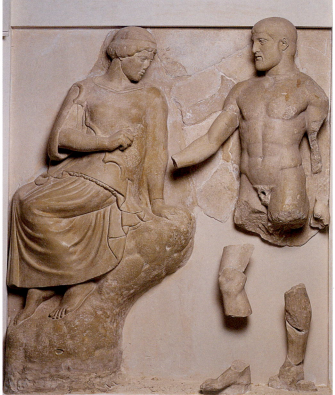

260, 261. Olympia, temple of Zeus: metopes, (260) the apples of the Hesperides; (261) the Stymphalian birds.

similar name (Motya), comes a rare marble sculpture in the Severe Style (fig. 262–263). It is a standing male figure, 1.81 m in height, wearing a long chiton belted high up on the chest with a broad band. The interpretation of the pose and the clothing is not secure but the figure is usually identified as a charioteer or a priest. The style of the work, the gentle molding of the thin pleated chiton and the rendering of the contours of the body beneath the see-through drapery which exposes the young man's anatomy have rightly been compared with the male forms on the pediments of Olympia, of which the Mozia statue appears to be a more developed version. The shape of the head, the expression on the face, and the pose of the body reinforce this comparison. The *Mozia Youth* demonstrates the quality of marble sculpture in the Severe period, as it is one of the few surviving free-standing sculptures. It is reasonable to assume that it comes from a Greek city in Sicily, such as Akragas (mod. Agrigento) and that it was transferred to Motya at the end of the fifth century, when some of these Greek cities were destroyed by the Carthaginians.

262

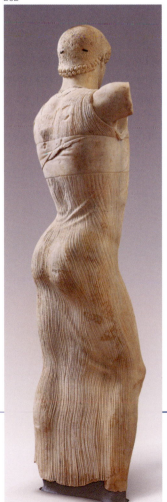

263

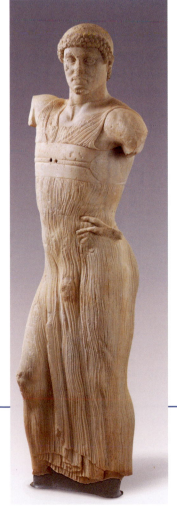

262, 263. Motya (Sicily), marble statue of a charioteer (?). c. 460 BC. Motzia, G. Whitaker Museum IG4310.

1.3 Architecture: 450–400 BC

The period between 450 and 400 BC is frequently called the "High Classical period." This characterization, which was first introduced by Winckelmann (p. 23), refers mainly to the art of the period, and the modern belief that the Greek, but mainly the Athenian culture of the second half of the fifth century BC, was the unsurpassed acme of ancient civilization, and a model for western modernity. The catalyst in this period was the role of Athens, which took on a long-term building program that changed the face and nature of public space in the city. The destruction of the Greek sanctuaries by the Persians in 480 BC was used as an opportunity, and for this reason Perikles actually misappropriated the funds of the Athenian League, something which provoked adverse reactions from many, both inside and outside Attica. This frenzy of building activity began in a climate of recrimination and, after 431 BC, continued during an open and bloody war between Athens and Sparta and its allies, and ended only shortly before the humiliating defeat of the Athenians in the Peloponnesian War. Despite this, the emergence of a new "Classical" ethos in art is evident: artistic activity in Athens during the second half of the fifth century BC provided the tone for the art of the whole of the Greek world, influencing the appearance of architecture, sculpture, painting, and the minor arts.

1.3.1 ARCHITECTURE: THE ACROPOLIS OF ATHENS

A significant number of temples and ancillary buildings were erected on the Acropolis of Athens between 450 and 400 BC. The main ones were (fig. 264):

- The Parthenon (447–432 BC).
- The Propylaia (437–432 BC).
- The Erechtheion (421–415 and 410–406 BC).
- The temple of Athena Nike (c. 426–421 BC).

The **Parthenon** was designed and built by the architects Ictinus and Kallikrates. The sculptor Phidias, who had been entrusted with the overall design of the building program, planned the sculptural decoration and created the chryselephantine cult statue of Athena. The temple, built entirely of Pentelic marble, including its roof, displays a series of important innovations. The Parthenon replaced the older Hekatompedon of the Archaic period and for this reason the cella was referred to as the "hekatompedos" in inscriptions of the Classical period. The new temple used the stereobate, the large solid base (77 × 31.4 m)

264

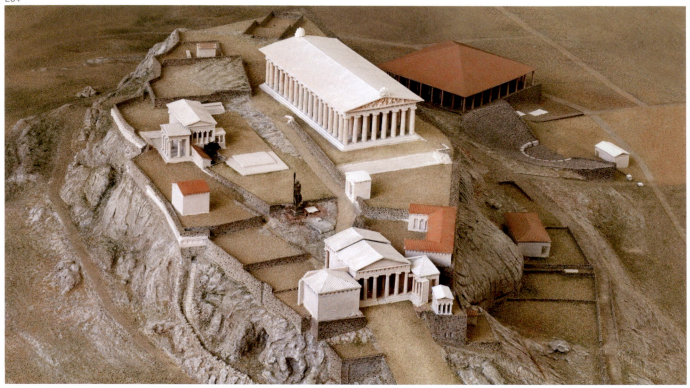

265

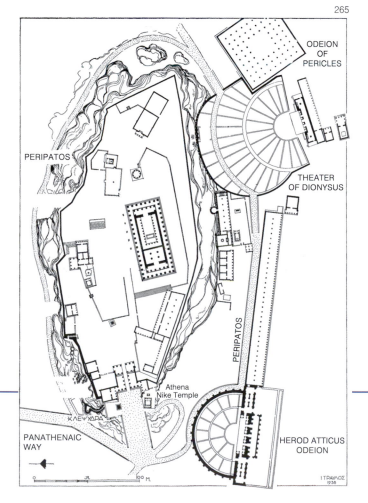

that had been built to support a majestic marble temple but re-
mained unfinished as a result of the Persian invasion. The "new"
Parthenon which was built in place of the older one is a Doric
peripteral temple, hexastyle, amphiprostyle with 8×17 columns
and dimensions of 69.50×30.88 m. Increasing the number of
columns on the narrow side to eight (from the six that the earlier

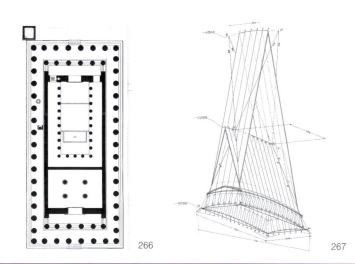

266 267

264. The monuments of the Acropolis in the fifth century BC.

265. Plan of the acropolis in the second century AD.

266. The Parthenon (plan).

268

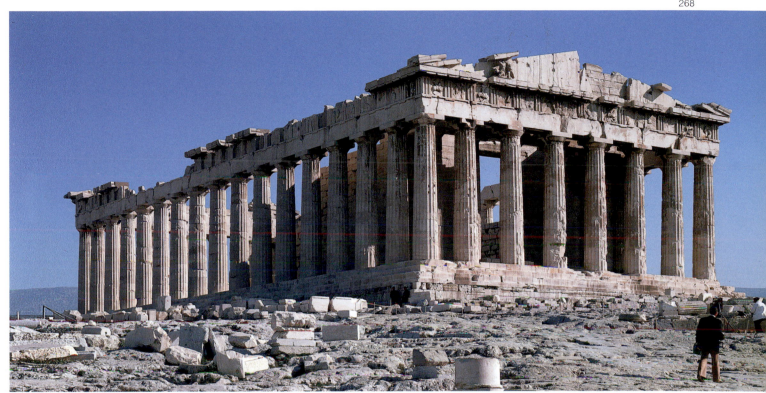

269

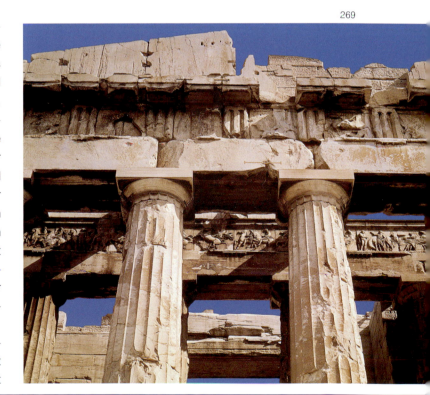

Parthenon had) gave the new temple a greater width and a harmonious ratio of width to length at 4:9. Other innovations in the temple included the style of the pronaos and opisthodomos (with prostyle columns, not, as was more usual, in antis) and the division of the cella into two separate rooms. The east room, the main cella where the cult statue was placed, included a two-tiered Π-shaped colonnade. The smaller west room was the *Parthenon* proper and was used as a treasury, i.e. a space for the storage of valuable dedications. The roof was supported on four Ionic columns. It should be noted that a large number of these special features already existed in the pre-Parthenon of 490 BC, given that the newer temple used the same plan and elements, such as column drums, which had been built for the older one. The great novelty was the change in the proportions, with the widening of the temple, but also the greater height of the columns in comparison to earlier "standard" examples of the Doric order.

The Parthenon of the Classical period incorporates, furthermore, a series of structural adjustments — "refinements" — that aimed at correcting the optical impression of the monument

267. The optical refinements of the Parthenon. The inward lean of the columns of the monument means that their axes would meet at a hypothetical point above the Parthenon. Graphic projection (M. Korres).

268, 269. Athens, the Parthenon. 447–432 BC.

THE PARTHENON: SCULPTURAL DECORATION

The sculptural decoration of the Parthenon was organized in groups of different function and iconography:

PEDIMENTS The two pediments of the Parthenon held majestic pedimental compositions sculpted in the round, each depicting a single mythical scene related to the primeval history of Attica. The *east pediment* depicts the Birth of the Goddess Athena, who stands to the right of her father Zeus (fig. 270). The chariot of Helios in the left corner of the scene and the chariot of ures of the river Ilissos and the Kallirrhoe spring as topographical markers, and includes the chariots of the two antagonists, various deities, and mythical characters associated with Attica (fig. 274–275).

METOPES The entablature of the temple was decorated with a total of 92 metopes 1.20 m high (32 on each one of the long sides and 14 on each short side). Their relief carving is particularly pronounced and their background was probably painted

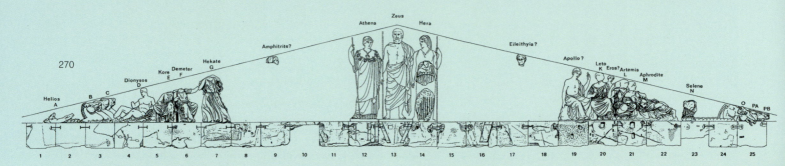

270

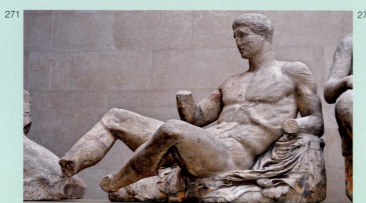

271

272

Selene on the right frame the composition, while gods and goddesses, mostly seated, flank the central figures (fig. 271–272). As a result of the conversion of the temple into a Christian church, and the addition of an apse on the east end, a large part of the pediment was destroyed. The *west pediment* depicts the contest between Poseidon and Athena for the naming of the city, a dispute Athena finally won with her gift of an olive tree (fig. 273). The composition is framed by the reclining fig-
red. The most recognizable themes are those of the Centauromachy on the south side (fig. 276–278) and the Amazonomachy on the west. The north side probably depicted the fall of Troy and the east side scenes of Gigantomachy.

FRIEZE The innovations in the Parthenon included the addition of a frieze, a traditionally Ionic element, in the sculptural decoration of the temple. With a length of 160 m and a height of 1 m the frieze ran round the outer wall of the cella, which made it

270. Athens, reconstruction drawing of the east pediment of the Parthenon.

271. The figure of Dionysus from the east pediment of the Parthenon. London, British Museum.

272. Three goddesses from the east pediment of the Parthenon. London, British Museum.

virtually inaccessible to the eyes of visitors (and perhaps for this reason it escaped the notice of the traveler Pausanias who does not mention it at all). Despite this it was a monumental, single-themed composition with hundreds of figures of men, women, and animals in low relief, with additional color and metal fittings (weapons, jewelry). It depicts a procession that starts, in two antithetically moving columns, from the southwest corner of the monument. The cavalry predominates (fig. 279–280), but char-

Panathenaic procession —even if it appears that important sections of the procession which are mentioned in written sources, are absent— and the handing over of the peplos to the priest of the temple (fig. 281).

AKROTERIA The central akroteria of the temple took the form of relief anthemia, which are preserved in part; there were probably also sculpted akroteria in the form of Nike or another winged figure which have not been preserved.

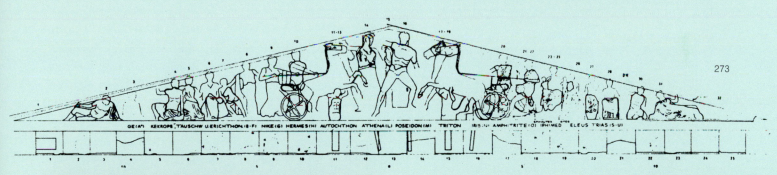

iots and infantry, as well as men and women who carry the animals for sacrifice and objects, mainly vessels such as hydriai and phialai, all take part. In the center of the east side the heroes of Attica and the Olympian gods surround an interesting scene which is usually interpreted as the handing over of Athena's new peplos with which the cult statue of the goddess was to be dressed. This was the climax of the Great Panathenaia. According to the standard interpretation the frieze depicts the

273. Athens, reconstruction drawing of the west pediment of the Parthenon.

274. The figure of Ilissos from the west pediment of the Parthenon. London, British Museum.

275. The figures of Kekrops and Pandrosos from the west pediment of the Parthenon. Athens, Acropolis Museum.

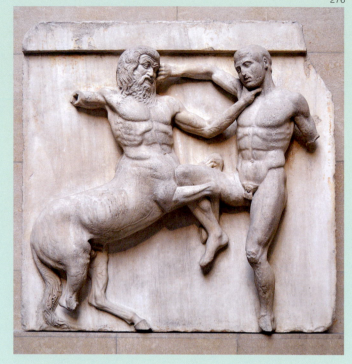

276

The sculptural decoration of the Parthenon summarized the religious significance of the temple: it is in effect a monument dedicated to Athens and not her patron goddess, a *treasury* of Athenian democracy promoting its spiritual and political glory, while housing the treasures of the city (and her allies). More than anything else the sculptures of the Parthenon appear to honor the autochthony of the Athenians, with frequent reference to local myths and cults. To the sculptural decoration of the temple must also be added the **cult statue**, which will be discussed in a later section (p. 177–178).

The unified character of the sculptural decoration of the Parthenon, in close connection with the style of the architecture, presupposes a single designer. According to written sources, this role was held by Phidias (see Plutarch, *Life of Perikles* 13.4–9). Many scholars attribute the design of the frieze and the stylistic integrity of the pediments to the sculptor himself. Although there are many sections of the decoration where the work seems awkward or even conservative, the sculptural whole, especially the pediments and the frieze, impress with the skilled management of morphology and composition. Perhaps the most important innovation in the sculptures of the Parthenon lies in the way that clothing was handled, especially that of the female figures. The volume of the

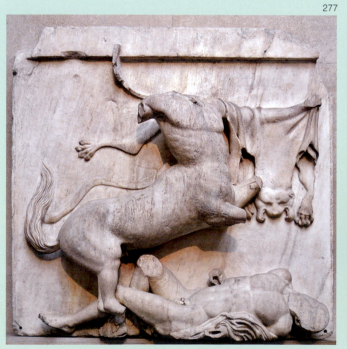

277

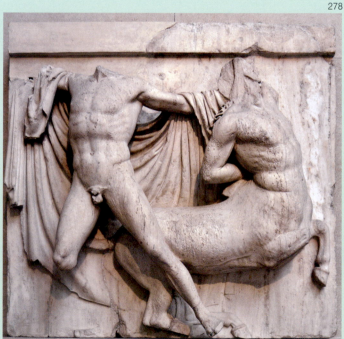

278

276–278. Metopes with scenes of centauromachy from the south side of the Parthenon. London, British Museum.

279 280

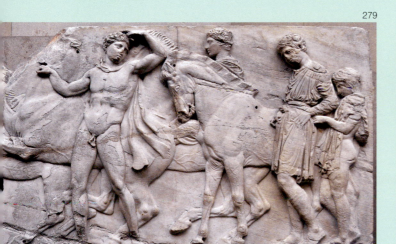
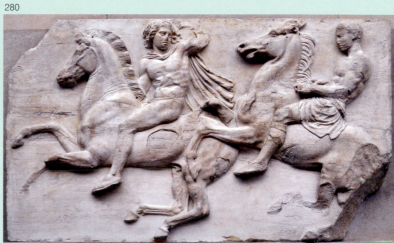

clothing reveals with its rich well-formed folds the voluptuous female bodies which seem to breathe beneath them (fig. 272). In contrast, the representation of the male body is perfected as an organic whole which appears to live and move beneath the almost transparent skin (fig. 274). It seems therefore that in the Parthenon, the attempts to achieve a realistic style which was already visible in the pediments at Olympia, reached their pinnacle (fig. 254–259).

The mustering of a well-trained work force from many parts of Greece on the Acropolis, for the whole of the second half of the fifth century BC, resulted in the systematic exercise and consequent dissemination of the solutions to technical and stylistic problems that shaped the look and ethos of Classical art. These features can be encountered in fifth century art outside Attica and remained visible also in the art of the fourth century BC.

281

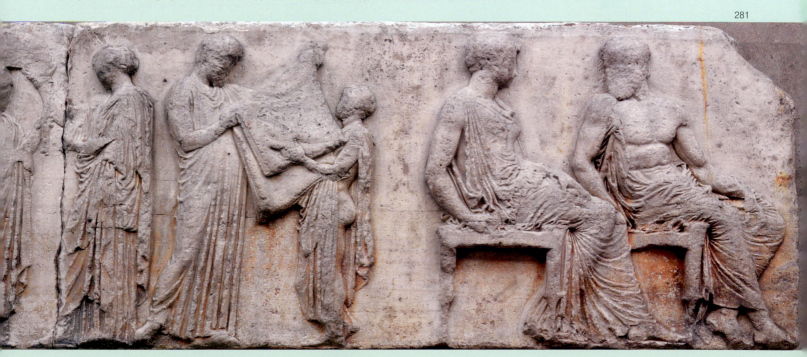

279, 280. Horsemen from the south side of the Parthenon frieze. London, British Museum.

281. Council of the gods and the peplos scene from the east side of the Parthenon frieze. London, British Museum.

(fig. 267). These modifications, like the curvature of the horizontal line of the stylobate and the entablature, the leaning towards the middle of the outer columns in order to get away from the unpleasant sensation that the building "looms" threateningly towards the visitor, the clever asymmetry of the curves of the building, were combined with contemporary philosophical ideas concerning vision and the accumulated experience in the building of Doric temples from the seventh century BC on.

The **Propylaia** was planned by Mnesikles to form a monumental entrance to the sanctuary of the Acropolis, creating at the same time the perfect visual alignment with the Parthenon, highlighting the northwest corner (from where the proportions of the building are better seen). The Propylaia is a complex composed of a hexastyle amphiprostyle propylon in the Doric order and two Doric wings to the northwest (the so-called *Pinakotheke*, "Picture Gallery") and the southwest (fig. 282). The original plan included two bigger wings on the east that were not completed, however, because of the outbreak of the Peloponnesian War. The porches of the propylon have pediments but are undecorated. Along the width of the central building they placed Ionic columns to support the coffering of the roof, built entirely in marble.

The **Erechtheion** is a complex and very idiosyncratic, cult building in the Ionic order, quite unparalleled in Greek architecture. The name means "the house of Erechtheus," from the legendary king of Athens who gradually became associated with the chthonic daemon of the same name. This building is referred to as the Erechtheion only in later literature; in the Classical period it was known as "the temple" or "sanctuary of Erechtheus". Elsewhere it is referred to as the "temple of (Athena) Polias", or even "*the ancient temple*," as it appears to have replaced a sacred edifice standing on that same spot during the Archaic period. The building consists of a central temple-like structure, with an Ionic porch with a pediment attached to the west end of the long north wall and a smaller porch on the south (fig. 284). The latter had an architrave that was supported by six caryatids

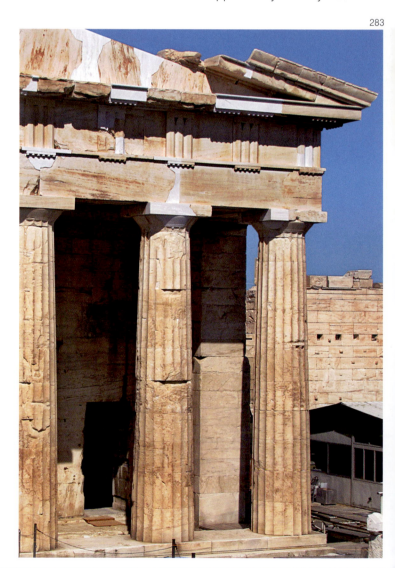

283

282. Athens, the Propylaia of the Acropolis. Plan. 437–432 BC.

283. Part of the east façade of the Propylaia. In the background to the right the east wall of the Pinakotheke.

284. Athens, Erechtheion. Plan. c. 421–406 BC.

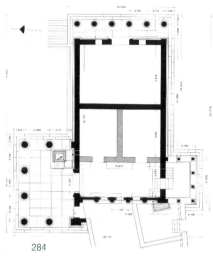

284

285

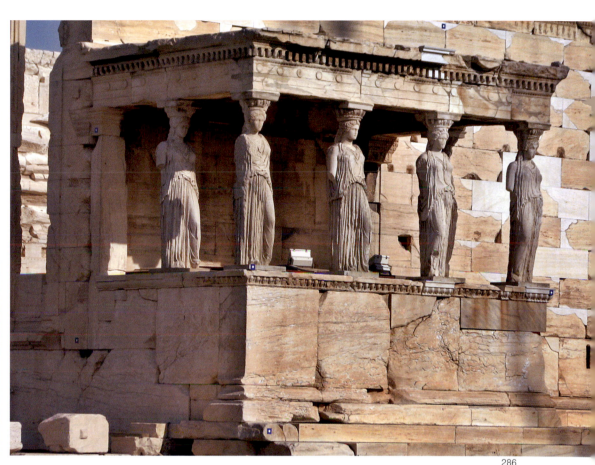

286

287

(posts sculpted as maidens), shown as if marching forward (fig. 286). The Erechtheion combines the ritual function of many ancient traditions and cults of Attica. The frieze that ran round the building demonstrated another of its distinctive features, as it is not a continuous relief in the standard fashion. In contrast, the figures were individually carved cut-outs, with flat backs, and fixed with iron clamps onto the frieze which was made of gray Eleusinian marble. The visual effect strengthened the elegant polychromy of the monument (fig. 287). Their fragmentary state does not permit a safe identification of the theme of the frieze, but it is most likely to have included narratives from local Attic myths. The Erechtheion is the perfect expression of the Ionic style on mainland Greece, while at the same time contributing to its development, with the three-part base of the column, where the lower curve is followed by a concave section and the upper curve which is decorated with relief guilloche (so-called "Attic type": fig. 285).

285. Erechtheion, base of an Ionic column (Attic type).

286. Erechtheion, the porch of the Caryatids.

287. Erechtheion, the frieze from the north porch. The gray Eleusinian stone and the holes for attaching the sculptures of the frieze can be seen. c. 421–406 BC.

288

The smaller temple of **Athena Nike**, also a work by Kallikrates, employed the Ionic order as well (fig. 289). It is a tetrastyle amphiprostyle temple, with a base 9.36×6.60 m and a height of 7 m. It had a rich sculptural decoration: a frieze 45 cm high with a scene of a council of the gods and — for the first time on a Greek building — a scene of a battle between Greeks and Persians (fig. 290–291), and also a battle between Greeks. The scenes that decorated the pediments were possibly a Gigantomachy and an Amazonomachy, which are, however, only preserved in a fragmentary state (the use of pedimental sculpture in an Ionic temple such as this is quite exceptional). The diminutive temple was built in the position of an earlier one, above the Mycenaean bastion that protected the approach to the fortified citadel of the thirteenth century BC. At the end of the fifth century BC, as part of the wider building program, the tower was encased with a stone wall, in which, however, a wide opening was left near the base through which the visitor could see the Cyclopean wall — "a window into the past" as it were. At that point the protective *balustrade* (1 m high) was added, which was decorated with reliefs of *Nikes* preparing sacrifices, erecting battle trophies, and so on (fig. 292–293).

By the end of the Periklean building program on the Acropolis, which, as we saw, was never completed in its entirety, the sanctuary had changed radically in appearance. In addition to the temples we have seen above, other temples and buildings, older or newer, provided for different ritual requirements (fig. 264–265):

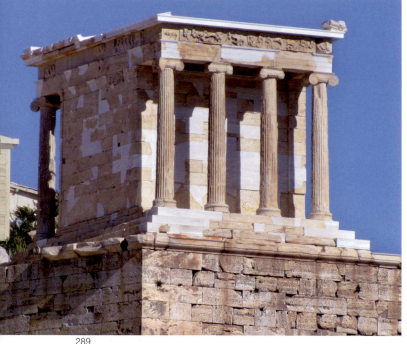

289

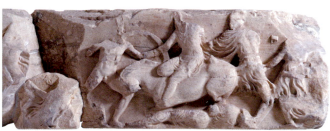

290

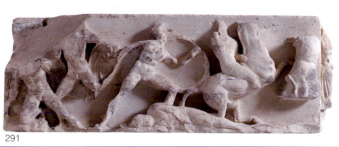

291

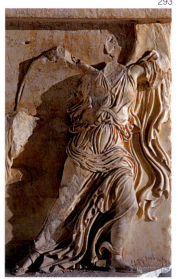

292 293

288. Athens, the temple of Athena Nike. Plan. c. 426–421 BC.

289. The temple of Athena Nike. c. 426–421 BC.

290–291. Section of the frieze from the temple of Athena Nike. Athens, Acropolis Museum.

292, 293. Athens, temple of Athena Nike. Nike figures from the balustrade. c. 410–400 BC. Athens, Acropolis Museum.

THE AGORA OF ATHENS IN THE FIFTH CENTURY BC

As we saw in a previous section (p. 134–136), during the Archaic period, and with the systematic intervention of the Peisistratids, the sphere of public worship in Athens was separated from the administrative sector. Similar interventions occurred in all the Greek cities, as the state –oligarchic or democratic– took the initiative to define the area where public political life took place. The area of the Athenian Agora had been defined as a public space from the sixth century BC, when the first administrative buildings were built on the west side of the Agora (fig. 295). Around 500 BC at the entrances to the Agora, as well as in other public spaces in Attica (such as sanctuaries and cemeteries) *boundary stones* (*horoi*) were placed, stone stelai around 1 m in height, inscribed with the phrase ΗΟΡΟΣ ΕΜΙ ΤΕΣ ΑΓΟΡΑΣ ("I am the boundary stone –*horos*– of the Agora": fig. 294). Horos stones could also refer to other boundaries, which they were made to mark ("boundary stone of the Kerameikos," "boundary stone of the fountain house"), and always using the first person, in the same way it was used in the epigrams on funerary sculpture which we studied in a previous section (p. 116). The use of the boundary stones was both religious/ceremonial and related to urban planning: according to ancient practice, entrance into sanctuaries was forbidden to certain categories of people (usually those who had been accused of impiety). In general, boundary stones defined public space in order to prevent illegal building or any other unlawful use of public land. In the Agora of Athens, in particular, public space had as much an administrative as a sacred character owing to the coexistence of sacred and administrative buildings. As a result, the use of weapons was forbidden in the Agora, as well as the entrance of perjurers, deserters, and those who had somehow managed to avoid military service or who had been accused of disrespect towards their parents.

An important feature of the topography of the Agora in the Classical period was the *Panathenaic Way*, which crossed it diagonally from the northwest to the southeast, connecting the area of the Kerameikos with the Acropolis hill (fig. 295). It was the route taken by the Panathenaic procession and other ceremonial parades and pageants. In the open area in the center of the Agora theatrical performances as well as dance festivals and athletic displays were held. Towards the end of the sixth century the *Bouleuterion* was built on the west edge of the Agora, a public edifice housing the *Boule* ("Council of 500"), a representative administrative body established by Kleisthenes, and the *Royal Stoa* a little further to the north, which was the seat of the Archon Basileus. Altars and sanctuaries of legal significance (such as the *Altar of the Twelve Gods or the Temple of Apollo Patroos*) completed the architectural formation of the area.

The fifth century BC saw increased building activity in the Agora. Around 470–460 the *Tholos* was built at the southwest edge of the Agora, a circular building with a diameter of 18.32 m. The tholos was a space for the *prytaneis* of the Athenian Boule to meet and dine (these were the rotating executives presiding over the Boule, according to the Kleisthenic reforms). As an architectural form, the *stoa* –a simple building with a rectangular plan– was developed further during this period. Stoas were usually closed at both ends and the one long side whilst a colonnade across the front permitted easy access to the roofed interior. The stoa was used as a place for meeting or trading. According to ancient literary sources, stoas could even be used to conduct lawsuits of criminal procedures. The stoas which were added to the Agora in the fifth century were the *Stoa of Zeus* to the west, the *Poikile Stoa* to the north and the so-called *South Stoa I* to the south, the ancient name of which is unknown. The latter had at the back, along its south wall, small square rooms which must have been used for dining. The *Poikile* ("Painted") *Stoa*, finally, is mentioned in ancient sources fairly frequently for administrative and ceremonial gatherings as well

294

294. Boundary stones from the Agora of Athens. c. 500 BC.

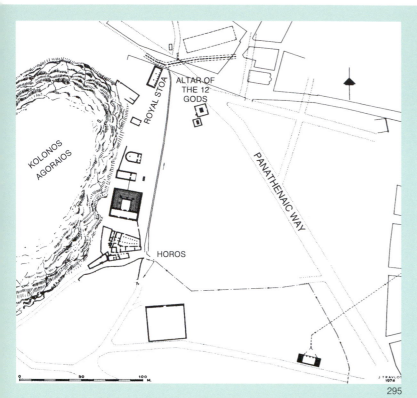

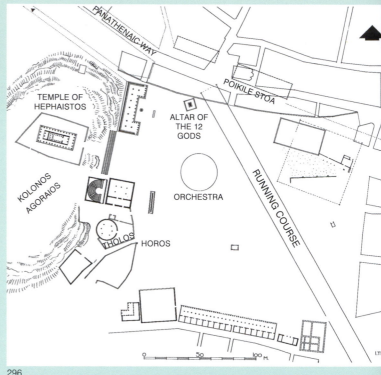

295

296

297

as a place to display paintings, which led to its name. It is located in a prime position, as it is closed on the north side, which protected visitors from the cold wind, but it had an uninterrupted view towards the Panathenaic Way. Philosophy lessons were conducted in the Poikile Stoa, from which indeed the philosophical school of the Stoics took its name. Zeno from Kition in Cyprus, founded the Stoic School in 300 BC and chose this specific spot to meet his pupils.

The Poikile Stoa was decorated with wooden panels painted by masters such as Polygnotus, Mikon, and Panainos (p. 183). The subject matter of the paintings was mythological (the *Amazonomachy*, the *Sack of Troy*) but also historical, which was an important innovation. In addition to the multifigured composition relating to the *Battle of Marathon*, there was also a representation of the Battle of Oinoe between the Athenians and the Spartans (c. 460 BC). The paintings from the Stoa were taken to Rome in the fourth century AD.

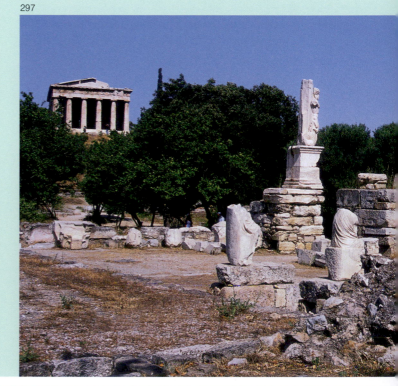

295, 296. The Agora of Athens: (295) end of the sixth century BC; (296) end of the fifth century BC.

297, 299. Athens, the Hephaistion. c. 449–420 BC.

298. Athens, the Hephaistion. Plan.

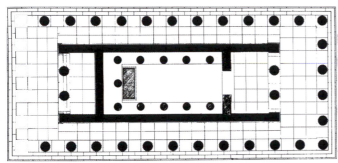

298

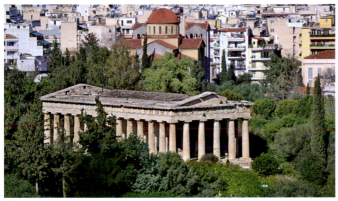

299

SANCTUARY OF BRAURONIAN ARTEMIS Founded in the Peisistratid reign, when the cult of the goddess was transferred from the Deme of Brauron in eastern Attica, from where the family of the tyrant came. The sanctuary had a roughly rectangular plan and was located in the southwest corner of the Acropolis rock, east of the temple of Athena Nike.

ARREPHORION A building with a square plan in the northwest of the Erechtheion built in the fifth century BC. It has been identified with the "building of the Arrephoroi," which Pausanias mentions in the area of the "temple of Polias" (i.e. the Erechtheion). The Arrephoroi were four girls aged 7–11 who were elected by the Athenians to weave the peplos for Athena. They also took part in a secret ceremony, the *Arrephoria*. With this ceremony are associated the two staircases close to the Arrephorion that led outside the walls of the Acropolis.

CHALKOTHEKE An elongated building with a Doric porch between the Parthenon and the sanctuary of Brauronian Artemis, where bronze objects were stored (hence its name: "storeroom for the bronzes"). It was built around 400 BC.

During the Classical period other sanctuaries also operated on the Acropolis, such as the **sanctuary of Pandion** and the **sanctuary of Zeus Polieus**, while the caves in the slopes of the hill housed numerous cults, including those of **Apollo Hypoakraios, Pan, Olympian Zeus, Aphrodite and Eros**, or the **Nymphs**.

1.3.2 ARCHITECTURE: ATHENS AND THE REST OF ATTICA

Construction of the **temple of Hephaistos** began on Kolonos Agoraios hill on the northwest side of the Athenian Agora at the same time as the Parthenon, but was completed quite sometime after it, with the result that the older Hephaistion seems to be copying the later Parthenon (fig. 299). It was built of Pentelic marble, with the exception of the lower step of the crepidoma, which was of limestone. Although it was not included in the "Periklean" building program of sanctuaries in Attica, as it did not appear to replace an older building destroyed by the Persians, it is still the product of the economic prosperity enjoyed by the Athenians in the second half of the fifth century BC.

It is a Doric peripteral, amphiprostyle in antis temple with 6×13 columns. It had rich sculptural decoration in Parian marble: a series of 10 metopes that depicted the labors of Herakles across the façade and 8 more, four on the each side of the eastern end of the side walls, with the labors of Theseus. In this

300

way the relationship of Athens with Theseus was highlighted in contrast to Herakles (who was linked to the Peisistratid tyranny).

As with the Parthenon, it seems that here also, the temple's architect attempted to place it in such a way that it was visible — along with its sculptural decoration — from all the levels of the Agora. Another element which the temple of Hephaistos "borrowed" from the Parthenon was the Ionic frieze: two friezes, one across the wall of the pronaos and the other above the wall of the opisthodomos, showed, respectively, hoplite battles in the presence of the gods and Centauromachy (fig. 300).

Around 450–440 BC a new **temple of Poseidon** was built at Sounion, to replace the older Archaic one (whilst an intermediate one, around 500 BC, had been left incomplete as a result of the Persian invasion). The new temple, built of local stone, is a typical peripteral amphidistyle in antis temple of the Doric order with 6×13 columns (fig. 301). Above the walls of the eastern peristasis was a continuous frieze depicting Gigantomachy, Centauromachy, and the labors of Theseus. Fragments of the pedimental sculptures have also been preserved.

A new **temple of Nemesis** was built in the 420s, close to an already existing, smaller temple dating from the beginning of the fifth century BC, in the sanctuary of the goddess at Rhamnous in Attica. It is a Doric peripteral, amphidistyle in antis temple with 6×12 columns, which however does not appear to have ever been finished. The temple of **Artemis Agrotera** in Ilissos appears to have had a similar plan to that of the temple of Athena Nike, as did several other temples in Attica that have been attributed hypothetically to Kallicrates.

Around 420 BC the sanctuary of **Artemis at Brauron** in Attica was enhanced with the addition of a Doric Π-shaped stoa, which

301

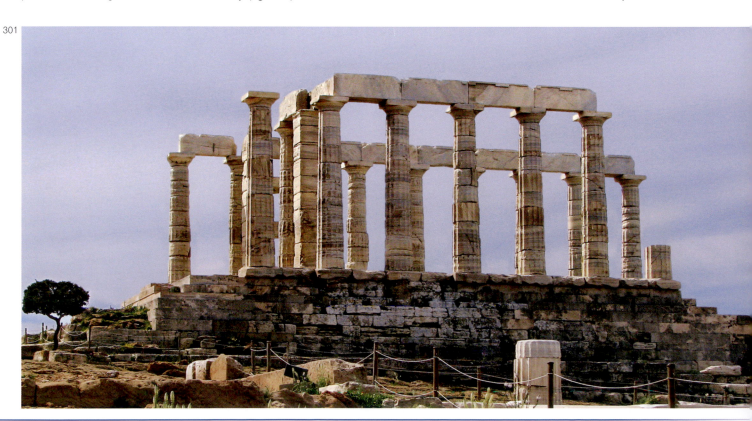

300. Section of the west frieze from the Hephaistion: two centaurs hammering the Lapith Kaineus into the ground.

301. Sounion, the temple of Poseidon. c. 450–440 BC.

was however left incomplete (fig. 303). The sanctuary, in use from the eighth century BC at least, honored Artemis as the goddess of the countryside and water. During the sixth century, when Brauron was placed under the control of Athens, the cult of the goddess was transferred to the Athenian Acropolis (p. 167), where a second sanctuary had been founded in her honor. The cult of Brauronian Artemis is associated with the lives of women: the dedicators of votives were mostly women, and the offerings were mainly cosmetic items and clothing. The most important ceremony at the sanctuary was the *Arkteia* (from *arktos*, meaning "bear"). Young girls were chosen to serve the goddess as "bears" in sacred rites of passage associated with puberty. The large Doric stoa housed the stands where the dedications were placed and where some of the dedicatory inscriptions are preserved, whilst behind the colonnade were small square dining rooms. The use of these rooms is evident from their plan (fig. 302), in which the door is placed off-center, to allow for the positioning of 11 couches along the length of the internal walls (see pp. 98–99). In front of the bases for the couches are preserved the bases for the corresponding dining tables.

302

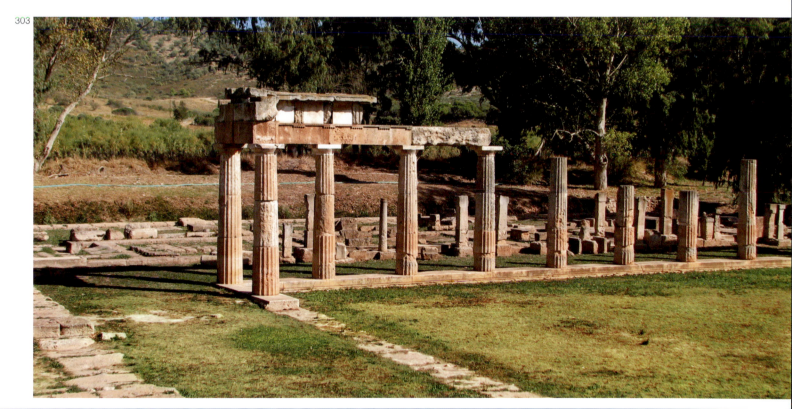

302, 303. Brauron in Attica, sanctuary of Brauronian Artemis. c. 420 BC.

THE TEMPLE OF APOLLO EPIKOURIOS

Between 420–410 BC a temple in the name of Apollo Epikourios was built at Bassae near Figaleia in Arkadia, probably by the architect Ictinus. It was built in a local gray limestone. Although built in the Peloponnese, the temple bears distinguishable Attic elements. It is a Doric peripteral, amphidistyle in antis temple with 6×15 columns. It is thus wider in relation to local Doric temples of the fifth century. To its peculiarities may be added its orientation (north/south rather than the standard east/west), the half columns built into the wall of the cella, and the single unattached Corinthian column in the cella towards the south end (fig. 306). The marble frieze that runs round the inside of the cella is also unprecedented (fig. 307). The Corinthian capital of the temple, which is not preserved today, is the earliest example of the type yet known.

The frieze depicted two now traditional scenes of Greek architectural sculpture, an Amazonomachy and a Centauromachy (fig. 309–310). The figures combine iconographic and technical features of the Attic workshop –especially in the composition of the scene and the execution of the clothing– with Peloponnesian elements, such as the comparatively larger head for both men and women and the sizeable, squarish body. Although the influences from the Parthenon in the execution of contour and motion are clear, the result at Bassae appears somewhat cold and standoffish.

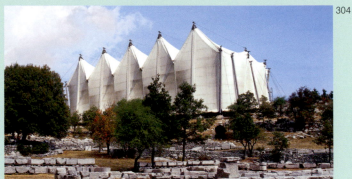

304

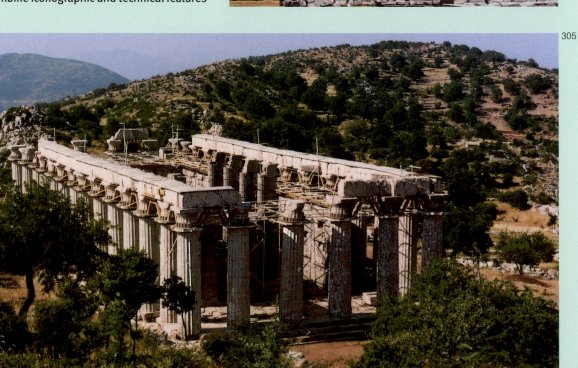

305

304. Bassae, Figaleia, the temple of Apollo with its special "tent" which protects it from weathering.

305. Bassae, Figaleia, temple of Apollo Epikourios. c. 420–410 BC.

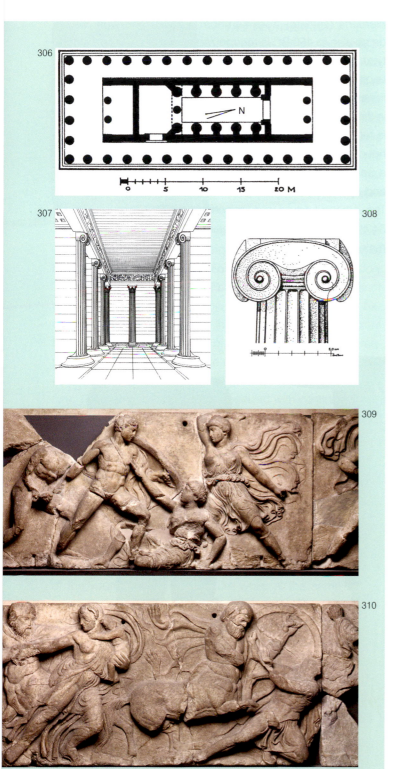

1.4 Sculpture: 450–400 BC

A distinctive "Classical" style encompasses in this period all Greek art, not just sculpture. Later historians recognized the second half of the fifth century BC as a period of great innovation and achievement in art, usually associated with specific named artists. After the sculptors of the Severe Style, those that stand out in the story of Classical art are Phidias from Athens and Polykleitos from Argos, as well as Alkamenes and Agorakritos. Any approach to Classical sculpture through the work of these and other famous artists runs into the lack of surviving works signed by them and the often unrewarding attempts to find reflections of their once-famous works in copies of the Roman period. Despite this, it is useful to study the way with which the state of Classical art of the fifth century BC has been transferred to us through later narratives, often of an anecdotal nature.

1.4.1 PHIDIAS

According to ancient literary sources, many works by Phidias adorned the Acropolis in Athens before the start of the Periklean building program. The construction of *Athena Promachos*, a bronze statue of colossal size that was set up between the Erechtheion and the Propylaia on the north side of the processional way (Pausanias 1.28.2), is dated to between 465 and 456 BC. The relief carving of a Centauromachy scene on the shield was the work of the sculptor Mys, based on a blueprint provided by the painter Parrhasios. According to ancient tradition, the tip of the spear and the crest of the helmet could be seen from the open sea at Sounion.

Two further bronze dedications by Phidias which Pausanias mentions have been recognized in Roman marble copies. One is the so-called *Apollo Parnopios* ("of the locusts") dedicated to the god as a thank offering for the relief from a plague of locusts which had afflicted Athens (*parnops* in Greek is a type of locust: Pausanias, 1.24.8). The Apollo by Phidias dates to around 450 BC and has been recognized, on the basis of stylistic features, in a series of Roman copies in marble (fig. 311). The statue type recalls works in the Severe Style, but there is also a significant development in relation to these. It depicts the god naked and beardless, with a relaxed right leg and his weight thrown on the left. In his right hand he must have held a laurel branch and in his left a bow (though some think the god may have held a supersided locust in his right hand). The

306–308. Temple of Apollo Epikourios: (306) plan; (307) reconstruction drawing of the inside of the cella; (308) drawing of an Ionic column capital from the temple.

309, 310. Section of the frieze from the temple of Epikourios Apollo: (309) amazonomachy, (310) centauromachy. London, British Museum.

shoulders in the well-known antithetical pose and rhythmical movement of the Classical contrapposto. Both men held spears in their right hands, while their bent left hands supported a shield, of which all that survives today is the *porpax* (the grip by which the hoplite held his shield). Only *Warrior B* appears to have originally worn a pushed-back helmet which is not preserved. Although in the past the two works were considered to have been products of the same workshop and even part of the same dedication, technical analysis undertaken on the bronze demon-

strated that they are likely to have come from different workshops, probably Argive (fig. 316) and Attic (fig. 317). At the same time, on the basis of stylistic criteria, they can be dated within a period of 20 years, *Warrior A* (fig. 316) to around 450 BC, and *Warrior B* (fig. 317) to around 430 BC. According to this analysis, *Warrior A* represents the latest phase of Severe Style bronze sculpture, with the fully developed contrapposto achieving a completely harmonious and balanced execution of the male form.

316
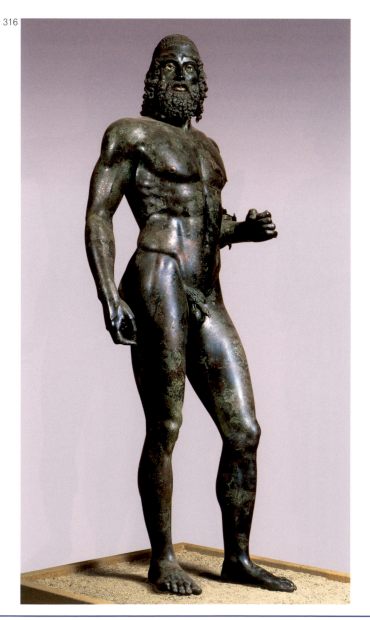

317
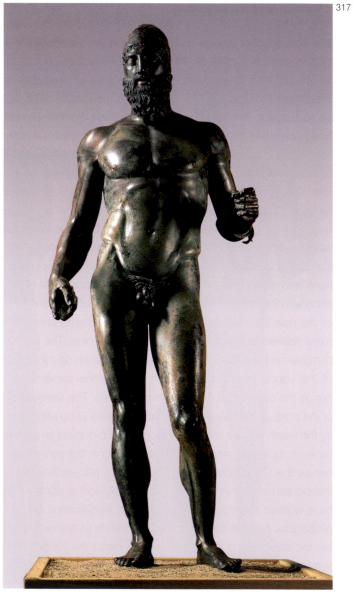

316, 317. Bronze statues of warriors (the Riace bronzes): Warrior A (316) c. 450 BC; Warrior B (317) c. 430 BC. Regio di Calabria, Archaeological Museum.

For **female figures** the prototype of the sculptures of the Parthenon, and particularly those on the pediments, is decisive. Among the numerous depictions of Athena, the *Athena Velletri* is typical, so termed after the conventional name of its best preserved copy (fig. 318). While the arms of the copy have been repaired and modified, it appears that the original work depicted the goddess standing upright, holding her spear in her outstretched hand with her weight on her left leg and her right leg relaxed. In her extended left hand she held another object, possibly a vase. Athena wears a Doric peplos belted with a snake and a himation which covers her left shoulder and is wrapped around her hips, to create a triangular overfold. Over her chest she wears the aegis with the gorgon's head and coiled snakes. The goddess wears a Corinthian helmet tipped back on her forehead. The pose, the execution of the body, and the clothing, but especially several stylistic innovations in the drapery that derive from the Parthenon sculptures (such as the swag-like folds of the himation along the right thigh) suggest that the prototype of this particular statue belongs to the post-Parthenonian period. Many experts on Greek art associate this statue with one of the pupils and followers of Phidias such as Kresilas or Alkamenes.

1.4.4 RICH STYLE

Gradually, the definition of the contours of a woman's body beneath heavy and complex drapery led to the development of clothing that appeared finer and more pleated, clinging to the body as if windblown. This phenomenon, which was not confined to Attica, has been called the "Rich" Style.

A characteristic Athenian example of the Rich Style is the headless body of a heavily draped woman or goddess, 1.83 m high, from the Agora (fig. 319). It is often identified as Aphrodite,

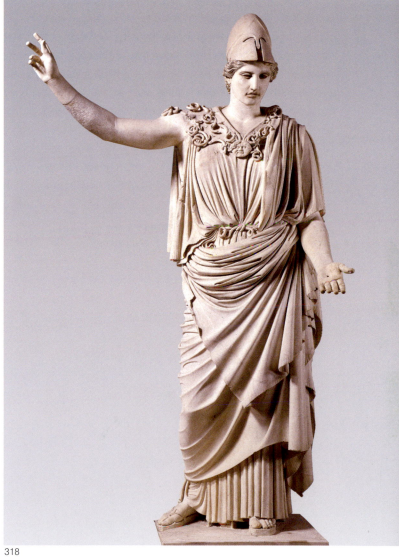

318

"RICH" STYLE: AN OVERVIEW

It appeared in Greek sculpture during the period 420–390 BC. It is distinguished by:

NATURALIST DRAPERY A multitude of deep folds envelope the female body, either hiding it completely or clinging to it, as if "wet" or "wind-blown," to show every bodily contour. The bulky complex folds of textiles represented seem much thinner, almost transparent, and artists seem to make an effort to distinguish between different fabrics and their texture.

MODELING Female musculature in Rich Style is delicately rendered. Partly exposed, or quasi-nude under their "wet-look" dress, the women of the Rich Style —mostly goddesses and other immortals— are endowed with luscious bodies, an outlook enhanced by the swirls of their clothing.

318. Marble statue of Athena. Roman copy of a bronze statue from 430–420 BC. Paris, Louvre Ma 46.

and although it cannot have been a cult statue, the sensuality of the Rich Style appears to have been accepted even in religious effigies, if we are to judge from the *Nemesis* which was made for the temple of Rhamnous by the sculptor Agorakritos. The few fragments of the marble original that have survived permitted the identification of the work with a type which is reflected in many Roman copies with characteristic features of the Rich Style (fig. 320).

Beyond Attica, a typical example is the *Nike of Paionios* from Olympia, a dedication 1.95 m tall, placed on a column c. 10 m tall (fig. 321), dating from c. 420 BC. The inscription on the base reads:

μεσσανιοι και ναυπακτιοι ανεθεν διι
ολυμπιωι δεκαταν απο τω[ν] πολεμιων
παιωνιος εποιησε μενδαιος
και τ ακρωτηρια ποιων επι τον ναον ενικα

The Messenians and the Naffpaktians dedicated this to Zeus At Olympia as a one-tenth share of the enemy (spoils) Paionios from Mende made (me) who won [the competition] to make also the akroteria on the temple

The theme of the winged Nike was immediately available for use by the artists of the Rich Style as it suited the illusion of movement and the impression of speed given by the clothing. The competition for the making of the akroteria for the temple of Zeus that Paionios mentions must have happened several years after the temple was completed. The Nikes and Nereids of the Rich Style are the perfect subject matter for the akroteria of this period and were frequently used as such. Similar elements in the execution of the drapery may be seen in the Nike Balustrade (fig. 292–293) and in the frieze at Bassae (fig. 309–310). The sophisticated elegance of the Rich Style influenced other crafts of the period, such as vase painting and the minor arts.

319

320

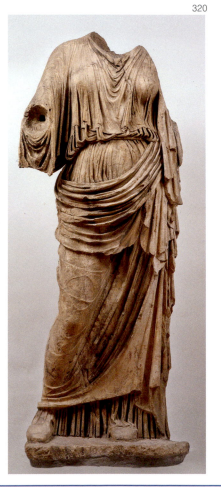

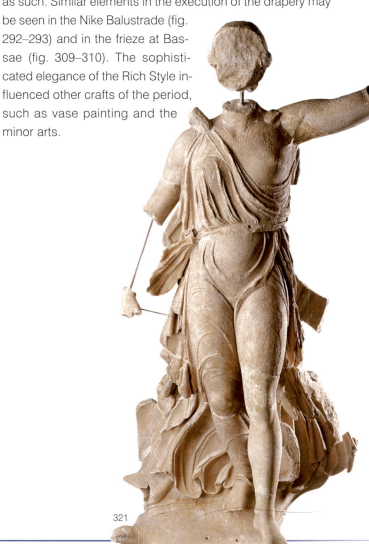

321

319. Athens, marble statue of a woman from the Agora. c. 420 BC. Athens, Museum of the Ancient Agora S1882.

320. Marble statue of a goddess. Roman copy of a marble prototype from 430 BC. Copenhagen, Glyptotek Ny Carlsberg 304a.

PHIDIAS' CHRYSELEPHANTINE STATUES

The Parthenon was built, as we have seen, as a monument to the city of Athens, to the autochthony of its citizens and the unparalleled value of democracy. The monument's stylistic sophistication and excessive use of valuable materials reveal a possibly over-confident society, a collective of (male) citizens who knew, or imagined, that they had conquered the world. The cult of their patron Athena continued, of course, in the old temple until it was replaced by the Erechtheion, where the age-old cult statue of the goddess was then located (the *xoanon* or *eidolon,* as it was referred to in ancient texts). Every four years the statue received a newly woven peplos, at the culmination of the procession of the Great Panathenaia. The Parthenon played a much less important role in the worship of Athena – indeed it shared the altar of the old temple and then later shared it with the Erechtheion. The cult statue housed at the Parthenon had been designed as part of the iconographic scheme of the temple as a whole, and was intended to promote the city and its values.

The chryselephantine statue of Athena, a work by the sculptor Phidias, was impressive for its sheer size (it stood 11.5 m with its base), the value of its raw materials (ivory for the bare flesh and gold for the clothing and the weapons attached to a wooden skeleton beneath), and the wealth of its iconographic program. It was dedicated in 438 BC, although the Parthenon had not yet been completed. The statue has not survived, nor is anything known of its fate in late antiquity (it was possibly moved to Constantinople where it was finally destroyed). Numerous ancient literary sources mention the statue, but the most detailed description is related by Pausanias (1.24.5–7). Copies at a smaller scale still exist and the so-called *Varvakeion Athena,* at 1:12 scale, is considered to be the most accurate (fig. 322). The goddess is represented in the *Athena Parthenos* type: she is standing with her weight on her right leg and with the heel of her relaxed leg back and to the side. She wears a peplos, belted at the waist, her aegis with a gorgon's head high on her chest, and an Attic helmet with three plumes, the central one in the form of a seated sphinx and the side ones in the shape

of galloping horses. Ancient sources relate that sphinxes in relief decorated the raised cheek pieces of the helmet. The outstretched right hand of the goddess held a Nike (about 2 m high in the original). According to the surviving copies of the statue, a column supported the goddess's hand, but we do not know if this was in the original, or was added to the later copies. Athena held her shield in her left hand which rested on the ground. Its exterior was decorated with a relief scene of an Amazonomachy and its interior with a Gigantomachy. The serpent-like Erichthonios, the daemon form of a mythical king of Athens, is coiled behind the shield. Pliny (*Natural History* 36.18–19) observed that every part of the statue bore pictorial representation of mythological stories that confirmed, in his opinion, the reputation of its creator. Even the soles of the goddess's sandals had relief scenes of Centauromachy, he informs us, while the base of the statue depicted the birth of Pandora.

The impact of the *Athena Parthenos* is visible also in the minor arts: references to her appear in jewelry (fig. 323) and on sealstones (fig. 324) for centuries after she was made, as the immense fame of the statue spread. On a sealstone of the first century BC (fig. 324), signed by the engraver Aspasios, we see that the fleshy features of the original have been idealized in classicizing fashion: the mouth is smaller, the chin is weightier, the nose is now straight and

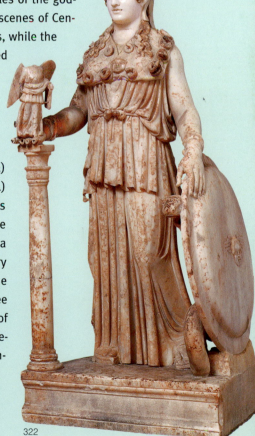

322

321. Olympia, marble statue of Nike. c. 420 BC. Olympia, Archaeological Museum.

322. Athens, marble statue of Athena Parthenos. Second century AD. Athens, National Archaeological Museum 129.

vertical. It is a highly idealized, Roman "translation" of Classical Greek art, which was disseminated in this way beyond the geographical and chronological limits of Greek culture, to revive once again in western art after the Renaissance.

According to historians of the Hellenistic period, Phidias was the object of political persecution because he was involved in the financial management of the building program in Athens, and went into self-imposed exile in the Peloponnese. There, probably between 435–425 BC, he took on the construction of the chryselephantine statue of *Zeus Olympios*, the cult statue of the temple of Zeus at Olympia which had been completed some decades before. Pausanias, once again, describes the statue as perhaps the most respected cult statue in the ancient world, and the most famous work of Phidias (5.11.1–11): the god was seated on a throne, holding a Nike in his right hand and a lightning bolt in his left. The throne was decorated with Nikes, Graces, Seasons (nymphs who were associated with nature), and sphinxes. There was also an Amazonomachy and the birth of Aphrodite. The work of Phidias influenced the depiction of Zeus in later Greco-Roman art. Indirect and direct references to the famous statue appeared in sculptural works and minor art works, coins, and so on, which depicted Zeus as the father-god with luxuriant hair and beard, and idealized features (fig. 325). During late Antiquity, the statue was transferred to Constantinople where it was destroyed in a fire in the fifth century AD.

1.5 Sculpture: funerary and votive reliefs

FUNERARY MONUMENTS Around 500 BC funerary monuments were banned in Athens, probably in an attempt to enforce egalitarian attitudes on its citizens. In the rest of Greece funerary stelai crowned with palmettes (see p. 124) continued to be used. The figures of the dead on these were distinguished according to age and, frequently, occupation (athletes, musicians). During the Classical period the dead were buried according to the way in which they lived or possibly according to the values which their families upheld. The stele of the "harpist" from Vonitsa in Acarnania, for example, depicts a bearded man with a himation around his shoulders, holding a lyre in his left hand and a plectrum (a guitar pick of sorts) in his right (fig. 326). In contrast, the stele in fig. 327, from Paros, illustrates childhood with remarkable tenderness: the little girl, who wears an unbelted peplos, is shown with two doves in her hands (birds and animals were frequently depicted on funerary stele as pets).

The onset of the Peloponnesian War and the catastrophic plague which hit Athens during the first year of hostilities appears to have necessitated a revision of the old ban on funerary

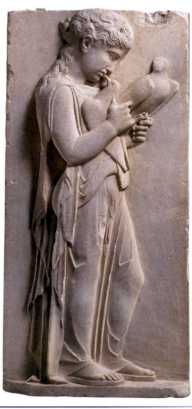

326

327

323. Crimea, elaborate gold pendant with the head of Athena Parthenos in the central medal. Fourth century BC. St. Petersburg, Hermitage KO 5.

324. Jasper sealstone with the head of Athena Parthenos. First century BC. National Roman Museum – Baths of Diocletian.

325. Silver didrachm from Elis. Head of Olympian Zeus. c. 330 BC.

326. Vonitsa, Akarnania, marble funerary relief of a musician. c. 460 BC. Athens, National Archaeological Museum 735.

monuments. At the same time the completion of the Parthenon, and the gradual completion of the remaining works of the Periklean building program, apparently created an excess of manpower, specialized in stone sculpture, who were seeking work. The return of the funerary monuments must have brought relief to the artists and their workshops, "privatizing" both supply and demand. The series of Attic funerary reliefs from between 430 and 400 BC show a clear stylistic link with the Parthenon sculptures (fig. 328). The most common type of funerary stele is the naiskos-style stele, with side panels and a pediment with a palmette akroterion.

To this type belongs the *Stele of Hegeso* (fig. 329), from the cemetery of the Kerameikos, which depicts Hegeso, the daughter of Proxenos, as the inscription carved on the cornice of the pediment informs the viewer, seated on a *klismos* (a wooden chair). The woman wears a chiton and a himation, and rests her left foot on a carved footstool. In her left hand she holds a pyxis (jewelry box) from which she is lifting some item of jewelry, probably a necklace which was depicted in paint on the stone. In front of her stands her female slave, wearing a typical foldless "barbarian" tunic with sleeves and a *sakkos* (a snood — for covering for the hair) who is passing the pyxis to her.

During the Classical period in Attica cremation was used in parallel with inhumation; the choice was a matter of personal or family preference. Cremation was generally a more expensive form of burial, as it required specialist professionals and materials that would be consumed along with the body on the pyre. It seems, however, that statistically an increase in the use of cremation can be observed in the fourth century BC. The rich funerary monuments of the Classical period came from the graves of the wealthy, covered with an earth *tumulus*. The same tumulus was frequently used by the same family for a number of generations. A group of tombs, usually of the same family, enclosed by a stone wall, formed a *funerary peribolos* —enclosure. The funerary monuments were set up on the walls of the funerary periboloi (see fig. 387).

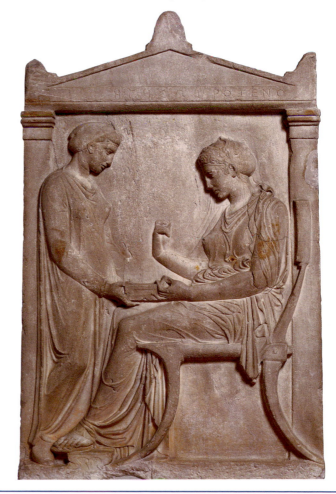

328

329

327. Paros, marble funerary relief of a girl. c. 450 BC. New York, Metropolitan Museum of Art 2745.

328. Aegina, marble funerary stele of a youth. c. 430–420 BC. Athens, National Archaeological Museum 715.

329. Attica, marble funerary stele of a woman. c. 410–400 BC. Athens, National Archaeological Museum 3624.

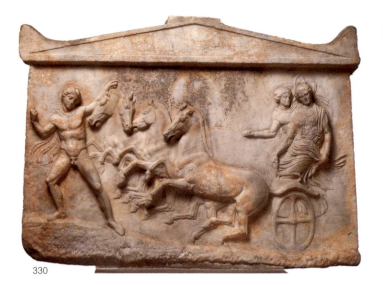

330

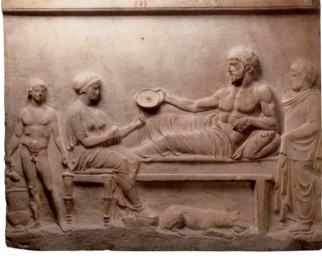

331

VOTIVE RELIEFS The stone votive reliefs of the Classical period reproduce shapes and themes that were probably produced in other, more perishable materials, such as wood. In Attica there was a deep interest in the production of such reliefs after 430 BC. They are usually rectangular in shape, of relatively small size (they were erected on columns). In several cases they had pediments while others had a simple raking cornice. The subject of local mythology appears to have interested many dedicators in this period, such as on the relief from Neo Faliro in Attica that depicts the kidnapping of the Nymph Basile by the hero Echelos in the presence of Hermes Nymphagogos ("leader of brides": fig. 330). From the inscription on the architrave of the relief it appears that it was dedicated in the sanctuary of the Nymphs. An important category of votive reliefs depict the *Nekrodeipnon* ("funerary feast"), a theme that was continued in the grave reliefs of the fourth century BC. The scene depicts the ritual conduct of a symposium where the central figure is the heroized deceased. In the votive relief in fig. 331, which comes from the sanctuary of Asklepios, the central figure of a bearded symposiast is shown reclining on a couch. He holds a *phiale mesomphalos* — a wide shallow bowl with a raised boss, an *omphalos*, in the middle — which he offers to a female figure seated on a stool. This type of phiale was mainly used for libations (ceremonial offerings of liquids). The symposium scene is completed by a naked youth on the left, who stands beside a krater and holds an oinochoe. On the right edge is depicted a dedicator-celebrant who appears to be observing the symbolic scene.

1.6 Pottery

The potters of Attica remained faithful to the red-figure style in the fifth century BC and their production rate appears to have increased immediately after the turmoil of the Persian wars and the destruction of their workshops in 480 BC. The desire for Attic pottery in the Etruscan market appears to have declined steeply during this period and certainly Athenian potters suffered a severe blow when, after the middle of the century, red-figure vases began to be produced in different regions of South Italy and Sicily, probably by Athenian migrants. The demand for Athenian pottery recovered again at the beginning of the fourth century, when demand from the Greek colonies in the Black Sea, among other places, was added to that of the western markets. Gradually the red-figure style was abandoned; in Attica its production ceases around 320 BC, in effect marking the end of Greek painted pottery.

Attic red-figure painting remained in contact with the developments in monumental art, as much in the area of technique as in iconography. In terms of subject matter, daily life was central to the interests of the vase-painters — and mostly life in the polis: festivals in which men and women participated, sacrifices, or theatrical performances. War and its associated iconography is another frequent subject: a stamnos from c. 430 BC depicts a fully armed hoplite pouring a libation as he is departing for the front. His wife and his elderly parents bid farewell to him, with the solemn expression and restricted movement that characterized Classical Greek art of every kind (fig. 332).

330. Attica, marble votive relief depicting the snatching of the Nymph Basile. c. 410 BC. Athens, National Archaeological Museum 1783.

331. Piraeus, marble votive relief depicting a funerary feast. c. 400 BC. Athens, National Archaeological Museum 1501.

332. Attic red-figure stamnos with a scene of a departing warrior. c. 430 BC. Munich, Archaeological Museum SH 2415 WAF.

333, 334. Attic red-figure epinetron. c. 425–420 BC. Athens, National Archaeological Museum 1629 (CC 1588).

The **white-ground vessels** are an important category of Attic pottery in the Classical period, one which appears to have been intended mainly for internal markets and not for export. In their decoration they used the mineral, unfired pigments of monumental painting (terracotta, purple, yellow, green, and blue). The pigment was applied with a brush after firing, onto the surface of the vessel, which had been colored white by means of a white-clay slip (possibly kaolin, which is native to Greece). The peculiarity of the technique makes the use of the white-ground vessels essentially impractical for everyday use, a need which was filled by other types of pottery. Their use appears to have been almost exclusively ceremonial and mainly funerary. A white-ground kylix from c. 470 BC highlights the quality of this particular technique (fig. 336). It depicts a standing female pouring a libation in front of an altar. As we have seen elsewhere (fig. 331), libation —for which the phiale mesomphalos was used— is a standardized ceremonial practice associated with sacrifice. The woman on the vessel wears a long chiton and purple himation around her shoulders. In her left hand she carries a staff with a volute top, and she wears two bracelets on each arm. Her hair is put up in a *krobylos* (a hairstyle similar to the modern "chignon," which was used

332

THE ERETRIA EPINETRON

The *epinetron* was an object purely for use by women who placed it on their knees while spinning wool, so that they would not be hurt by the pointed spindle. Epinetra like the richly decorated example in fig. 334 probably had a votive use. This example, which was found in Eretria, is wheel made, with a relief female protome on the knee (Aphrodite or a Nymph). Behind the protome is a frieze with a painted scene of the abduction of Thetis by Peleus. Along the two long sides of the object are two more painted friezes which appear to be associated with wedding ceremonies. In one Alcestis is shown outside the palace of Ferai, accompanied by her sister Asterope and other women (fig. 333). The depiction in the scene of ritual vessels such as a hydria-loutrophoros and lebetes gamikoi (which the women are decorating with branches) connects the scene with some wedding ceremony. Even if this scene has been connected to the *Epaulia* (the offering of gifts to the newly wed woman by her female friends on the day after her wedding) it is also quite likely that it makes a direct reference to Euripides' *Alcestis*, which was first performed in 438 BC. The other frieze depicts Aphrodite with her followers. The figures on the epinetron are reminiscent

333

of the Parthenon sculptures, in both their pose and their clothing. The decorative character of the latter, the volume, and the sophistication of their execution recalls in some way the sculpture of the Rich Style which appeared in Athens during the last two decades of the fifth century BC.

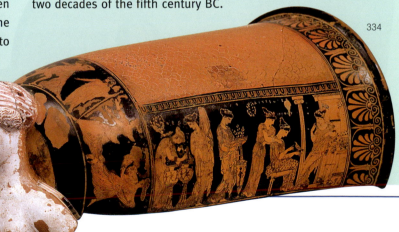

334

such example of this influence may be seen in a red-figure volute krater of the middle of the fifth century BC on which is depicted the slaughter of the children of Niobe by Apollo and Artemis (fig. 341). The scene does not have a single ground level, but each figure is placed at a different height on zigzag lines which indicated the rough ground. Some, indeed, are shown half hidden behind rocks, something that was unthinkable in traditional vase painting (where the figures usually stand side by side in a frieze of sorts).

Polygnotus followed the four-color principle, even if, according to ancient historians, he developed this technique in such as way that he was able to depict the *character* of the figure he painted. It is said that his figures had rosy cheeks and half open mouths, to give the illusion of being alive. These accounts recall developments in the painting of the Classical period which were not necessarily the invention of any one painter. In the so-called *Tomb of the Diver*, for example, from Paestum (Poseidonia) in South Italy there is a symposium scene in which the figures are rendered on the basis of the tetrachromy scheme with clear outlines and varying shades of color, but with half open mouths and reddish cheeks (fig. 340). This tomb (called after the scene which decorates the inside of the cover slab) is just one example of Greek painting outside of Greece. In general we can say that it is possible to get some impression of the monumental painting of the fifth century from Attic white-ground lekythoi of the period (see fig. 335–336).

Shading (in Greek: *skiagraphia*), the basic way with which the artist tried to achieve realistic imitation of the real world, developed gradually towards the end of the fifth century BC.

PAINTING TECHNIQUES: AN OVERVIEW

FRESCO A thick layer of plaster was applied on to the surface to be painted (usually a stone wall), which was subsequently coated with a fine layer of lime wash, and painted over while still wet. It is an ancient technique, already in use in Greece in the Bronze Age. In the Classical period it was the most common method of wall painting.

FRESCO-SECCO In this technique the colored pigments were added to a soluble, adhesive material, usually organic, (e.g. egg white) and applied to a dry surface (as in our own *tempera*). It was typically used in the painting of wooden panels.

ENCAUSTIC A less common technique, similar to tempera, which was to become quite widespread during late antiquity. In this technique the colored pigments were mixed with melted wax which worked as a binding material. The application of the color onto the painted surface was accomplished with the help of a metal or ivory spatula which was also warmed to keep the mixture of pigments in pliable form. It appears that this encaustic method was mostly used to color marble statues (p. 119).

According to Pliny (*Natural History* 35.60), the first painter who "glorified the brush" in attempting to render the actual appearance of things and men was the Athenian Apollodorus. Apollodorus is often described as a "shadower" (*skiagraphos*), because he was an exceptional craftsman when it came to shading. According to the descriptions of ancient historians, the paintings of Apollodorus are distinguished for their modulation of light and shade in order to achieve lifelike results. Mixing of the basic colors and the creation of shades thus recreates on the flat surface the way in which the indirect or direct light on the subject invites the viewer's gaze. More than just light-and-shadow play pleasing to the eye, skiagraphia ultimately achieves the illusion of depth, a requirement that was to become standard in Greek painting. This development was a real revolution for Greek art, as it gave the artist the ability to achieve the absolute illusion of reality, *mimesis* ("imitation"), which according to the Greek philosophers was the primary

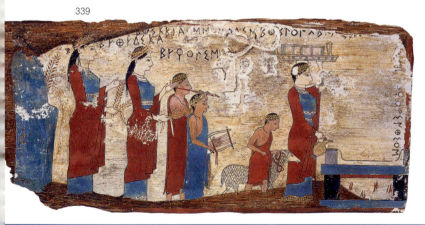

339

339. Pitsa, Corinth, painted wooden plaque with a scene of sacrifice. c. 540–530 BC. Athens, National Archaeological Museum 16464.

aim of art. The elements of shading, as well as the conventional depiction of three-dimensional space, were the great innovations in Greek painting at the end of the fifth century BC, which would be capitalized on during the fourth century but also in the Hellenistic and Roman periods. The creation of an optical illusion is a common goal of the paintings in this period, according to many anecdotal stories in the narratives of ancient historians. In painting this technique is often termed a *trompe l'oeil* (a French term meaning "to deceive the eye"), which aimed to create an illusion of depth on a flat panel. According to ancient historians, Zeuxis from South Italy and Parrhasios from Ephesus were distinguished for this type of work. Several philosophers, however, considered that the works by these two painters, even if they demonstrated an impressive technical skill, remained superficially impressive and lacked the Polygnotan sobriety and *ethos*.

Another fifth century technique that was associated with the optical illusions that can be created in a work of art is *skenographia* ("scene-" or indeed "stage-set painting"). In the ancient texts skenographia is sometimes confused with skiagraphia, and some writers refer to Apollodorus as a *skenographos* rather than, as the correct form would be, as a *skiagraphos*. With the technique of skenographia the artist attempted to represent on a flat panel three-dimensional images, principally of buildings, within a space that the viewer could understand empirically (i.e. with a view to shortening lines and volume according to perspective). Skenographia, as is clear from its name, began in the theater, where, to meet the need for scenery, they painted the façades of buildings on wooden panels which, for the sake of realism, had to create the illusion of three-dimensional space and depth (achieved in a similar way in European art during the Renaissance and after). The invention of skenographia has been attributed to Agatharchos, a painter from Samos who lived in Athens and painted, according to some sources, scenery panels for the performance of one of Aeschylus' tragedies, although according to other sources he also worked for the Athenian general Alcibiades (p. 193). These two pieces of information potentially place Agatharchos in 460–420 BC, but it is possible that the performance of the tragedy in which he took part was a later revival, which would place him in the period 430–400 BC.

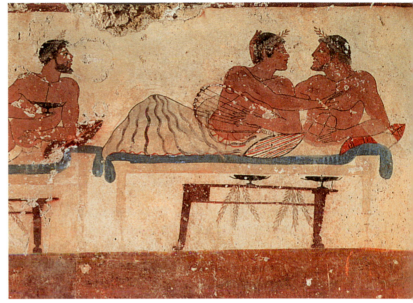

340

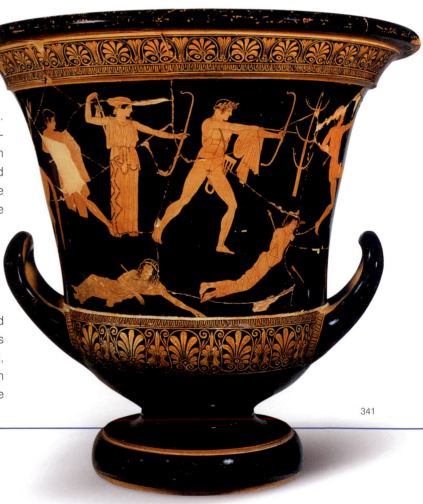

341

340. Paestum (Poseidonia), South Italy. Symposium scene from the *Tomb of the Diver*. c. 470 BC. Paestum, Archaeological Museum.

341. Attic red-figure krater depicting the slaughter of the Niobids. c. 455–450 BC. Paris, Louvre Museum G341.

2. THE FOURTH CENTURY BC

The temporary collapse of Athens with the end of the Peloponnesian war and the termination of the Athenian hegemony of Greece provoked new clashes between Greek cities, as Sparta renewed its attempt at panhellenic domination. The first half of the century is characterized by constant warfare and repeated, but unsuccessful, peace agreements. In the period between 371 and 362 BC the short-lived Theban hegemony developed, while already from the first decade of the century Persia played a more active role in the internal politics and conflicts between the Greek city-states. The period of conflict lasted for most of the fourth century BC creating a deep crisis in democratic politics and also the institutional functions of the city-state. Gradually, the kingdom of Macedon came to play a greater political role, until the eventual subjugation of all the Greek cities after the battle of Chaeronea in 338 BC. Immediately afterwards, the destruction of the Persian kingdom by Alexander III of Macedon opened new horizons for Greek civilization, marking the end of the Classical period.

2.1 Architecture

As a result of the extensive building programs of the fifth century BC, the construction of new buildings in Greece in the fourth century BC was limited. The architectural orders had already been defined, therefore the new buildings tended to follow the principles established in the previous period.

2.1.1 TEMPLES IN THE FOURTH CENTURY BC

An important example of the temple architecture of the early fourth century BC is the **temple of Asklepios** in the sanctuary of Epidaurus, which was completed around 370 BC. It is a relatively small Doric (23.06×11.76 m) peripteral, distyle in antis temple (fig. 344), and was designed by the architect Theodotos according to the surviving inscriptions. The temple was constructed in limestone and had 6×11 columns; it was therefore wider than examples of fifth century Doric temples. According to construction accounts which have survived inscribed in stone, the temple bore a particularly rich sculptural and painted decoration. The cult statue, which has not survived, was chryselephantine, a work by Thrasymedes from Paros. The building accounts mention Timotheos and The[…(his full name does

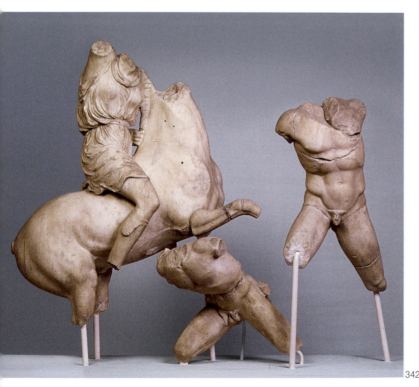

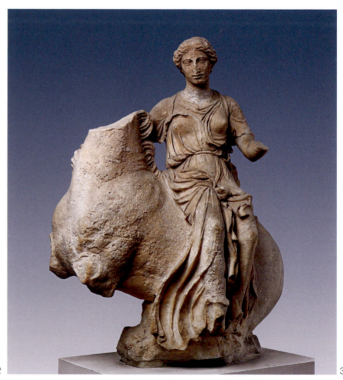

342. Epidaurus, temple of Asklepios. Figures from the west pediment. c. 375–370 BC. Athens, National Archaeological Museum.

343. Epidaurus, temple of Asklepios. Right akroterion, in the form of a Nereid or Aura. c. 375–370 BC. Athens, National Archaeological Museum.

not survive) as the creators of the akroteria for the temple, and the sculptor Hektoridas as the creator of the east pediment. According to the same source, Timotheos also created the *typoi*, a term presumably referring to preliminary models or templates for the cult statue or its base. The west pediment portrayed a scene of Amazonomachy, while on the east was the sack of Troy. Several figures in Pendelic marble survive from the sculptural decoration of the temple. The battle scenes (fig. 342) preserve the dynamism of their fifth century predecessors, while retaining the iconographic canons of pyramidal composition and classical counterpose. Nevertheless the figures in the sculptures from Epidaurus are constructed in innovative fashion and a strong sense of drama. The female figures on the akroterion, nereids or auras (water and sea nymphs), are shown in the manner inherited from the Rich Style: clinging, wet, and diaphanous clothing with sinuous folds that accentuates the dynamism of their motion (fig. 343). The central akroterion of the west pediment was a Nike, while the east seems to have been adorned with a group consisting of Apollo and a female figure.

of the cella (fig. 345). The east pediment depicted the hunt of the Caledonian Boar, a mythical tale in which the local heroine Atalanta played a leading role, and on the west the attack by Achilles on Telephos, ruler of Mysia in the Troad (in Asia Minor).

In the sanctuary of **Athena Pronaia** at Delphi, in the area called "Marmaria" today, an unorthodox building, known as the *tholos,* was constructed between 380 and 370 BC (fig. 346). Tholoi were round structures, as much secular in nature (such as the Tholos in the Athenian Agora, see p. 165) as religious. The Tholos at Delphi was built by the architect Theodoros. The building, 13.50 m in diameter, consists of a circular colonnade of 20 Doric columns standing on a three-stepped crepidoma. The entablature had 40 metopes, while a further 40 smaller ones decorated the inner wall. The outer metopes depicted Amazonomachy and Centauromachy scenes, while the interior ones were probably associated with Herakles. In the interior of the building stood 10 Corinthian columns parallel to the circular wall of the cella and on a base of black limestone. The sanctuary of Athena Pronaia housed many cults. The first temple to Athena had been built in the seventh century BC, while a second was added in

344

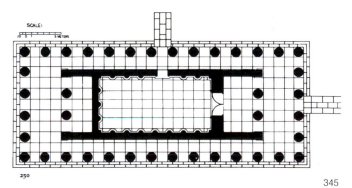

250

345

The Archaic **temple of Athena Alea** at Tegea in Arcadia was destroyed in 395/4 BC and a new one was built in its place after the middle of the fourth century BC. According to Pausanias (8.45.4–7), the architect of the new temple was Skopas from Paros, who was better known as a sculptor (see pp. 207–208). The temple was marble in the Doric order with dimensions of 46.55×19.19 m, and 6×14 columns. It was peripteral, amphidistyle in antis, with a side entrance into the cella from the north and Corinthian half-columns along the sides and west end

the fourth century. There were also treasuries, altars, and ancillary buildings, in addition to the Tholos; we do not know whether this was used as a temple (possibly of Artemis) or for some another function. During the second half of the fourth century BC (360–320 BC), the **Tholos in Epidaurus** was built in the sanctuary of Asklepios (fig. 347–348). This building, which was located on the southeast side of the Asklepion was also peristyle, with 26 Doric columns, and richly adorned with sculptures and painted decoration. Its floor, of white and black marble, supported here

344. Epidaurus, temple of Asklepios. Plan. c. 380–370 BC.

345. Tegea, Arcadia. Temple of Athena Alea. Plan. c. 340 BC.

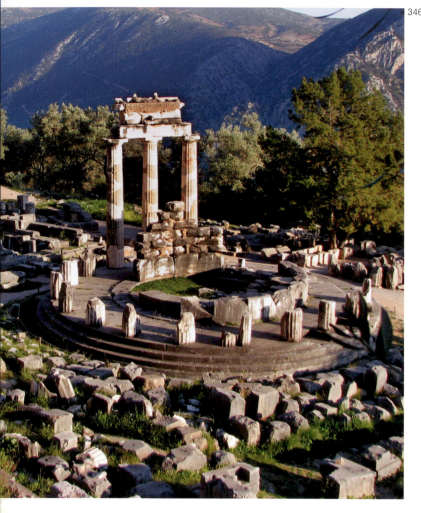

346

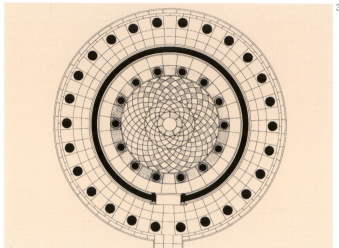

347

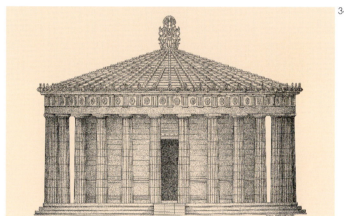

348

also a ring of 14 Corinthian columns. The basement of the building, accessible through an opening in the floor, consisted of six concentric rings with openings which formed a maze. It is possible that the Tholos at Epidaurus had a ritual use which related to the chthonic nature of Asklepios.

During the 330s BC a new **temple to Apollo** was built in the sanctuary of Delphi, in the same place as that that had been destroyed by a landslide in 373 BC (fig. 349). The new Doric peripteral temple had marble pedimental compositions with central figures of Apollo (east pediment) and Dionysus (west pediment). The figure of the latter has been tentatively identified with a male figure playing the *kithara* (a stringed instrument similar to the lyre but with a chunky wooden sound box) to which a head of Dionysus found in the area of the temple has

been joined (fig. 350). Dionysus is thus represented in the *citharoedus* style, beardless, with a long, heavy chiton belted high on the waist. In the vicinity of his left arm, which was rendered bent, is a square socket probably for attaching the musical instrument that the god held.

2.1.2 OTHER BUILDINGS OF THE FOURTH CENTURY BC

The spectacular development of Greek architecture and sculpture during the fifth century BC made the style of Classical art particularly popular outside Greece. Greek architects and sculptors were often invited by clients in the periphery of the Greek world in the fourth century BC, in the same way Greek metal work and jewelry was frequently commissioned by a non-Greek wealthy clientele in the colonies (particularly in the Black sea and Magna Graecia).

346. Delphi, sanctuary of Athena Pronaia. The Tholos. c. 380–370 BC.

347, 348. Epidaurus, sanctuary of Asklepios. The Tholos (plan and reconstruction drawing). c. 360–320 BC.

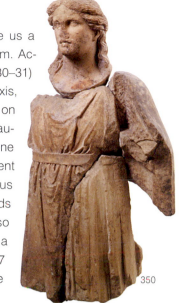

The most important work of Greek artists outside Greece during this period is the so-called **Mausoleum of Halicarnassus**, on the southwest coast of Asia Minor. Mausolus was the local ruler of Caria, which at the time was a semi-independent state within the vast Persian Empire. When Halicarnassus became the new capital of the kingdom, Mausolus ordered the construction of his personal grave monument, a lavish building which finally took the name of its owner —*mausoleum*— and gradually the term came to mean every monumental funerary edifice. Building work on the monument must have started around 360 BC. In 353, however, Mausolus died and in 351 so did his wife Artemisia, and so the work was continued by their successors. The monument was completely destroyed during late antiquity, and the descriptions provided by several ancient historians are not sufficient to give us a clear picture of its architectural form. According to Pliny (*Natural History* 36.30–31) four Greek sculptors (Skopas, Bryaxis, Timotheos, and Leochares) worked on the sculptural decoration of the Mausoleum, which eventually became one of the seven wonders of the ancient world. The Roman architect Vitruvius (first century BC–first century AD) adds that its architects —who were also Greek: Satyros and Pytheos— wrote a theoretical study on the monument (7 pr. 12–13). The total height of the

350

349

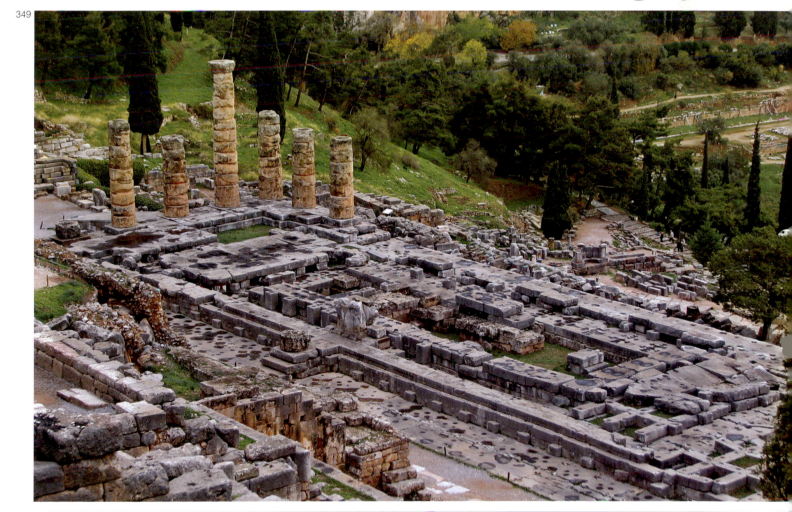

349. Delphi, temple of Apollo. c. 330–320 BC.

350. Delphi, temple of Apollo. The figure of Dionysus from the west pediment. Delphi, Archaeological Museum.

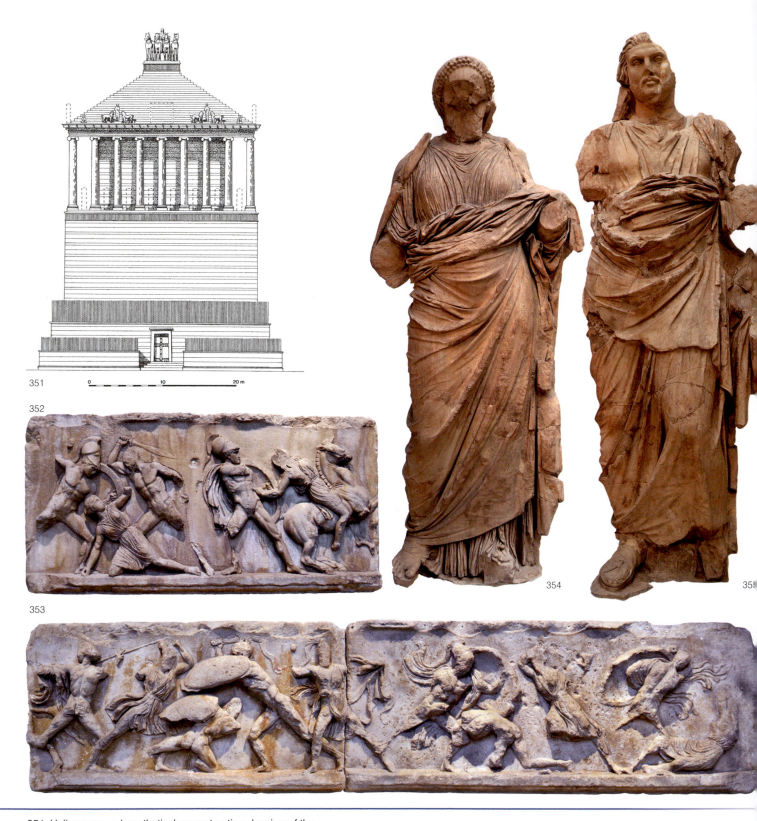

351

352

353

354

355

351. Halicarnassus, hypothetical reconstruction drawing of the Mausoleum. c. 360–350 BC.

352, 353. Halicarnassus, slabs from the frieze of the Mausoleum with a scene of Amazonomachy. c. 350 BC. London, British Museum.

354, 355. Halicarnassus, free-standing sculptures from the decoration of the Mausoleum. c. 350 BC. London, British Museum 1000, 1001.

Mausoleum must have exceeded 45 m. It stood on a high, stepped base which was decorated with relief friezes and free-standing statues (fig. 351). According to Pliny, the monument was crowned by a stepped pyramidal structure (with 24 levels) on the top of which stood a quadriga (four-horse chariot), with a passenger, probably Mausolus himself, a work also by Pytheos. Even though the form of the building is clearly eastern, the sculptural decoration belongs to the milieu of Greek sculpture of the period: one of the friezes on the monument (height 89 cm) —probably located on the steps of the base— depicted the well-known by then Amazonomachy theme, with the usual mastery of narrative in Greek art (fig. 352–353). The opponents were separated into pairs or trios, in arrangements —pyramidal or chiastic— which had been used at Bassae and elsewhere (see fig. 293–294). The figures on the Mausoleum frieze are characterized by anatomical precision and attention to detail, as well as an exaggerated rendering of the clothing (especially the men's cloaks) that was used not only to emphasize the vigorous motion but also to give depth to the relief (see fig. 353).

Two of the sculptures adorning the base of the monument and depicted the owner's royal ancestors are almost intact (fig. 354–355): they are conventionally called "Mausolus" and "Artemisia," even if it is almost certain they did not actually depict them. They were 3 m in height and are exceptional examples of the way in which Greek art of the period depicted foreigners. The male figure in particular, with his unruly long hair and distinctive features, while not a portrait in the exact meaning of the term (a development that appears in Greek sculpture only at the end of the fourth century BC), is far removed from the idealized realism of Classical art. The way the clothing is rendered contributes to this, with bulky forms which break the

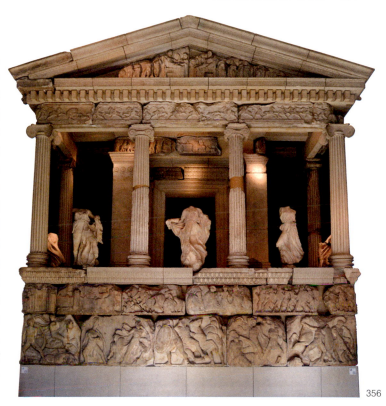

356

vertical axis of the figures and disrupt the harmony of the Classical contrapposto.

In contrast with the Mausoleum, to which the Greek sculptors transferred, unaltered, the stereotypical styles of mainland Greece in their work, in other cases the orders that were fulfilled for eastern clients are characterized by the mélange of Greek and Eastern aesthetics. A typical example is the **Nereid Monument**, constructed in the first 20 years of the fourth century BC, as a funerary monument for an anonymous ruler of Lycia (on the south coast of modern Turkey). The monument was built in Xanthos, the capital of Lycia, by Greek artists, to the model of local

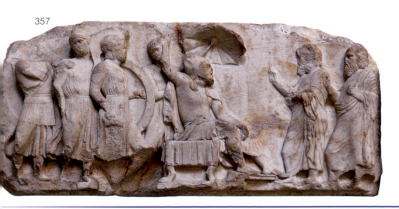

357

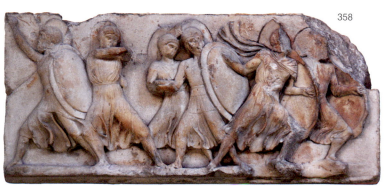

358

356. Xanthos, Asia Minor. The Nereid monument. c.400–380 BC. London, British Museum.

357, 358. Xanthos, Asia Minor. The frieze from the Nereid monument. c.380 BC. London, British Museum.

traditional funerary monuments that stood on a square pillar. In the Nereid Monument, however, the pillar was replaced with a podium, like the one that the Mausoleum of Halicarnassus was to have later, on top of which stood a temple-like building in the Ionic order (fig. 356). The sculptural decoration was particularly rich: it included relief pediments and frieze, akroteria, and sculptures in the round in the spaces between the columns, a second frieze on the wall of the cella, and relief scenes on the steps of the base. The relief scenes depicted scenes from the life of the dead king or the mythical past of his kingdom: battles, sieges, a royal hunt, the ruler himself enthroned, or receiving guests or courtiers (fig. 341–342). The depiction of the Persian style clothing is typical (short chitons, helmets, and diadems), as well as the established Classical style of the Greek reliefs, which was probably the reason this particular artist was invited to Xanthos in the first place. In contrast to the reliefs, the fully sculpted Nereids, which gave the monument its name (fig. 359–360), are pure examples of Greek sculpture of

the end of the fifth and beginning of the fourth century BC: their drapery recalls similar depictions on the Parthenon, but mainly the style of the clothing in the Rich Style (see fig. 319, 321): the thin chitons, blowing in the wind, cling wetly to the figures of the women, revealing their entire anatomy. The Nereids of Xanthos also display features in common with the figures on the akroteria from the temple of Epidaurus (fig. 343).

In fourth century Athens, building activity was curtailed significantly, not only as the result of the political and economic difficulties that followed the crushing defeat in 404 BC, but also because, not unsurprisingly, the presence of the fifth century buildings did not allow for many additions to Athenian public space. However, private enterprise increased during this period — probably an indication of the loss of interest in democracy and civic values which limited the desire for displays such as those of the sixth or fifth century BC. One typical monument of the late fourth century is interesting for the way in which it demonstrates how a *private* initiative could intrude, though always in a socially acceptable way, in a *public* space and enrich the daily visual experience of the citizens.

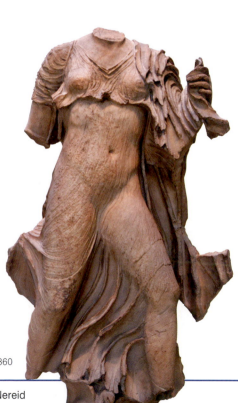

359

360

359, 360. Xanthos, Asia Minor. Sculptures from the Nereid monument. c.380 BC. London, British Museum 910, 909.

The **monument of Lysicrates** is one of the many such *choragic* monuments which were set up in the Classical period, and for many years after, in the area of the southeast slope of the Acropolis, and particularly in the area of the theater of Dionysus (fig. 361). The institution of *choregia* — the obligatory financing of regular or exceptional expenses by individuals who had the financial means to do so — was one of the key duties of Athenian public life. This obligation extended to the theater, which as a public event rooted in religious belief and ceremony, was the expression of a collective Athenian identity. The *choregos* took on the expenses for the training for the plays that were performed at Athenian festivals such as the *Dionysia*. In the case of victory in the dramatic competitions (which was probably dependent on the amount spent on costumes and so on) the *choregos* received a bronze tripod as a prize, which was then dedicated in the sanctuary of Dionysus. The choragic monuments were majestic stone constructions, essentially bases, on which they placed the honorific prize. The numerous choragic monuments to the left and right of the road that encircled the Acropolis hill at this point led to it being called the "road of the Tripods." According-

ing to the inscription that has survived on this monument, Lysicrates, son of Lysitheos of the Akamantis tribe was victorious in a competition for a boy's chorus in 335/4 BC. The monument, approximately 4 m in height, took the form of a circular naiskos built on a square limestone base. Originally six Corinthian columns of Pendelic marble supported the roof on top of which stood a base where the bronze tripod was placed. There was probably a statue of Dionysus inside. In later years, however, the spaces between the columns were filled in with curved panels of Hymettan marble, possibly for support. The monument had a relief frieze, just 25 cm high, which depicted the kidnap of Dionysus by pirates and their subsequent punishment. Beside the monument are the bases for other similar dedications.

2.1.3 DOMESTIC ARCHITECTURE

In contrast to the public architecture of the Archaic and Classical periods, private dwellings were small and insignificant structures, usually built from cheap materials. The typology of the Greek house changed little from the seventh to the fourth century BC, when for specific historical and social reasons it underwent significant changes. The emergence of privacy as a morally and politically desirable commodity was gradual and steady, in parallel with the decline of democratic values, particularly in cities such as Athens. In the fourth century, the most conservative Athenians decried the "modern" fashion amongst their wealthy fellow citizens of self-promotion through luxurious displays of monumental houses, sophisticated clothing, jewelry, and the consumption of expensive food and drink.

In a speech on the management of public funds, the Athenian orator Demosthenes (384–322 BC) discussed with contempt the practice of his contemporaries of erecting houses more imposing than public buildings, or of buying more land than they could ever cultivate (*On Organisation* 28–30). In the same polemic, the scathing orator, in referring to the Athenians of the fifth century BC, adds that "the private homes of those who then had political power were so humble and so much in line with the principles of their city, that Kimon, Aristides, and other glorious men of those years, did not have houses bigger than their neighbors." Naturally Demosthenes' words are not without exaggeration, as it is known from other sources that there was a tendency to excess already in Athens in the fifth century BC: the descriptions of the houses where the Platonic dialogues were played out for example, such as those of

361. Athens, choragic monument of Lysicrates. 334 BC.

Agathon and Kallias, are dramatically different from the "humble" dwellings that Demosthenes describes (and for this reason alone, made them a target of criticism by their contemporaries). From Plutarch, for example, we learn that the house of Alcibiades, who scandalized his contemporaries with his flamboyant lifestyle, was even decorated with wall paintings, executed by the artist Agatharchos (*Alcibiades* 16, see p. 185).

In any case, the archaeological evidence, both in Athens and in the rest of Greece, is consistent with the picture that emerges from the texts, i.e. small and humble dwellings for the most of the Classical period, but with an emphasis on wealth and social display — which were probably the privilege of the upper class— from the fourth century and later. As a rule the building materials of the houses were cheap: the foundations were either stone or dug into the natural rock, and the walls stood on a stone base and were built of mud bricks with wooden frame. The roofs, which were thatched during the Early Iron Age (p. 48) were usually of wood and clay tiles from the Archaic period on. The houses were usually on one level, but there are examples of houses with a second story which extended over part of the building. The layout, configuration, and decoration of them reflected Greek views on gender segregation, the role of the family in the social system, and the relationship of man to his environment. The house is a self-contained unit, designed to house the family and those who depended on it. In ancient Greek society the family was understood as monogamous and nuclear: it consisted of the two spouses and their children, but also sheltered other relatives of the key members (the widowed mothers of the couple, the unmarried or widowed sisters). The members of the family, together with their slaves (the average Greek house might have one or two slaves), formed the *oikos*, which was considered to be a social but also an economic unit. The role of the oikos was the protection of the family property and of family members and the production of new citizens.

The house was included in a communal network since it bordered on other houses, used part of the public road and the public drains. Especially in cities such as Athens, where the road network followed the natural contours and not a regular grid plan, the houses could be irregular in plan and the

THEATERS

The theater is one of the building types for special purposes that were devised by Greek architects. Its structure developed from the need to organize mass spectacles such as dramatic performances and dithyrambs (choral songs or chants). The theater owes its architectural form, which was the result of a long period of development, to its religious origins and its connection with ritual dances. The first Greek theater consisted of only an *orchestra*, a circular space where ritual dances were performed around the altar of Dionysus, the *thymele*. One such area existed in the sixth century BC in the central part of the Athenian agora (fig. 296). It was here that theatrical events of the *City Dionysia*, the great celebration of Dionysos that Peisistratus formally instituted in 534 BC, took place.

The *cavea* ("theatron" in ancient Greek) of the ancient theater, the amphitheatrical area where the spectators sat, was developed during the fifth century, set into the hillside with the help of retaining walls and artificial platforms. At first the spectators sat on the bare earth or on wooden seats (*ikria*). By the fourth century BC stone theaters with stone seats (*edolia*) had appeared. Gradually two *parodoi* developed in the area of the orchestra, the two side aisles that permitted entrance to the area and the *skene*, originally a wooden podium from which the actors spoke. The stage building was perfected towards the end of the Classical period. The cavea was divided vertically by radiating stairways into banks of seats sometimes referred to as *cunei* ("kerkides" in ancient Greek). In larger theaters there was a *diazoma*, a wide aisle around the middle of the cavea which divided the seating into two levels (the upper level was called the *epitheatron*). Frequently the lower seats of the cavea, which were reserved for officials, had a privileged position (*proedriai*).

The **theater of Dionysos** was founded in Athens around 500 BC on the south slope of the Acropolis (fig. 265). The theatrical performances of the City Dionysia, which until this point had been held in the Agora, were relocated here. The theater belonged to the sanctuary of Dionysus Eleuthereus

which extended further to the south. After an expansion in the fifth century BC the theater underwent extensive modifications in 325 BC, when it was equipped with stone seating with a total capacity of 17,000 spectators. In the first century AD the theater was modified again with the addition of a stone skene and a balustrade around the orchestra.

The **theater of Epidaurus**, an integral part of the sanctuary of Asklepios, was built during the second half of the fourth century BC by an architect called Polykleitos. It is one of the finest and best preserved theaters in the ancient world, with perfect proportions. It is defined by its perfect symmetry and its unique acoustics. It has 12 kerkides in the lower part and 22 in the epitheatron with 55 rows of seats giving a capacity of 13–14000 spectators. The orchestra is a full circle and the two parodoi are provided with monumental gateways (fig. 362).

362

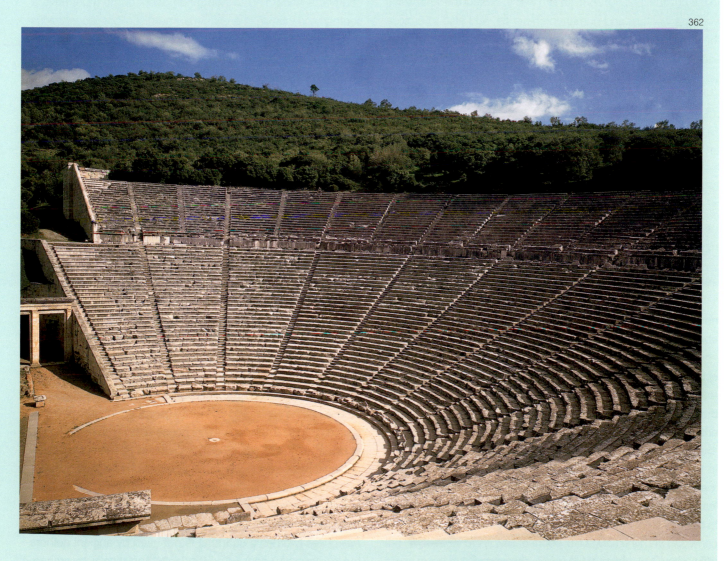

362. Epidaurus, the ancient theater. c. 330 BC.

SPORTS AND GAMES

The Greeks loved competitive sports, which they considered an integral part of their social as well as religious life. In Greek culture, athletic prowess went hand-in-hand with military excellence –a young man's sporting skills were thought to mirror his bravery on the battlefield. Sports, on the other hand, were always practiced within a religious setting, as part of some festival dedicated to a specific divinity who was expected to oversee the proceedings. In a sense, athletic competition was yet another offering to the gods it celebrated, part of the sacrifices performed prior to any major or minor sports event.

Athletic competitions were organized in every Greek city, large or small, and wherever a Greek community established itself –from the western Mediterranean to Asia Minor and beyond. Among the hundreds of such events, however, only four acquired such a universal acclaim as to become *Panhellenic*, that is celebrated by all Greeks: the Olympic Games at Olympia, dedicated to Zeus (see pp. 151–154), the Pythian Games at Delphi, dedicated to Apollo, the Isthmian Games at Isthmia, in the Peloponnese, dedicated to Poseidon, and the Nemean Games at nearby Nemea, also celebrating Zeus. The prize at all four was a wreath made from their respective host's sacred tree: olive from Olympia, laurel for Delphi, pine for Isthmia, and celery for Nemea. Victory at these games brought honor to the athletes and their families, as well as their hometowns. Greek art often reflects this, as we possess numerous statues of athletes originally erected in com-memoration of their victories (see fig. 250; 313; 315; 456; 457), while several scenes on vases depict either the competitions themselves or the crowning of the victors (fig. 374–376).

According to Greek tradition, the oldest and greatest Games were those at Olympia, already established by the eighth century BC. According to Greek historians, nudity in sports was first adopted by the Spartans some time in the Archaic period and was later accepted by all Greeks. By the Classical period, competing in the nude had become a distinguishing feature between the Greeks and the non-Greek "barbarians." Athletes were mostly amateurs, though their coaches and trainers were professionals. The basic Greek sports included running, jumping, wrestling, and boxing, as well as the javelin-, discus-, and hammer throw. Equestrian sports were also included; chariot-racing was introduced to the Olympic Games in the seventh century BC, and several types of horse-racing were added soon afterwards. Women were generally excluded from the games, even though there is considerable evidence, mostly from the Peloponnese, of athletic competitions organized specifically for girls (see fig. 373).

Besides artistic representations of athletes and games, the archaeology of Greece has produced significant finds related to ancient sports, including the architectural structures in which they took place: a *stadium* was the standard racecourse, the *gymnasium* provided training grounds surrounded by porticoes, the *palaestra*, also porticoed, served as wrestling school, while the *hippodrome* was reserved for equestrian sports.

373. Dodona, bronze figurine of a girl-runner. Sixth century BC. Athens, National Archaeological Museum Kar. 24.

374. Eretria, Panathenaic amphora with wrestling scene (detail).
360/59 BC. Athens, National Archaeological Museum 20044.

375. Panathenaic amphora showing Victory crowning an athlete (detail).
363/362 BC. Los Angeles, The J. Paul Getty Museum 93.AE.55.

376. Panathenaic amphora with runners (detail). c. 530/520 BC.
New York, Metropolitan Museum of Art 14.130.12.

2.3 Monumental painting

The fourth century BC was a period of great achievements by Greek painters. According to writers in the Roman period, like Cicero and Pliny, who dealt with the history of Classical Greek art, the fourth century was marked by great technical innovations, the great mobility of the artists themselves and the recognition of the finest of them as persons of high repute, financial standing, and social position. The artist **Pamphilos**, a native of Sikyon or, according to others, from Amphipolis in Macedonia, worked in the first half of the fourth century. According to Pliny, Pamphilos was the first artist who studied arithmetic and geometry to perfect his art (*Natural History* 35.76). It is probable that this means that he studied the theory of ratio in determining the proportions of natural forms, as other artists had already done from the fifth century BC (see p. 173). From Pliny also we learn that Pamphilos charged high tuition fees to young budding artists, which seems to have contributed as much to his fame as to his fortune. Other later sources attribute to him also the authorship of essays relating to theoretical research and teaching, such as *On Draughtsmanship* and *On Painting and Illustrious Painters*.

The painter **Nikias** lived after the middle of the fourth century BC, pupil of the painter Antidotos who according to Pliny had been taught by the sculptor and painter Euphranor (see p. 207). He was, according to the same source, the first who used the technique of shading on the female body (*Natural History* 35.130–131). It is possible that in this he was influenced by his collaboration with Praxiteles, given that, it is said, the Athenian sculptor preferred him to paint his sculptures (see p. 205). In the second half of the fourth century BC the artist **Nikomachos** from Thebes was also renowned, the son and father of painters. Pliny mentions that one of his paintings, the *Rape of Persephone*, was transferred to the Capitolium in Rome (*Natural History* 35.108).

According to later historians, the artists of the second half of the fourth century perfected absolute realism in their painting, using the technique of shading that had been invented towards the end of the fifth century BC (p. 184–185). The creation of the perfect illusion, with the tools of shading, the tonal gradation of color, and the foreshortening of perspective, seem to have been achieved by artists during this period. Although the monumental works that have survived from the fourth century come usually from funerary monuments —and mainly the Macedonian tombs which will be studied in the following section— paintings by the great artists of the period which adorned the panhellenic sanctuaries and other public spaces in Greece, travelled —either as loot or purchases— to Rome and the rest of Italy. It appears moreover that the Romans of the late Republican and early Imperial periods (first century BC–first century AD) also had at their disposal copies of famous Greek wall paintings. In this way the Greek monumental paintings of the fourth century BC could have survived until the lifetime of Cicero or Pliny, so as to be studied by them. The impression that the painting of the fourth century BC made on the orator Cicero (106–44 BC), for example, was such, that he declared that "all of them are perfect" both in design and shading (*Brutus* 18.70). The combination of *skiagraphia* and *skenographia*, i.e. shading and perspective, allowed Greek artists already from the Classical period to render objects as they appeared in nature (and not simply as if they were isolated from their environment). Although the results of this appear to have been impressive, the more conservative philosophers of this period, such as Plato, rejected the tendency of contemporary painters to paint objects as they *appear* rather than as they *are* (*Sophist* 235e–236a).

2.3.1 PAINTING IN MACEDONIA

The relatively recent discoveries of rich funerary monuments in Macedonia, which date to the middle of the fourth century BC and later, have come to fill in what was a significant gap in our knowledge of Greek painting in the Classical period. The wall paintings of Macedonian tombs and other funerary monuments of the fourth century BC from Macedonia are reflections, possibly of inferior quality, of the wall paintings and paintings that adorned the Macedonian palaces, sanctuaries, and possibly even private villas of the period.

The most important evidence for Greek painting of the time comes from the so-called *Tomb of Persephone* at Vergina, a cist grave with dimensions 3×4.5 m dug into the ground and lined with large limestone blocks. It contained the bones of a man, as well as a young woman of about 25 years who died in childbirth and was buried along with her baby. The grave had been looted but has been dated to around 350 BC based on the few pieces of pottery left behind by the tomb robbers. Three walls of the tomb carried wall paintings, about 1 m high. Three seated females were depicted on the south wall and another one on the east wall. The focal point of the composition was on the north wall (fig. 391), where the rape of Persephone by Hades was de-

picted. The god and the girl are mounted on a four-horse chariot, which is moving at speed to the left. Hades is depicted as a mature man with wild hair and beard. In his right hand he holds a staff as well as the reins of the chariot horses, while with his left he tries to restrain Persephone who is shown desperately turning back with hands stretched out, begging for help. In front of the chariot we find Hermes in profile striding to the left. The god wears only a cloak fastened with a brooch at the level of his neck and *petasos*, the wide hat that identifies him in Greek iconography. In his right hand he holds the *kerykeion* (the iconic caduceus with entwined snakes), while with his left he grabs the reins of one of the chariot horses. Behind the chariot is a young woman on her knees who lifts her right hand in fear.

The color palette of the composition gives prominence to red, yellow, and purple, while there is also a little blue. The composition is both expressive and dynamic, the clothing is ren-

dered with a skilled use of shading (particularly the brilliant purple himation of Hades with its deep dramatic folds), while the outlines are rendered with fluidity. The feeling of movement and depth is emphasized by the foreshortened view of the wheels. The execution is perhaps hurried, a little rough and abbreviated. The artist had sketched a rough outline of the composition that is still visible beneath the painted surface. Of particular interest is the execution of the outlines of the female figures, predominantly the bare arm of Persephone, where there is not a single continuous outline but many small parallel dashes that give curvature to the female flesh. The execution recalls the comment that Pliny made regarding the rendering of the outline already by the first years of the fourth century, according to which a good artist could, in sketching the outline of bodies, paint it in such a way that "the outer frame, to be properly executed, requires to be nicely rounded" (*Natural History* 35.67).

391

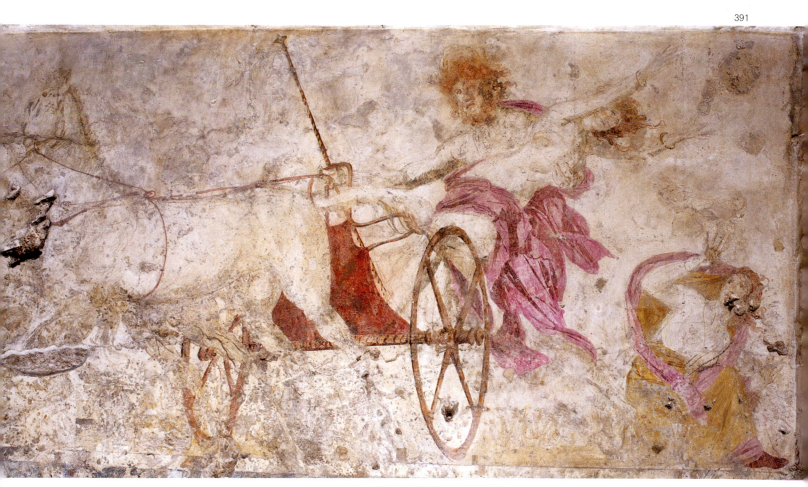

391. Vergina, "Tomb of Persephone." Wall painting depicting the rape of Persephone by Hades. c. 350 BC. Vergina, Museum of the Royal tombs at Aigai.

MACEDONIAN TOMB PAINTING

The *Macedonian tomb*, invented in Macedonia, is one of the most impressive examples of ancient Greek funerary monuments, as much for its construction and its decoration, as well as its rich grave goods. Macedonian tombs:

■ appeared in the fourth century BC and remained in use until the late Hellenistic period

■ are subterranean monuments, built from local limestone, lining the roads outside the walls of the city

■ have a square or rectangular plan and barrel-vaulted roof

■ may be single or double-chambered (i.e. an anteroom and a main burial chamber). Usually access to the tomb is via a built *dromos* (i.e. a downwards sloping passageway with a barrel-vaulted roof or a simple sloping ramp cut out of the rock). The

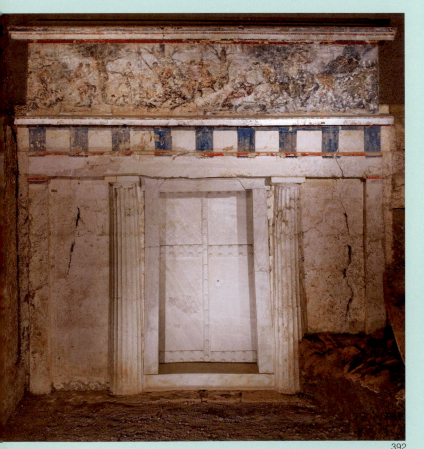

tomb and the dromos were covered with an earth mound, in order to prevent access

■ are usually family tombs, i.e. they were used for more than one burial and for a number of generations

■ featured monumental façades, made in plaster and sculpted stone (especially for fake doors) to look like the front of a house or temple: they were usually provided with pediments or architraves and a "door" in the center. The façade could be in the Ionic or Doric order or a combination of both. Vivid colors (red, deep blue, purple, green, black) emphasize the architectural decoration creating a visual contrast with the off-white color of the walls.

The most important monuments of this type have wall paintings on the interior and/or exterior, many of which are ambitious painted compositions of monumental character. The colors used were mineral-based, and the techniques employed were both those of fresco and tempera (see p. 184).

Important Macedonian tombs –but also the *Tomb of Persephone* cist grave mentioned above– have been excavated in the modern town of Vergina, in central Macedonia; as a result, and in view of the massive palace excavated nearby, the site has been identified as Aigai, the ancient capital of the kingdom of Macedon. The so-called *Tomb of Philip* is a typical example of a Macedonian tomb from the second half of the fourth century BC. It is a two-chambered tomb with a barrel-vaulted roof, 9.50 m wide and 5.96 m high. The façade (on the east side) is provided with a full architectural form in the Doric style with two columns in antis, an epistyle, a Doric frieze made up of 8 white, undecorated metopes and 9 blue-painted triglyphs (fig. 392). Instead of a pediment this tomb features an important modification, as it was crowned with an Ionic frieze 1.16 m high. The frieze is topped by a cornice and carries a painted hunt scene with numerous figures –three hunters on horseback and seven on foot– who are depicted in six scenes with their respective prey. From left to right, these are an antelope, a deer, a boar, a lion, a bear, and one unidentifiable creature. The scene is "set" with trees, in full leaf or bare, together with the rocks on the right edge of the frieze which articulate the space. Human presence is also evident in the landscape, in the shape of bands

392

392. Vergina, "Tomb of Philip" (view). c. 330–310 BC Vergina, Museum of the Royal tombs at Aigai.

393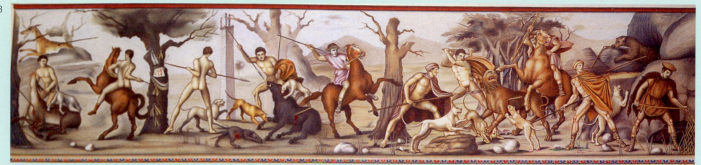

wrapped around the trunk of one of the trees or a tall pillar-stele on which stand unidentifiable objects (possibly vases).

The identification of the occupant of the tomb as Philip II of Macedon (and therefore its date as 336 BC when Philip was assassinated) has been seriously doubted by many scholars, who see elements of the early Hellenistic period in the scene of the hunt on

394

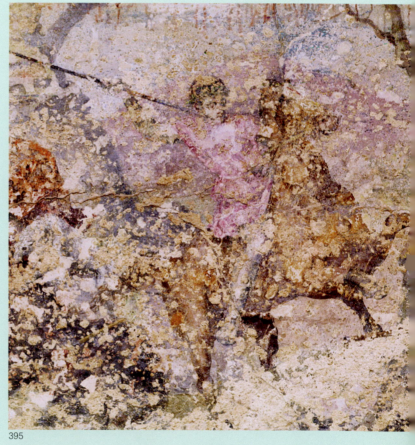

the monument. It is most likely a royal tomb dating to the first decades after Alexander's campaign (330–310 BC). Even though the surface of the wall painting is severely abraded, the identification of the central rider of the composition with Alexander himself is relatively secure (fig. 395). The scene, furthermore, is recognized as a royal hunt, in which the King and his *Hetairoi* ("companions": his courtiers and bodyguards, see fig. 393) took part. Since the scene is cut off at the right edge of the frieze (it seems as though the scene which is depicted there should continue further to the right) it is likely that the wall painting on the tomb was a shortened version of a wall painting that was visible elsewhere, possibly in the palace of Aigai itself, during the same period.

395

393. Vergina, "Tomb of Philip." The hunt scene (drawing). Vergina, Museum of the Royal tombs at Aigai.

394, 395. Vergina, "Tomb of Philip." The hunt scene (detail). Vergina, Museum of the Royal tombs at Aigai.

3. METALLURGY AND THE MINOR ARTS IN THE CLASSICAL PERIOD

Beyond the monumental arts of the Classical period, which must have had a strong impact on the way ancient Greek daily life looked like (and certainly influenced the way modern aesthetics still receive Classical art), the so-called (and often misunderstood) "minor arts" equally contributed to the diffusion of classical ethos and to the consolidation of a common style throughout the Greek world during the fifth and fourth centuries BC. For the Classical archaeologist, the minor arts —metallic and clay figurines, jewelry and seals, coins— are valuable immediate sources for ancient Greek culture, as they have survived in large numbers, and are indeed originals (in contrast to monumental painting, for example, of that only a few examples have survived to the present day, or sculpture which we must study to a large extent through later copies and derivatives).

3.1 Metalworking

The dedications at the great sanctuaries of the Classical period recreate the types of monumental sculpture, widening at the same time their scope. The correlation is particularly evident in the cases such as the bronze figurine from the sanctuary of Zeus at Dodona (fig. 397), a few centimeters tall, which represents the *Zeus Kerauneios* ("he who hurls the thunderbolt"), a type which a decade later we see in the monumental *Artemision Zeus* (fig. 243). The figurine indeed still preserves the thunderbolt, in this way making the identification of the Artemision statue almost certain. In contrast, a number of figurines of female deities of the *Peplophoros* type appear to have developed from a prototype in monumental sculpture (see fig. 242). The appearance of the type also in metal objects of a functional nature (such as the mirror in fig. 396), which, however, could either be placed in a sanctuary or be deposited in graves as offerings, demonstrates how familiar such figures were to Greeks in the period of the Severe Style (c. 480–450 BC).

The so-called "noble" metals of antiquity —gold, silver, bronze— carried intrinsic exchange value: a metal object (worked or not) was directly exchangeable with a quantity of metal of the same weight or with objects of equal market value. The bronze or iron tripod cauldrons dedicated as offerings during the Early Iron Age and later (see. fig. 68 and 94) convey such an intrinsic value according to their weight. The Homeric epics, of course, refer to a period when coinage, that is stamped coins of specific value which are still used today (p. 221–223), had not yet made their appearance into economic exchange. Even so there are cases in the epics when the valuation of metal objects, such as weapons, was done with reference to the equivalent value in a number of animals, mainly oxen (such as in *enneavoia* or even *hekatomvoia* weapons, worth 9 or 100 oxen respectively). These are vestiges of a *premetallic*, barter economy,

396. Bronze mirror. c. 470–460 BC. Athens, National Archaeological Museum 7579.

397. Dodona, bronze statue of Zeus Kerauneios. c. 470–460 BC. Athens, National Archaeological Museum 16546.

METAL: INTRINSIC AND RELATIONAL VALUE

During the historical period the standard for exchange was silver. A unit of weight *and* value was the silver drachma (in Athens 1 drachma = 4.313 g). A silver vase with a weight of 30 drachmas would cost 30 silver drachmas. In contrast, the cost of a vase of the same weight but in a different metal would be defined according to the relational value of that metal in terms of silver at the specific time. For example, the value ratio of gold to silver fluctuated significantly during the first millennium BC, depending on political circumstances and technological advancements: while in the seventh century BC the value of gold was identical to the value of silver (owing to the rarity of the latter), in the sixth century the gold : silver ratio was around 13:1, in the fifth century 15:1 and in the fourth century 10:1. Political developments contributed to this fluctuation –such as the Peloponnesian war that led to a shortage of gold in the second half of the fifth century BC– and then the exploitation of gold resources in eastern Macedonia by Philip II, and the ensuing minting of large gold coins. Therefore, a *gold* vessel weighing 30 drachmas (i.e. 130 g) would cost, comparatively, 390 silver drachmas in the sixth century BC, 450 in the fifth century BC and 300 in the fourth century BC. The exchange rate of metal vessels appears to have imposed standards of size and weight for silver and bronze vessels. According to inscriptions from the Classical period, we may infer that metal phialai were usually manufactured according to a weight standard of 100 drachmas (about 430 g) and hydriai of 1000 drachmas (about 4300 g).

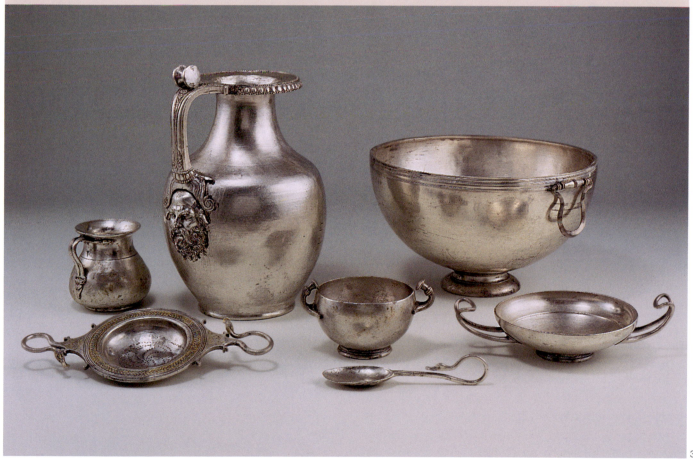

398

398. Group of silver vessels from the "Tomb of Philip." Second half of
the fourth century BC. Vergina, Museum of the Royal tombs at Aigai.

when commercial trade was based on an exchange of goods according to an established system of equivalents.

The shapes of Greek metal vessels are similar to those of clay vessels which we have already met, for which incidentally they are also the prototypes. In contrast to these, however, it would appear that silver, bronze, and (more rarely) gold vessels of the ancient Greek world were undecorated, with the exception of banding or other stamped decoration (such as flowers or rosettes). There are very few surviving examples from Greece, since these valuable items were usually recycled. Their use is exemplified in other works of art such as sculpture (see fig. 331) and vase painting (see fig. 332, 336). The deposition of metal objects as grave offerings in the Classical period occurs most frequently in areas of the northern periphery of the Greek world such as Macedonia. A typical example is the case of the Macedonian graves of the late fourth century, as well as the cist graves that were found, unlooted, at Derveni (10 km northwest of Thessaloniki). The silver and bronze vessels that were found in them provide a useful benchmark for the level of Greek metalworking during the late Classical period.

From the so-called tomb B at Derveni came the Derveni krater, one of the most important examples of Classical metalworking (fig. 399). It is a bronze volute krater, 90 cm tall. The body is hammered while the handles and its base, as well as the four protome-statues on the shoulder are all cast (see fig. 237). Silver and copper foil was used to decorate several areas. The figurative theme of the relief scene is Dionysian. On the main face is depicted the *Hieros Gamos* (sacred wedding) of Dionysus and Ariadne. The couple are depicted seated outdoors surrounded by Maenads who are dancing or resting, by other mythical figures, wild beasts, and branches of vine and ivy. Dionysus is naked, seated in a languid pose on rock which has been covered with his himation. His right arm is around his head, at the same time resting his right leg in "marital" familiarity on the left thigh of Ariadne, who is also seated in her chiton and her himation with which she covers her head (in the pose of *anakalypsis* — "revelation" — a typical gesture for the wife or bride in Greek iconography).

On the rim, an inscription with inlaid silver letters names the some-time owner of this vessel (perhaps the occupant of the tomb): Astion, son of Anaxagoras, from Larisa. The metal alloy of the vessel is a special mix, with a high tin content, so that the krater might appear gilded.

399. Derveni, tomb B. Bronze volute krater. c. 330–320 BC
Thessaloniki, Archaeological Museum B1.

3.2 Jewelry

During the Classical period it appears that there was initially a decline in the production of excessively embellished jewelry in comparison to the sophisticated examples of the sixth century BC (see fig. 236). This is due in part to the relative scarcity of precious metals, but also to the more general austerity which characterizes attitudes in the early Classical period. The shapes are simpler, the jewelry is more delicate, smaller in size, and more balanced. Gradually sculpted details are added onto necklaces and earrings, which feature mainly on the jewelry at the periphery of the Greek world. A typical example of necklace in the fifth and fourth century is that with a braided chain from which hang spear-shaped or fruit-like pendants. The necklace from tomb Z at Derveni belongs to this

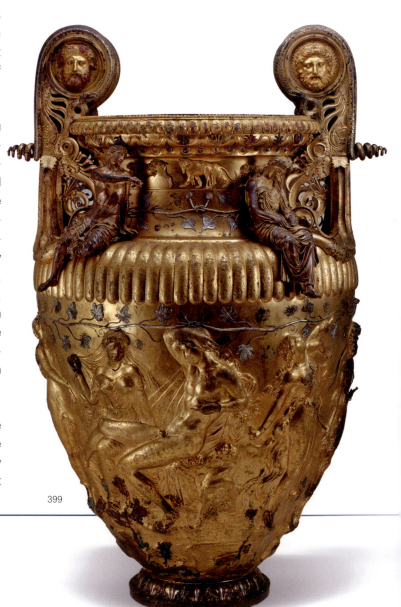

399

type: it was found in a woman's grave along with 6 gold, cast, *bow fibulae*, of a type which was particularly widespread at this time (fig. 400). The same grave produced a gold pendant in the form of a Herakles' head.

The "golden age" for ancient Greek jewelry began from the middle of the fourth century BC as a result of the abundance of the raw material, the expanding boundaries of the Greek world and the close contact with other cultures, especially to the north and east of Greece. Technological developments allowed the creation of miniature sculptures that were used as earrings (fig. 402). Especially famous in this period were the Greek gold-workers in the area of the Black Sea and even further east on the western shores of the Caspian Sea (ancient Colchis, modern Georgia). The burial customs and the social stratification of the communities in the region, such as the Scythians, allowed Greek jewelers to work for wealthy clients, who were after both sartorial sophistication and social advancement. Objects such as the gold bracelet with terminals in the form of sphinxes (fig. 401) combined Scythian themes with Greek aesthetics (which certainly in the eyes of its owner, a Scythian who was buried in a monumental tomb at Kul Oba in the Crimea close to ancient Panticapaeum, must have seemed very sophisticated). The twisted band of the bracelet made of forged plate with embossed grooves and filigree decoration, and the protomes of the sphinxes, also forged, are

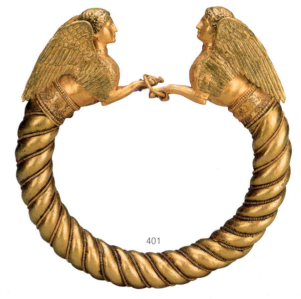

401

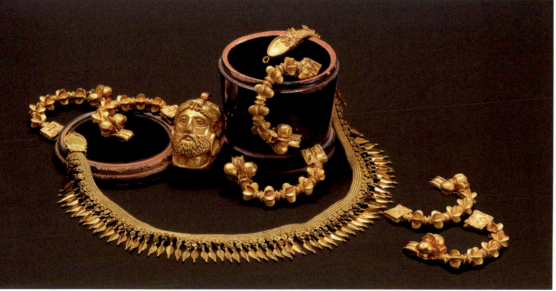

400

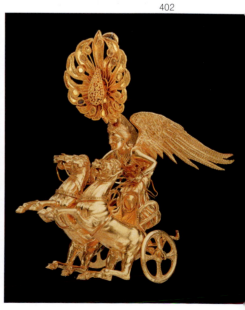

402

400. Derveni, gold grave goods from tomb Z. Second half of the fourth century BC. Thessaloniki, Archaeological Museum.

401. Kul-Oba barrow, Crimea. Gold bracelet with protomes in the form of a sphinx. Middle of the fourth century BC. St. Petersburg, Hermitage Museum.

402. Thessaly, gold earring – Nike driving a two-horse chariot. c. 340 BC. Boston, Museum of Fine Art.

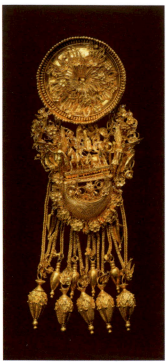 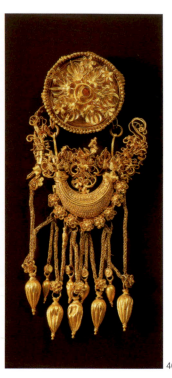

403 404

THE PECTORAL FROM TOLSTAYA MOGILA

THE PECTORAL FROM TOLSTAYA MOGILA

One of the most important works of Greek gold-working in the fourth century BC comes from the Scythian tomb of Tolstaya Mogila in the area of Depropetrovsk in modern Ukraine. It has a diameter of 30.6 cm and weighs 1.15 kg. The pectoral has two friezes with figures entirely in the round, each of which were either molded or sculpted separately. The lower frieze features a mythical theme, wild animals and beasts tearing animals apart. The upper frieze is of greater interest, depicting scenes of animal husbandry supposedly taking place in the region: milking, slaughter and skinning of sheep and goats, grazing, animals nursing their young. The naturalism of the human and animal forms is impressive –clothing and hairstyle, facial characteristics, animal hair– as well as the ability of the goldsmith to work in miniature. Works such as this have permitted the assumption that mobile Greek gold-workers operated in the area of Scythia (to the north and east of the Black Sea) during this period, possibly with a base in the Greek cities further south, on the Crimean peninsula and the coast of the sea of Asov.

typical of a series of similar —but less precious— bracelets that we meet in Greek graves. The Scythian occupant of the tomb at Kul Oba was accompanied by a woman, also furnished with jewelry of Greek manufacture, amongst which was a pair of gold pendants featuring the head of Athena Parthenos on the central disc (fig. 323). In the typology of earrings, an important development during the fourth century is the crescent type, which featured a central particle in the shape of a crescent hanging from a disc usually decorated with embossed rosettes. From the crescent hung other, smaller appendages in the shape of fruits, spears, or vessels. Those from the Crimea are typical examples, but others come from Greece, such as the pair from tomb Z at Derveni (fig. 403–404).

As we saw in a previous section (p. 188–193) Greek sculptors were particularly famous in the fourth century BC for their ability to represent the diversity of other ethnic groups, in such a way that these depictions were consistent with the rules of Greek art but also with the wishes of their clientele (see pp. 355 and 358). The same phenomenon is apparent also in the minor arts of the period. Miniature sculptural compositions on jewelry, probably made for non-Greek clients, are characterized by the same rendering of foreign elements.

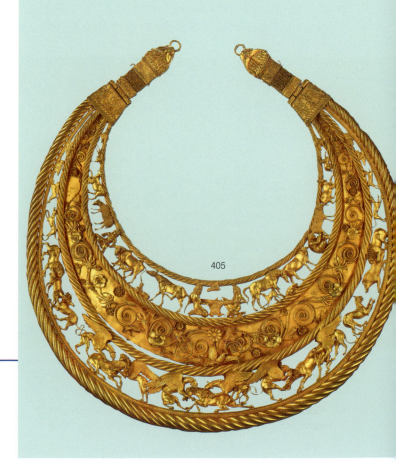

405

403, 404. Gold disc earrings with boat-shaped pendants: (403) Crimea, (404) Derveni. Second half of the fourth century BC. St. Petersburg, Hermitage Museum and Thessaloniki, Archaeological Museum.

405. Ukraine, gold pectoral from the Tolstaya Mogila tomb. Fourth century BC. Kiev, Museum of Historical Treasures of the Ukraine.

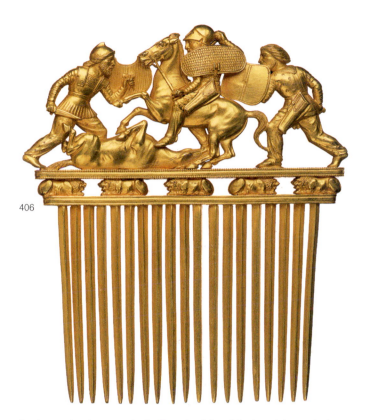

406

407

408

An important example is the double-sided gold comb from one of the Solocka tombs, on the east bank of the river Dnieper in modern Ukraine (fig. 406). It probably belonged to a Scythian aristocrat who may himself have designed the scene which decorates the elaborate cast handle: a battle between a horseman and an opponent on foot beside his dead horse, while a foot soldier, a comrade of the first horseman, follows. The three warriors are depicted as Scythians wearing short chitons with sleeves, *anaxyrides* ("trousers") and closed shoes rather than the Greek sandals. On the other hand, the bearded cavalryman is wearing a Corinthian helmet pushed back on his forehead, a detail that makes him appear rather "Greeklike." Another Hellenizing feature is the "pedimental" composition of the scene, which seems to be derived from Greek architecture.

3.3 Sealstones

The transition from the Archaic to the Classical period is marked in seal-carving by a series of changes in the shape, in the raw material used, in the techniques, and in the iconography of the sealstones. The motifs on the sealstones become smaller, no longer filling the entire space, while the style re-

flects the parallel developments in sculpture and vase painting. The most popular themes are the heads of gods or humans, standing male or female figures, certain mythological scenes, and some "studies" of animals or birds. During the Classical period new themes were introduced into the repertoire of Greek seal-cutting, which are not encountered in other areas of Greek art, an example of the originality of the engravers of the period. Areas of East Greece, as well as the Cyclades, remained important centers for the manufacture of sealstones, but important workshops appear elsewhere. The beetle-shaped scarab was gradually abandoned to be replaced with its featureless version, the plainer *scaraboid*. The stones were frequently set into metal rings, something which was to become standard in the Hellenistic period. Another change that may be observed during the Classical period is the gradual transfer of the figurative scene from the flat base of the stone (where traditionally it belonged because of the scarab typology) to its convex back, leaving a much deeper imprint in its use for sealing.

The most popular material used in the Classical period was white, gray, or blue chalcedony. They also used cornelian, agate, jasper in many different colors, and rock crystal. During

406. Ukraine, double-sided gold comb. First half of the fourth century BC. St. Petersburg, Hermitage Museum.

407. Gold ring with a scene of a woman and fawn. Fourth century BC. St. Petersburg, Hermitage Museum.

408. Blue chalcedony scaraboid. Nike raising a trophy. Fourth century BC. London, British Museum.

429

Money and credit in the Greek world

The rise of trade in Greece in the fifth century BC was a consequence of the end of the Persian Wars and the imposition of Athenian hegemony, which led to an economic boom and a population increase. The number of slaves also increased, as did industrial manufacture of goods, at the expense of household production; specialist artisanship replaced non professional and occasional entrepreneurship. The consequence of these developments was, as already discussed, that money replaced the old methods of exchange. The monetarization of the economy had political consequences, as money became a commodity in its own right and disposable wealth competed with aristocratic descent and land ownership as factors of social discrimination. Silver was abundantly available, but was controlled by the authorities of each city. At the same time, however, the price of essential goods, particularly imports, increased: in Athens, the price of grain is thought to have tripled in the fifth century. This was due to increased demand, as a result of population growth, the need for imports, and the emergence of businesses specialization in production and retail. At the same time, the price of animals increased more than tenfold from the time of the Persian Wars to the end of the fifth century BC. The search for capital for the ever increasing commercial enterprises created the practice of borrowing and the profession of usurer. While in previous years the lending of money with interest was the prerogative of the sanctuaries (according to inscriptions from Delos and elsewhere), at the end of the fifth century private banks emerged (the Greek term for "bank," *trapeza*, comes from the table that the money lenders used for their transactions). Private bankers also devised deposit interest, offering in this way an increase of the capital with which their clients entrusted them (usually 1 drachma per mina per mounth, that is a monthly interest of 1%). Thus, while the sanctuaries also offered simple safe storage, private banks began to attract those who discovered the benefits of saving as a form of investment. Gradually the sanctuaries followed the lead of the private money market and offered interest to their clients, but it seems that the majority of borrowers and depositors continued to use the private bankers. At the end of the fifth century BC the large quantities of valuable metal which had been put into circulation as a result of the long drawn out war created an abundance of money, including in the coffers of private citizens. The increase in trade maintained the mobility of capital and interest remained high. In the fourth century BC, deposit interest rate in Athens was around 10% while interest rate on loans had reached 12%. In Athens, but also elsewhere, the bankers were usually metics, who did not have political rights, nor the right to own land.

Smaller amounts were concealed by their owners, a method offering secrecy but little security, and in many cases savings fell prey to others or were completely lost. A *coin hoard* is the term used for a group of coins found together either in excavation or by chance. They are usually the result of ancient hoarding and concealment, which remained unexploited in antiquity as a result of some extraordinary event (most likely the death of the owner). The archaeological significance of hoards is of particular importance, especially in cases were the same hoard contains coins from different mints, as in this way we can build a more secure picture of coin circulation at a particular point of time. Instances of hoards which contain, besides coins, gold and silver jewelry as well as metal vessels are frequent.

429. Myrina, Karditsa, hoard of 149 Aeginetan silver staters. c. 440 BC. Athens, Numismatic Museum.

430. Olympia, terracotta statue of Zeus and Ganymede. c. 470 BC. Olympia, Archaeological Museum T 2/T 2α/Tc 1049.

The majority of works of ancient terracottas ("cooked earth" in Italian) are usually small figurines (c. 10–30 cm). Already by the Early Iron Age, and especially in the eighth century BC, clay figurines were made in large numbers as offerings for sanctuaries and as grave goods for the dead. There are also examples of terracottas that had a domestic use as children's toys. Their construction is particularly simple: they are made en masse in a mold, usually in two parts (back and front) which are joined together. The most frequent subject of Greek sculpture during the Archaic and Classical periods was a goddess (the oldest types derived from Syro-Palestinian prototypes). Figures of dedicants, female and young men, also appear mainly during the late fifth and fourth century BC. During the Classical period, there was an increase in the num-

ber of depictions of Dionysus (like the votive terracotta protome in fig. 431) and Dionysian themes in general.

During the fourth century a relative secularization of the iconography of Greek figurines may be observed. The use remains mostly dedicatory and funerary, but the figurines tend to avoid any iconographic relevance to worship. A typical example is the so-called *Tanagra type*, which depict elegant women in a languid pose (fig. 432). The type appears to have been invented in Athens during the first half of the fourth century BC, from where it spread to the whole of the Greek world. The wholesale illegal excavation of such figurines from graves in the area of Boeotian Tanagra at the end of the nineteenth century gave the type its name, as collectors and scholars thought then that they were the products of a Boeotian workshop. The same workshops created figurines of other types, such as depictions of Aphrodite, young boys, or animals, but the most common remains the upright female type who is wrapped coquettishly in a himation that was worn over her chiton. Frequently the female figures of the type hold a fan or wear elegant broad brimmed straw hats.

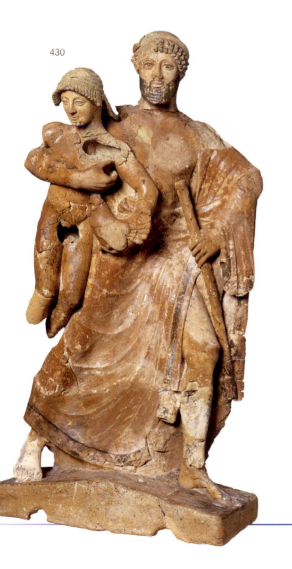

430

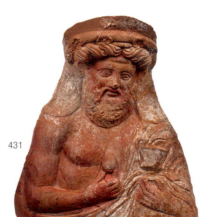

431

432

431. Exarchos, Lokris, terracotta protome of Dionysus. c. 350 BC. Athens, National Archaeological Museum 5675.

432. Terracotta model of a woman. c. 350 BC. Paris, Louvre CA 3312.

SELECT BIBLIOGRAPHY

General

J.J. Pollitt, *Art and experience in Classical Greece*. Cambridge: Cambridge University Press (1972).

Sculpture

J. Boardman, *Greek Sculpture. The Classical Period*. London and New York: Thames and Hudson (1985).

J. Boardman, *Greek Sculpture. The Late Classical Period and Sculpture in Colonies and Overseas*. London and New York: Thames and Hudson (1995).

I. Jenkins (ed.), *The Defining Beauty. The Body in Ancient Greek Art*. London: British Museum Press (2015).

O. Palagia (ed.), *Greek Sculpture. Function, materials, and techniques in the Archaic and Classical Periods*. Cambridge: Cambridge University Press (2008).

N. Spivey, *Greek Sculpture*. Cambridge: Cambridge University Press (2013).

A. Stewart, *Greek Sculpture. An Exploration*. New Haven and London: Yale University Press (1990).

Pottery

J. Boardman, *The History of Greek Vases*. London and New York: Thames and Hudson (2006).

F. Lissarrague, *Greek Vases. The Athenians and their Images*. New York: Riverside Book Company (2001).

J.R. Mertens, *How to Read Greek Vases*. New York: Metropolitan Museum of Art (2011).

J.H. Oakley, *The Greek Vase. Art of the Storyteller*. Los Angeles: J. Paul Getty Museum (2013).

T. Rasmussen and N. Spivey (eds), *Looking at Greek Vases*. Cambridge: Cambridge University Press (1999), ch. 5–7, 9–10.

M. Robertson, *The Art of Vase-Painting in Classical Athens*. Cambridge: Cambridge University Press (1994).

Painting

I. Kakoulli, *Greek Painting Techniques and Materials. From the Fourth to the First Century BC*. London: Archetype Books (2009).

J.J. Pollitt, (ed.), *The Cambridge History of Painting in the Classical World*. Cambridge: Cambridge University Press (2015).

Architecture

I. Jenkins, *Greek Architecture and its Sculpture*. Cambridge MA: Harvard University Press (2007).

A.W. Lawrence, *Greek Architecture*. New Haven and London: Yale University Press (5th ed. 1996).

A. Spawforth, *The Complete Greek Temples*. London and New York: Thames and Hudson (2006).

Minor Arts

J. Boardman, *Greek Gems and Finger Rings. Early Bronze Age to Late Classical*. London: Thames and Hudson (2001).

W.E. Metcalf (ed.), *The Oxford Handbook of Greek and Roman Coinage*. Oxford: Oxford University Press (2012).

D. Williams and J. Ogden, *Greek Gold. Jewellery of the Classical World*. London: British Museum Press (1995).

MAP II: THE HELLENISTIC WORLD

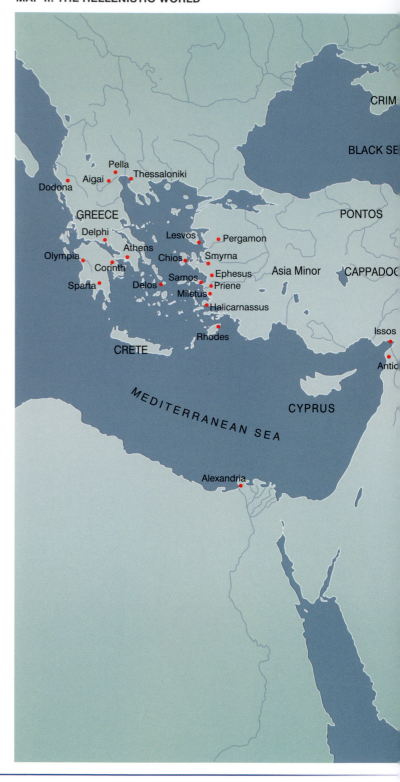

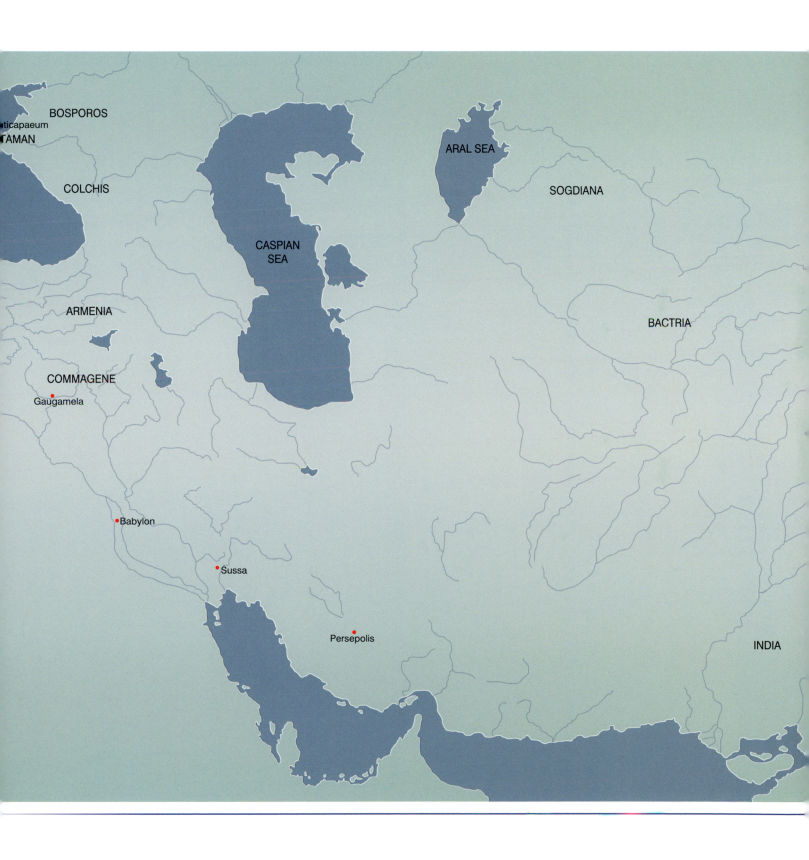

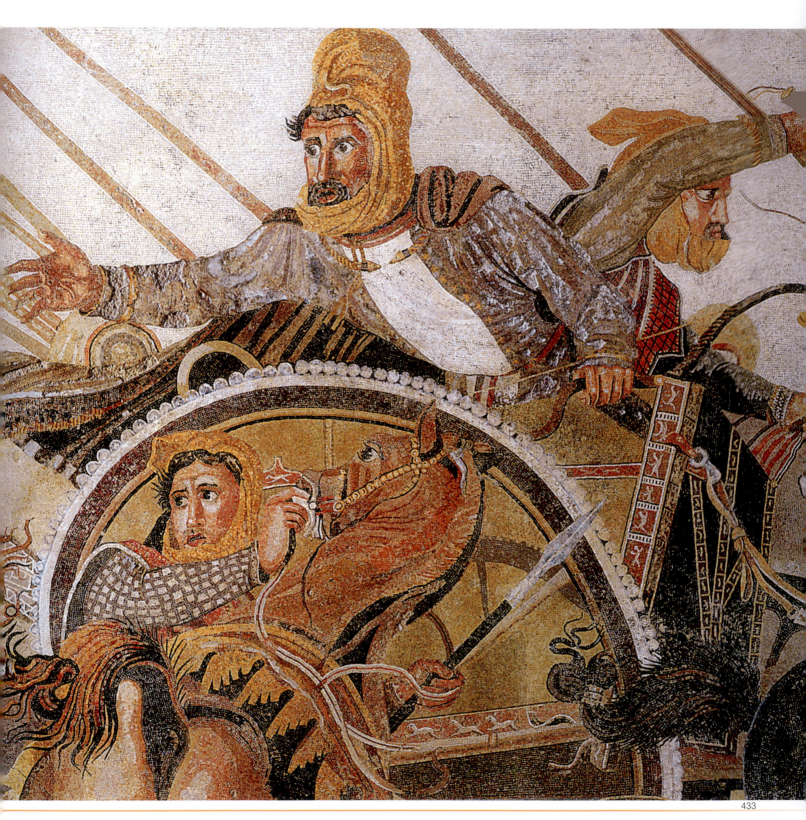

433. Detail of the mosaic in fig. 525.

THE HELLENISTIC PERIOD
(336 BC–30 BC)

The timespan between the late fourth century BC and the late first century BC is called the Hellenistic period. The term "Hellenistic" (from the German "Hellenismus") was proposed by historians of the nineteenth century in order to define the historical era inaugurated with the rapid expansion of the kingdom of Macedon, followed by the emergence of a number of smaller kingdoms created by the successors of Alexander the Great in the territories he conquered. The end of the period, 30 BC, is marked by the dissolution of the last independent Hellenistic kingdom, that of the Ptolemies in Egypt, and the decisive advent of Roman rule over the former Greek world.

In brief, the Hellenistic period is characterized by:

THE POLITICAL DECLINE OF THE CITY-STATE Already by the first half of the fourth century BC, the degeneration of the institution was apparent, but the unprecedented expansion of the Greek world after 330 BC, the promotion of monarchy, and the newly established realities of centralized power led to the gradual abandonment of old ideas under the pressure of new political factors.

INTERCULTURATION The old division between *Greeks* and *barbarians* was undermined significantly, as large sections of the populations of Greek cities (mostly their youth) sought their fortunes in the dazzling cities of the Hellenistic east (epitomized by Alexandria in Egypt). Whether as soldiers or as traders or professionals, those Greeks came into direct contact with the indigenous peoples and their culture. In Ptolemaic Egypt, in Seleucid Mesopotamia, in the kingdom of Pontos, in Cappadocia or Bactria the locals adopted "Hellenizing" elements from Greek civilization (mainly by learning the Greek language which thus became international), but also the Greek newcomers adopted many elements of local culture (such as religion). The mixture that resulted is generally called "Hellenistic culture" —because of the older belief of historians that Alexander's campaign also had a "civilizing" character; today, however, we are in the position to know that this period is less Greco-centric than we once thought and that local cultures played a large part in its composition and development. Therefore, the study of individual manifestations, as much in political as in cultural history, requires an in-depth knowledge of the local culture (language, religion, art, traditions).

THE SECULARIZATION OF GREEK CULTURE The development of Greek culture from the Early Iron Age until the end of the Classical period was firmly rooted in Greek religious tradition. Although the Greek cities were far from the theocratic hegemonies of the East, religion had a clear institutional role in the city-state, affecting every political and cultural activity from the theater to architecture and the visual arts. During the Hellenistic period, although Greek religious tradition remained active, the prevalence of monarchy as a concept led to the replacement, even in part, of the distant Olympian and other deities by the powerful kings of the moment who were often also worshipped in life. Furthermore, the contact between the Greeks and the religious syncretism that gradually prevailed in the eastern Mediterranean from as early as the third century BC and the acceptance, in part, of the local deities that did not come from the Greek tradition, led inevitably also to a more relativist reception of religious beliefs. On the other hand, the foundation of mystery cults, such as those of Isis and Mithras, and the personification

of abstract concepts, such as Tyche, were to lead to the fundamental turn towards monotheism in the Roman period, marking, with the decisive predominance of Christianity, the end of the ancient world.

NEW WAYS OF THINKING The extension of Macedon to the East, the overthrow of the Persian kingdom, the conquest of Egypt and of Asia, expanded the boundaries of the Greek world. At the same time, however, it brought the Greeks and their leaders face to face with the administration of new, spear-conquered lands and the managing of complex political, state, economic, and cultural matters. The institution of kingship and state administration now increasingly occupied Greek (and Hellenizing) philosophers. In contrast, taxation, bureaucratic management, and the political and economic control of the disparate peoples who lived (sometimes harmoniously and sometimes not) within the boundaries of a vast kingdom, such as Egypt, Syria, Pergamon, and so on, created the need to dis-

cover new solutions for running the state — many of which have survived until, or been revived, today. Besides the central authority, Hellenistic culture is characterized by a more open, cosmopolitan reconciliation between humans and their place in society. The emergence of the individual — which replaced the old civic commitment of a citizen to the principals and needs of his city — now characterized the philosophical and ideological discourse of the Hellenistic period. At the same time, systematic patronage of philosophers by royalty led to the development of science and technology, spearheaded by physiology, medicine, and engineering (mainly focussed on siege techniques) but also on the "noble" sciences of astronomy and mathematics. Finally, the intense interest in Classical Greek culture, as the Hellenistic kings sought to highlight their intellectual inheritance from it, led to the development of philology and the codification of language and grammar with consequences that are evident to the present day.

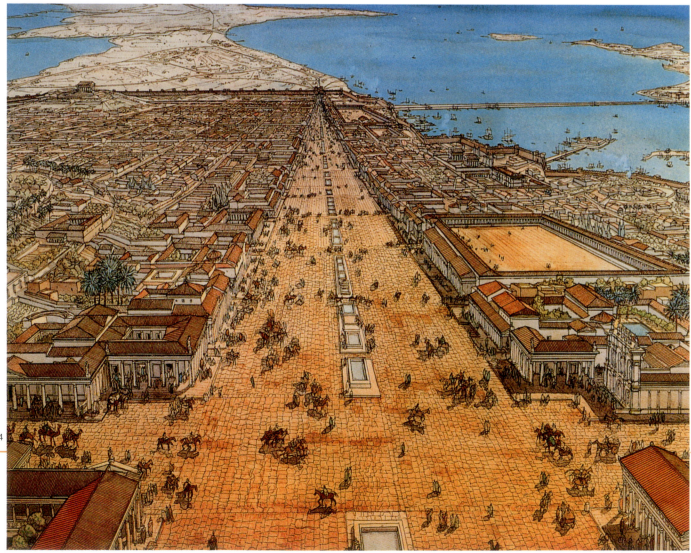

434

THE DEVELOPMENT OF "HELLENISTIC ART" As is clear from the above, Hellenistic art was a continuation of Classical Greek art, but it emerged with strong acculturated elements from the new political environment in which it evolved. Since a large part of it was created outside the boundaries of the Greek world, its development was heavily influenced by local traditions. Besides this, an important change that occurred in this period was royal patronage, which now replaced the faceless intervention of the city-state, but also the emergence of named artists, who were called on to offer their work for a lavish fee and were often treated, to a certain extent, just as are the famous artists or painters of our time.

The new conceptions about art, along with the new conditions, which determined the production and distribution of works of art, led to a significant diversification from the principles of the previous period.

The Hellenistic period is conventionally divided into three subperiods:
- The period from the onset of Alexander's campaign to the consolidation of the Hellenistic kingdoms (336–275 BC).
- The period of expansion and floruit of the Hellenistic kingdoms (275–150 BC).
- The period of increased Roman presence and intervention in political and cultural matters relating to the Hellenistic kingdoms (150–30 BC).

As has often been noted in previous chapters, historical periodization is purely conventional; this is especially so in the Hellenistic period, when cultural developments are not easy to pinpoint or monitor. In the case of the Greek world in particular, the Roman presence is already evident from the first half of the second century BC and very obvious after the battle of Pydna in 168 BC, which marked the final subjugation of Macedon and the rest of Greece to the Romans. It must also be stressed that while the political changes in Rome and the rest of the Mediterranean during the last decades of the first century BC were radically innovative, culture itself moved with different rhythms. Art, in particular, did not experience any obvious change with the establishment of the Empire and the onset of the Imperial period, and to a large degree appeared to preserve its "Hellenistic" character until the second century AD.

435

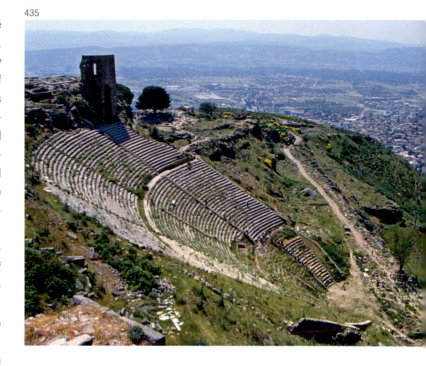

1. ARCHITECTURE AND URBAN PLANNING

The foundation of new cities across Alexander's newly formed empire provided the opportunity for experimentation in architecture and urban planning. The use of the Hippodamian system became widespread, with the most important examples being Alexandria in Egypt, Antioch, Laodicea, and Apamea in Syria. Emphasis was placed on the central roads of the grid system, which gradually took on a monumental appearance with the addition of porticoes lining them (fig. 434).

In other cases, such as at Pergamon on the coast of Asia Minor, the natural slope of the terrain, with significant differences in height, was used to emphasize the monumental character of public architecture. The different civic spaces developed in stages and at different levels, promoting the image of the city itself and its leaders, the royal family of the Attalids (fig. 435–436).

1.1 Public architecture

The traditional technique of *terracing* (building man-made platforms supported by specially constructed retaining walls) was employed in the structure of major Hellenistic sanctuaries,

434. Reconstruction drawing of Alexandria in the second century BC.

435. Pergamon, the theater.

THE AGORA OF ATHENS
DURING THE HELLENISTIC PERIOD

The late fourth and the entire third century BC was a period of wars and political conflict for Athens which led to the city's decline. During the last decades of the third century, however, Athens started to attract the interest of the powerful kings of the Hellenistic East who sought to associate their name with the splendid Athenian tradition of the Classical period.

First Ptolemy III Euergetes of Egypt (246–222 BC) funded the construction of a gymnasium within the city walls around 229 BC. In the Agora no noteworthy building activity has been observed in the third century BC, with the exception of a sizeable, but cursorily made square edifice featuring a peristyle (sides measuring 35 m) in its northeast corner, probably intended for use as a court.

During the second century BC, the forceful interventions by Rome in Greece gradually neutralized Macedonian power and permitted Athens to live in relative independence. The philosophical schools of the city kept alive the intellectual traditions of the Classical period, continuing the teachings of Plato, Aristotle, Zeno, and other great teachers of the fourth century BC, and, like a magnet, attracted the sons of the royal families of the East (as well as the representatives of the Roman ruling class). Very quickly Athens became the field for noble rivalry between the royal

442

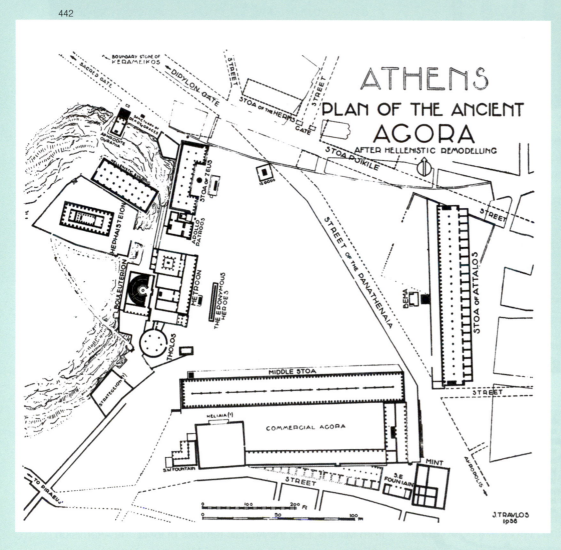

443

442. The agora of Athens during the middle of the second century BC.

443. Reconstruction drawing of the Stoa of Attalos.

444. Athens, the Stoa of Attalos after its reconstruction in 1953–1956.

houses of the Hellenistic East –from the Ptolemies in Egypt, the Attalids in Pergamon, and the Seleucids in Syria to the kings of Cappadocia and Pontos– who tried to outdo each other, aiming to adorn the city and promote themselves. King Eumenes II Soter of Pergamon (197–160 BC) donated the monumental stoa of the same name on the south slope of the Acropolis, while his successor Attalos II Philadelphos (160–139 BC) funded the building of his own stoa along the length of the eastern edge of the Agora (fig. 442).

The **Stoa of Attalos** was 115 m long and 20 m wide. It is one of the most developed examples of its type: it has two stories with a double-tiered colonnade on both floors and a series of 21 rooms at the back which were used as shops (fig. 443–444). The stoa was built in limestone and marble. It combines both Doric and Ionic elements, as well as a special type of column capital in the inner colonnade of the upper floor, which is called "Pergamene." The building, along with many others in the Agora, was destroyed by the Herulians, a Germanic tribe raiding Greece in AD 267. It was completely rebuilt in 1956 and today houses the Museum of the Ancient Agora.

To the second century dates the erection of the "Middle Stoa" (as it was called by its excavators) along the south side of the Agora (fig. 442). The stoa is particularly large (147×17.5 m) but was built out of relatively cheap material –mainly limestone and only a little marble. Traces of color that survive confirm its brilliant façade in antiquity. It has been suggested that the Middle Stoa was a gift of king Pharnaces I of Pontos (185–170 BC). Along with a further stoa (known today as "South Stoa II") and a long rectangular building erected at right angles to it on the east (the East Building) it forms a four-sided structure, possibly commercial in nature (fig. 442). In this way the public space of the Agora was arranged during the Hellenistic period as an architectural whole and acquired a splendor equal to that of the most important cities of the Hellenistic world.

Around 140 BC, in the area of the old Bouleuterion on the west side of the Agora (fig. 442) the new sanctuary to the Mother of the Gods, as well as the city archive (*Metroon*) were built. The Metroon complex was adorned with an Ionic colonnade on the east side, continuing the alignment of the Stoa of Zeus and the Basileus Stoa further to the north.

444

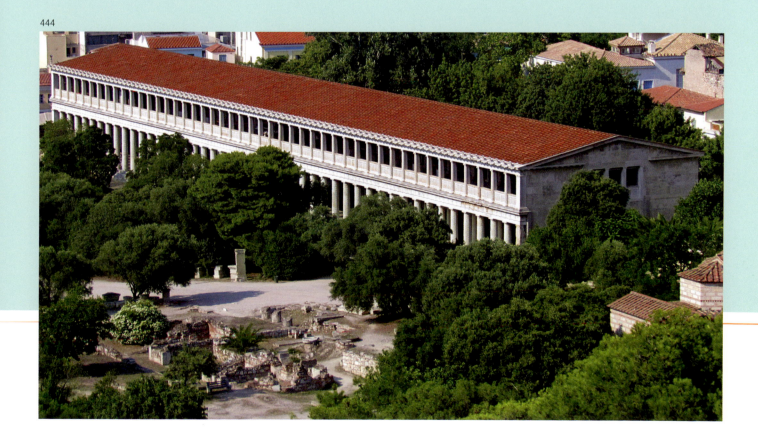

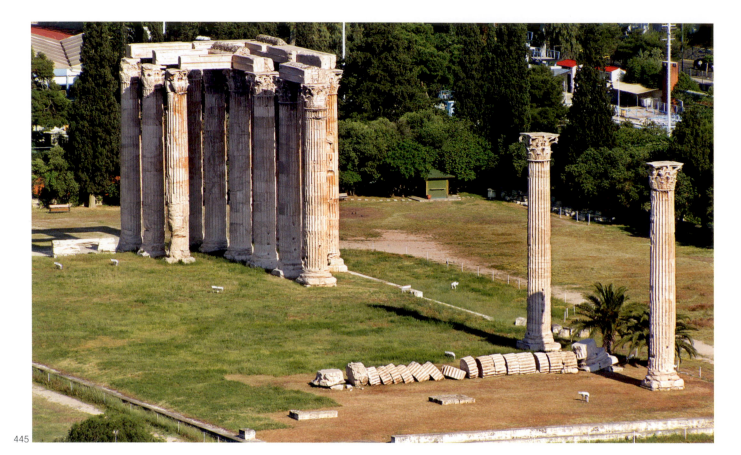

445

viewer by hiding the cella behind a "forest of columns." According to preserved inscriptions, the cost of finishing just one of the columns of the temple was 40.000 drachmas, a fact which may explain the long duration of the work.

Similar influences may be seen in the **temple of Olympian Zeus** in Athens in the Ilissos area (fig. 445). The site bears traces of use from as early as the prehistoric period. During the first half of the sixth century BC a temple was built on this site in local limestone, while around 515 BC the construction was begun of a dipteral temple of monumental proportions in limestone, the prototype for which must have been the large Archaic temples in eastern Greece. With the expulsion of the Peisistratids and the end of the tyranny the work was abandoned

and parts of the building were incorporated into the Themistoklean wall. An attempt was made in the fourth century to continue the erection of the temple, but this time in marble. In 174 BC the king of Syria, Antiochos IV Epiphanes (175–164 BC) — who studied in the philosophical schools in Athens a little before coming to the throne— funded the continuation of the work with new plans drawn up by the Roman architect Cossutius. The temple followed the old dipteral plan, with a footprint of 41.8×108 m, with 8×20 columns and triple rows of columns on the narrow sides, but with Corinthian capitals instead of the earlier Doric. The removal of architectural members to Rome by the Roman general Sulla in 86 BC appears to have visibly influenced the development of the Roman Corinthian order. The temple was completed by Hadrian (who was worshipped alongside Olympian Zeus as *symbomos*, "as a god at the same altar") and it was inaugurated in AD 131/32 (fig. 446).

446

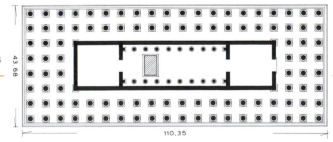

43.68

110.35

445. Athens, temple of Olympian Zeus.

446. Athens, plan of the temple of Olympian Zeus at its completion.

THE TOWER OF THE WINDS

This is a fascinating building in the area of the Roman Agora of Athens. The elegant tower, 14 m tall, is octagonal, made from Pendelic marble and bears on the upper sections of its walls relief scenes of the Winds (which gave it its unofficial name). The names of the winds are carved onto the bottom of the relief: Boreas (N), Kaikias (NE), Apeliotis (E), Euros (SE), Notos (S), Lips (SW), Zephyros (W), and Skiron (NW). On the top of the conical, tiled roof stood a bronze wind vane in the form of a Triton. Radiating incised rays in different arrangements on each side of the tower were used as sundials. On the south side of the tower is a lower semi-circular projection, while the northeast and northwest sides feature porches with two columns each. The interior of the structure is thought to have contained a water clock, and traces of a blue color in the interior of the roof possibly indicate its use as a "planetarium," with drawings representing the heavens, according to the theories of the time. The semicircular projection has been identified as a water cistern, which was fed by a pipe connecting it to a spring on the north slope of the Acropolis; it is thought to have facilitated the operation of the water clock. Although the interpretation of the building remains uncertain, it is clearly associated with observation of the heavens and astronomy, as well the measurement of the passage of time, with all the innovations of the period.

According to ancient authorities, the architect of the tower was Andronikos from Cyrrhus in Macedonia. In the past it was thought that the *Horologion* ("clock") was built in the later first century BC; recently, however, it has been asserted that the building dates to between 120–100 BC. In this case, the donors may have been the Ptolemies of Egypt, frequent patrons of Athens in the second century BC, who also supported scientific innovations –Ptolemaic Alexandria was, furthermore, an important center for the development of astronomy and observation of natural phenomena (see p. 280–282). The gymnasium of Ptolemy III appears already to have been built in this area and it is possible that the Horologion was added to this older complex.

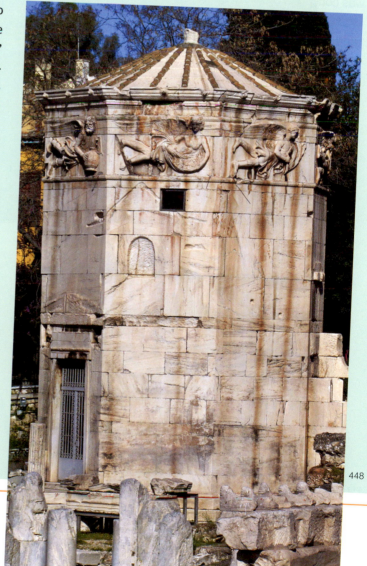

447

448

447, 448. Athens, the Horologion of Andronikos (Tower of the Winds): (447) Euros; (448) the winds Skiron, Zephyros, Lips. Second century BC.

THE PERGAMON ALTAR

The altar of Zeus was constructed on a specially created platform on the acropolis of Pergamon, possibly by Eumenes II after the treaty of Apameia (188 BC), when the intervention of Rome gained Pergamon large areas of the Seleucid state. Its construction was never completed, possibly because of the annexation of the kingdom of Pergamon to Rome in 133 BC, after the death of the last king of the dynasty, Attalos III Philometor. The altar took the form of a monumental enclosure, 36.44×34.20 m, built on a high podium with access from the west side via a wide staircase. The enclosure, in the middle of which was located the altar itself, took the form of an Ionic peristyle (fig. 468). The base of the peristyle, 2.3 m in height, bore a marble frieze executed in very high relief, with a total length of c. 120 m, which ran around the structure on the east, north, and south sides, while on the west it ran round the two wings of the peristyle and the steps up to the altar.

The subject matter of the frieze was a Gigantomachy, which obviously paralleled the military triumphs of the Attalids. The composition is characterized by strong theatricality, an exaggerated dramatic tone, violent movement underlined with passive gestures and expressions, and exceptional dynamism overall (fig. 466–471). About 100 figures of gods and giants are depicted (today fragments of about 85 figures have survived), as well as more figures of animals and beasts. Each figure is named with an inscription (the names of gods are inscribed on the upper cornice of the frieze, while those of giants on the molding of the base and in smaller letters). There are also signatures of the sculptors of the monumental composition each under his own work. Today fragments of 16 signatures have survived of about 30 artists who appear to have worked to complete the building.

The frieze follows the Classical *isocephalic* principle, i.e. the figures are equal in height, occupying the whole height of the frieze. As a result, the action is depicted as taking place all at the same point in time. The iconographic prototypes for the Pergamon artists were likely the great compositions of the fifth century BC, such as the frieze and pediments of the Parthenon (pp. 158–161), the grandiose composition of which they adapted with exaggeration. The high relief provided strong shading, which is even more pronounced as a result of the deeply folded clothing. Weapons and accessories (shoes, details on the clothing and horse-tack) and every other detail were rendered in relief and not painted on as had been usual before. Different textures of clothing and bodies, particularly those of the monstrous giants, are also rendered with great attention to detail. The frieze of the Gigantomachy thus represents the acme of Pergamene sculpture, combining trends which have been ob-

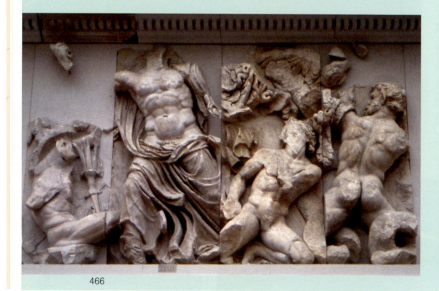

466

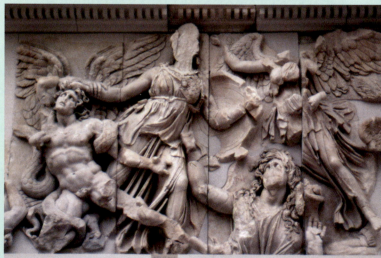

467

466–467, 469–471. Berlin, Pergamon museum, the Gigantomachy frieze. c. 190–150 BC.

468. Partial reconstruction of the Altar of Zeus. Berlin, Pergamon Museum.

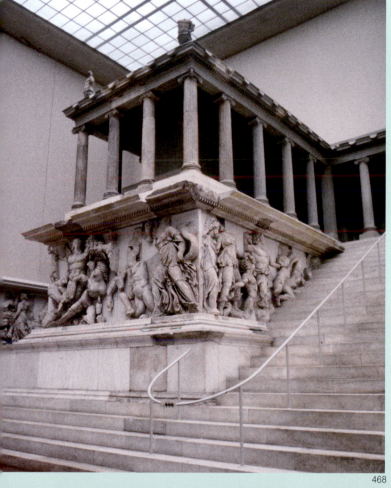

served elsewhere, both in Attalid dedications (fig. 464–465), and in free standing sculpture, many of which were placed in the enclosure of the altar (fig. 472–473).

The altar of Zeus also bore a second frieze, along the inner walls of the Ionic peristyle which surrounded the enclosure. It is 1.85 m high and was originally 80–90 m long, but just one-third of it survives today. Its subject was the story of Telephos, the mythical king of Mysia (the region in which Pergamon was located), whom the Attalids had appropriated as their heroic ancestor. Telephos originated from Arcadia and was the son of Herakles, but found himself in Mysia where he established the cult of Athena, while later he became involved in the events leading to the Trojan War. In contrast with the Gigantomachy of the frieze, here the tone is calmer and the narrative is divided into separate episodes. It is, therefore, a continuous linear narrative that covered a long period of time. The landscape here plays an important role with the depiction of trees, rocks, naiskoi, and altars, while the appearance of the protagonists in several points of the frieze, according to the needs of the narrative, is also typical and something that had only been observed in Classical art in groups of metopes and not in friezes.

468

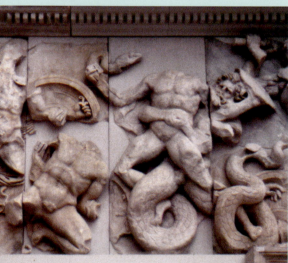

469

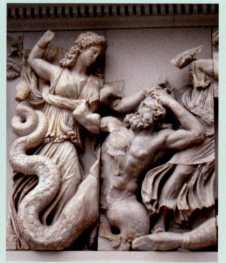

470

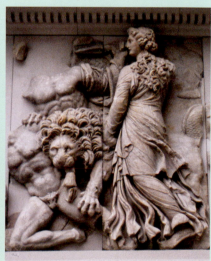

471

Some fragments of this base have been found, bearing dedicatory inscriptions mentioning victories against the Gallic tribes (fig. 463). According to ancient written sources, a second Attalid dedication was set up on the Acropolis in Athens. In this, dating either from the reign of Attalos I (who had indeed visited Athens in 200 BC) or to that of Attalos II, the victories of Pergamon against the enemy acquired a mythical base, since alongside the Gauls were also depicted Giants and Amazons, as well as Persians. In this way Pergamon promoted itself as the "Athens" of the Hellenistic period, putting forward both its military and its cultural excellence.

Many free-standing sculptures from Pergamon dating to around 200–150 BC highlight its position as a flourishing center

ows, and by the attempt to render convincingly the texture of the material (fig. 473).

Beyond the clear references to Classical art that can be seen in Pergamene sculpture of the late third and second century BC, there also developed a fashion during the first half of the second century of reviving the art of the fifth, with a strong classicizing character. Archaeological evidence from the acropolis of Pergamon demonstrates that the prototypes for this, that is sculptures of the Classical period, had been moved there by the Attalids, but it seems that the sculptors of the period were also attempting to revive Classical art in their innovative work. The most typical example is a colossal statue of Athena Parthenos, 3.10 m tall, which had been set up, proba-

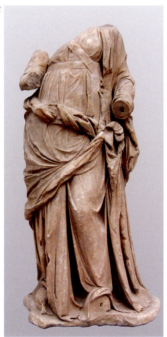
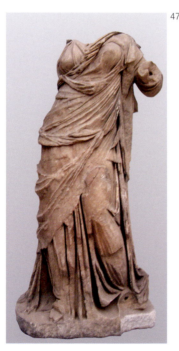
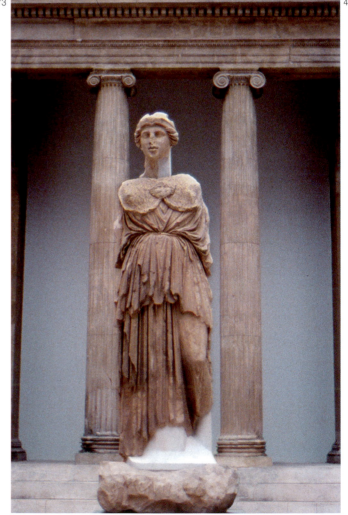

of sculpture during the late third and second century BC. The monumental depiction of a female figure with belted sword is thought to be a personification of Tragedy (fig. 472). The heavy, deeply folded clothing of the figure reveals its volume, while the rope-like twists of fabric girdling her waist or hanging behind her disrupt the harmony of the contrapposto and give the sculpture an intense sense of drama. Another female figure from Pergamon is similar, possibly a Muse, characterized by the same dramatic rendering of the clothing, the strong shad-

472. Pergamon, marble statue of a female. c. 200–150 BC. Berlin, Pergamon Museum P47.

473. Pergamon, marble statue of a female. c. 200–150 BC. Berlin, Pergamon Museum P54.

474. Pergamon, marble statue of Athena Parthenos. c. 200–150 BC. Berlin, Pergamon Museum.

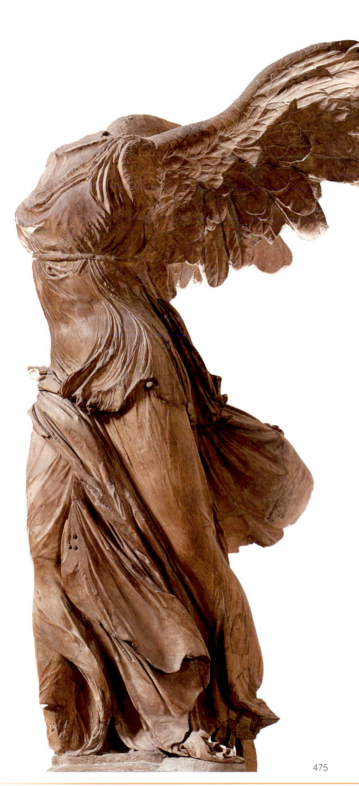

bly during the reign of Eumenes II, in the central reading room of the city's library (fig. 474). The work is rendered in the classical style of works by Phidias (though it does not merely copy them): the body of the goddess twists more than its Classical prototype (as far as we can tell from the surviving copies, such as that in fig. 322), the features of the face are less strong and more idealized, and the clothing follows the trend of Pergamene sculpture for evocative, intense shadows.

Outside Pergamon, the fashion for intensely theatrical statues designed to be seen from all sides may also be observed. The *Nike of Samothrace*, a marble statue 2.45 m high, of a winged Nike who has just landed on the prow of a warship, is thought to be a dedication of the Rhodians at the sanctuary of the Great Gods on the island after a series of victorious sea battles at the beginning of the second century BC (fig. 475). The Nike is represented with a powerful stride, with her body turned to the right and wings unfurled to the rear. She wears a long belted chiton and himation, which cling to her body and reveal her figure beneath the complex, and sometimes bulky folds. It is an imposing monument highlighting the development of Hellenistic sculpture during the second century, with clear references to the art of the Classical period (see fig. 321). The mixture of traditional elements with new ones makes dating those works on purely stylistic grounds particularly insecure: for the *Nike*, specifically, several other dates have been proposed — from the third to the second century BC — the safest however seems to be around 200–190 BC.

During the first half of the second century BC classicism becomes typical in sculpture and in Hellenistic art in general. The revival of the Classical style appears to have been attempted in many centers of Hellenistic art at the same time, but it developed particularly in the old Greek world, as was perhaps to be expected. In the Peloponnese, but also in other areas of the Greek mainland, the sculptor Damophon worked during the period 200–180 BC. Fragments of his work are preserved in the sanctuary of Demeter and Despoina in Arcadian Lykosoura. In the temple there was a group of four cult statues, a seated Demeter and Despoina and a standing Artemis, while

475

475. Marble statue of Nike. c. 200–190 BC. Paris, Louvre Ma 2369.

the Titan Anytos who is mythologically associated with the goddesses, was also a standing figure. Among the remains of the statues, the piece from the himation of Despoina is particularly interesting, since it bears "embroidered" relief scenes with floral and animal themes, but also marine creatures such as Tritons and Nereids riding dolphins and sea monsters (fig. 476). The largest part of the scene, however, is taken up with two winged Nikes who hold a *thymaterion* (censer). The surviving fragments of the heads show strong classicizing trends, especially the head of Anytos, with its half-open mouth and deep set eyes, and his thick unruly ringlets in his hair and beard (fig. 477). This type of male head with fleshy, frowning forehead, the deep-set eye sockets with heavy arched eyebrows, and the half-open mouth is a revival of the male heads of the fifth century BC and particularly of those of Zeus.

There is a clear dependence on the type of Phidian Zeus from Olympia, as preserved in later copies (see fig. 325), a dependence, which in the case of Damophon appears to be explained also by his presence in Olympia at the same period when, according to ancient authorities, he was entrusted with the restoration of the chryselephantine statue of Phidias.

Classicizing trends become more obvious as we approach the middle of the second century BC. The heads of male deities — such as Zeus, Poseidon, Asklepios, and other "father gods" of the Greeks — bear distinct characteristics that seem to revive the Phidian prototype. The part of a colossal head found in ancient Aigeira is thought to have come from a statue of Zeus mentioned by Pausanias, a work of the Athenian sculptor Eukleides (fig. 478). The head, 0.77 m tall, had inset eyes and a metal wreath in the fluffy, unruly locks of the god's hair, as demonstrated by the existence of holes for its attachment. It has the characteristically fleshy, half-open mouth of this type of statues, a thick moustache, and a full beard divided in the middle at the level of the chin. The rendering of the head of Asklepios from Melos is also similar, 0.53 m tall with its characteristic deep-set eyes, frowning forehead and thick head of hair (fig. 479).

476

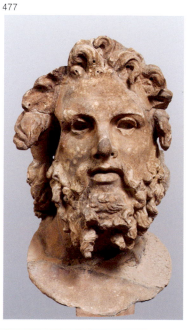

477

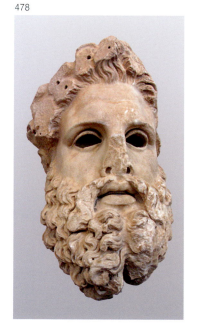

478

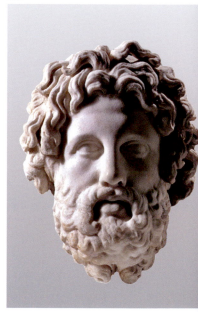

479

476. Lykosoura, Arcadia, marble fragment from the statue of Despoina. Beginning of the second century BC. Athens, National Archaeological Museum 1737.

477. Lykosoura, Arcadia, head of the Titan Anytos. Beginning of the second century BC. Athens, National Archaeological Museum 1736.

478. Aigeira, Achaea, head of a colossal statue. Middle of the second century BC. Athens, National Archaeological Museum 3377, 3481.

479. Melos, head of Asklepios. Second century BC. London, British Museum 550.

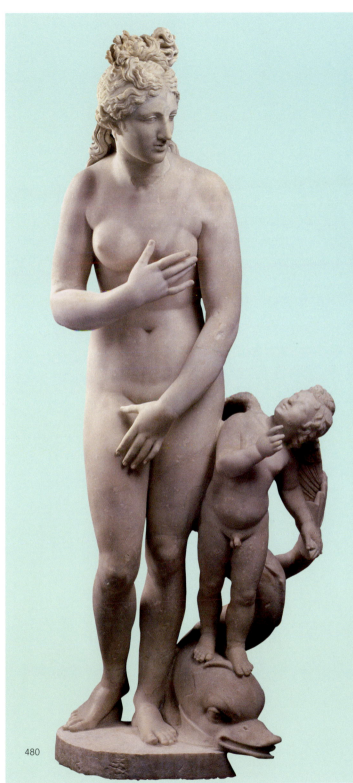

APHRODITE IN HELLENISTIC SCULPTURE

Aphrodite was the goddess of carnal pleasures; the Knidian Aphrodite by Praxiteles (fig. 378) introduced, as we have seen, a new way of depicting the goddess, with a poignant emphasis on eroticism. The heritage of Praxiteles is evident in sculptures of the Hellenistic period, especially of women, many of which revive or recreate the famous Knidian Aphrodite. A version of Praxiteles' work can be recognized in a naked Aphrodite that was copied several times in the Roman period: it is the so-called "Capitoline type" which also appears in further variations (fig. 480). A feature of this type is the elaborate hairstyle of the goddess, which crowns the top of her head but also covers her neck with voluminous ringlets. The goddess is depicted before or after her bath, just like the Knidian Aphrodite, which is why the most faithful copies have a hydria beside them, and is completely naked but shielding her breasts with her right hand and her pelvic area with her left.

A further type of naked Aphrodite, crouching and with a strong twist in the upper body and head, is preserved in many Roman copies (fig. 481). It is often attributed to someone called "Doidalsas," but it is possible that this name results from a corruption of the Latin text related by Pliny (*Natural History* 36.35) where he mentions a "bathing Aphrodite."

480. Marble statue of Aphrodite and Eros, copy of an original from 300 BC. Paris, Louvre Ma 335.

481. Marble statue of Aphrodite, copy of an original from the third century BC. Rome, Palazzo Massimo alle Terme 108597.

The realistic rendition of female flesh, in an absolute secularization of an otherwise unapproachable goddess, gives new meaning to the relationship of mortals with the images of their gods.

In other versions Aphrodite is depicted semiclad, with a himation wrapped around the lower half of her body. The *Aphrodite of Arles* in France (fig. 482), seems to be a copy an early Hellenistic statue of Aphrodite (several scholars consider it to be a copy of a work by Praxiteles). The work, with the two arms restored today in their likely positions, is closer to the seminude Aphrodites of the third century BC which are frequently also found in minor art works. The *Aphrodite of Melos*, an original work of the second half of the second century BC, is a distant descendant (fig. 483). The goddess is shown naked from the waist up with the lower half of her body wrapped in a thin himation. On her head she wears a fillet and her hairstyle is completed by a *korymbos* ("chignon") at the back. Traces of holes indicate the presence of added metal jewelry (diadem, earrings, bracelets). The arms of the goddess, missing today, were raised to the left and according to the prevailing interpretation of the type held a shield (which belonged to the god Ares) in which Aphrodite was looking at herself, in accordance with a literary foundation, as was popular in the Hellenistic period. The work is inspired by a strong sense of classicism which maintains the characteristics of the sculpture of the fifth and fourth centuries BC.

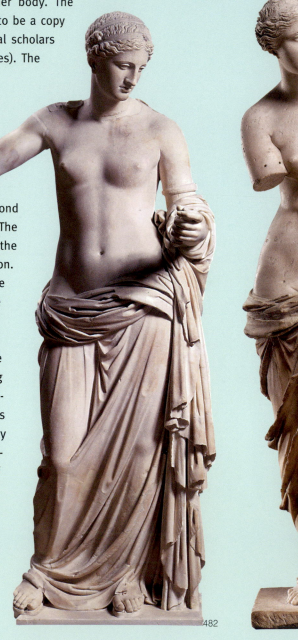
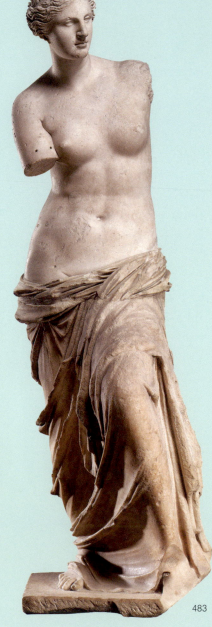

482

483

482. Marble statue Aphrodite, copy of an original form the late fourth–third century BC. Paris, Louvre Ma 365.

483. Marble statue Aphrodite. c. 130–110 BC. Paris, Louvre Ma 399.

2.4 Sculpture in the late Hellenistic period (150–30 BC)

The classicizing trend of Hellenistic sculpture continues also after the middle of the second century BC, which, as has already been noted, only forms a conventional boundary division for Greek art. The marble *Poseidon* from Melos (fig. 484), 2.35 m tall, strikes a commanding pose similar to the Classical contrapposto, with a decisive turn of the body and head, strongly recalling other works of the second century BC. The head of the god incorporates the classicizing characteristics that have been mentioned already (see fig. 477–479); the statue thus gives us an impression of what the complete figure of Zeus or the Asklepios of Melos would look like. The dissemination of the type at a smaller scale is indicated by the marble figurine of Serapis from Amorgos (fig. 485), just 0.52 m tall, which preserves many of the elements of the pose and look of the Poseidon of Melos. At the same time the head of the god adopts classicizing elements from male heads of the second century BC. Serapis, an invention of the Ptolemies of Egypt, took the form of a father-god (similar to the Greek Zeus) whom they placed at the head of the Egyptian pantheon with the aim of providing a deity who was accessible to the local Egyptians as much as the Greek newcomers. The name of the god comes from a combination of Osiris and Apis, the primeval gods of Egypt. The consort of Serapis was Isis, the once secondary Egyptian deity who during the Hellenistic period acquired great popularity, gathering characteristics, mainly chthonic, of members of the Greek pantheon such as Aphrodite and Demeter, but also of the Egyptian, such as Hathor and Sekmet. The worship of Serapis and Isis throughout the whole of the Greek world, as is demonstrated by this statuette from Amorgos, but also others, are a symptom of the extensive religious syncretism that may be observed in the Hellenistic period, a phenomenon that contributed to the "internationalization" of Greek art.

A parallel trend in Hellenistic sculpture, apparent already by the third century BC, was the switch to more mundane themes, with an emphasis on scenes from everyday life, or the retreat from traditional ambitious themes which are now rendered de-mythicized with a more anti-heroic tone. Typical examples are the sculptural groups with children, which frequently appear to mimic the epic battle scenes of

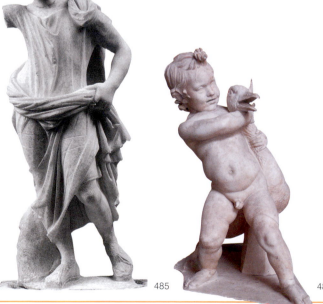

484 485 486

484. Melos, Marble statue of Poseidon. c. 120–100 BC. Athens, National Archaeological Museum 235.

485. Amorgos, marble figurine of Sarpedon. End of second century BC. Athens, National Archaeological Museum 4546.

486. Marble statue of a boy strangling a goose, copy of an original from the second century BC. Paris, Louvre Ma 40.

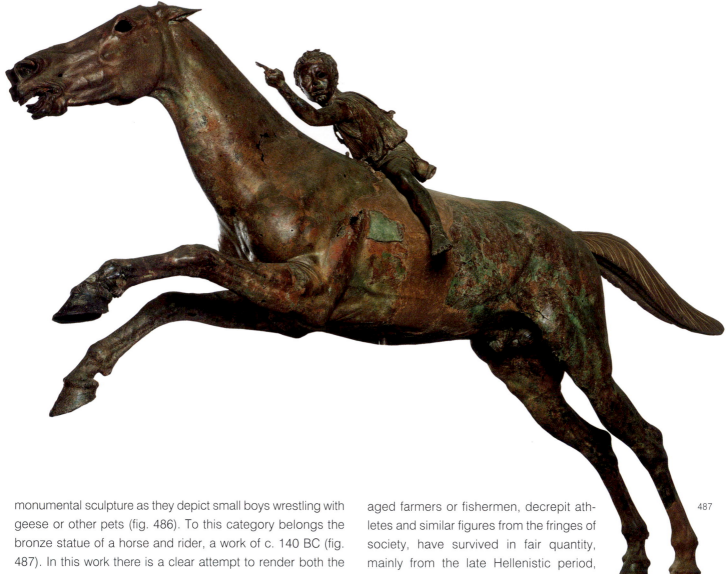

487

monumental sculpture as they depict small boys wrestling with geese or other pets (fig. 486). To this category belongs the bronze statue of a horse and rider, a work of c. 140 BC (fig. 487). In this work there is a clear attempt to render both the animal and the boy realistically. To the same genre also belong statues that distance themselves from the classical love for idealization of the human figure and the rendering of idealized beautified forms which attract the gaze. The *Drunken old woman* (fig. 489), a copy of a work from the second century BC, represents an old woman seated on the ground clasping a lagynos (a type of oinochoe of the Hellenistic period, see fig. 541) and singing. The harsh depiction of the old woman, the merciless exposure of the half-naked, aging decadent flesh and the far from flattering depiction of drunkenness are a mocking social observation which was probably shared by its viewers — or its owners. Other such works, depicting aged farmers or fishermen, decrepit athletes and similar figures from the fringes of society, have survived in fair quantity, mainly from the late Hellenistic period, though their probable function remains unclear. As it is unlikely that they would be suitable for anything else, it seems that they must have decorated luxury villas, giving their financially secure and socially successful owners the enjoyment of observing the life of the "others" from a safe distance.

There is often a mocking tone in works of purely exotic character. The exotic is an intrinsic element of Hellenistic culture, a product of a cosmopolitan outlook on the world, but also of the ever-expanding knowledge of the boundaries of the then known world. The turn towards the strange and the wondrous is almost always accompanied by a warning tone,

487. Bronze statue of a horse and rider. c. 140 BC. Athens, National Archaeological Museum X15177.

488. Marble statue of a satyr. Second century BC. Munich, Glyptothek 218.

influenced by contemporary philosophy (both the teaching of the Stoics as much as the Epicurean philosophers, but also other Hellenistic schools of thought). The charming depiction, for example, of the elderly *Centaur* who endures the teasing of a small eros figure (fig. 490) hides the somber warning that erotic pleasures become burdensome or dangerous from a certain age onwards. The playful pose of the sleeping *Hermaphrodite*, in contrast (fig. 492), warns that the unknown frequently "hides" surprises. Sleep is a common theme in sculpture of the second and first centuries BC, especially when the subject matter exudes the exotic. The *Sleeping Satyr* (fig. 488), the date of which is uncertain but seems to belong to the second century BC, combines exoticism with the use of three-dimensionality, which had already been observed in sculpture form the middle of the Hellenistic period.

A secure date is known for the *Aphrodite and Pan* group from Delos, which is placed around 100 BC on the basis of the dedicatory inscription that accompanies it (fig. 491). The goddess, hiding her pudenda, threatens Pan playfully with her sandal, while Eros hovers between them. The work had been set up in the area of a "club" in the cosmopolitan island of Delos with the obvious purpose of delighting the patrons, possibly also with the underlying ironic references to the passion of the "epic" compositions of the Pergamene school — examples of which were to be found on the same island.

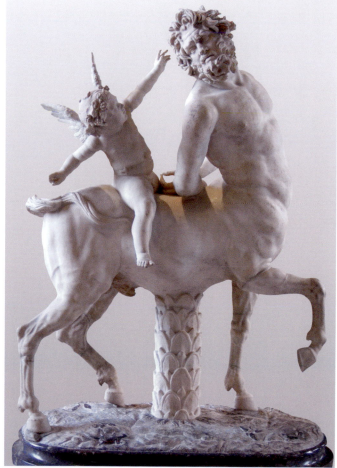

489

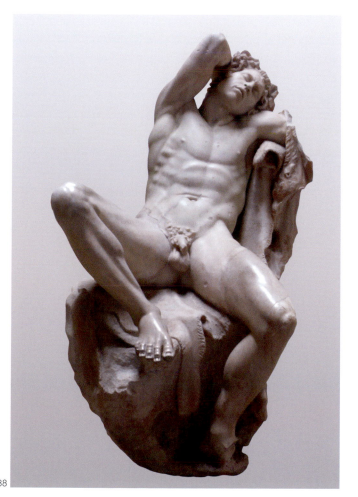

488

490

489. Marble statue of a drunken old woman, copy of an original from the second century BC. Munich, Glyptothek 437.

490. Marble group of a Centaur and Eros, copy of an original from the second century BC. Paris, Louvre Ma 562.

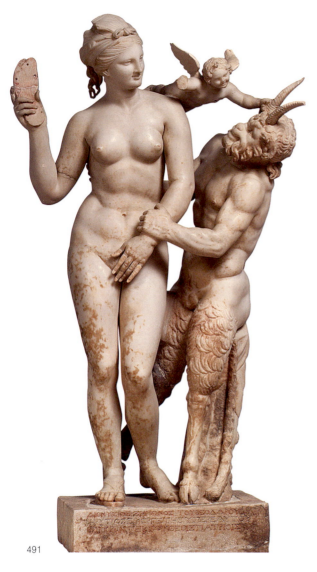

491

2.5 Greek sculpture in Roman "translation"

The Romans had taken control of the Greek cities in South Italy and Sicily already by the third century BC. The natural consequence of the conquest of a city, especially if it had been the result of a long and painful siege, was the looting of precious objects and works of art that were then transported to Rome. The historical sources of the period describe the "flood" of Greek art works in the erstwhile rural Latium and the crucial impact it had on the aesthetics and character of the Romans. The historian Livy, for example, talks of the capture of Taranto in 209 BC, informing us that the Romans took with them "huge quantities of silver vessels and coins, 83,000 pounds of gold, statues and paintings, almost as many as they had taken from Syracuse," that is from the looting of the Sicilian city after its subjugation in 211 BC (27.16.17). Rome had exploited with diplomatic subtlety and acute strategic decisiveness the military weaknesses and tragic political mistakes of its opponents such as the alliance of the southern Italian and Sicilian cities with the Carthaginian Hannibal from Africa or the reckless involvement of the kings of Macedon in the political games of the Hellenistic kingdoms in the East. Already by the beginning of the second century BC Rome had placed mainland Greece under its control. The sanctuary of Delphi was visited by the Roman general Aemilius Paullus in 168 BC, after his victory at Pydna against the Macedonian king Perseus. Delphi, as with the rest of the major sanctuaries in Greece, continually supplied the Romans with original works of Greek art: in 86 BC the Roman general Sulla took gold and silver dedications from the

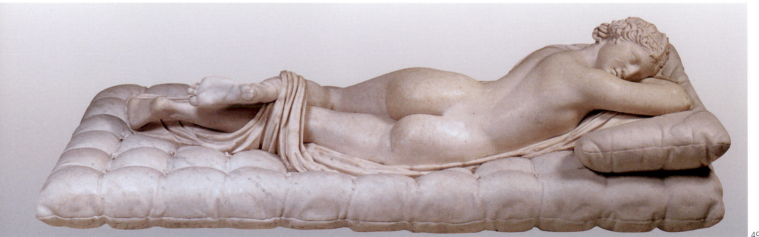

492

491. Delos, marble group of Aphrodite and Pan. c. 100 BC. Athens, National Archaeological Museum 3335.

492. Marble statue of an hermaphrodite, copy of a (bronze?) original from the second century BC. Paris Louvre Ma 231.

sanctuary, while in AD 67 the Emperor Nero took 500 statues back home to Rome with him. This of course had been preceded by the wholesale destruction and looting of Corinth in 146 BC, as well as that of other Greek cities and sanctuaries. This violent but systematic contact of the Romans with Classical art created a strong desire in Rome for works of Greek art — either originals or copies, and even new creations and revivals in the classical style. For the Greek artists of the second and first century BC this also came as an indication as to where a more promising market could be found.

Of a more direct consequence was the willing or unwilling migration of Greek artists to Italy during this period. Aemilius Paullus — who celebrated his victory over the Macedonians with a three-day triumphant procession in Rome in which 250 chariots carried statues, paintings, colossi, silver vessels and rhyta, gold items and other treasures — also took with him the Athenian painter Metrodoros. In Rome the painter created paintings for his new customer, but also became his son's tutor as he was also a well-known philosopher of his time. A little earlier, around 180 BC, the general Lucius Scipio had invited a group of Greek artists to Rome with the intention of creating "embellishments" (Livy, 39.22.9–10). A well-known family of Greek artists who worked in Rome in the second century BC was the Athenian Timarchides and his sons Dionysios and Polykles. To them is attributed the revival of the Phidian style of sculpture of the period, as well as the prolific production of copies. According to Pausanias, they copied figures from the shield of Athena Parthenos (10.34.8). According to Pliny, moreover, Dionysios created a cult statue of Hera while the two brothers together created a statue of Zeus in Rome (*Natural History* 36.35). He also refers to a statue of Apollo with a lyre, a work of Timarchides (possibly the son of Polykles and grandson of the Athenian sculptor). The *Apollo Citharoedus* that Pliny mentions has been recognized in a classicizing late Hellenistic statue of 150–100 BC, which shows a clear mixture of Classical and Hellenistic traits (fig. 493). The sculpture recalls late Classical prototypes — mainly the sculpture of Praxiteles — which however are recreated with the gravity of the Classical style.

The so-called neo-Attic tradition is similar, in which works of classicizing character were produced in workshops in Greece (mainly in Athens) and in Rome guided by knowledge of the artistic preferences of a Roman clientele. The neo-Attic

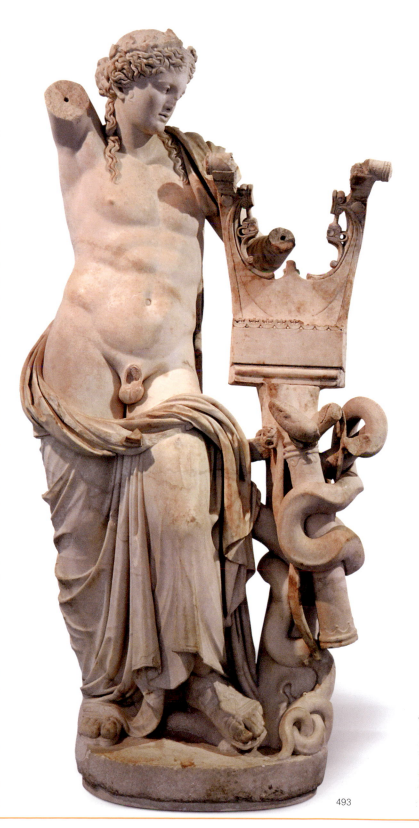

493

493. Marble statue of Apollo. c. 150–100 BC. London, British Museum 1380.

style appears to have been born from the intensive copying of Classical works and the increasing demand for sculptures that revived the aesthetic traditions of the fifth and fourth centuries BC. The center of the neo-Attic tradition was initially Athens during the period from 150 BC to the sacking of the city by Sulla in 86 BC, when it appears that the production of neo-Attic works transferred to Rome where it flourished under the reign of Augustus in the second half of the first century BC and the first half of the first century AD. Frequently the neo-Attic work took the form of reliefs (plaques but also marble vases), which freely copied earlier work but with an emphasis on ornateness. The relief plaque in fig. 494, possibly from the facings of a pedestal or statue base is a typical example: it depicts a dancer who is throwing her weight forward and tilting her head back. She is wrapped in a rich himation which is billowing out behind in deep s-shaped folds. Similar dancers —Nymphs, Maenads— are especially frequent in neo-Attic reliefs. Their style is clearly associated with the "rich" Classical style of the late fifth century BC (see p. 175–176) but in shallower relief. The dancers in these neo-Attic reliefs have been associated by several scholars with the sculptor and architect of the fifth century BC Kallimachos, of whom Pliny (*Natural History* 34.92) said that he was known as "perfectionist" in his work, while according to Pausanias he was distin-

LAOCOON

Pliny relates that in the palace of the Emperor Titus (AD 40–81) one could see "a work superior to any painting and every sculpture," a group which represented Laocoon and his sons writhing in the "awe-inspiring" coils of snakes (*Natural History* 36.37). The work, which according to that author had been carved from a single piece of marble, was signed by three Rhodian sculptors: Agesandros, Polydoros, and Athenodoros. In 1506, close to the location which Pliny describes, an impressive marble group was found, 1.84 m high, with the same subject matter, which was immediately recognized as the masterpiece created by the three Rhodian sculptors (fig. 496). The interest that its discovery aroused amongst artists and intellectuals of the Renaissance was tremendous —Michelangelo was indeed present during its unearthing— and it continued for centuries, until the lifetime of Winckelmann, to be considered the supreme masterpiece of Greek art, in which the beauty of the three male figures was enhanced by the agony of their death throes. The identification as early as the late nineteenth century, of the signature of a Rhodian sculptor who was called "Athanodoros, son of Agesander," which appears to date to the first century BC, led to the conclusion that the *Laocoon* belonged to the same period and that it was the work of a family of artists from Rhodes who worked in Rome, like the family of Timarchides a century earlier.

In the middle of the twentieth century, on the basis of comparisons with works of Pergamene sculpture, it was suggested that the *Laocoon* was a work of the second century BC reflecting the existence of a hypothetical "Rhodian" workshop for Hellenistic sculpture; this suggestion, however, does not seem to be tenable.

The *Laocoon* is a typical work of Greco-Roman composition, where Greek concepts of beauty were used to promote a theme reserved for Roman consumption. Laocoon was the priest of Troy who had warned his fellow citizens about the dire threat that was hidden inside the Greek-made Trojan Horse, an episode of the epic cycle which the poet Virgil took full advantage of in his *Aeneid* (2.199–277), written in 29–19 BC. To the eyes of the Roman, the tragic end of the priest of Troy hid —apart from the

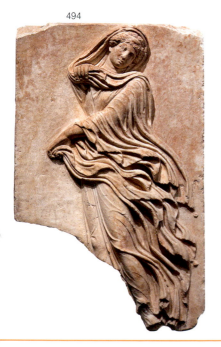
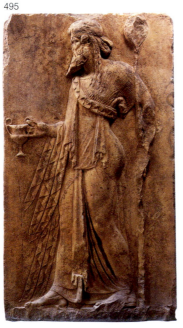

494. Marble relief with depiction of a dancer. First century BC. Athens, Acropolis Museum 260.

495. Marble votive relief with a depiction of Dionysus. First century BC. Athens, National Archaeological Museum 3727.

epic dimensions of the monument– a subtly ironic admonition for intractable lovers of Greeks art: the title of *Laocoon* could also have been "timeo Danaos et dona ferentes"!

Apart from the analysis of its contents, and beyond the thought that the subject matter would not have been likely for a sculptor in Rome before the composition of the *Aeneid*, the *Laocoon* is judged to be a work of the late first century BC, both for its somewhat cold nature and the typical handling of several elements, such as the lifeless look of the clothing.

The discovery in 1957 of an important group of sculptures of the first half of the first century AD contributed to this dating. These sculptures had been set up in the cave of Sperlonga, south of Rome, which was used as a "holiday resort" by the Emperor Tiberius. The statue groups evoked Homeric themes such as the *Blinding of Polyphemos*, the attack of *Scylla* on Odysseus' boat, and the theft of the *Palladion* from Troy. The *Scylla* group was signed by three sculptors: Athanodoros, son of Agesandros, Agesandros son of Paionios, and Polydoros son of Polydoros, all from Rhodes. The emphasis on the Greek origin of the sculptors, conveyed by the repeated use of the patronymics, shows that the works were carved in Rome, by sculptors of Rhodian descent settled there (possibly the two were father and son). The stylistic similarities of the statues from Sperlonga with the *Laocoon* suggests that the latter should be dated at the end of the late first century BC, or even a little later. This is supported by the observation that a piece of the statue is carved from a particular variety of marble of Italian origin that was not in use before the period of Augustus.

496. Marble group with Laocoon and his sons. Late first century BC. Rome, Vatican Museums 1059.

Granikos River in 334 BC and the other *Alexander's hunt*, which was dedicated by Krateros at Delphi after the king's death. Although there is little evidence for the appearance of these dedications, as for many of the other numerous depictions of Alexander in sculpture in the late fourth century and early third century BC, reflections of them appear to have been preserved in the minor arts: a bronze statuette, 25 cm tall, part of a figurine that depicted a mounted Alexander, naked apart from a cloak made from an Elephant's hide, is possibly a copy of one such statue (fig. 504). The elephant hide is a reference to the conquest of India by Alexander in which he had to fight difficult battles against the local rulers who used elephants as offensive weapons. At the same time the reference to his victorious campaign in the Indian peninsula associates Alexander with Dionysus, as India was that god's place of origin.

2.6.3 HELLENISTIC PORTRAITS: KINGS AND PHILOSOPHERS

Portraits of rulers during the Hellenistic period usually took the form of full-body statues, the majority of which have not survived. The study of Hellenistic royal portraits is therefore conducted out of necessity on the basis of existing copies — frequently in other materials and of less accomplished execution — or from surviving fragments, which however do not provide us with a complete picture of the statues in their original form. Identification of surviving works is undertaken on the basis of the attributes they bear, most frequently the royal *diadem*, a simple or decorated band which was tied around the head, a royal accoutrement that Alexander himself introduced copying Persian practice. The identification of specific kings is extremely difficult, as inscriptions are relatively rare and there is no available reference material. The comparison of the heads with the portraits depicted on royal coins of the Hellenistic period (see pp. 291–295) can in most cases be constructive, although an exhaustive study of all available coin types is necessary before at-

tempting an identification with a particular statue.

The marble head in fig. 505 has been identified as the royal portrait of Attalos I of Pergamon (241–197 BC) created in two stages, before and after he was officially proclaimed king. The head, with a strong twist of the neck and upward turned gaze, ought to belong to an over-life-size statue. The addition of new, thick, curly locks in a second reworking of the statue gave the work a stronger and more impressive outlook.

The marble head in fig. 506 has been compared with royal coins of Antiochos III of Syria (223–187 BC) and has been recognized as a portrait of the same ruler. The Seleucids had generally adopted the Alexander archetype in their portraiture — with an emphasis on the youthful vigor and military character of their leaders; in this portrait though, the appearance is more restrained, emphasizing facial characteristics such as the shape of the nose and lips and the consequent intimation of power that is underlined by the presence of the *strophion*, a developed type of the royal diadem. The identification of Mithridates VI Eupator, king of Pontos from 120 to 63 BC is more secure (fig. 507). Mithridates nurtured ambitions of world dominance which led to him appearing as a distant successor of Alexander

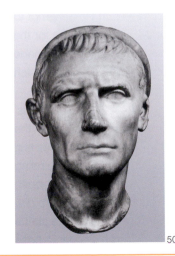
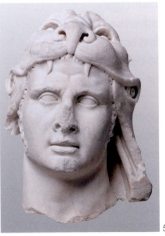

504. Bronze figurine of Alexander as a rider (horse missing). Third century BC. New York, Metropolitan Museum of Art 55.11.11.

505. Marble portrait head of Attalos I. c. 240–230 BC. Berlin, Archaeological Museum P130.

506. Marble portrait head of a leader, copy of a Hellenistic portrait (?Antiochos III, The Great). c. 200 BC. Paris, Louvre Ma 1204.

507. Marble portrait head of Mithradates VI Eupator of Pontos, copy of a work from the late second–early first century BC. Paris Louvre Ma 2321.

and as the liberator of the Greek cities from the domination of Rome. His official portrait, as it appears on the coins of the Pontic Kingdom (fig. 572), combines the dynamism of Alexander's portraits with a strong idealization of Mithridates' own physiognomy. In this portrait, a copy of an original which must have dated to the reign of Mithridates, the ruler appears with mouth half open and with a fierce gaze. The lion skin he wears is a further royal, but also god-like, attribute.

If the statues of the Hellenistic leaders sought to convey the heroic, quasi divine nature of the men they portrayed, **portraits of philosophers** continued to highlight the value of particular men as teachers and intellectuals. For philosophers too, a complete understanding of their effigies comes only from the study of the whole body, whose pose seems to reflect their ideas and their teachings. A portrait of the Stoic philosopher Chrysippos (c. 280–204 BC) typifies this. His teachings revolved, like Stoic philosophy in general, around the workings of the universe and the place of human freewill in relation to impersonal fate. His portrait is recognized in a later marble copy (fig. 508), where he is depicted seated and at advanced age, counting his fingers (according to ancient sources one such statue of this philosopher had been erected in the Kerameikos in Athens).

The surviving fragments of a bronze philosopher from the well-known Antikythera shipwreck (fig. 510–512) must also have belonged to a similar evocative pose. Portrayed standing in a long himation, the philosopher held a staff in his left hand and had his right hand outstretched. His sandals are typical of their age, with the thick soles and wide straps tied around

THE DEMOSTHENES BY POLYEUKTOS

The use of the pose of the body to render not only the personality and character of the person portrayed but also their psychological disposition, is evident in the case of the portrait statue which the sculptor Polyeuktos created to depict the Athenian orator Demosthenes 42 years after his death. According to a later source, the statue was placed in the Agora of Athens around 280 BC, when the Athenians reassessed his anti-Macedonian stance during the dramatic political conflicts of the fourth century BC, although it is surprising how Polyeuktos knew the accurate image of the orator Demosthenes so as to execute it so many decades after his death. The sculpture is preserved in later copies (fig. 509). The enclosed introverted posture is interesting, with the hands joined low in front and the bowed head. The orator is shown as a stern politician, thoughtful, and somewhat cantankerous, as he was possibly remembered by some of the Athenians who decided to set up the statue at the heart of the political life of their city on the occasion of a temporary overthrow of Macedonian control. The orator's frowning and severe depiction, underlined by the hexagon formed by his hands, shoulders, and head, is reminiscent of the way that the early Hellenistic sculpture exploits the position of the hands to suggest artistic forms which help convey the meaning of the work (see the women in fig. 461, 462).

509

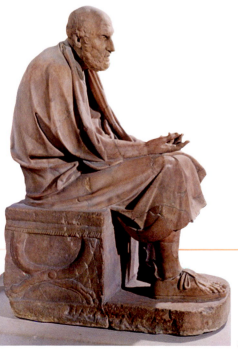

508. Marble statue, portrait of a philosopher, copy of a late third-century work BC. Paris, Louvre Ma 80.

509. Marble statue, portrait of Demosthenes, copy of a work from 280 BC. Copenhagen, Glyptotek Ny Carlsberg 2782.

508

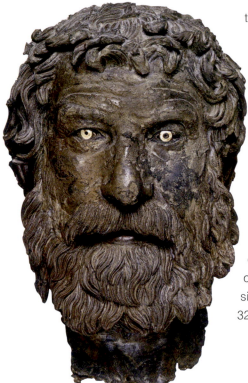

510

the man's ankle. The head is rendered in a strong realistic style with an emphasis on the personalized features such as the wild eyes (this particular work still preserves the inset eyes with the white irises), the unruly hair, the long nose, the thin lips, and deeply furrowed brow. As a result of his appearance the statue has been considered to be a portrait of a Cynic philosopher, possibly Bion of Borysthenes (c. 325–c. 250 BC).

2.6.4 HELLENISTIC PORTRAITS: PRIVATE INDIVIDUALS

During the late second and first century BC, the accumulated experience of Greek sculptors in portraying the human figure was exploited also in the private market. In Athens and in Delos, but also in other areas of Greece, and later still in Italy, a different approach to portraiture was devised, beyond the idealized realism of the royal portraits. The portraits of private individuals, mainly merchants who were active in Delos and other "international" areas of the ancient world, are characterized by deeply realistic, almost prosaic, features without idealizing elements. On the contrary, it is possible to argue that the sculptor sought to focus on "demythicizing" personal traits such as hooked noses, small eyes, and crooked lips, while the face is scored by deep wrinkles. The portraits of the period also effected the birth of the "Republican Portrait" that is characteristic of Roman portraiture — as much in sculpture as in coinage, sealstones, and other media — in the period of the

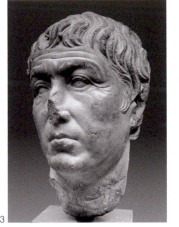

513

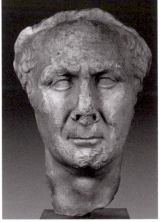

514

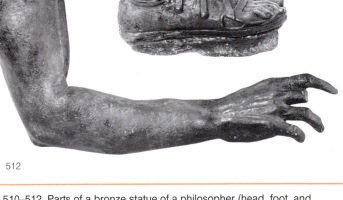

511

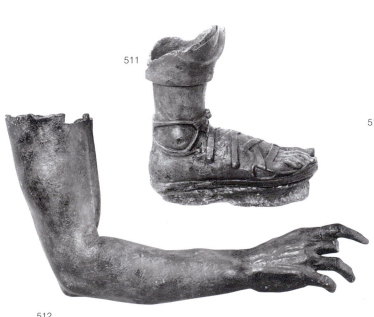

512

Republic, that is before the establishment of the Principate at the end of the first century BC.

This fashion, although particularly loved by the Romans as it did not recall the strong idealism of Hellenistic portraiture, also influenced portraits of Greeks: the head in fig. 513 is a typical example of this prosaic trend with its deep furrows, small eyes, and serious expression. Similarly, the head in fig. 514 is of a middle-aged man with short sparse hair and morose expression. The *strophion* he wears identifies him as a priest.

510–512. Parts of a bronze statue of a philosopher (head, foot, and arm). Late third century BC. Athens, National Archaeological Museum X15091, X15105.

513. Athens, marble portrait head. First century BC. Athens, National Archaeological Museum 320.

514. Athens, marble portrait head. Late first century BC. Athens, National Archaeological Museum 437.

The private portrait head of the late Hellenistic period formed part of statues, in the same way as portraits of kings, philosophers, athletes, and so on. The head in fig. 513, for example, with the distinct twist of the neck that typifies it, probably came from a statue with a pose similar to that of the Hellenistic rulers (see fig. 503). The bodies for these statues relate to standard types of idealized Classical sculpture, which can be combined without too much difficulty with realistic portraits. The Pseudo-Athlete from Delos (fig. 515) illustrates this fashion very clearly: it depicts a naked man with the body and stance of an athlete, which recalls Polykleitan contrapposto. The chlamys he wears wrapped around his right wrist and over the left shoulder creates the feeling of "classicism." The head is, however, purely anti-Classical, without idealistic additions: it is bald and bony with a triangular chin, prominent ears, a small nose, and thin lips. The face of the middle-aged man is in complete contrast to the idealistic representation of the well-formed youthful body to which it belongs, expressing at the same time in this way his admiration for Classical sculpture and his desire for his statue to be recognizable as his own likeness.

The social function of the private portrait in the late Hellenistic period is demonstrated by the example of Cleopatra from Delos. A little after 138 BC, according to the inscription that accompanies the two statues, the Athenian Cleopatra erected in her home a statue of her husband Dioscourides, along with her own, in order to remind their visitors at home that Dioscourides had provided two Delphic tripods as offerings to the temple of Apollo on the island (fig. 516). The couple, from Myrrinous in Attica ac-

cording to the inscription, were depicted side by side. Cleopatra is particularly detailed: the modest pose of the figure, in accordance with established beliefs about women's behavior, with her right hand folded across her chest and her left clasping her chin, belongs to the *Pudicitia* type, the Roman personification of decency. In contrast with his wife, Dioskourides' statue wears a simple himation, without any special artistic ambitions. The statues had been placed in the couple's house after a general refurbishment during which a peristyle was added to a preexisting courtyard. The creation of the two statues, which would only have been visible to those who passed through the gates of the house, appears therefore to be a means of social display, which Cleopatra probably sought (according to the inscription, after all, it was *she* who initiated the work), considering that the social status of the couple, resulting perhaps from recently acquired wealth, permitted it.

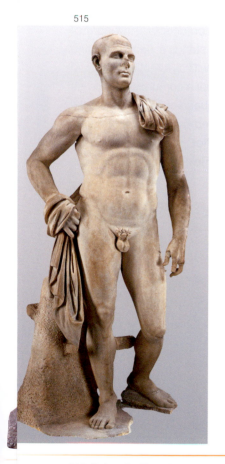

515

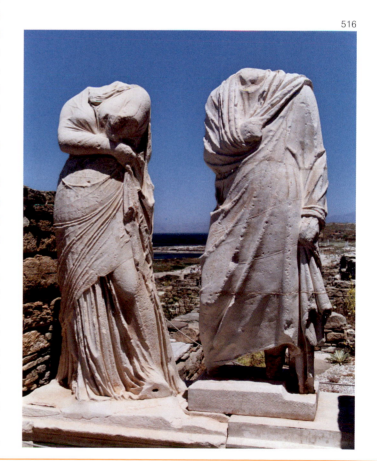

516

515. Delos, the Pseudo-Athlete. First century BC. Athens, National Archaeological Museum 1628.

516. Delos, marble statues of Cleopatra and Dioscourides (copies). c. 138–120 BC. Delos, Archaeological Museum A7763, A7799.

picture plane) creates the illusion of three-dimensional space as perceived by the human eye, projecting objects or bodies towards the viewer. Pliny speaks enthusiastically about one of his works, the *Alexander Keraunophoros* ("the thunderbolt bearer"), housed in the temple of Artemis at Ephesus, in which Alexander is depicted holding a thunderbolt "in fingers which appear to protrude and the thunderbolt that comes out of the painting" (*Natural History* 35.92). For this work Apelles was paid "twenty gold talents" (1 talent = 26 kg of metal) according to the stories circulating at the time, a sum which is likely exaggerated, but which demonstrates that the work of famous artists was rewarded in accordance to their reputation.

Apelles also adopted the technique of *skiagraphia*, which had been invented in the later fifth century BC (pp. 184–185). According to several anecdotal stories it seems that Apelles, along with others of his contemporaries, excelled in the use of tonal gradations to render shading. The use of lighter colors over darker surfaces in order to simulate the reflection of light

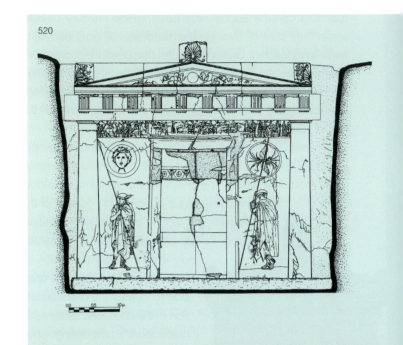

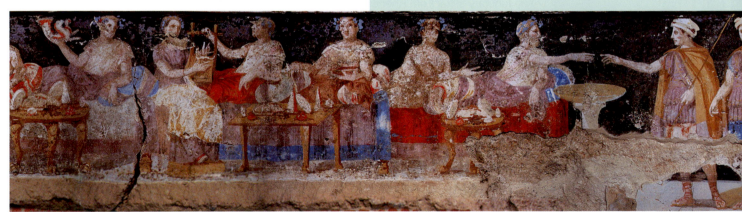

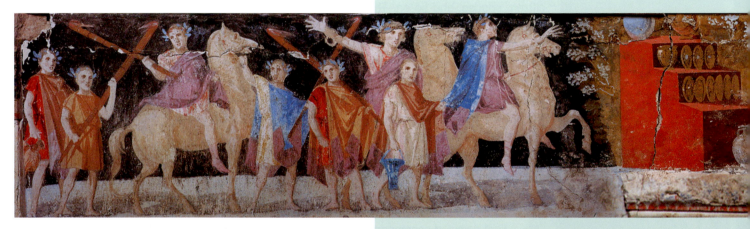

520. Ag. Athanasios, Thessaloniki, Macedonian tomb (drawing of the façade). c. 300 BC.

521–522. Ag. Athanasios, Thessaloniki, Macedonian tomb: the painted frieze. c. 300 BC.

THE MACEDONIAN TOMB AT AGIOS ATHANASIOS, THESSALONIKI

It is a single-chambered Macedonian tomb with barrel-vaulted roof. It features a façade in the Doric order without columns, but with two pilasters. It bears a frieze with 9 undecorated metopes and a pediment with a painted scene of griffins on either side of a disc (a shield?). The tomb in Agios Athanasios is one of the most important funerary monuments in Macedonia, mainly because of its richly painted decoration (as it was found looted). On the façade between the two pilasters and the door, are depicted two soldiers in Macedonian dress as guards of the tomb (fig. 520). The two figures are 1.45–1.52 m tall and are shown in different poses: the one is almost fully frontal and the other has his back turned to the viewer, his head almost fully turned to the left and his left leg relaxed. Both hold a *sarissa* (long spear) and are

521

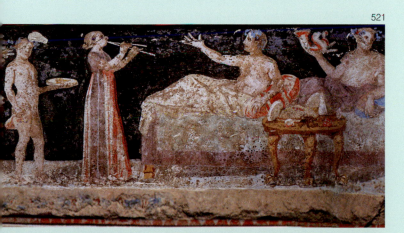

522

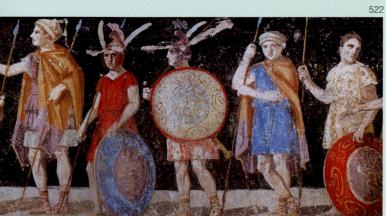

wearing a *kausia* (felt hat), a long rectangular chlamys and leather *krepides* (boots), while above them, on the wall of the tomb are painted their shields "hanging" by straps from nails (also painted on). The poses of the soldiers show elements of foreshortening and are an attempt to render the third dimension with the technique of *trompe l'oeil*, as for example the nails from which the shields hang, which project at an angle towards the viewer.

Above the door of the tomb, at the height of the capitals of the two pilasters, we find a painted frieze 3.75 m long, and with a height of just 35 cm (fig. 521–522). The subject is a composite scene of a symposium in which the deceased is depicted with his companions –possibly his fellow soldiers from Alexander's campaign in the East. It is a composition with many people and an especial historical interest. In addition to the central scene of the symposium are two further scenes that appear to be associated with the first –a group of cavalrymen who are approaching the party from the left and a group of Macedonian soldiers to the right. The event takes place in a featureless setting, without any indication of location, but showing the luxurious utensils and furniture of the symposium. The presence of a *kylikeion*, a brightly colored sideboard of sorts on which sympotic plates and other utensils are displayed waiting to be used, is characteristic, as is the detailed depiction of the distinctive equipment of the soldiers who are attending.

The painted decoration of the Tomb at Agios Athanasios exceeds the boundaries of traditional four-colors technique, as it also used hues which are achieved by mixing the four basic colors: the purple, for example, which we see on the shields of the guards and elsewhere comes from mixing Egyptian blue with cinnabar. Also clear is the use of an outline. The standard technique employed for the decoration of the tomb is fresco, using egg as a binding material, but also natural substances such as *tragacanth gum*, the resin of a plant known to ancient physiologists such as Theophrastus or Dioskorides.

on a curved surface was called *splendor* ("shine") by Pliny, and corresponds to the "highlights" still used by artists today to indicate reflected light on parts of the body. These innovations secured Apelles the respect of his contemporaries and his subsequent fame. Pliny, for example, thought that Apelles "brought to art more than all the other painters combined" (*Natural History* 35.79). According to what ancient historians tell us, this painter had won, besides the patronage of Alexander, the trust of many of his successors, including Ptolemy and Antigonos. The lack of original works by Apelles and his contemporaries is covered, in part, by the surviving mosaics of the period, the study of which should be attempted in accordance with the developments in the field of monumental painting. The study of Hellenistic mosaics permits us to follow the development of the technique and also to form perceptions of color and representational art from the late fourth century until the end of the Hellenistic period.

3.2 Mosaics

The technique of mosaic was perfected in the Hellenistic period. Mosaic, which in antiquity was principally used to deco-

rate floors but also walls, was formed of small square *tesserae* ("minute cubes") of stone or glass arranged so as to create a pictorial scene. Earlier attempts, at the end of the fifth century BC, to create mosaics used river or sea pebbles. These pebble mosaic floors are considered to be the forerunners of Hellenistic mosaics. Their subject matter was usually aniconic floral or geometric patterns but there are several figurative compositions. The invention of the technique is usually attributed to workshops in Asia Minor (Phrygia and elsewhere). Pebble floors appeared in private houses at Olynthos in the late fifth century and during the first half of the fourth century BC, in Eretria during the middle of the fourth century BC, as well as in houses in Pella around the end of the fourth century BC. The luxurious houses in Pella likely belonged to prominent Macedonians, possibly even royal courtiers who, having excelled in Alexander's campaign, returned to their homeland much richer and more powerful. The iconography of the surviving mosaics often seems to represent court life, possibly also real events from the time when Alexander still lived. The theme of the hunt appears in two mosaics from villas in Pella. The one with the signature of the mosaicist Gnosis (Γνῶσις ἐποίησεν = Gnosis

523

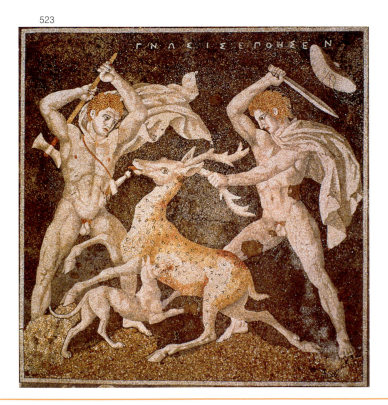

524

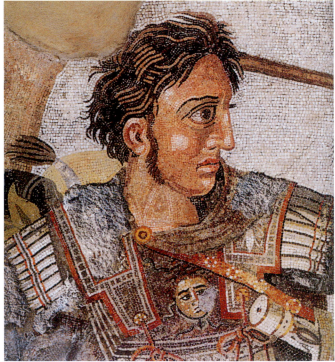

523. Pella, pebble mosaic floor with a hunting scene. c. 300 BC.

524, 525. Pompeii, the Alexander Mosaic from the House of the Fawn. Second century BC. Naples, Archaeological Museum.

THE ALEXANDER MOSAIC

The surviving Hellenistic mosaics, which are frequently thought to be copies of monumental paintings, testify to the continued use of the *four color* palette in the Hellenistic period. A typical example is the *Alexander Mosaic,* a monumental composition 3.17×5.55 m from the "House of the Faun" in Pompeii (fig. 525). The work is executed in fine *opus vermiculatum* (see p. 274). It is created from millions of tesserae, with a density which reaches 30 tesserae per square centimeter in some parts. This achieves the rendering of tones and shading within the limited framework of the strict four colors system. Set in against a featureless background –the only indication of the landscape is a dead tree trunk– the two armies of Alexander and Darius clash violently. Alexander on horseback attempts to approach, menacingly, the terrified Darius while all around the battle rages on. The finely worked mosaic successfully renders the shine of the weapons and the appearance of the bodies of both men and animals, while the composition uses the whole repertoire of foreshortening and other techniques to achieve depth and movement. The mosaicist also successfully uses highlights to convey volume, mainly on the bodies of the horses but also on the faces, such as on Alexander's, where a white tessera is used to create the glint in his eye (fig. 524).

The work is thought to reproduce a monumental painting of the late fourth century BC. The prevailing view is that the original of the mosaic is a famous work which, according to Pliny, had been painted by the artist Philoxenos from Eretria (*Natural History* 35.110). According to the text, Philoxenos painted his "unsurpassed" painting, in which the "Battle of Alexander and Darius" was depicted, for king Cassander (306–297 BC). It is thought, therefore, that the lost painting of Philoxenos depicted the Battle of Issos, since, according to ancient sources, it was in that battle that Alexander got within a spear's throw of Darius. Although it is not certain whether the mosaic from Pompeii actually copies the painting by Philoxenos or some other work with a similar theme (it has also been suggested to be associated with a lost work by Apelles or other painters of the later fourth century), it is clear that it preserved, if nothing more, valuable information for the techniques of Greek painting in the later fourth century BC.

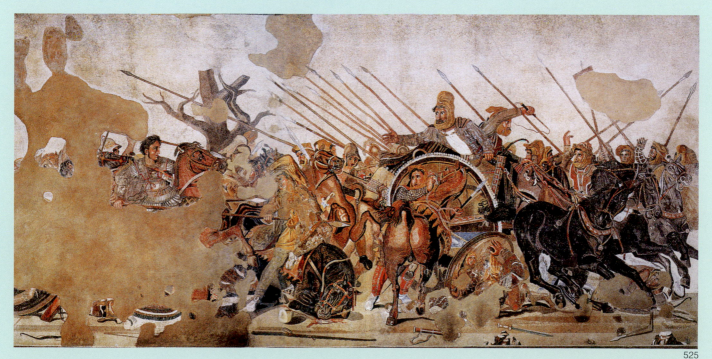

525

made me), depicts a deer hunt (fig. 523) which uses older compositional forms such as the chiastic juxtaposition between the two attacking male figures. The dark colored background and the strong shading gives the impression of three-dimensionality (especially in the tonal execution of the himation).

During the third century BC the pebble technique was abandoned. Pebbles were replaced with smaller tesserae in order to achieve a greater variation in color and tone. The invention of this technique probably occurred in Sicily or in Alexandria but its spread was immense, as it gave mosaics an almost paint-like quality, copying the tonal gradations and nuances of painted works. *Opus tessellatum*, as it is called in Latin (from the noun *tessella*, a pebble, diminutive of tessera), proved particularly popular for decorating luxurious houses and villas, especially for reception areas and the peristyle. The more sophisticated version of this type, with particularly small tesserae, as small as 1–2 mm in thickness, is called *opus vermiculatum* (from *vermiculus*, "little worm"). Examples of Hellenistic mosaics have survived in Pella, Delos, Pergamon, Alexandria, and cities in Italy such as Pompeii.

The *Mosaic of Dionysus* from a luxurious private villa in Delos (fig. 526) is one of the most important examples of *opus vermiculatum*. Its polychromy and the rich gradations in tone highlight the form and texture of the body of the clothes. Here also the background is dark colored and plain, emphasizing the dramatic quality of the work. During the Hellenistic period it was usual for mosaics to have in their center inset *emblemata* (mosaic panels with figurative themes), of higher technical quality than the surrounding decoration. It is likely that these central panels were commissioned from famous mosaicists who travelled from city to city seeking work.

526

526. Delos, mosaic floor with a scene of Dionysus from the House of the Masks. c. 160–100 BC.

527. Demetrias, painted funerary stele of Hediste c. 200 BC. Volos, Archaeological Museum.

3.3 Painted funerary stelai

Funerary stelai with painted decoration, rather than the more usual reliefs, have survived in many areas of the Hellenistic world. Although quite rare, because of the perishable nature of their decoration, they provide important information about the development of painting during this period. The most important collection of painted funerary stelai from the Hellenistic world comes from the city of Demetrias in Thessaly, 1.5 km south of modern Volos. The city was founded in 294 BC by the Macedonian king Demetrios Poliorketes (306–283 BC) as the new capital of his state, replacing the old Macedonian capital cities of Aigai and Pella. At first the population of the new city was formed from the inhabitants of Neleia and Pagassai, settlements that already existed in the area. Soon however the city received immigrants from many other areas of Greece and beyond. Merchants and professionals, artists, and of course the Macedonian military aristocracy settled in the city until the beginning of the first century BC when its gradual economic and political decline led to its abandonment.

Most of the painted stelai of Demetrias were found built into the fortification wall of the city that had been hastily repaired in 88 BC under the threat of attack by the king of Pontos, Mithridates VI Eupator. Their iconography appears to belong to the Attic tradition (see fig. 528). The city must have received migrant artists from Athens, as the erection of luxury funerary monuments had been forbidden there towards the end of the fourth century BC. They usually depict the deceased with their families, often performing the *dexiosis* gesture. The inscriptions provide their owners' ethnic epithets, especially if they were newcomers: soldiers from Crete and Acarnania are mentioned, as well as merchants from mainland Greece, and Epirus, but also Syria, Phoenicia, and Sicily. The pigments were the same as those used in Greek painting as a rule (see p. 182): various types of ochre, cinnabar, malachite, and other minerals, but also metals such as different lead oxides. They also used the synthetic *Egyptian blue*, as well as simple wood charcoal for black. The technique used on the stelai was that of egg tempera. In many of these stelai the attempt by the painter to render naturally the volume and third dimension, according to the principles of skiagraphia can be observed. The technique of outline is also used, however, especially for the clothing.

The *Stele of Hediste* (fig. 527), height 0.73 m, is a special case: it belonged to a young woman who died in childbirth, and it is one of the few examples of Greek funerary art where the actual time of death is depicted, something that appears to be an innovation of the Hellenistic period.

According to Pliny (*Natural History* 35.90) Apelles had created "images of men who are dying," we do not know however if he is referring to funerary compositions like this one, or of battle scenes (like the one which was copied in the *Alexander Mosaic* for example). Greek literature of the Hellenistic and Imperial periods also mentions "painted *typoi*" (painted reliefs, stelai) that bear depictions of women who died in childbirth. It seems that the changes in social and religious customs in the Hellenistic period allowed for the concept of death as an inexplicable event that was difficult for the human mind to accept. The six line epigram on the stele blames Tyche for the untimely death of "ill-fated Hediste," whom "she did not allow to hold her baby." The whole composition accentuates the heavy mood of the monument: the deceased lies, half naked, on the bed at the exact moment she breathed her last. At the foot of the bed stands her husband who looks at her in disbelief. Two female figures, possibly the midwife and relatives of the victim or slaves, are shown half hidden behind an open doorway,

527

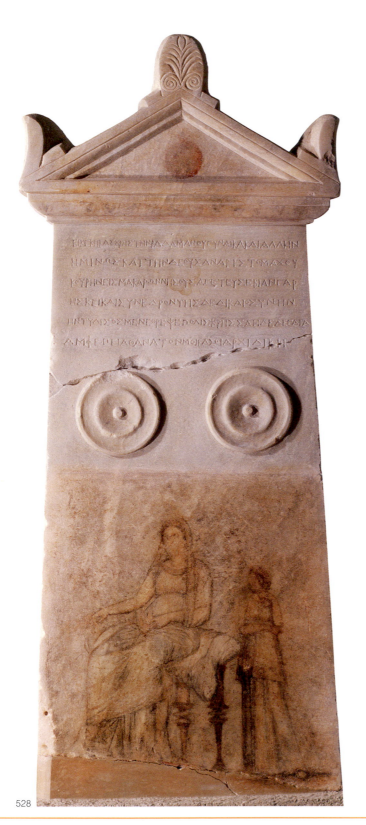

528

STYLES OF HELLENISTIC PAINTING: AN OVERVIEW

"Pompeian Styles" or "Greco-Roman painting styles" are the terms used for the four distinct stylistic trends which followed after one another in the decoration of the interiors of villas, but also other buildings of the Later Hellenistic and Early Imperial periods.

According to the conventional division the four Styles are:

■ **First style** (c. 200–60 BC). The wall is decorated in a pseudo-architectural style that consisted of fake masonry (fig. 529). The parts of the walls such as the lower courses (the footings and orthostats) and the courses of the upper structure and moldings are all rendered in different vivid colors. Examples of this come from Pergamon, Delos, Pompeii, and almost all of the Hellenistic and Roman world, whilst precursors were already in existence by the late fourth century BC.

■ **Second style** (c. 80–20 BC). In its early phase (80–60 BC) it coexisted with the First style. Its main characteristic is its "scenery style" wall paintings in which are rendered impressive complex urban landscapes (fig. 531). Through a complex system of rendering perspective, these wall paintings present a composition with multiple levels with stoas, balconies, and arches creating a false illusion of three-dimensional space, with strong realism and probably of symbolic character.

■ **Third style** (c. 30 BC–AD 20) achieves a purely decorative but unreal effect. It preserves the pseudo-architectural theme, but removes the illusion of a built environment. The "columns" and other architectural parts that are depicted now have a vegetal form, or recall candelabra and other very delicate objects which seem unable to bear weight (fig. 530).

■ **Fourth style** (c. AD 20–80) the illusion of three-dimensional space that prevailed in the Second style, returns in painted narrative scenes including exotic locations of a bucolic nature (fig. 532).

529

530

531

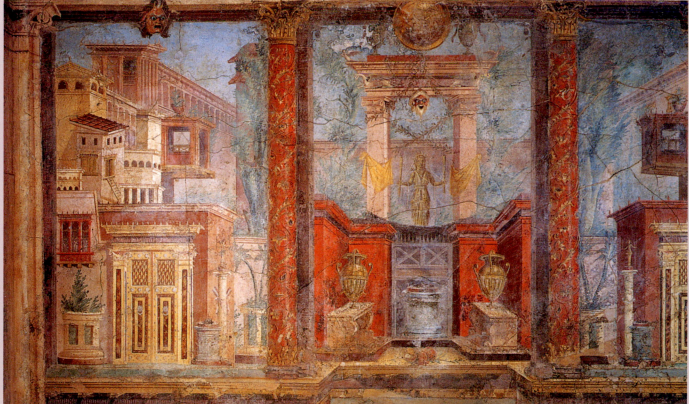

529. Reconstruction drawing of the painted decoration in the First Style. End of the second–beginning of the first century BC.

530. Reconstruction drawing of the painted decoration in the Third Style. Late first century BC–early first century AD.

531. Boscoreale, Italy. Wall painting from a private villa. c. 50–40 BC. New York, Metropolitan Museum of Art.

532

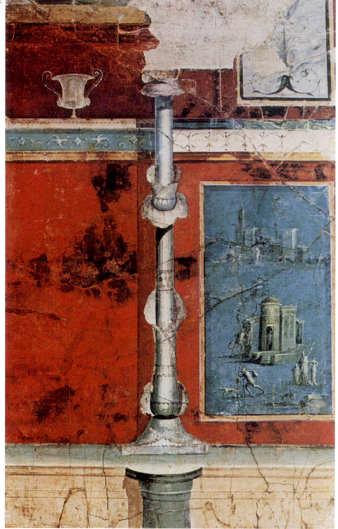

which in combination with the high walls framing the scene create a dark, claustrophobic interior space. It is one of the earliest surviving depictions of a built environment, and particularly of an indoor space that is rendered with such completeness in Greek art.

3.4 *Skenographia* and landscape-painting

The techniques of *skiagraphia* and *skenographia* ("theatrical set design") which the Greek painters devised (p. 184–185) in seeking the illusion of light and shadow, volume, and perspective, influenced Italian painting of the second and first centuries to a great degree, and also that of the Imperial period. From the beginning of the second century BC there appeared in Greco-Roman art the four successive styles of painting called "Pompeiian Styles" that took their name from the city of Pompeii, from the houses in which they were first identified and studied. Today we know that their spread was much wider and far exceeded the borders of Italy and that their invention occurred in the Hellenistic East.

The luxurious villas of the Italian cities, mainly in the area of Campania in the southern part of the Italian peninsula, were also decorated with wall paintings with figurative scenes, usually mythological, which are thought to have copied Late Classical and Hellenistic originals. In some cases, these wall paintings formed "panels" set into the pseudo-architectural decoration of the Second and Third Style, creating the illusion of an exhibition of paintings (frequently, of course, with a unified figurative theme). A typical example is the villa in the Italian city of Boscoreale, in the foothills of Mt. Vesuvius, which

533

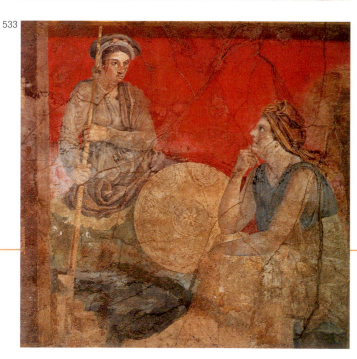

534

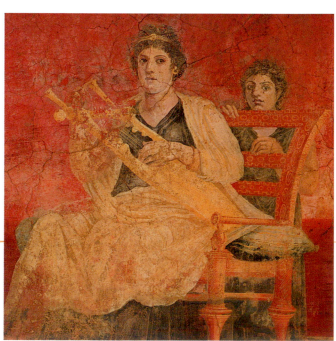

was destroyed in the volcanic eruption of AD 79 that overwhelmed Pompeii. A series of 8 wall paintings from one of the reception areas appear to refer symbolically to the history of Macedon, and furthermore to copy work from some Macedonian building — possibly even a palace — in Greece or in the wider Hellenistic world. In one of these scenes (fig. 533) two women are depicted, who appear to be personifications of Macedonia (with a Macedonian shield and other regional paraphernalia) and Asia (with a head cover resembling the

period. The works belong to a wider cycle which depicted scenes from Homer's *Odyssey*. In contrast, however, with the traditional styles of Hellenistic art, in which the human presence was the most important — a presence hitherto considered to be the sole conveyor of the narrative — here the landscape plays such a definitive a role that the human figures are almost inconsequential. The wall paintings, which date to the second half of the first century BC, exploit the established techniques of using light and shade to create atmospheric perspective and

535

Persian tiara). The purple clothing of "Macedonia" gives the scene a majestic regal character, while the style of the work indicates that the original painting may have dated to the early Hellenistic period.

Gradually landscape took on a more important role in the sphere of narrative art. Its portrayal in sculptural works such as reliefs or in paintings took on, towards the end of the Hellenistic period, a symbolic nature, as now it had a close relationship with the action, contributing to the content of the scene and not just a superficial representation. A group of 11 wall paintings from a private house in Rome, known as the *Odyssey landscapes*, illustrate the new role of landscape in art of the

diffuse lighting. The architectural features, such as the palace of Circe (fig. 535), are rendered according to the principles of *skenographia*, that is with foreshortening and multiple entrances / openings. The dominance of the landscape in the compositions gives the scenes a reflective and contemplative feel, elevating the dramatic narrative of events to a new level. The cycle of the *Odyssey Landscapes* seems to reflect the wider fashion of the Second and Third Styles, to which Vitruvius himself refers when he informs us that "there are some walls with large paintings which depict figures of the gods, myths, the Trojan War or the wanderings of Odysseus from place to place" (7.5.18).

532. Pompeii. Section of wall painting from a private house. First century AD.

533, 534. Boscoreale, Italy. Wall paintings from a private villa. c. 50–40 BC. New York, Metropolitan Museum of Art.

535. Rome, wall painting from a private house with a scene of Odysseus in Circe's palace. c. 50–30 BC.

HELLENISTIC SCIENCE

The Hellenistic age is usually considered to be a period of spectacular scientific and technological advancement, encouraged by significant intellectual achievements in areas such as theoretical mathematics. The inventions usually ascribed to the Hellenistic period include the cogged gear wheel, the pulley, the screw, the water clock and the musical water organ, a fire-engine of sorts, the advanced techniques of glassblowing and hollow bronze casting, the torsion catapult, and other types of sophisticated war machinery.

Such achievements were inevitably subject to widely held assumptions and beliefs of their time. As most Greek intellec-

536. Greek papyrus preserving the treatise by Hero of Alexandria. Paris, Bibliothèque Nationale de France Parisinus gr. 2515.

tuals despised manual labor, prizing theory for its own sake and not as a means to save manpower (which was amply supplied by slaves) and time (which was not considered as costly a commodity as in our own time), their scientific endeavors lacked the incentive to be practical and applicable. Seneca, a Roman philosopher, statesman, and dramatist of the first century AD, maintained that time- and labor-efficient inventions were harmful for society, as they encouraged idleness and self-indulgence. Plutarch, moreover, reports that Archimedes of Syracuse (c. 287 BC–c. 212 BC), a great mathematician, physicist, engineer, and astronomer, refused to write a treatise on engineering because he believed that any endeavor related to menial, everyday tasks was vulgar and lacked nobility. For him, beauty and refinement were the preconditions of true science. Greek engineers and physiologists were philosophers rather than scientists; quantification —a true scientific staple— was not considered necessary, as imaginative hypotheses took precedence and experiments were both rare and unsystematic.

Industrial efficiency, therefore, was rarely an issue (except perhaps in some cases in agriculture), as neither an increase in productivity nor the rationalization of the economy were expected as a possible outcome of their work. War was a notable exception, and this is where a lot of the inventive ingenuity demonstrated by Hellenistic scientists and thinkers was focussed. In Ptolemaic Alexandria, for example, the ingenious engineer Ktesibios (c. 300–320 BC) worked hard in order to improve various types of catapults. Even so, the obvious goal there was to create as forceful an impact as possible, regardless of the considerable amount of man-labor they required for their operation.

For the most part, Hellenistic inventions were meant to be sophisticated toys, designed chiefly for amusement and display. Hence, the Greeks usually referred to them as *mechanai* (contraptions), a term originally meaning a "trick" or a "hoax." The case of Hero of Alexandria, a Greek mathematician and engineer of the first century AD, offers a good example of the domain where

537. Alexandria, Greek papyrus preserving the treatise by Eudoxos of Knidos. Second century BC. Paris, the Louvre.

Hellenistic science excelled: his contraptions include a ball automatically rotated by steam in midair, a mechanism enabling temple doors to open automatically when a fire was lit on the altar, and other such gadgets designed to amuse the guests at a symposium or impress pilgrims at a sanctuary. Although it may be argued that such inventions introduced vast fields of physics such as pneumatics or hydraulics, they were obviously not designed with an eye to practicality or productivity. Several potentially useful devices, like the Alexandrian fire engine, were never put to practical use.

537

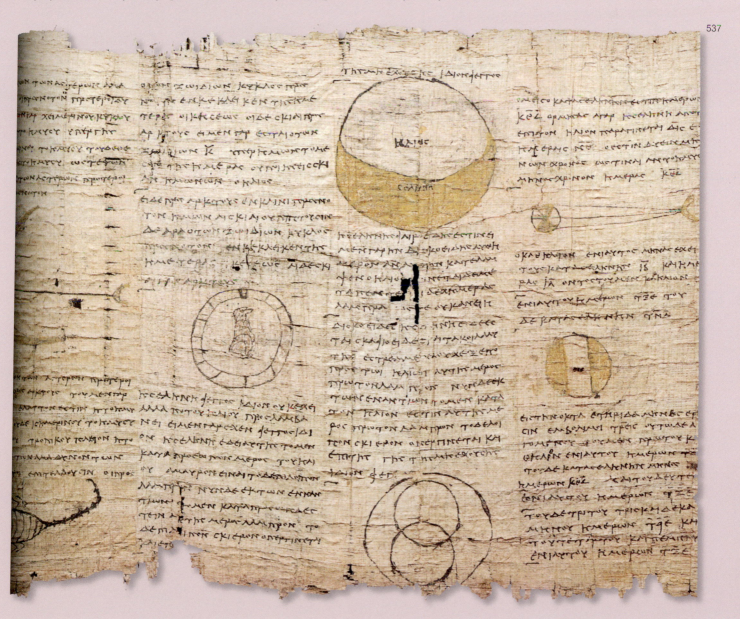

ASTRONOMY

The Hellenistic Kingdoms, mostly Egypt and Pergamon, provided a welcome environment for philosophers, scientists, and scholars to develop their research. Ptolemaic Alexandria was the basis of Euclid (c. 300 BC), Apollonios of Perga (third–second c. BC), and the above mentioned Archimedes, the three greatest mathematicians of the Hellenistic era. The mathematician and astronomer Eudoxos of Knidos (c. 408–355 BC) also used his time in Egypt to perfect his work on mathematical astronomy and his observations on the planetary movements. Another, slightly later, astronomer and mathematician, Aristarchos of Samos (c. 310–230 BC), was able to formulate his heliocentric theory (placing the Sun in the center of our solar system, and thus concluding that the Earth was not fixed in the center of the universe as was firmly believed by Plato and Aristotle).

Hellenistic astronomy was a rather rare occurrence in Greek science where innovative theory was translated into its necessary practical applications. One such example is the astrolabe-like mechanism discovered in the sea off the small Greek island of Antikythera (fig. 538–539). Carried by a merchant ship that sank in the area sometime in the early first century BC (also carrying valuable statuary, such as that in fig. 384), the so-called "Antikythera Mechanism" is considerably older, dating from the first half of the second century BC. It was made of copper, and was probably encased in a wooden box that has long since disappeared. The mechanism consists of a gear train containing over thirty interdependent gearwheels, expertly designed in order to calculate lunar and planetary cycles, predicting solar and lunar eclipses, operating as a calendar, and so on. This sophisticated, portable astronomical calculator is the earliest-known modular mechanism in the world.

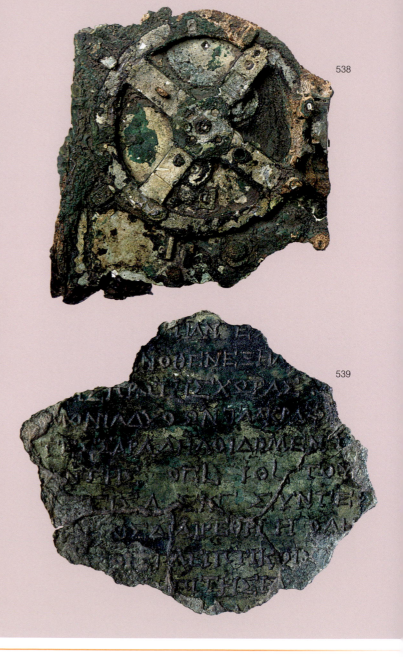

538

539

538. Copper fragment from the Antikythera mechanism. Athens, National Archaeological Museum.

539. Inscribed copper fragment from the Antikythera mechanism. Athens, National Archaeological Museum.

4. POTTERY AND MINOR ARTS

The emergence of luxury as a social value during the Hellenistic period, and the improvement in quality of life for the upper and middle levels of society, hastened the development of many industries producing objects for everyday use. Vessels and utensils for household, ritual and burial use, elegant works of art of dedicatory or simply decorative character, jewelry and small luxury items, compose an intriguing picture of indulgence and consumerism which, we assume, was widespread throughout society in the large Hellenistic cities. Technical and stylistic fashions gained a considerable range of influence, the identification of local "workshops" on the other hand becomes a futile exercise, considering the wide distribution of the objects themselves and of the ideas they expressed.

4.1 Pottery

Hellenistic pottery encompassed a wide variety of technical and stylistic categories. The flourishing of trade and the increased mobility of human groups or individuals contributed to the spread and mix of particular types that were no longer restricted geographically to a single workshop.

The **decoration** of pottery became simpler during the Hellenistic period, abandoning the sophisticated vase painting tradition of the Archaic and Classical workshops, while now metal prototypes predominated as much in terms of shape as of decoration. Pots are now most commonly decorated with the **painted**, **relief**, and **impressed** techniques and are usually *black-glazed*. Only after 100 BC did *red-glazed* pottery dominate, a typical example being the drinking cups produced in Pergamon and other areas of the Hellenistic world. The main categories of Hellenistic pottery are:

WEST SLOPE WARE A category that was identified and studied initially in Athens (large quantities of it were found on the west slope of the Acropolis, which gave its name to the type), but it had a wide distribution in the eastern Mediterranean and many centers of production

(Athens, Pella, Pergamon). The pots are essentially black-glazed, in shapes that copy metal prototypes (kraters, hydriai, amphorae), and decoration that consists of simple floral or geometric patterns in added white or brownish-red clay onto the black ground (fig. 540). The most characteristic feature of this pottery is the relief or inlaid decoration which mimics grooved or hammered work on metal vases and simple painted decoration (usually ivy leaves shaped like a wreath or a garland). The category dates to the end of the fourth century BC until the first century BC. At the same time in the Greek colonies of South Italy and Sicily, possibly originating in Apulia, a corresponding type of "Gnathian" ware was in use (named after the modern Italian city of Gnathia in Apulia — ancient Egnatia). The decoration of Gnathian ware resembles that of West Slope. It dates from the first half of the fourth to the end of the third century BC, and was widely distributed in the West.

HADRA VASES This category of Hellenistic pottery had its main production centers in Egypt, Crete, and Rhodes and a wide distribution throughout the eastern Mediterranean. Its main shape is the hydria. "Hadra" hydriai were used as cinerary urns, their name, in fact, comes from the cemetery of the same name near Alexandria in Egypt. Their decoration was mainly painted, in black or polychrome (tempera), on top of a white or creamy slip. In the Cretan variant of the type the decoration was added directly onto the surface of the vessel (fig. 543). The decorative themes were basically floral, animal and (more rarely) human figures. The cinerary urns from Alexandria frequently are inscribed with the date of death of the person whose remains they contain, a fact that contributes to their dating but is also an important chronological tool for the dating of Hellenistic pottery in general. "Hadra ware" examples are usually dated from the first half of the third to the first quarter of the second century BC.

LAGYNOI The lagynos is a typical shape in Hellenistic pottery, a variant of the lekythos. The decoration of the Hellenistic lagynoi is similar to that of the "Hadra type" vases, with floral or animal themes (wreaths, dolphins) either painted directly

540

540. Athens, a "west slope" style hydria. Third century BC. Athens, National Archaeological Museum 2547.

546

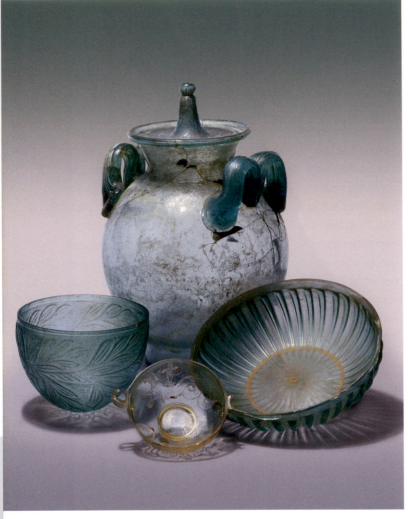

opulent. The shapes are once again inspired by metal styles, with grooving, imitation of hammering, and so on (fig. 547).

As is natural, the feeling of luxury increases in the centers of political power, in the palaces of the Hellenistic kings, and their surroundings. The financial management of the Hellenistic kingdoms, a mixture of Macedonian traditions and Eastern practices that Alexander had adopted after the overthrow of the Persian Empire, placed the chief responsibility for the economic stability of the kingdom in the king's hands and thus also made him the main beneficiary of the wealth produced. The royal treasure vaults took on mythical proportions in the hands of the most famous kings of the Hellenistic world, from the Ptolemies in Egypt and the Seleucids in Syria to the adventurous King of Pontos Mithridates VI Eupator. The latter, for example, according to ancient historians, kidnapped the young Ptolemy Auletes from Cyprus whither he had fled for reasons of safety while in Egypt a civil war was raging between his father and other members of his family. He also hijacked the treasure of the Ptolemaic dynasty that had been sent to the island for safe keeping. After the decisive defeat of Mithridates, the treasure ended up in Rome where it greatly influenced the technical production of precious items but also the wider concepts about what constitutes a life of luxury.

The so-called "Farnese Cup," named after the Italian Renaissance family to whom it once belonged, probably reached Italy through a series of similar reversals of fortune, ending up in Naples. This is an impressive phiale (bowl), 20 cm in diameter, made of *sardonyx*, as the ancient Greeks called this

547

548

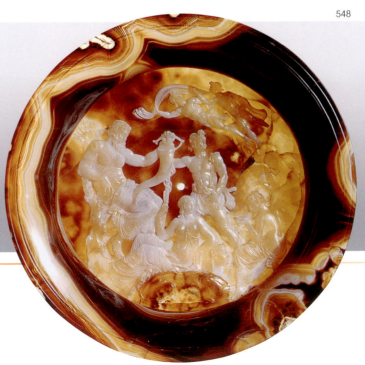

546. Glass vessels. First century BC–second century AD. Athens, National Archaeological Museum 23712, 23727, 12522, 16275.

547. Glass phiale. First century BC. Athens, National Archaeological Museum 12522.

548. The Tazza Farnese, phiale of sardonyx with a scene of Isis and Horus. First century BC. Naples, Archaeological Museum 27611.

549

variety of agate with multiple, multicolored layers (fig. 548). On the interior of this phiale there is a complex scene that is associated with the cult of Isis and the fertility of Egyptian land. In the center of the composition we find Isis seated on a sphinx, holding a torch, while beside her sits the personification of the River Nile enthroned with a cornucopia. Behind them strides tempestuous Horus, son of Isis, who symbolizes the passing of the seasons. The two Hours or Seasons are depicted on the right edge of the scene, with drinking vessels in their hands, while in the upper part of the scene the Etesian, "summer" winds are depicted flying towards the center, symbolizing the season during which the Nile floods and fills the land of Egypt with rich harvests and fertility. The exterior of the phiale is decorated with a gorgon's head, amidst leafy decoration. The symbolism of the Farnese Cup conforms to Ptolemaic ideology (the deified queens of the dynasty, in particular, were thought to generate the fertility of the Egyptian land that granted prosperity to its inhabitants) and the narrative-symbolic content is a good example of the survival of the principles of Greek art roughly eight centuries after its gradual establishment.

4.3 Jewelry

The typology and morphology of Hellenistic jewelry continued the Classical tradition: necklaces, earrings, diadems, bracelets, and rings are the most common categories and their decoration remains geometric or floral, with frequent additions of miniature sculptures which depicted people or animals. During the Hellenistic period there is an increase in naturalism in the iconography of the jewelry, while the floral decoration, including foliage, flowers, fruit, and seeds, became more frequent and more accomplished. In contrast with the jewelry of the Classical period — especially that of the fifth century BC — the jewelry of the late fourth century and later was more valuable, frequently more sophisticated and elaborate, while gradually the fashion developed for polychromy, which was achieved by insetting precious stones (garnet, cornelian, amethyst, rock crystal, glass). Gem-studded (*dialitha*) necklaces, bracelets, and diadems, usually made of gold with inset precious stones, became the most typical form of Hellenistic jewelry. This custom of decorating jewelry with gemstones is also to be found in metalworking.

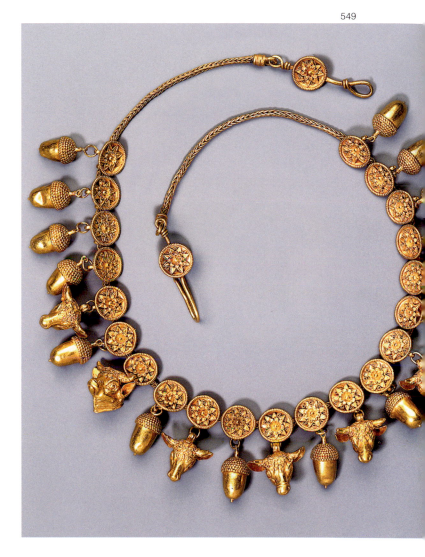

549. Troad. Asia Minor. Gold necklace. Third century BC. Athens, National Archaeological Museum Στ. 306.

550. Karpenisi, gold bracelets. Third century BC. Athens, National Archaeological Museum Στ. 370–371.

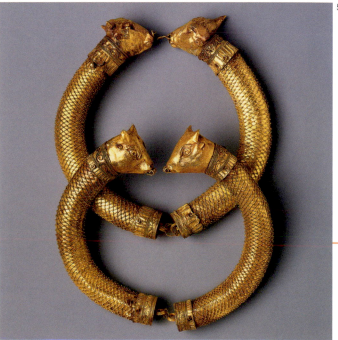

550

551

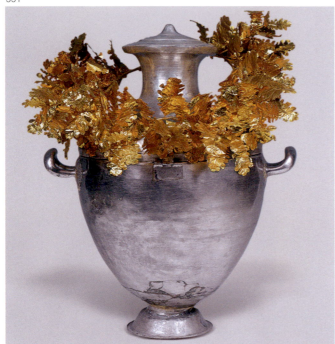

The gold diadem from the antechamber of *Philip's tomb* at Vergina dating to the second half of the fourth century BC (330–310 BC) is a typical example of the fashion for greater realism in Hellenistic jewelry (fig. 552): it is a sophisticated composition of spiraling leaves and tendrils, flowers, and anthemia (leaf clusters) around a *knot of Herakles* (see p. 109), a theme that is particularly favored in Hellenistic decorative arts. The imitation of nature extends to additions of miniature sculptures representing bees and other insects that appear to sit on the flowers forming the diadem. The Vergina diadem is also bejeweled, as it is decorated with inset discs of blue enamel. The gold diadems from the tombs of Macedonia (Vergina, Derveni) and other tombs of the late Classical and Hellenistic period, are exclusively for funerary use, made to accompany the deceased into his or her grave, usually crowning the funerary urn (see fig. 551). They are in addition a valuable testament to the technical skill of Greek jewelry-making during the second half of the fourth century BC.

The level of luxury that appears to have been available to the upper and middle classes of Hellenistic society is demon-

552

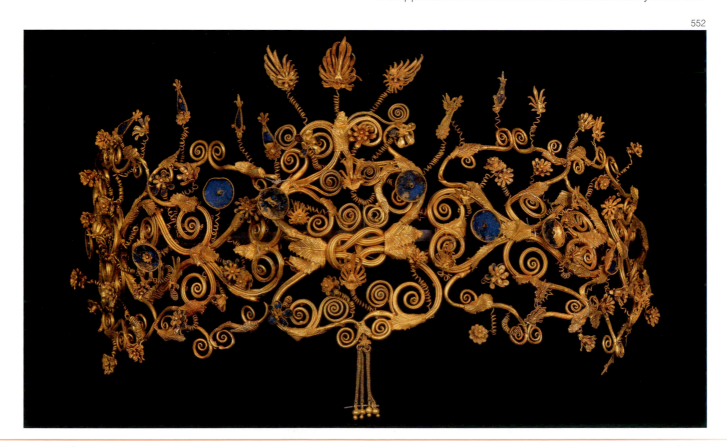

551. Vergina, "Tomb of the Prince." Gold wreath of oak leaves crowning a silver hydria. c. 310 BC. Vergina, Museum of the Royal Tombs at Aigai.

552. Vergina, "Tomb of Philip." Diadem from the antechamber. c. 330–310 BC. Vergina, Museum of the Royal Tombs at Aigai.

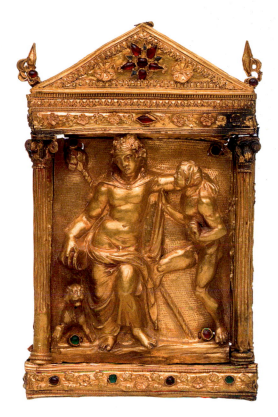

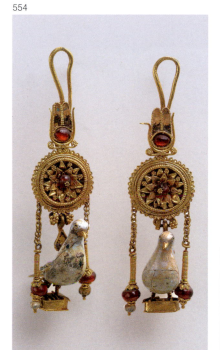

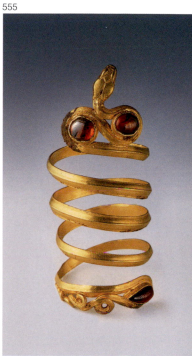

strated by the precious and rather sophisticated jewelry that was made in many areas of the Greek world but also beyond it. The pair of gold earrings with miniature sculptures in the form of doves from the Taman peninsula in the Black Sea, for example, combines sophisticated technical execution (granulation, filigree, chains) with color (garnet, cornelian, enamel) and religious symbolism: the disc of each earring is crowned with the sacred diadem of Isis (sun disc, cow's horns, and feathers of a hawk) as defined in Pharaonic tradition (fig. 554). Alongside jewelry, Hellenistic goldsmiths created a variety of decorative items that demonstrate their tendency for sophistication and color. A typical example is the gold naiskos from the third century BC, from Thessaly, with a relief scene of Dionysus, a satyr, and a panther (fig. 553). The object, possibly of votive use, bears jeweled decoration in garnet and glass paste.

The diadems with the central motif of the knot of Herakles are typical of Hellenistic jewelry (fig. 557). Many of these, mostly coming from Thessaly, appear to have been made in other areas of the Hellenistic world, and are characterized by strong polychromy, as they have inset elements in cornelian, garnet, enamel, and glass. The many armbands, bracelets, and rings of the period, which frequently take the form of a

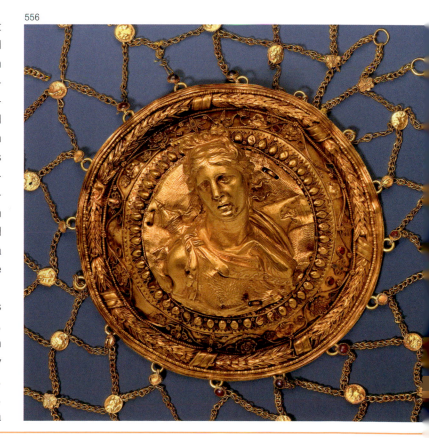

553. Thessaly, "gold" naiskos with a relief scene of Dionysus and a satyr. Third century BC. Athens, National Archaeological Museum.

554. Taman peninsula, Black Sea, pair of gold earrings. Second century BC. St. Petersburg, Hermitage Museum.

555. Gold ring in the form of a snake. c. 200 BC. Athens, Archaeological Museum.

556. Gold disc with a bust of Artemis. Second century BC. Athens, National Archaeological Museum Στ.369.

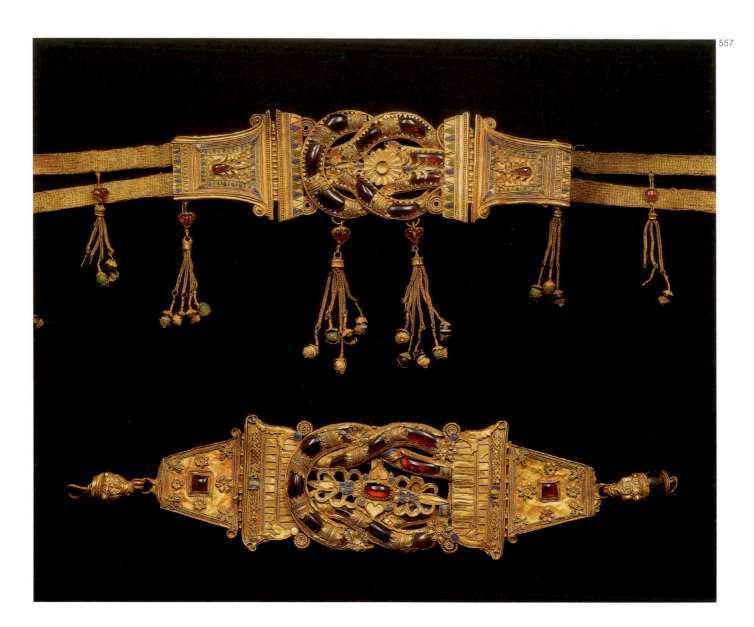

557

snake twisting around the body part which they adorn, are also set with jewels (fig. 555).

Of interest, finally, is a category of gold medallions with prominent relief busts of female deities (fig. 556). The medallions that came from illegal excavation and as such are divorced from the context of their final use, are set within a network of gold chains attached to their edge. Possibly they were produced as central bosses for metal vessels that were in secondary use, modified with the addition of the chains to form a "brooch" for the chest or for the hair.

4.4 Coins

Hellenistic coins continued the Classical tradition with the addition of several important innovations. At the same time, as a result of the expansion of the kingdom of Macedon and the Hellenistic kingdoms which succeeded the empire created by Alexander, Hellenistic coinage became an international device applied to economic, political, and even diplomatic use.

When Philip II of Macedon died in 336 BC, he bequeathed his son two fixed monetary standards for the Macedonian realm: from 345 BC and after, the gold Macedonian staters

557. Gold diadems with the knot of Herakles. Third–second century BC. Benaki Museum.

558

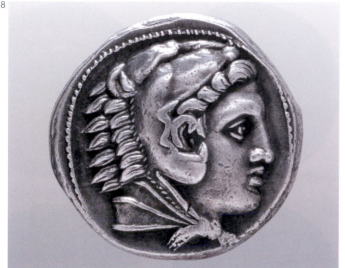

559

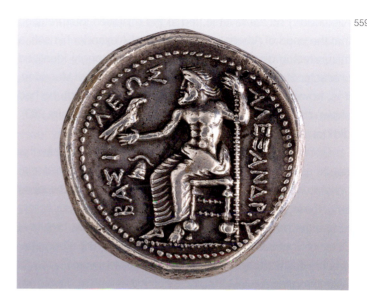

(didrachms) followed the Attic standard (c. 8.64 g) while the silver tetradrachm (c. 14.52 g) was a multiple of a lighter drachma according to the local Macedonian practice. As the ratio for the value of gold to silver during the reign of Philip was about 13 ¹/₃, 8 silver tetradrachms were worth the same as 1 gold stater. Alexander converted the silver tetradrachm to follow the Attic weight system (c. 17.28 g), which led to the gradual replacement of the internationally recognized Attic "owls" with the new Macedonian coins. During the period between 336–323 BC, Alexander's treasury received a rapid influx of capital, culminating in the 40,000 talents of gold and silver coming from Susa in the autumn of 331 BC and the 120,000 talents from Persepolis the following winter. It has been calculated that up to 330 BC the royal treasury had received 4,680 tonnes of silver, while further revenue must have been secured from the conquest of Sogdiana, Bactria, and India. The conversion of the majority of this capital into coinage fixed the Macedonian silver tetradrachm as the primary coin in international trade, displacing the Attic drachma. At the same time the abundance of gold led to a slight devaluation in precious metals, revising the ratio of gold to silver to 10:1 and as a result the equivalent value of silver tetradrachms and gold staters was changed to 5 tetradrachms to one stater.

The silver tetradrachm of Alexander depicts a bust of Herakles in the obverse and an enthroned Zeus on the reverse (fig. 558, 559). Both images carry Classical stylistic echoes

and a strong "Panhellenic" character. The Zeus probably refers to the chryselephantine statue from Olympia while Herakles bears Phidian similarities. This coin was destined to become the commonly accepted currency throughout the Greek world and beyond.

In the same way the gold staters and double staters employ types adopted from the common Greek tradition (fig. 560–561): the obverse carries a bust of Athena in a Corinthian helmet, possibly a distant copy of the Phidian Athena Promachos from the Acropolis in Athens, with a winged Nike and crown on the reverse. The impact of these types in antiquity, as well as during the Renaissance, in combination with the inscription ΑΛΕΞΑΝΔΡΟΥ ("of

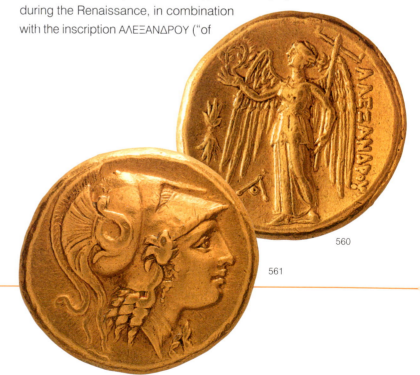

560

561

558, 559. Silver tetradrachm (reverse and obverse) of Alexander III of Macedon. 336–323 BC.

560, 561. Gold double stater (obverse and reverse) of Alexander III of Macedon. 336–323 BC.

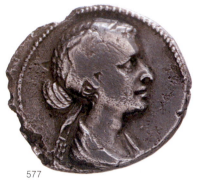

574 575 576 577

on the coin highlight the real facial features of the kings they portray (crooked noses, thinning hair, fleshy faces), without any apparent attempt at beautification, idealization is clear at the same time: the majority of the kings on Hellenistic coinage are portrayed younger than they were in reality at the time the coin was issued (fig. 565). Dynastic continuity is underlined by the emphasis on facial characteristics demonstrably inherited from generation to generation, such as the fleshiness or the protruding eyes of the Ptolemies. A typical example is the "dynastic" gold tetradrachms and octadrachms, which were anniversary issues first minted by Ptolemy II Philadelphos a little before 260 BC, and continued for many decades (fig. 566–567). The obverse carries the jugate busts (*capita jugata*) of Ptolemy Philadelphos and his sister/wife Arsinoe Philadelphos and the reverse, in a similar composition, those of their parents Ptolemy I and Berenice. These valuable coins emphasized the value of dynastic continuity and stability for the prosperity of the kingdom —the fruit of which was, evidently, the coins themselves. The inscription ΘΕΩΝ ΑΔΕΛΦΩΝ ("of the sibling-gods"), is split over the two faces of the coin, referring to the dynastic epithet of Ptolemy II and Arsinoe. In the texts of the period the octadrachm is called a *mina* (based on an equivalence of 1:12½ with silver, 1 gold octadrachm was worth 100 silver drachmai) and the gold tetradrachm is called a *pentakontadrachmon* ("fifty-drachmai piece"). The image of the paired busts seems to have been devised by the Ptolemies themselves, for the promotion of their dynastic imagery and possibly to mimic the Pharaonic sculptures in Egyptian art. The theme had a significant impact on later coinage (see fig. 574), was adopted by Roman art, and finally passed into the western art of the Ren-

aissance and later, where several examples of coins and medals depicting royalty in such a way may be found.

The gold octadrachms and silver decadrachms and tetradrachms issued by Ptolemy II in honor of Arsinoe Philadelphos after her death in 270 BC were similar in character (fig. 568–569). The newly deceased queen was depicted on the obverse with an elaborate *stephane*, a triangular-shaped crown, and a bulky "melon-coiffure" covered by her himation. Behind her head we can discern the tip of a scepter in the shape of a lotus flower. Beside the queens' ear is a ram's horn, a symbol of her deification. The reverse carries the double cornucopia (*dikeras*), a dynastic attribute devised for this particular queen by her widowed king (see fig. 542), tied with the royal diadem, as well as the inscription ΑΡΣΙΝΟΗΣ ΦΙΛΑΔΕΛΦΟΥ ("of Arsinoe Philadelphos"). The combination of divine and dynastic symbols, as well as the inscription of the dynastic epithets, clarifies the message of the depiction and underlines the elements that each coin attempts to promote.

Beyond the kingdom of the Ptolemies, the imagery employed by the kings of Syria, Macedonia, Pontos, and other Hellenistic dynasties was closer to the prototype devised for Alexander, as established in the coins of Lysimachos (fig. 563). The kings appear young and energetic, usually only distinguished by a royal diadem (fig. 570, 576). The coherence of the types is explained by their wide circulation as well as the mobility of the engravers themselves who appear to have travelled from palace to palace seeking work. A particularly idealized style may be seen in the image of Mithridates Eupator on coins (fig. 572). The ruler is depicted rather youthful, considerably younger than his real age, with an upraised head mimicking

574. Silver didrachm of the Epirote League. 234/3–168 BC.

575. Silver tetradrachm of Eukratides I of Bactria. c. 170–145 BC.

576. Silver tetradrachm of Antiochos VIII Grypos of Syria. 126/5–96 BC.

577. Silver tetradrachm of Cleopatra VII of Egypt. 48 BC.

Alexander's, wavy hair, and diadem whose bands billow out behind him. The royal image on these coins is exploited as an instrument of political propaganda, since Mithridates appears as the "liberator" of the Greek cities and conqueror of East and West. The coins from the periphery of the Greek world, in the kingdoms of India and Bactria, are an interesting category of Hellenistic royal issues, where the Greek or Hellenized rulers attempted to combine the ethos of the Hellenistic portrait with the needs of their politics. In the numismatic portrait of Eukratides I, for example, the king is portrayed as a soldier, with the heavy, wide helmet of the cavalryman, and harsh features, demonstrating the tough character of an army man who is called upon to govern an inhospitable and frequently wild land (fig. 575).

The Roman general Titus Flamininus, the victor against Philip V of Macedon in the battle of Cynoscephalae in Thessaly in 197 BC, was depicted on a series of gold staters issued by Greek cities to honor his victory and their liberation from the Macedonian yoke which was proclaimed immediately afterwards. The portrait of the general adopts in part the sophisticated idealism of Hellenistic portraiture, but avoids any elements of beautification (fig. 573). The general is depicted as old and tired with small eyes and bristly hair, neither "heroic" nor "hegemonic," as befits his position as an officer who was acting on behalf of the Roman Senate.

Finally, in the portrait of Cleopatra VII, with whom the Ptolemaic dynasty ended and the kingdom of Egypt was subjugated to Rome, can be made out the reverse effect of the Roman portraits of the Republican period (see p. 266–267). The queen is depicted here with a crooked nose and "realistic" features, in contrast with the older issues and portraits of her in other art forms. The absence of any idealization (in contrast Cleopatra is depicted as older than her actual age), and the emphasis on facial features, appears designed to highlight the decisive and dynamic temperament of the queen, at the time of her clash with her brother Ptolemy XIII and her sister Arsinoe, from which she emerged victorious with the decisive help of Julius Caesar.

4.5 Sealstones

During the Hellenistic period sealstones changed shape and appeared more usually in the form of ring bezels (see fig. 580–581). The engravers turned towards more lustrous and impressively colored stones set in precious gold, silver, or bronze rings, which were much heavier than those of the Classical period (fig. 579). The most common form in Hellenistic sealstones was the elongated oval intaglio with curved sealing surface. Circular stones were frequently used for the depiction of heads, usually portraits. The conquest of the East encouraged the trade in precious stones and the entrance onto the Greek repertoire of materials such as garnet (usually of a bright red color) and other transparent varieties of quartz, with a clear preference for bright colors. The use of glass expanded widely

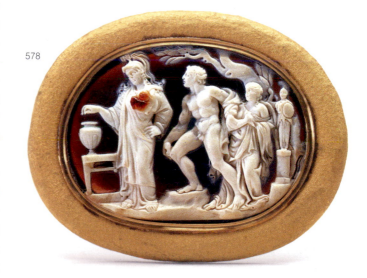
578

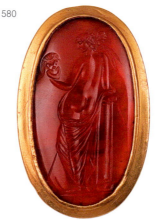
580
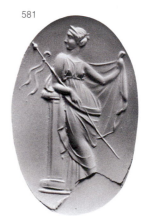
581

579

578. Sardonyx cameo with a depiction of Orestes and Athena. c. 30 BC. St. Petersberg, Hermitage Museum.

579. Profiles of characteristic types of Hellenistic rings.

580. Aetolia, gold ring with inset cornelian with the depiction of a Muse. c. 200 BC. Athens, National Archaeological Museum Χρ. 801.

581. Cornelian sealstone with a scene of Aphrodite or a Nymph (impression). Second century BC. Oxford, Ashmolean Museum 1892.1515.

during the Hellenistic period, probably to imitate precious materials and to create cheaper sealstones.

The main technological advance during the late Hellenistic period was the innovation of the *cameo* which is cut in relief rather than incised ("intaglio"). The material used for cameos was usually *sardonyx*, a variety of multicolored agate where the scene is created by exploiting the color contrast of the different layers of the stone. Cameos became especially widespread in the first century BC, when they were used frequently for multi-figured mythological scenes usually executed in the classicizing style. Fig. 578 shows a cameo, c. 4 cm wide, on which is depicted the story of Orestes, with Athena casting the vote for his innocence while the hero and his sister Elektra look on anxiously. The scene has the typical characteristics of Late Hellenistic art and recalls the reliefs of the neo-Attic tradition (p. 258).

In Hellenistic glyptic arts, the standing male or female became particularly popular. Gods, demigods, heroes, and other minor deities (muses, nymphs) are depicted in relaxed, nonchalant poses, leaning against columns or pilasters. The muse in fig. 580 is a typical example in terms of pose and clothing for female figures in Hellenistic signet rings. In the example in fig. 581 Aphrodite (or a nymph) appears in a similar leaning pose with rich clothing, crown, and scepter on an engraved cornelian found in the modern city of Tartus in Syria (ancient Antaradus). The wide distribution of these small items in every corner of the Hellenistic world makes it difficult to identify individual workshops, but it is likely that sealstones were produced in every major administrative and commercial center of the period (Alexandria, Antioch, Pergamon, Babylon, as well as the cities of mainland Greece).

The use of portrait heads on Hellenistic coinage also influenced the seal-carving of the period. The references in ancient sources to the gem-engraver Pyrgoteles (p. 263) as the exclusive carver of Alexander's portrait led to the suggestion that the image of the king of Macedon was cut on royal signet rings (*daktylioi semanteres*). According to the ancient texts, the gift of such a ring by the king to one of his courtiers was an indication of favor and preference. A rare sealstone in tourmaline (from the family of silicopyritic minerals that are still used as precious stones today) from Afghanistan portrays the deified Alexander in a similar way to that to be seen on the silver tetradrachm of Lysimachos (fig. 582–583, see fig. 563). Of interest is the microscopic inscription just below the line of the neck, probably an early form of *Karoshti*, the alphabet that was used in the area of Ghantara in modern Pakistan from the middle of the third century to the third century AD. Its early date and the size of the inscription make it impossible to read. The existence of the object, however, its origin and its "exotic" inscription demonstrate the influence of portraiture and that of Greek art even in the periphery of the Hellenistic world.

The portrait heads of rulers on Hellenistic sealstones follow along general lines the developments that have been observed in coins — and are usually thought to have been created by the same engravers. In contrast with coinage, however, portraits on sealstones have a more "private" nature, without resorting to the accumulation of dynastic or divine symbols that we see on coin portraits. In many cases, such as that of "Berenice I" (the wife of Ptolemy Soter) on an iron ring with a gold bezel from Corfu (fig. 584), the portrait may belong to a member of

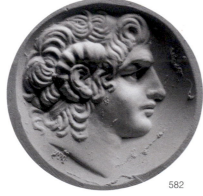

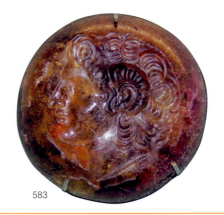

582

583

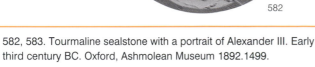

582, 583. Tourmaline sealstone with a portrait of Alexander III. Early third century BC. Oxford, Ashmolean Museum 1892.1499.

the ruling class who simply copied the way the queens of her time chose to represent their likeness. This particular representation with its impressive "melon-coiffed" hairstyle, which was especially popular during the late fourth and the third century BC, the fine jewelry and the confident, but in no way idealized expression, is one of the most interesting Hellenistic portraits. The portrait of Philetairos of Pergamon (283–263 BC), founder of the Attalid dynasty, is recognizable on a remarkable jasper sealstone (fig. 585). Philetairos did not ever proclaim himself king, formally remaining a satrap of the Seleucids, but after his death his successors depicted him on their coins as a symbol of dynastic continuity (fig. 571). Although the posthumous portraits on the coins show him wearing a diadem, on the jasper sealstone in fig. 585 his head is unadorned, a fact that probably dates it to before his death.

Ptolemaic Alexandria is considered to have been one of the most important production centers of Hellenistic sealstones. The promotion of the Ptolemies through the medium of art was also attempted with the engraving of precious sealstones that they either used themselves or gave to friends, companions, or supporters. Two gold rings that both depict Ptolemy VI Philometor (180–145 BC), but each with different clothing — traditionally Greek with a chlamys and diadem and traditionally Egyptian with a double pharaonic crown— seem to indicate the dual role of the Ptolemaic rulers as Greco-Macedonian kings and at the same time Pharaohs (fig. 586–587). The depictions are realistic and give emphasis to the distinctive facial features of the monarch that are related to the coin portrait. In Ptolemaic Alexandria it seems that a very valuable type of ring

was introduced, made in solid metal, which was considered to be a symbol of financial stability and political excellence. A typical example is the gold ring with the twin heads of Serapis and Isis (symbolizing the royal couple) with the typical symbols of Pharaonic power (fig. 588).

Private portraits are quite common in Hellenistic sealstones. A special category is the portraits of non-Greek "barbarians," which were rendered with the characteristics of their national clothing or individual facial characteristics (fig. 589). In parallel, the revival of classicism in the art of the second century BC also influenced seal engraving. The head on the amethyst sealstone in fig. 590, which was found in India and has a diameter of 2.25 cm, is rendered with the typical characteristics of a male deity in the Hellenistic sculpture of the period (see fig. 479). The gem features the head of Poseidon or Zeus with a band in his hair. The hairstyle, and the well-formed beard with the two separate curls beneath the chin, improve upon the elements of the classical tradition. The wide distribution of Hellenistic sealstones, in areas of the East such as Iraq and India, but also the West, as Italy, demonstrate how popular these objects were. According to several historical sources, during the late Hellenistic period, the first *dactyliothecae*, collections of sealstones, appeared.

Among the rulers of the Hellenistic world Mithridates VI Eupator of Pontos was the best known collector of engraved stones, and consequently must have been a great patron of Greek engravers, as appears, at least, from the coins he issued. Appian (*The Mithridatic Wars* 115) mentions the sizeable collection belonging to the Pontic king, and Pliny (*Natural History* 37.11–12) informs us that after the defeat of Mithridates

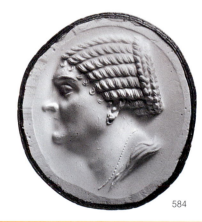

584

585

584. Gold bezel ring with a portrait of a head (impression). Third century BC. Oxford, Ashmolean Museum FR.36.

585. Jasper sealstone with the head of Philetairos of Pergamon. Third century BC. London, British Museum.

586 587 588

589 590 591

by Pompey, the latter transferred his collection to Rome and dedicated it in the Capitolium. Athenaios (*Deipnosophists* 5.212d–e), finally, mentions an Athenian politician, Athenion, who showed his fellow citizens the ring he wore, with an engraved sealstone which depicted Mithridates, as a symbol of his favor and political support.

The presence of the Romans in Greece and in Asia Minor was particularly obvious by the second century BC. Their interference in the political matters of the Hellenistic kings, and the fateful role that they played in the destruction of most of them, brought Roman patrons into contact with Greek artists. Often Roman generals and officials behaved towards the artists in the same way as had the Hellenistic rulers. More specifically, Roman officials charged with the minting of coins to cover the needs of individual campaigns in Greece and Asia Minor, appear to have recruited local engravers. In this way they adopted elements

from Greek mythology, such as the Gorgon and other characters from the repertoire of Greek art. The artists themselves sought their fortune in Rome at the end of the Hellenistic period. These migrations, as well as the transport of the material itself (such as the treasury of Mithridates that was mentioned above), influenced anew the sealstone carving in the West. The sealstones from the time of Augustus, frequently signed by Greek engravers or Romans with Hellenized names, bear witness to the strong influence of Hellenistic art. Engravers with names such as "Dioscourides" or "Solon" followed successful careers in the second half of the first century BC and the beginning of the first century AD. Dioscourides is mentioned as the engraver of the personal sealstone of Augustus and Solon had signed many of the stones which survive today (see fig. 591).

The way in which they "translated" or modified Greek traditions is particularly clear in a cornelian sealstone, 3 cm wide, de-

586, 587. Gold rings with the head of Ptolemy VI of Egypt. Second century BC. Paris, Louvre.

588. Gold ring with the paired heads of Serapis and Isis. Third century BC. London, British Museum.

589. Garnet sealstone with a portrait head (impression). Second century BC.

590. Amethyst sealstone with the head of Poseidon or Zeus (impression). Second century BC.

591. Amethyst sealstone with the head of a gorgon (impression). First century BC.

picting a scene from the "rape" (theft) of the Palladion by Diomedes and Odysseus during the Trojan War (fig. 592). According to ancient tradition, the Palladion (a wooden effigy of Athena) guaranteed that Troy would remain impregnable while it was kept in the city. The two Greeks moved the statuette to their camp, in their attempt, however, they committed an act of hubris in slaying a priest of Poseidon inside his temple and thus invoked the rage of the gods. The scene on the sealstone follows the essence of Virgil's reciting of the story rather than that of Homer, emphasizing the cruelty of the Greeks rather than their heroism. The dead priest is depicted behind the altar, while the column with the statue of Poseidon forewarns of the misfortunes awaiting the two heroes in their effort to return to their homelands. Although the content of the scene has been adapted to satisfy the aesthetic and ideological needs of the owners of the sealstones, the Roman engraver never ceased to resort to the Greek tradition that he appears to have appropriated. The gem is signed in Greek, ΦΗΛΙΞ ΕΠΟΙΕΙ ("Felix made me"), in the same way as the name of the person who commissioned it is written in Greek: ΚΑΛΠΟΥΡΝΙΟΥ ΣΕΟΥΗΡΟΥ ("of Calpurnius Severus"). The fact that the engraver Felix and his client Calpurnius both understood and enjoyed the principles of Greek art eight centuries after its inception explains the impact of Classical culture in late antiquity, as well as its modern revival.

SELECT BIBLIOGRAPHY

General

J.J. Pollitt, *Art in the Hellenistic Age.* Cambridge: Cambridge University Press (1986).

A. Stewart, *Art in the Hellenistic World. An Introduction.* Cambridge: Cambridge University Press (2014).

Sculpture

J. Boardman, *Greek Sculpture. The Late Classical Period and Sculpture in Colonies and Overseas.* London and New York: Thames and Hudson (1995).

R.R.R. Smith, *Hellenistic Sculpture.* London and New York: Thames and Hudson (1991).

N. Spivey, *Greek Sculpture.* Cambridge: Cambridge University Press (2013).

A. Stewart, *Greek Sculpture. An Exploration.* New Haven and London: Yale University Press (1990).

Pottery

T. Rasmussen and **N. Spivey** (eds), *Looking at Greek Vases.* Cambridge: Cambridge University Press (1999), ch. 8.

Painting

J.J. Pollitt (ed.), *The Cambridge History of Painting in the Classical World.* Cambridge: Cambridge University Press (2015).

Architecture-Topography

I. Jenkins, *Greek Architecture and its Sculpture.* Cambridge MA: Harvard University Press (2007).

A.W. Lawrence, *Greek Architecture.* New Haven and London: Yale University Press (5th ed. 1996).

A. Spawforth, *The Complete Greek Temples.* London and New York: Thames and Hudson (2006).

Minor Arts

J. Boardman, *Greek Gems and Finger Rings. Early Bronze Age to Late Classical.* London: Thames and Hudson (2001).

W.E. Metcalf (ed.), *The Oxford Handbook of Greek and Roman Coinage.* Oxford: Oxford University Press (2012).

D. Williams and J. Ogden, *Greek Gold. Jewellery of the Classical World.* London: British Museum Press (1995).

D. Plantzos, *Hellenistic Engraved Gems.* Oxford: Oxford University Press (1999).

592

592. Cornelian sealstone depicting the theft of the Palladion (cast). First century BC. Oxford, Ashmolean Museum.

INDEX

A

Agatharchos 185, 194
Abu Simbel 105, 106
Achilles 93, 96, 100, 187
Adorno, Theodor 29
Aegina 73, 126
Aemilius Paullus 256, 257
Aeschylus 185
Afghanistan 296
Agathon 194
Agesandros 258, 259
Agias 241, 242
Agorakritos 171, 175
Aigai 212, 240, 275
Ajax 92, 134
Akragas (mod. Agrigento) 155
Aktoriones (or Moliones) 61
Alcestis 181
Alcibiades 185, 194
Alcmaeonidae 126, 132
Alembert, Jean d' 19
Alexander I 222–223
Alexander III 141, 186, 213, 229, 242, 260, 263, 264, 269, 270, 272–274, 291, 292, 296
Alexander IV 293
Alexandria 229, 231, 237, 268, 274, 280–282, 283, 297
Alkamenes 171, 175
Alpheios 152
Amasis 21
Amazonomachy 158, 164, 170, 177, 178, 187, 261
Amorgos 253
Amphipolis 210
Andron 196
Andronikos from Cyrrhus 237
Andros 63
Antaradus 296
Antenor 126, 127, 132, 143
Anthropocentricism, -and greek art 25
Anthropology 12, 26, 30
Antigonos Monophthalmos 269
Antikythera 265, 282
Antikythera, mechanism 282
Antioch 231, 236
Antiochos III 264
Antiochos IV 126, 236
Anytos 250
Apamea 231
Apelles 262, 269–272, 275, 293
Aphrodite 76, 107, 175, 178, 181, 203, 225, 251, 252, 255, 296
 of Knidos, 203, 222
Apollo 62, 69, 73, 75, 80, 120, 123, 126, 128, 132, 147, 171, 184, 187, 188, 204, 233, 257, 261, 268
Apollodoros 20, 204
Apollonas, Naxos 106
Apollonios of Perga 282
Apoxyomenos 241

Archaeology
 as an academic discipline 11–13, 27, 28
 as history 27, 28
 definition 12
Archaeology, classical
 as an academic discipline 12–29
 at the University 30, 31
 and management of culture 29–32
Archaeometry 22
Archelaos 268
Archermos 123, 126
Archimedes 280, 282
Architecture, Greek 24
Ares 110, 252
Arethousa 222
Argos 51, 63, 75, 112, 173
Ariadne 107, 216
Aristarchos of Samos 282
Aristion 117, 125
Aristogeiton 126, 143
Aristonothos 88
Aristotle 115, 182, 234, 260, 262, 263, 282
Arkteia 169
Arrephoria 167
Arrephorion 167
Arsinoe II 285, 294
Arsinoe III 268
Art 24–26
 and Classical archaeology 19, 20, 24
 and literature 89
 and Greek culture 25
Artaphernes 183
Artemis 73, 107, 127, 128, 130, 132, 167, 169, 184, 207, 233
Artemisia 189
Ashmolean Museum, Oxford 31
Asia Minor see East Greece
Asklepios 180, 186, 232, 250, 253
Aspasios 177
Assyrian 66, 72, 135, 221
Astarte 76
Astronomy 230, 282
Atalanta 187
Athena 25, 74, 102, 131, 133, 135, 136, 158–159, 162, 171, 172, 175, 177, 187, 202, 206, 207, 222, 232, 233, 247, 261, 292
Athenion 298
Athenodoros 258, 259
Athens-Attica 40, 45–48, 50, 51, 54, 56, 65–67, 73, 78, 81, 86, 92–96, 100–103, 106, 108, 109, 111, 112, 121, 123, 124, 126, 134, 135, 141, 142, 155, 158, 160, 162, 163, 165, 167–169, 171, 177–183, 185, 186, 192–194, 196, 198, 199, 202, 206–208, 221, 222, 224, 225, 234, 236–238, 242, 243, 248, 257, 258, 266, 269, 275, 283, 284

Acropolis 23, 37, 102, 115–118, 121, 126, 131, 134, 135, 143, 155–169, 182
Agora 54, 134, 135, 165, 166, 196, 207, 234, 235, 265
Altar of the Twelve Gods 134, 165
Andronikos, Horologion 237
Apollo Patroos, temple 165, 207
Archaios neos 135
Artemis Agrotera, temple 168
Athena Nike, temple 155, 164
Attalos, Stoa 235
Brauronian Artemis, sanctuary 167, 168, 169
Chalkotheke 167
Enneakrounos 135
Erechtheion 16, 135, 155, 162, 163, 171, 177
Fountain 94, 135, 165
Hekatompedon temple 134–135, 155
Hephaistion 167
Hymettan 106, 135;
Kerameikos 56–58, 87, 93, 109, 126, 165, 179, 196, 208, 209, 265
Metroon 235
Middle Stoa 235
Nemesis, temple 168, 175
Olympian Zeus, temple 236
Panagia Gorgoepikoos 14
Panathenaic Way 165
Pandion, sanctuary 167
Parthenon, 14, 16, 135, 155–162, 177–179, 182, 246
Pendelic 106
Pinakotheke 162, 183
Poikile Stoa 165, 166, 183, 261
Poseidon, temple 109, 168
Propylaia 155, 162
Royal Stoa 165, 235
South Stoa I 165
South Stoa II 235
Themistoklean walls 126
Tholos 165, 187, 188
water supply system 94
Athletes 173, 174, 200, 201
Attalids 235, 246
Attalos I 244, 245, 248, 264
Attalos II 235, 245
Attalos III 246
Attic pottery shapes 90, 91
Augustus 258, 298

B

Babylonian culture 50, 221
Bacchiad 72
Bactria 229, 291
Banks 224
Basile 180
Bassae, Figaleia, temple of Apollo 170, 171

Beazley, John 21, 26
Berenice I 294, 296
Bion 266
Black Sea 19, 180, 188, 218, 289
Black-figure style 70, 86–97
Boeotia 70, 73, 75, 198
Boscoreale 278, 279
Bouleuterion 165
Boundary stones 165
Bourdieu, Pierre 30
Boutades 127
Brauron 167, 168, 169
British Museum, London 16, 30, 31
Bryaxis 189
Burial customs 46, 49, 54, 56, 179, 182, 212, 217
Burton, Decimus 16

C

Caere (Cerveteri) 97
Caledonian Boar 89, 187
Calf Bearer 121
Calpurnius Severus 299
Campania 278
Cappadocia 229
Caria 105, 188
Carthage 86, 155, 256
Caryatids 132, 162
Centauromachy 89, 152, 158, 160, 168, 170, 187
Chaeronea, battle 186
Chairestratos 243
Chalkis 48
Cheiron 48, 88
Chios 67, 74, 123, 220
Chronology, in archaeology 21–23, 29
Chryselephantine statues 177, 178, 152, 155
Chrysippos 265
Cicero 210
Cilicia 66
City-state 44, 48, 49, 65, 141, 186, 229
Classicism 249 252, 267, 297
Classification 12, 19–23, 26, 27, 31
Cleopatra (Delos) 267
Cleopatra VII 295
Clothing 114, 115, 133, 152–155, 170, 175, 176, 191
Colchis 217
Colonization 47, 49, 141
Coloring (in sculpture) 78, 119
Constantinople 177, 178
Contrapposto (counterpose) 142, 145, 172–174, 191, 203
Copies, Roman 23, 143, 145, 149, 150, 171–178, 204
Corfu 127, 128
Corinth 38, 46, 51, 66, 71–73, 80, 96, 127, 128, 183, 257
Corinthian capital 15, 85, 232, 233, 236

Cos 232
Cosimo de' Medici 15
Cossutius 236
Cremation 45, 46, 54, 55
Crete 47, 52, 61, 63, 66–68, 75–79, 107, 108, 126, 275, 283, 285
Crimean 218, 220
Cultural Resource Management 29–33
Cyclades 70, 73, 74, 104, 106, 108, 219
Cycladic civilization 37
Cyprus 37, 40, 43, 66, 147, 166
Cyriac of Ancona 15
Cyrrhus, Macedonia 237

D

Daedalic style 76–78, 104, 106–108, 112
Daedalus 78, 107
Damophon 249, 250
Daochos 241, 242
Daphnis 233
Darius 273
Dark Ages 40
Datis 183
Delos 11, 31, 73, 107, 132, 224, 238, 239, 255, 266, 267, 269, 274, 276, 285
Delphi 58, 62, 67, 68, 69, 72, 78, 100, 122, 126, 182, 187, 200, 256, 261, 264
 Apollo, temple 188
 Charioteer 147
 Daochos, monument 241, 242
 Kleobis and Biton 111, 112
 Knidos, Lesche 183
 Siphnians, treasury 100, 132, 133
 Tholos 187
Demeter 130, 243, 249, 253
Demetrias 275
Demetrios Poliorketes 275
Democracy 86, 141, 186
Demokritos 183
Demosthenes 193, 194, 261, 265
Derveni 216, 218, 288
Despoina 249, 250
Dexamenos 220, 223, 261
Dexileos 208
Dexiosis 209, 269, 275
Diadoumenos 173
Diderot, Denis 19
Didyma 120, 233
Diodorus Siculus 78
Diomedes 284, 297
Dionysermos 120
Dionysios 257
Dionysus 92, 97, 106, 188, 189, 193, 194, 204, 205, 216, 225, 258, 260, 264, 274, 289
Dioscuri 122
Dioscourides, gem engraver 298
Dioskourides (Delos) 267
Dipinti 88

Dipoinos 126
Dipylon 55–57, 60, 61, 103
Discobolos 149–151
Dodona 67, 214
Doidalsas 252
Domestic 193–199, 238–240
Doric order 15, 79–85, 232–240
Doryphoros 173, 241
Drachma 215
Draco 65

E

East Greece 67, 68, 74, 86, 96, 97, 105, 113, 120, 121, 132, 138, 183, 219, 220
Echelos 180
Economy 44, 45, 49, 64, 65, 70, 76, 92, 94, 95, 224–226, 231–233, 224, 295–299
Egypt 37, 41, 50, 104–106, 229, 230, 234, 237, 285
Eirene 202, 204
Ekphora 56
Eleusis 74
Eleutherna 77
Elis 152
Emery 104
Empedocles 183
Encaustic, method 119, 184
Endoios 126
Enlightenment 19, 21
 and classical antiquity 12
Entasis 81, 83
Epaulia 181
Ephesus 74, 128, 185, 207, 269, 270
Epiblema 77, 106, 114
Epidaurus
 Tholos 187, 188
 Temple of Asklepios 186
Erechtheus 135, 162
Eretria 48, 49
Ergotimos 89
Erichthonios 177
Etruria 70, 86, 88–89, 92, 96, 97, 180
Euboea 48, 49, 51, 63, 70, 75
Eudoxos of Knidos 282
Euclid 282
Eukratides I 295
Eumenes II 235, 246, 249
Euphorbus 74
Euphranor 207
Euphronios 21, 100–103
Euripides 181
Euryale 74
Eurytos 96
Euthymides 100, 103
Eutychides 242, 243
Euxitheos 100
Excavators 28
Exekias 21, 92–94
Exotic 254–256, 296

F
Felix 299
Filigree 54, 67
François, vase 89
Fresco 184, 212
Fresco-secco (Tempera) 184, 212
Funeral games of Patroklos 87, 89
Funerary monuments 110–112, 116, 117, 123–126, 178, 179, 208–209, 269, 271, 275, 276
Furtwängler, Adolf 26

G
Ganymede 223
Gauls 244, 245
Gela 71, 147
Geneleos 121
Geometric style 50–56
Geranos 73
Gigantomachy 132, 133, 135, 136, 158, 164, 168, 177, 246, 247
Glyptothek Munich 16
Gnathian pottery 283
Gnosis 272
Gombrich, Ernst 20
Gorgon 74, 86, 87, 127, 128, 135, 298
Graffiti 88, 105
Granulation 39, 54, 67
Grave marker (sema) 56, 87, 104, 110, 111, 116, 117
Griffin 66–69, 74

H
Hades 210–211
Hadrian 236
Halicarnassus 189–192
Hannibal 256
Harmodius 126, 143
Hector 74
Hediste 275
Hekate 196
Hekatompedon temple (Samos) 79
Hektoridas 187
Helios 158
Helmet, "Attic" 150, 177–178
 "Corinthian" 72, 145, 149, 150, 174, 206
 "Chalcidian" 150
Henning, John 16
Hephaestus 89
Hera 112, 113, 114, 126, 128, 257
Herakles 43, 48, 61, 62, 87, 96, 97, 132, 135, 154, 167–168, 187, 217, 222, 242, 247, 289–291
Herakles, knot of 107, 109, 288–290
Herculaneum (Italy) 243
Herculaneum Women 243–244
Hermes 100, 101, 180, 196, 204, 205, 208, 211
Hermes 204, 205

Hermogenes 233
Hero of Alexandria 281
Herodotus 11, 112, 132
Herulians 235
Hesiod 21, 50, 130
Himera, Battle of 86
Hipparchus 126
Hippias 143
Hippodamus 197, 231, 238
History
 and archaeology 27, 28
 academic discipline 12–19, 30
Hittite civilization 41, 50
Hoards (coinage) 224
Hodder, Ian 29
Homer 49, 53, 74, 94, 130, 214, 268, 299
Horror vacui 75
Horus 287
Hyperbolos 103
Hypnos (Sleep) 101

I
I.C.O.M. 32
I.C.O.M.O.S. 32
Icarus 78
Iconography 19, 20, 24, 25, 26
Iconology 26
Ictinus 155, 170
Idaean Cave 61, 62, 67
Ilissos 158, 168
Incision (on pottery) 70, 73, 74, 78, 87, 92
India 264, 291, 295, 297
Inwood, Henry 16
Inwood, William 116
Iole 96
Ionic order 15, 16, 79–85, 233–239
Iria (Naxos) 79
Ischia 52
Ischys 113
Isis 229, 253, 284–286, 289, 297
Isthmia 80
Isthmia, games 200

J
Johnson, Matthew 27–28, 33

K
Kallias 194
Kallikrates 155, 164
Kallimachos 258
Kallirrhoe 158
Kalos (inscriptions) 93
Kameiros 76
Kapodistrias, Ioannis 31
Kekrops 135
Kephisodotos 202, 204
Khrysaor 128

King Ludwig I of Bavaria 18
Kition 166
Kladeos 152
Kleisthenes 136, 141, 165
Kleitias 89
Klenze, Leo von 18
Kleon 103
Knidos 183, 203
Kore 107, 114–119
　Acropolis 115–119
　Antenor 126, 127, 132
　Peplophoros 115
　Phrasikleia 116, 117, 126, 261
　Cheramyes 114
Kouros 22, 107–113, 143
　Anavyssos (Kroisos) 22, 110, 111, 261
　Aristodikos 22, 110, 117
　Volomandra 111
　Dipylon 103, 104, 109
　Kerameikos 108
　Kleobis and Biton 111, 112
　Kitylos and Dermys 112, 124
　Melos 113
　Munich 22
　Samos 113
　Sounion 108
Krateros 264
Kresilas 175
Kritian Boy 143
Kritias 143
Ktesibios 280
Kynaigeiros 183
Kypselos 66, 72

L
Landscape-painting 278, 279
Lane-Fox Pitt-Rivers, Augustus 28
Laocoon 258, 259
Laodicea 231
Lapiths 152
Larisa, Asia Minor 84
Latrobe, Benjamin Henry 18
Lefkandi, Euboea 48, 49
Lemnos 172, 173
Leochares 189
Leto 132
Libation 131, 180, 181, 182
Libon 152
Lindos 232
Linear B 38, 39, 41, 45, 221
Linguistics 26
Literacy 38, 39, 44, 45, 50, 52, 53, 69, 87, 88, 89, 92, 93, 94, 96, 110, 111
Literature and art 89
Livy 256, 257
Lucius Scipio 257
Lucretius 22
Lychnitis 106
Lycia 101, 191
Lycurgus 65
Lydia 221
Lydian 92
Lykosoura 249, 250

Lysicrates, monument 193
Lysimachos 293–294
Lysippos 241, 242, 262, 263, 269, 293

M
Macedon 186, 197, 216, 222–223, 229, 230, 231
　Macedonian tombs 212, 213, 216
Magnesia in Asia Minor 233
Mantiklos 69
Marathon, battle 183
Masonry 199
Mausoleum 189–192, 233
Mausolus 189–191, 238
Meander 51, 60, 68
Medusa (gorgon) 74, 87, 127
Megara 66
Megarian bowl 284
Melos 60, 73, 74, 250, 252, 253
Menelaos 74, 75, 284
Mesopotamia 229
Metallurgy 37
Metrodoros 257
Michelangelo 258
Mikon 261
Miletus 74, 120, 197, 223
Miltiades 183, 261
Mimesis 104, 109, 131, 184, 202, 205
Minoan civilization 37
Minos 78
Minotaur 73
Mithras 229
Mithridates VI 22, 238, 264, 265, 275, 286, 295, 297, 298
Mna 221
Mnesikles 162
Moldings, architectural 81, 85
Moliones (or Aktoriones) 61, 62
Monarchy 229
Monumentality 43, 44, 68, 78, 103–107, 108–113
Motya (Mozia) 155
Museology 30–32
Mycenae 37, 43
　Lion Gate 43
Mycenaean civilization 37–45
Myron 149
Mys 171
Mysia 187, 247

N
Narrativity 25
Naxos 79, 104, 104–108, 113, 122, 123
Neandreia, Asia Minor 84
Near East 37, 38, 44, 48, 49, 50, 54, 66, 99, 138
Nearchos 92, 127
Nekrodeipnon 180
Nekyia 183
Nemea, games 200
Neoclassicism 15–18
Nereid Monument 191, 192
Nero 257

Nesiotes 143
Nessos 61, 87
Nestor 53
Nichoria, Messenia 48
Nikandre 106
Nike 123, 159, 164, 176, 177, 178, 187, 220, 222, 249, 285, 291
Nikias 205, 210
Nikomachos 210
Nikosthenes 94
Niobe 184

O
Obol 221–222
Odysseus 61, 74, 183, 259, 279, 299
Oechalia 96
Oenomaus 152
Oikos 194
Olympia 58, 59, 62, 67, 68, 132, 176, 200, 225
Olympic Games 50, 152, 200
Olynthos 23, 197–199, 238, 272
Onetorides 93
Opus tessellatum 274
Opus vermiculatum 273, 274
Orontes 242
Outline technique 70, 73, 74, 182–185, 210–214

P
Paestum 128, 129, 184
Paionios
　(from Ephesus) 233
　(from Mende) 176
　(from Rhodes) 259
Pakistan 296
Palestine 66
Palladion 259, 299
Pamphilos 210
Pan 255
Panainos 166, 183, 261
Panathenaia 94–96, 134, 159, 177
Pandora 177
Panticapaeum 217
Parrhasios 171, 185
Paris 206, 284
Paros 73, 106, 108, 113, 117, 178
Pastas 196, 198, 199
Pausanias 11, 78, 107, 126, 152, 159, 167, 171, 172, 177, 178, 183, 187, 202, 204, 206, 250, 257, 258, 262
Pederastic ethos 93
Pegasus 127
Peikon 102, 103
Peirithous 152
Peisistratus/Peisistratids 66, 94, 126, 134–136, 165, 167, 194, 236
Peleus 87–89, 181
Pella 238–240, 272, 274, 275, 283, 284
Peloponnese 39, 43, 47, 63, 78, 81, 86, 103, 111, 112, 198, 200, 249
Pelops 152
Peplophoros style 115, 119, 145, 202, 214

Perachora 63
Pergamon 230, 231, 235, 239, 240, 244, 246–249, 264, 274, 276, 282–285, 296, 297
Periander 66
Perikles 155, 261
Perirrhanteria 131
Peristyle 238
Persephone 210, 211, 243
Perseus (hero) 74, 87, 97, 128, 206
Perseus (Macedonian king) 256
Persia/Persians 86, 109, 136, 141–143, 155, 164, 167, 186, 223, 230, 248
Phalanx 72, 110, 111, 150
Pharnaces I 235
Phidias 152, 155, 160, 171–173, 175, 177, 178, 183, 202, 249, 50, 261
Philetairos of Pergamon 297
Philip II 22–23, 141, 213, 215, 269, 290
Philip III 293
Philoxenos 273
Phintias 100
Phocaea 97
Phoenicians 50, 66
Phryne 203
Pictorial scenes 19, 24, 25, 50–58, 60–62, 70, 89
Pigments 119, 181, 182, 184, 275, 284
Piraeus 197, 202, 207
Pisa 152
Pithekoussai 52, 53, 88
Plato 93, 210, 234, 262, 282
Pliny 123, 126, 127, 172, 173, 177, 183, 184, 189, 191, 202–205, 210, 211, 251, 257, 258, 262, 270, 272, 273, 275, 297
Ploutos 202
Plutarch 193, 261–263, 280, 293
Polos 60
Polycrates 66
Polydoros 258, 259
Polyeuktos 265
Polygnotus 166, 183, 184, 261
Polykleitos 20, 171, 173, 195, 202, 206, 241
Polykles 257
Polymedes 112
Polyphemos 25, 74, 259
Polyxena 284
Polyzalos 147
Pompeii 243, 260, 273, 274, 276, 278, 279
　Alexander, Mosaic 273, 275
　"Pompeian Styles" 276–279
Pompey 298
Pontos 229, 235, 238, 264, 275, 286, 293, 294, 297
Portraiture 220, 223, 260, 261, 264, 266, 293, 295–295
Poseidon 80, 109, 158, 168, 200, 250, 253, 297, 299
Potter 88, 92, 94, 95, 102, 103
Potter painter 88, 92, 102, 103
Praxiteles 203–205, 207, 210, 244, 251, 252, 257
Priene 233, 238, 268, 285

Priests 107, 130, 131
Prinias 78
Prostas 238
Prothesis 56
Protoattic pottery 73
Protocorinthian style 70–74, 76
Protogeometric style 45–47, 51
Psamtik (Psammetichos) I 105
Ptolemies 229, 235, 237, 253, 286, 293, 294, 297
Ptolemy I Soter 269, 292, 294
Ptolemy II 293, 294
Ptolemy III 234, 237
Ptolemy IV 268
Ptolemy VI 297
Pylos 37, 39, 53
Pyrgoteles 263, 269, 293, 296
Pythagoreans 183
Pytheos 189–191, 233
Pythian games 147, 200

Q
Quarries 106

R
Rahl, Karl 27
Red-figure style 100, 101, 180–182
Reggio di Calabria 173
Religion 130, 131
Renaissance 12, 14, 15, 26, 28, 258, 291, 294
 and classical antiquity 12, 23
Restoration 29, 31, 32
Rhamnous 168, 176, 243
Rhodes 40, 63, 66, 67, 76, 258, 259, 283
Riace, Warriors 173
Rich style 175, 176, 181, 187, 192
Roman civilization 12, 19, 24, 25, 150 (copies), 231 (presence), 256–260
Romanticism 12, 17
 and Classical archaeology 23
Rome 210, 231, 234, 236, 238, 240, 246, 256–260, 263, 265, 279, 286, 295, 298

S
Sack of Troy 166, 183
Sacrifice 130, 131, 183
Salamis, Battle 86, 141, 143
Samos 63, 66, 67, 68, 74, 78, 79, 113, 121, 126, 128, 132, 185, 282
Samothrace 249

Sanctuaries 50, 58, 59, 79–81, 102, 106, 130, 131, 142, 224, 232–236, 269, 285
Sarpedon 100, 101
Satyr (Sleeping) 255
Satyr 101, 139, 289
Satyros (architect) 189
Satyros (boxer) 262
Scarab 138, 139, 219
Science 230, 280–282
Sculptors 104, 106, 108, 109, 111, 118, 123, 125, 126, 143, 188, 189, 191, 202, 203, 218
Scythians 217–219
Seals 138, 214, 219–220
Selene 158
Seleucid Babylonia 239
Seleucid dynasty 242
Seleucid Mesopotamia 229
Seleucid Prince 263
Seleucid state 246
Seleucus I 242
Seneca 280
Serapis 253, 268, 297–298
settlements 48, 49, 49, 62–63
Severe Style 142–155, 171–175, 261
Shading (in Greek: skiagraphia) (in painting) 184, 185, 210, 211, 269, 270, 274, 278
Sicily 19, 71, 81, 86, 128, 154, 155, 180, 220, 222, 256, 274, 275, 283, 284
Sikyon 127, 183, 210
Silanion 262
Silhouette (in Greek pottery) 46, 47, 51, 70, 71, 73, 74, 87, 98, 183
Simon 196
Siren 66, 68
Skenographia 185, 210, 278, 279
Skopas 187, 189, 207, 208
Skyllis 126
Slip 87, 92
Smikros 100, 103
Smilis 126
Smyrna 63, 67
Socrates 196
Solon 58, 65, 102, 121
Sophilos 87
Sounion 108, 109, 168
South Italy 19, 71, 81, 86, 128, 180, 183, 184, 185, 206, 210, 220, 222, 256, 257, 284
Sparta 48, 65, 126, 142, 155, 186, 222
Sperlonga 259
Sphinx 66, 68, 122, 124, 177, 217
Sports 200
Statue 104, 114, 131

Stheno 74
Stickland, William 18
Stoa 165
Stoa of Zeus, 165, 235
Stratigraphy 28
Style 18, 20, 21, 24, 26, 34
Sulla 206, 236, 256, 258
Surface survey 29
Symposium 52, 66, 70, 89, 90, 91, 93, 96, 98, 99, 180, 184
Syracuse 71, 222, 223, 256, 280
Syria 59, 61, 66, 68, 76, 77, 81, 230, 236, 242, 264, 275, 285, 286, 294, 296

T
Talent 221
Taman 289
Tammasos in Cyprus 147
Tanagra in Boeotia 112, 152
Tanagra Women (type) 225, 285
Taras (Taranto) 71, 147, 256
Technology 12, 13, 19, 21, 45, 70, 104
Tegea 187, 208
Telamon 133
Telephos 187, 247
Temple (morphology) 62, 63, 81–85
Temple of Aphaia 18, 133
Tenos 63
Tetrachromy 183, 184
Thanatos 101
Thasos 67
The lost wax technique 148
Theagenes 66
Thebes 37, 69, 186, 210
Themis 243
Themistokles 261, 262
Theodoros 187
Theodotos 186
Thermon in Aitolia 63, 80, 127
Theseus 48, 73, 107, 152, 167, 168
Thessaly 289
Thetis 181
Thrasymedes 186
Thucydides 11, 126, 143, 144
Tiberius 259
Tiles (typology) 80
Timarchides 257, 258
Timotheos 186, 187, 189
Tiryns 37, 39, 40
Tissaphernes 221, 261
Titanomachy 128
Titus (Emperor) 258
Titus Flamininus 295
Trafficking, of antiquities 30, 31
Travelling (traveler) 11, 15
Treasuries (architecture) 132, 133

Triton 135
Trompe l'oeil 185
Troy 100, 158
Tyche 230, 242, 243, 245, 275
Types (of Greek temple architecture) 79–85
Typology 20
Tyrannicides 27, 126, 143, 144, 261
Tyranny 65, 86, 126, 134, 136, 144
Tyrtaeus 72

U
U.N.E.S.C.O. 24, 32
Urban planning 165, 196, 197, 199, 231, 238, 239

V
Vergina 210–215, 240, 288
Vernant, Jean Pierre 26
Vidal-Naquet, Pierre 26
Virgil 22, 258, 299
Vitruvius 189, 279
Vix, krater 138
Vonitsa, Akarnania 178
Votive reliefs 180, 268
Votives 58, 61, 68, 102, 103, 121, 123, 169, 178, 180, 181

W
West slope ware 283
Wheel (pottery) 38, 181
Wheeler, Mortimer 28
White-ground vessels 181–185
Wild goat, style 74, 75
Winckelmann, Johann Joachim 23, 258

X
Xanthos 191, 192
Xenophon 196
Xerxes 126
Xoanon 104, 106, 107, 131, 177

Z
Zeno 166, 234
Zeus 25, 50, 68, 100, 132, 146, 151–154, 158, 165, 167, 176, 178, 200, 202, 214, 222–224, 235, 236, 246, 247, 250, 253, 257, 268, 291, 292, 297
 Artemision Zeus 147, 148, 214
 Zeus Polieus, sanctuary 167
 Zeus, temple 151–155, 177, 178
Zeuxis 185

SOURCES OF ILLUSTRATIONS

I would like to thank those who kindly allowed me
to use their photographs and plans:
The Archaeological Society at Athens, Melissa Publishing House,
F. de Callataÿ, D. Damaskos, A. Kokkou, M. Korres, S. Mavrommatis,
I. Ninou, O. Palagia, Th. Sideris, M. Tsimpidou-Avloniti, C. Wagner, E. Hasaki.

D.P.

1. IMAGE DEPOSITORIES

• Dimitris Plantzos: figs. 2, 5, 6, 11, 14, 17–20, 158, 283, 285–287, 289, 300–301, 303, 319, 346, 361, 382, 444–445, 447–448, 579, 586–588.

• Kapon Editions: figs. 7, 8, 12, 32, 42, 44, 46, 47, 48, 59, 60, 69, 70 72, 77–83, 95, 97–99, 101, 102–103, 104–105, 106, 107, 108, 111, 112, 113 115–116, 119, 125, 131–133, 134 137, 138–139, 142, 145–146, 147, 153, 157, 159–164, 166, 172–174, 177, 179, 191, 192, 194, 197, 207–210, 212–213, 217, 233, 235, 239 245–248, 268, 271, 272, 274–281, 299, 304, 305, 309–314, , 320, 322, 324, 326, 327, 330–332, 337, 338, 340–343, 349, 352–360, 362, 377–380, 383–384, 386, 408, 411–412, 419, 423, 424, 427–429, 431–432, 436, 441, 458–462, 464–474, 476–486, 488–490, 492–493, 495–500, 502–503, 505–509, 515–517, 519, 528, 541, 544, 547–548, 553–578, 580, 585.

• Beazley Archive, Oxford: 62, 63, 64, 72, 390, 391, 555, 556, 557, 558, 563–566.
• ARTstor Academic Publishing: figs. 1, 9, 10, 336, 504
• Bibliothèque Nationale, Brussels: 309, 3104–399, 402, 403, 406, 407.
• École Française d'Athènes: figs. 200, 203, 334.
• D. Damaskos: 435, 439.
• The Archaeological Society at Athens: 266, 268, 272, 424, 427.
• Foundation of the Hellenic World: 108, 109, 110, 112.
• O. Palagia: 270.
• M. Tsimpidou-Avloniti: 501–503.
• Metropolitan Museum of Art: εικ. 52, 376, 531, 533–534

2. PUBLICATIONS

M.L. Anderson, *Pompeian Frescoes*. Metropolitan Museum of Art (1987): figs. 511, 515.

Α.Γ. Βλαχόπουλος (ed.), *Αρχαία Αθήνα και Αττική*. Athens: Melissa Publishing house (2010): 250, 279.

W.R. Biers, *The Archaeology of Greece*. London: Cornell University Press (2nd ed. 1996): figs. 35, 37, 41, 74, 76, 88, 111, 328, 329, 350, 351.

J. Boardman, *Greek Sculpture. The Archaic Period*. London: Thames & Hudson (1985): figs. 149, 154, 164, 177, 183.

J. Boardman, *Archaic Greek Gems*. London: Thames & Hudson (11048): fig. 218.

V. Brinkmann et. al., *Πολύχρωμοι Θεοί. Χρώματα στα Αρχαία Γλυπτά*. Athens: National Archaeological Museum (2007): figs. 173, 174.

P. Bruneau & J. Ducat, *Guide de Délos*. Paris: Éditions E. de Boccard (1983): figs. 431, 434.

J. Camp, *The Athenian Agora. Excavations in the Heart of Classical Athens*. London: Thames & Hudson (1986): figs. 46, 278, 282, 347, 348.

J. Camp, *The Archaeology of Athens*. London: Yale University Press (2001): fig. 286.

G. Ch. Chourmouziadis, *The Gold of the World*. Athens: Kapon Editions (1997) figs. 90, 110, 236, 323, 400–407

D. Damaskos & D. Plantzos (ed.), *A Singular Antiquity. Archaeology and Hellenic Identity in Twentieth-Century Greece*. Athens: Benaki Museum (2008): figs. 16, 17.

N. Dimopoulou-Rethemiotaki, *The Archaeological Museum of Herakleion*. Athens: EFG Eurobank Ergasias S.A. / John S. Latsis Public Benefit Foundation (2005): fig. 80.

Chr. Dionysopoulos, *The Battle of Marathon. An Historical and Topographical Approach*. Athens: Kapon Editions (2016): figs. 316, 317, 413–414.

S. Drougou & Ch. Saatsoglou-Paliadeli, *Vergina. Wandering through the Archaeological Site*. Athens: Ministry of Culture, Archaeological Receipts Fund (1999): 435, 436.

Y. Galanakis (ed.), *The Aegean World, Guide to the Cycladic, Minoan and Mycenaean Antiquities in the Ashmolean Museum*. Athens: Kapon Editions (2013): fig. 31.

E. Georgoula (ed.), *Greek jewellery from the Benaki Museum collections*. Athens: Benaki Museum – Adam / Pergamos Publications (1999): fig. 45.

G. Gruben, *Ιερά και ναοί της αρχαίας Ελλάδας*. Athens: Kardamitsa Publications (2000): figs. 115, 236, 290, 291, 292, 418, 419, 421.

W. Hoepfner – E.-L. Schwandner, *Haus und Stadt im klassischen Griechenland Neubearbeitung*. Berlin: Deutscher Kunstverlag (1994): 349, 355.

V. Karageorghis, *Excavating at Salamis in Cyprus*. Athens: The A. G. Leventis Foundation (1999): figs. 82.

E. Korka (ed.), *Greece, World Heritage Monuments and Sites*. Athens: Hellenic Ministry of Culture (2009): fig. 195 (E. & M. Myers).

A. Kottaridi, *Macedonian Treasures: A tour Through the Museum of the Royal Tombs of Aigai*. Athens: Kapon Editions (2011): figs. 391, 392, 394–395, 551–552.

S. Lydakis, *Ancient Greek painting*, Athens: Melissa Publishing House (2004): 414, 504, 505, 506, 508, 512–514, 516.

Χ.Θ. Μπούρας, *Μαθήματα Ιστορίας της Αρχιτεκτονικής*, vol. I. Athens, National Technical University of Athens (1980): figs. 114, 430.

Νόστοι. Επαναπατρισθέντα Αριστουργήματα. Athens: Ministry of Culture (2008): figs. 138, 139.

Α. Ορλάνδος, *Τα Υλικά Δομής των Αρχαίων Ελλήνων*. Athens: Βιβλιοθήκη της εν Αθήναις Αρχαιολογικής Εταιρείας (1959–60): fig. 354.

R. Osborne, *Greece in the making, 1200–479 BC*. Abingdon: Routledge (1996): figs. 48, 49.

L. Parlama – N.Chr. Stampolidis (eds), *The City Beneath the City*. Athens: Ministry of Culture – Museum of Cycladic Art (2000): figs. 27–32, 128.

D. Plantzos, *Hellenistic Engraved Gems*. Oxford: Oxford University Press (1999): fig. 553.

A. Samara-Kauffmann, *The Sea: Of Gods, Heroes and Men in Ancient Greek Art*. Athens: Kapon Editions (2008): figs. 64, 136, 148

I. Scheibler, *Ελληνική Κεραμική. Παραγωγή, εμπόριο και χρήση των αρχαίων ελληνικών αγγείων*. Athens: Kardamitsa Publications (1992): fig. 118.

R.R.R. Smith, *Hellenistic Sculpture*. London: Thames & Hudson (1991): fig. 444.

R.R.R. Smith, *Hellenistic Royal Portraits*. Oxford: Oxford University Press (1988): fig. 487.

N.Chr. Stampolidis – Y. Tassoulas (eds), *Magna Graecia*. Athens: Organising Committee of the Olympic Games – Museum of Cycladic Art (2004): figs. 131, 233, 246, 247.

I. Τραυλός, *Πολεοδομική εξέλιξις των Αθηνών*. Athens: Kapon Editions (2004): figs. 222, 224, 265, 296, 442

P. Tournikiotis (ed.), *The Parthenon: And its impact in modern times*. Athens, Melissa Publishing House (1994): figs. 3, 4, 251, 257.

I. Trianti, *The Acropolis Museum*. Athens: Eurobank / Latsis Group (1998): fig. 140.

P. Valavanis, *The Acropolis through its Museum*. Athens: Kapon Editions (2013): figs. 21, 89, 156, 181, 186–188, 195, 196, 203–205, 225–226, 227, 238, 240, 241, 264, 290–293, 494, 501.

P. Valavanis, *Games and Sanctuaries in Ancient Greece*. Athens: Kapon Editions (2004): figs. 66–68, 71, 85, 93, 96, 114, 144, 149, 150, 198, 215, 218, 220–221, 244, 250, 251, 253–261, 297, 318, 321, 373–375, 420, 456–457.

P. Valavanis (ed.), *Great Moments in Greek Archaeology*. Athens: Kapon Editions (2007): figs. 167–168, 169, 175, 178, 182–185, 269, 381, 385, 388, 393, 430, 451, 452, 475, 510, 538-539.

J. Vokotopoulou, *Guide du Musée Archaéologique de Thessalonique*. Athens: Kapon Editions (1996): figs. 237, 398, 399

S. Walker & P. Higgs, *Cleopatra of Egypt. From history to myth*. London: The British Museum Press (2001): figs. 415, 499, 520.

J. Whitley, *The Archaeology of Ancient Greece*. Cambridge: Cambridge University Press (2001): figs. 33, 105, 106, 331, 332, 335, 352, 353, 356.

ARTISTIC DESIGNER: **RACHEL MISDRACHI-KAPON**
ARTISTIC ADVISOR: **MOSES KAPON**
COPY EDITOR: **VASILIKI SCHIZA**
DTP: **ELENI VALMA, MINA MANTA, DEMETRA POULAKI**
PROCESSING OF ILLUSTRATIONS: **MICHALIS TZANNETAKIS**
PRINTING-BINDING: **PRINTER TRENTO** (Trento), ITALIA